ISBN 978-1-331-93359-5
PIBN 10256442

English
Français
Deutsche
Italiano
Español
Português

www.forgottenbooks.com

Mythology Photography **Fiction**
Fishing Christianity **Art** Cooking
Essays Buddhism Freemasonry
Medicine **Biology** Music **Ancient**
Egypt Evolution Carpentry Physics
Dance Geology **Mathematics** Fitness
Shakespeare **Folklore** Yoga Marketing
Confidence Immortality Biographies
Poetry **Psychology** Witchcraft
Electronics Chemistry History **Law**
Accounting **Philosophy** Anthropology
Alchemy Drama Quantum Mechanics
Atheism Sexual Health **Ancient History**
Entrepreneurship Languages Sport
Paleontology Needlework Islam
Metaphysics Investment Archaeology
Parenting Statistics Criminology
Motivational

FRENCH ENGRAVERS
AND DRAUGHTSMEN
of the XVIIIth Century

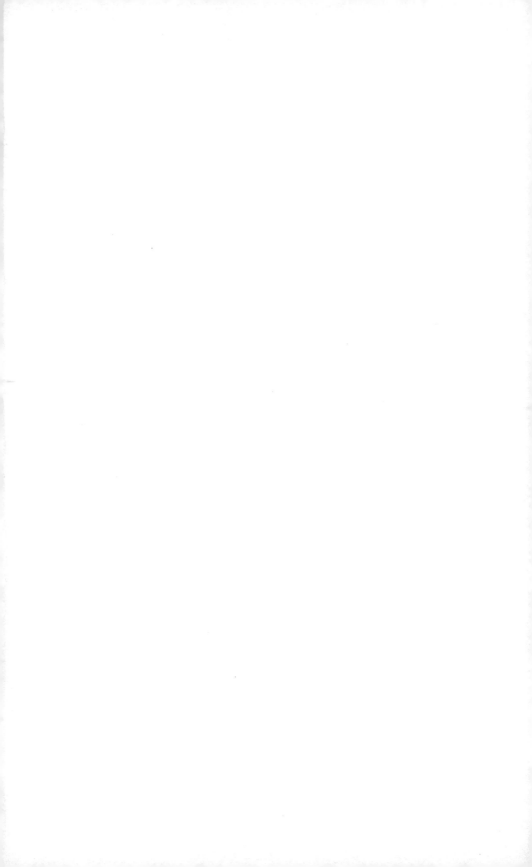

La Revue de la Plaine des Sablon

(Engraved by Malbeste, Liénard and Née, after

By LADY DILKE

AUTHOR OF "THE RENAISSANCE IN FRANCE," "CLAUDE LORRAIN, SA VIE ET SES
ŒUVRES," "ART IN THE MODERN STATE, OR THE AGE OF LOUIS XIV.," "FRENCH
PAINTERS OF THE XVIIITH CENTURY," "FRENCH ARCHITECTS AND SCULPTORS
OF THE XVIIITH CENTURY," "FRENCH DECORATION AND
FURNITURE IN THE XVIIITH CENTURY," ETC.

LONDON: GEORGE BELL AND SONS
YORK STREET, COVENT GARDEN
1902

CHISWICK PRESS: CHARLES WHITTINGHAM AND CO.
TOOKS COURT, CHANCERY LANE, LONDON.

PREFACE

WITH this volume ends the series in which I have attempted to sketch the leading features of French Art in the eighteenth century and to trace the action of those social laws under the pressure of which the arts take shape just as dogma crystallizes under the influence of preceding speculation. The difficulties of selection and omission have been great, and every day I have received fresh suggestions as to the way in which I ought to have dealt with my subject. For my purpose it seemed better not to venture on a systematic history but to follow lines on which I have previously found myself able to interest my readers. I therefore have throughout selected in each division one or two artists who seemed to represent special tendencies connected with the life of the day and whose work, still existing, could be treated in some detail.

In respect to the illustrations of these final pages, special difficulties, not unforeseen, have had to be encountered. Architecture, Painting, or Sculpture can secure better representation in a volume of this size than can be obtained for the art of Engraving. The reproduction of an engraving, even by a costly process in skilled hands, is always unsatisfactory unless carried out on the same scale as the original. Of a necessity the texture of the execution is confused by reduction : the lines, crosslines, hatchings and stipplings run together and are choked in each other so that what should be a luminous expression of form becomes a meaningless pond of ink. As far as possible, therefore, examples have been selected that could be given of their full size. Yet in spite of the friendly help of M. Bouchot and his staff at the Cabinet des Estampes, the equally kind services of my friends of the Gazette des Beaux Arts and the counsels of that distinguished engraver,

M. Achille Jacquet, I find myself baffled by very delicate work such as Choffard's portrait of himself in the " Contes de la Fontaine," or the exquisite head of Marie-Leczinska engraved after Nattier by Gaucher. That these reproductions are even—approximately —excellent is due to the zealous supervision of M. André Marty and the skill of Paris printers.

Drawings of course come out better, and I owe grateful thanks to Baroness James de Rothschild; to Madame Aboucaya, M. Jacques Doucet, M. Beurdeley and other collectors for the generosity with which they have allowed me to make use of their treasures.

<div align="right">EMILIA F. S. DILKE.</div>

CONTENTS

CHAPTER I

THE COMTE DE CAYLUS AND THE GREAT "AMATEURS"

CHAPTER II

MARIETTE AND BASAN

CHAPTER III

LE CHEVALIER COCHIN

CHAPTER IV

THE DREVET AND JEAN-FRANÇOIS DAULLÉ

The traditions of Edelinck, Nanteuil and the Audran inherited by the Drevet. The family of Drevet de Loire one of the first in their district. Pierre Drevet with Germain Audran at Lyons, then with Gérard Audran at Paris. Associate of the Academy in 1703. Pierre-Imbert Drevet presents himself in 1724. Father and son work together. Portrait of

CHAPTER V

WILLE AND HIS PUPILS

CHAPTER VI

LAURENT CARS, FLIPART AND LE BAS

CHAPTER VII

THE PUPILS OF LE BAS AND THE ENGRAVERS OF THE VIGNETTE

CHAPTER VIII

GRAVELOT AND EISEN

CHAPTER IX

THE SAINT-AUBIN, MOREAU LE JEUNE, BOILLY, PRIEUR

CHAPTER X

The Engravers in Colour

CHAPTER XI

Engravers and the Academy

APPENDIX

xiii

LIST OF ILLUSTRATIONS

All engraved works are entered under the names of the engravers. With one exception (No. 5) they have been reproduced from examples in the Print Room of the Bibliothèque Nationale.

XV

TO FACE List of
PAGE Illustra-
tions.

xvii

LIST OF ABBREVIATIONS

G. B. A.	= Gazette des Beaux Arts.
A. de l'A. fr.	= Archives de l'Art français.
N. A.	= Nouvelles Archives de l'Art français.
P. V.	= Procès-verbaux de l'Académie Royale.
Wille Mém.	= Mémoires et Journal de Jean-Georges Wille.
Basan, Dict.	= Basan, Dictionnaire des Graveurs.
Cochin, Mém. inéd.	= Mémoires inédits de Charles-Nicolas Cochin.
A. B. C. Dario	= Abecedario de P.-J. Mariette.
Not. hist.	= Notice Historique.
Portalis and Béraldi	= Portalis et Béraldi, "Les Graveurs du XVIII Siècle."
Portalis, "Les Dessinateurs"	= Portalis, "Les Dessinateurs d'Illustrations au XVIII Siècle."
French Painters, etc.	= French Painters of the XVIIIth Century.
French Architects and Sculptors, etc.	= French Architects and Sculptors of the XVIII Century.
French Decoration, etc.	= French Decoration and Furniture in the XVIII Century.
B. M.	= Print Room, British Museum.
Chal. du Louvre	= Chalcographie du Louvre.
A.	= Agréé.
R.	= Reçu.
Engd.	= Engraved.
Ex.	= Exhibited.
lt.	= livres tournois.

FRENCH ENGRAVERS AND DRAUGHTSMEN
OF THE XVIII CENTURY

CHAPTER I

THE COMTE DE CAYLUS AND THE GREAT "AMATEURS"

IT is even more difficult to give a systematic account of French engravers and draughtsmen in the eighteenth century than to write of the painters, the architects, the sculptors and the decorators. To treat of them chronologically or to break up their work into sections according to the subject would be to give this volume the character of a text-book—useful, perhaps, but unreadable. I have therefore again attempted to select the man in each division who has impressed me as a typical personality, and to group round him others who appear less marked in character or who present features which may be emphasized by way of contrast.

The notice of the Comte de Caylus with which this volume opens has been reserved till now because, though he exercised during the early part of the century an extraordinary influence over every branch of art, his own practice connects him specially with engraving. His close alliance with Mariette carries us naturally to the consideration of that famous printseller, collector and publisher, who, if he engraved little, bought and sold a great deal. In conjunction with de Caylus, Mariette exercised an authority with which, as long as they lived, every dealer, draughtsman and engraver had to reckon. In this connection Basan— whom Mariette appointed to deal with his collections—cannot be overlooked. These men form the background for the activity of

The
Comte de
Caylus
and the
great
"Ama-
teurs."

others, but their influence was contested even during their lives
by the growing power of Cochin fils, who, backed by Marigny,
exercised a vigorous direction in his name.

When we come to the engravers and draughtsmen proper the
first thing that strikes us is their marvellous power of drawing—
due to the severe studies of which they possessed the wholesome
tradition. The Drevet—those great engravers of portrait—were
the direct heirs of Nanteuil, and to them Daullè, Beauvarlet,
Wille and their pupils were deeply indebted. If we turn to those
men, who devoted themselves to *pièces historiques*, the name of
Laurent Cars stands first, and his character and connection with
business may be contrasted with the character and business of his
younger rival Le Bas, out of whose workshop went nearly all the
vignettistes and engravers of the "estampe galante" to whom I
have devoted the following chapter.

Gravelot and Eisen, amongst the draughtsmen, precede the
Saint-Aubin, Moreau le jeune, Boilly and those other designers
whose work lent itself specially to the pretty art of engraving in
colour, which is essentially of the later days of the century ; and for
the concluding pages I have kept a short account of the relations
of engravers to the Academy of Painting and Sculpture, with the
suppression of which and the proclamation of the " Commune des
Arts " this work ends.

It was the fashion to engrave in the eighteenth century.
Cochin's famous pupil, Madame de Pompadour, was by no means
original in her efforts to practise the art. Everybody of distinction
knew something of the use of the needle or the graver, and lengthy
would be even a list of amateurs, some of whom—like de Thiers
or the Chevalier de Valory—left a considerable group of work. If
we pick out only the most noted names, the Marquis d'Argenson
may stand first in point of time with his "Vue du Chàteau des
Bergeries." Then come the Dukes of Chevreuse, of Charost and
of Chaulnes; the Princess de Condé; the Marquise de Belloy ;
the Marquis de Coigny ; the Marquis d'Harcourt ; the Count de
Breteuil, the Count de Clermont and the Count d'Eu. Others as
widely different in type as Bachaumont, the writer of those " Mé-
moires Secrets " which are the most excellent chronicle of their
day, and Bertinazzi dit Carlin, the famous actor, shared the enthu-
siasm of the Court, to which Philippe Egalité himself paid tribute
when, as Duke de Chartres, he engraved in 1761 two little subjects
after Carmontelle.[1]

[1] "Paysanne de St.-Cloud" and "Manœuvre de St.-Cloud."

2

For the most part these courtly artists left little behind them. They contented themselves, after the fashion of Campion,[1] the gallant *contrôleur général*, with a dozen or so examples of a skill by which they paid homage to the divinity of the moment:— à Mme. de Cypierre, "Vues des bords de la Loire"; à Mme. de Guillonville, "Vues des bords du Loiret"; à Mme. la marquise de Pilles, "Vue de Meung." Others employed their art with so much indiscretion that it might be said of them, as of Vivant Denon,[2] one of the most distinguished of this group of amateur engravers, that their chief occupation was "la gravure et les femmes." He, indeed, seems to have owed much of his success and even his great position at the beginning of the nineteenth century to this means of popularity with women. They were all delighted to sit to him. The list, which begins with Madame Vigée Lebrun and includes Lady Hamilton, is a long one, and his charm is said to have been sufficient to soften even the bitterness of captivity to the outraged Pius VII.

Painters have always, like Coypel,[3] Rivalz, "M. le chevalier d'Origny,"[4] Pierre and others, engraved or etched their own work as a matter of course. Throughout the eighteenth century the etching needle was never out of their hands, though few, if we except Watteau, Oudry perhaps, and Fragonard, ever attained to a high degree of skill or showed any originality of method. The student days in Italy generally saw the birth of these attempts. There it was, as we may remember, that Fragonard engraved and re-engraved subjects after Tiepolo, "son maître de gravure"; there, too, he rendered with deep personal feeling and spirit that forgotten corner of the neglected garden of some patrician villa, which is known to collectors as "Le Parc." In Italy, also, Fra-

[1] 1734-1784.

[2] 1747-1825. He was Director of the Imperial Galleries during the reign of the first Napoleon, and had an enormous influence on the movement of the arts. In 1815, after having resisted obstinately the removal of the spoils amassed in the Louvre, he resigned his post. "Toutes les fois," we are told, "qu'un enlèvement devait avoir lieu, il était pris au collet et gardé à vue dans son cabinet par un peloton de soldats prussiens" (Clément de Ris, "Les Amateurs d'autrefois," p. 437).

[3] Charles Coypel, the designer of the famous illustrations of "Les Aventures de Don Quichotte" ("French Painters, etc.," p. 28, and "French Decoration, etc.," p. 103), is the author—amongst other pieces of a like character—of "L'Histoire d'une Dévote," which consists of four satirical subjects: 1. "La Dévote va à la messe"; 2. "Elle s'offre en holocauste"; 3. "Elle querelle sa servante"; 4. "Elle calomnie son prochain." One may also note an amusing "Assemblée de brocanteurs" with asses' heads examining works of painting and sculpture, and a "lady making her will in the presence of her lover, her lawyer and her cat"—the cat evidently is to be the universal legatee.

[4] See Salons of 1739 to 1743.

3

The
Comte de
Caylus
and the
great
"Ama-
teurs."

gonard etched his four "Bacchanales" or "Jeux de Satyrs" (1763), the handling of which—like his brilliant work of a different character and later date, " L'Armoire "—shows an intuitive perception of the resources of the process employed and qualities which are not revealed by many of the easel pictures which now, in some cases, enjoy an exaggerated reputation. Many of Fragonard's etchings have all the charm of his drawings or of his best decorative work, whereas his achievements as a painter are of an amazing inequality, and differ in value to a quite exceptional degree.

Amongst amateurs, the learned, self-consequent nephew of Madame de Maintenon, the Comte de Caylus[1]—whose authority and influence form one of the most remarkable features of the day—stands in the front rank. The importance of his position, the very nature of his faults and failings, his vast pretensions, real merit and indifferent accomplishment combine to make him an admirable representative of the wealthy amateur in the earlier half of the century, just as we find in Watelet and Saint-Non the finished pattern of the inferior types fashionable at a later date. The exaggerated seriousness with which Caylus took himself might be expected of a man who had sat on the knees of the Great King,[2] but we may recollect that his sense of his own dignity and importance was no hindrance to those touching relations with Watteau which are the consecration of de Caylus's life.

" It is well to remember," says Cochin, " in respect of the petty despotism which M. de Caylus sought to exercise over the arts, that he had become accustomed to it little by little, which is as it were his apology. Perhaps, indeed, in the beginning of his relations with artists he had no such scheme."[3] His friendship with Watteau was certainly untainted by any of that ambition to play the patron by which he was devoured in later years. No estimate of his character will be just that omits to reckon with his real love of and devotion to the arts, or to take into account that he most certainly knew more about them than any other amateur of his day. When he died, the loss of " ce connoisseur profond "

[1] 1692-1765. Anne-Claude-Philippe de Thubières, de Grimoard, de Pestels, de Levi, Comte de Caylus, was the son of Marguerite de Villette, great-niece of Mme. de Maintenon and stepdaughter of that Marquise de Villette who married Bolingbroke after the death of her first husband.

[2] " N'étant encore que mousquetaire, il se distingua à la bataille de Malplaquet, de façon qu'au retour de la campagne, le roi, par amitié pour Mad⁰ de Maintenon, le prit sur ses genoux, en disant : 'Voyez mon petit Caylus ; il a déjà tué un de mes ennemis ' " (A. B. C. Dario, Mariette).

[3] Cochin, Mém. inéd., p. 64.

4

was sincerely regretted by the Academicians, in spite of their personal and painful experience that, as Cochin puts it, "men of quality, though doubtless conferring honour on the body to which they attach themselves, unfortunately know it too well, and it is rare that their protection does not degenerate into something like tyranny." [1]

The pretensions of de Caylus to be an universal expert were at least backed by persistent study and some practical knowledge of more than one branch of art. . He was not only a draughtsman and etcher of no mean excellence, but all that experience which may be won by the constant direction of the attention and steady training of the powers of perception was undoubtedly his. He started for Italy on the death of the old King, from whose favour he had much to expect: " huit mois après," we are told, " il saisit l'occasion de passer dans le Levant. Il partit avec M. de Bonac, qui alloit relever M. Desalleurs à la Porte Ottomane." [2] Thenceforth, de Caylus gave up his whole existence to the serious study of those subjects in which he honestly delighted. Rich and well-placed, he abandoned the dignities of the Court [3] and the pleasures of his class in order to devote himself to literature, [4] to archæology, to every branch of art. When he finally returned to Paris after a prolonged exploration of Asia Minor, he settled with his mother in a house surrounded by the gardens of the Petit Luxembourg, and at once began to reproduce the treasures of Crozat's famous collections with his indefatigable needle.

In a most touching letter, written on the occasion of his mother's death to the abbé de Conti, de Caylus lets us see how beautiful his life with her at this date had been. "Je ne sçais plus vivre . . .," he writes; "à tout ce que le commerce le plus aimable peut avoir de plus séduisant, à toute la volupté de la paresse qu'il entraînoit à sa suite, il a succedè une solitude affreuse." [5] Rallying his strength, de Caylus devoted all his powers to the task which he had set himself, when the riches of de Crozat's portfolios were revealed to him, with that deliberate persistence which sustained him throughout his life.

[1] Cochin, Mém. inéd., p. 25.
[2] Le Beau, "Eloge de Caylus." An account of this journey, of interest to all who concern themselves with classical archæology, was given by M. Müntz from an unpublished MS. at a sitting of the Acad. des Inscriptions, April 6th, 1900.
[3] He lived at first, after leaving the Petit Luxembourg, in a small building on the terrace near the Tuileries. When the growth of his collections forced him to seek larger quarters, he built an hôtel in the rue Saint-Dominique.
[4] See Appendix A for list of his works.
[5] Letter of June 17th, 1729 (de Goncourt, "Portraits intimes," t. ii., p. 22).

The
Comte de
Caylus
and the
great
" Ama-
teurs."

The restless energy which never allowed him to remain idle for a moment, and which found a certain vent in the voluminous writings, published and unpublished,[1] which were the excuse for his election to the Academy, could not long be diverted from its main channel. He returned always to his favourite occupation with renewed zest and vivacity. After he had surprised Europe by his reproductions of the treasures of Crozat's admirable collections, de Caylus set himself to etch those in the Royal Cabinet, his access to which was facilitated by the appointment of his intimate friend, Charles Coypel, as *garde des dessins du roi*.[2] In 1747 Coypel, whose nomination as First Painter and Director of the Royal Academy had been supported by de Caylus, in his capacity of " conseiller et honoraire amateur," against the party which would have recalled de Troy from Rome,[3] presented to the Society two hundred and twenty-three proofs of etchings made by de Caylus from the drawings under his care.[4]

This set, considerable though it seems, includes but a small portion of his accomplishment, for the famous " Recueil " of his complete engraved work, now in the Cabinet des Estampes, fills four folio volumes,[5] every example in this unique collection having its counter proof facing it. The early efforts here represented, the little figures etched after Watteau, " Un Nouvelliste," " Le beau Cléon," etc.,[6] are amongst the most pleasing. The slight but not unintelligent point with which they are indicated has an attraction denied to the more ambitious facsimiles of drawings and reproductions of set and solid work.

An exception must, however, be made as regards later work, in favour of the brilliant and workmanlike renderings of Bouchardon's drawings of the " Cris de Paris." It is true that we find in

[1] The "Catalogue des Manuscrits provenant de Caylus," and now in the " Bibliothèque de l'Université," is printed in the Appendix to the " Mémoires de Cochin " (p. 151 *et seq.*). This represents but only one side of the writer's activity, which, as it contains numbers of comedies and society verses, probably belongs to the class of work referred to by Mariette when he says that de Caylus " dans sa jeunesse avoit beaucoup écrit, mais pourtant des bagatelles " (A. B. C. Dario).

[2] Coypel was also " garde des planches gravées et des estampes." He was named in succession to Claude de Chancey, " prieur de la Sainte Madeleine," who had robbed the collections and only left the Bastille for the Petites Maisons. See Delaborde, " Département des Estampes," pp. 61, 62.

[3] See " French Painters, etc.," p. 40.

[4] P. V., May 27th, 1747. See also August 1st, 1750, and January 10th and November 27th, 1756, for other gifts, and Catalogue of the Chalcographie du Louvre, Nos. 100 to 322.

[5] The set (also in four volumes) sold at the death of Mariette consisted of 3,200 pieces.

[6] " Suites de figures inventées par Watteau et gravées par son ami C"

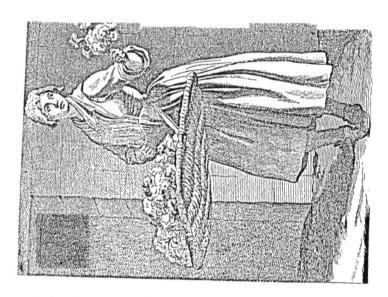

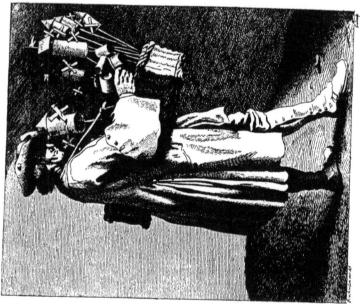

Achetés des Moulins and Mon bel Œillet : "Cri

(Comte de Cavius, after Bouchardon.)

this "Recueil" reproductions of drawings by Michel Ange, by Raphael, by Rubens, by Rembrandt and Van Dyck, rendered with absolutely faithful intention; it is true that we rise from turning over its pages with an enlarged conception of the services rendered by de Caylus, not to archæology only but to art, yet it is impossible not to see that he interprets the work of his contemporaries with a superior liberty and ease. Gillot and Coypel are more within his grasp than the landscapes of Titian, nor are there many among the more studied examples from his hand which can rival the "Colleur d'Affiches" or the "Porteur d'Eau" of the "Cris de Paris."

This "Recueil" was but one of the important gifts actually transferred to the Cabinet des Estampes by de Caylus during his lifetime. Beside many single examples he handed over various "Collections," each in its way unique. Amongst these was a series of drawings from objects in his possession which he had caused to be executed for reproduction in his own works,[1] as well as the "Peintures antiques trouvées à Rome," copied by Pietro Santi Bartoli in gouache for Queen Christina of Sweden.[2] Of all these gifts the Print Room was, however, temporarily deprived on an appeal made by his heir, the Duke de Caylus, to the King.

De Caylus himself had never married, but he inherited at the age of sixty-eight, from an uncle who had taken service with Spain, an income of 60,000 lt., "la grandesse espagnole et son titre de duc réversible à perpétuité sur les héritiers du nom et des armes de Caylus."[3] The title, which he never assumed, went by patent to his nearest relative, the Marquis de Lignerac. He demanded and obtained from Louis XV., "la jouissance, sa vie durant, des choses rares qui composaient le cabinet de feu son oncle." Books and portfolios, therefore, as well as the treasures bequeathed to the Cabinet des Médailles, returned to their old quarters, where they remained till the death of the Duke permitted the Print Room the free exercise of its rights.

[1] Amongst these may be mentioned the volumes in which were reproduced and described his own collections, "Recueil d'Antiquités égyptiennes, étrusques, grecques, romaines et gauloises" (1752-1767, Paris, Dessaint et Vaillant, then Tilliard), the seventh volume of which was published after the death of de Caylus; "Recueil de peintures antiques"; "Nouveaux sujets de peinture et de sculpture," etc. See Appendix A.

[2] See Delaborde, "Le Département des Estampes," p. 90 and note 2. Before presenting the original drawings of Bartoli to the Cabinet du roi, Caylus had them engraved and coloured at great cost. Thirty copies were, Le Beau tells us, given to the public; that in the Catalogue of Mariette, and which is described by Basan in the Catalogue of Mariette's sale, is now in the Bibliothèque Nationale.

[3] "Les Amateurs d'autrefois," pp. 279, 280.

The
Comte de
Caylus
and the
great
"Ama-
teurs."

Whoever wrote or spoke of de Caylus in his own day, if of a
friendly turn, invariably attached to his name the solemn epithet
"profond." To the Academy he is a "profond connoisseur."
Gaburri,[1] the friend and correspondent of Mariette, writes of the
"profonde intelligence de M. le Comte de Caylus." Yet "pro-
fond" de Caylus was not, nor had he any trace of that sense of
exact science in which others were then equally lacking. The
text and illustration of his "Recueil des Antiquités"[2] are both
open to criticism. The one is full of errors; the other, especially
where works of sculpture are concerned, shows—whether we
recognize the hand of Bouchardon or of Caylus—a pure travesty
of classic style.

All the same our debt to Caylus remains immense. We can-
not be too grateful to the man who devoted his fortune to bring
together these vast collections, who gave his time, his labour, his
intelligence to the scrupulous exactitude of their description, and
who did so much in this and in every other direction to raise the level
of taste in his day. At the Academy he was a frequent lecturer,
and when, as a consequence of a discourse on "Testes d'expres-
sion," a petition was got up by the students, funds were found by
him for the maintenance of a class which has been immortalized
by Cochin's drawing,[3] and the prize for a duller subject—"l'Ostèo-
logie"—was also instituted through his initiative.[4]

His own work shows that his taste was not always sure, and
that he could dwell as fondly on a drawing by one of the Caracci
as on the work of Lionardo. He could prefer Vassé[5] to Pigalle, in
which he was certainly wrong, and we may be sure that Cochin
says no more than the truth when he avers that Caylus, if he had
given a hasty judgement, was loth to retract or modify it—a most
usual weakness with critics. But when we have made all deduc-
tions, there remains a remarkable man, one whose character and
life had unity and dignity, one who deserves something more than
to be remembered only as the friend of Watteau, the lover of
Mademoiselle Quinault-Dufresne[6] and Madame Geoffrin, the

[1] His collection of engravings and drawings was sold in London, after his death,
in 1742. "Elle n'y a pas eu beaucoup de faveur, chose assez singulière, car tout ce
qui vient d'Italie est reputé bon pour les Anglois" (Mariette, A. B. C. Dario).
[2] See p. 7, note 1.
[3] See the reproduction in "L'Art du XVIII. Siècle," ed. 1882, t. ii., p. 51.
[4] P. V., October 6th and 27th, 1759; February, 1760; April 28th, 1764.
[5] See "French Architects, etc.," pp. 39 note, 75, 109 and note, 147 note, etc.
[6] Jeanne-Françoise, the younger sister of Quinault-Dufresne, a brilliant actress
and witty woman, often consulted by Voltaire on his plays. She made her début at
the Comédie Française in 1718. This, it has been suggested, preceded by two years
the date of her relations to de Caylus.

etcher of "Les Petits Pieds," that supplementary illustration to the romance of Longus without which collectors hold that no copy of "Daphnis et Chloé" can be complete.

The references made to de Caylus in Cochin's Memoirs are by no means friendly ; they lay bare all the flaws of a nature prone both by birth and inclination to the exercise of authority, but show at the same time that de Caylus was one to whom, as Cochin himself says, much must be forgiven because he really loved much. The venomous attack made by Marmontel on the man by whose good-will he had probably been admitted to Madame Geoffrin's table conveys the impression that de Caylus had been justly displeased by the bumptious and underbred familiarity of the author of those mawkish "Contes Moraux" which owe their only value to Gravelot's brilliant illustrations.

The quarrel with the Encyclopædists, which began with their intentional exclusion of de Caylus from their list of authorities,[1] embittered the last years of his life and had no doubt contributed to develop hostile relations between himself and Marmontel. Neither side could tolerate the pretensions of the other and de Caylus dealt with Diderot as insolently and more frankly than Diderot dealt with him. "Je connais peu Diderot," he wrote to Pacciaudi in 1761, "parce que je ne l'estime point ; mais je crois qu'il se porte bien. Il y a de certains b qui ne meurent pas tandis que pour le malheur des lettres de l'Europe d'honnêtes gens . . . meurent dans leur plus grande force."[2]

Cochin even attributes a certain coolness which crept between de Caylus and Watelet to the fact that Watelet undertook to write those articles "on the arts" for the Encyclopædia which had not been offered to himself. "Il est aimable," writes de Caylus, "mais son genre d'esprit et sa société ne vont pas avec la façon dont je pense sur certaines choses," and in these words we have probably an exact and even kindly statement of the situation. Watelet belonged to the new generation, de Caylus represented the old.

The indefatigable activity and high ambitions displayed by de

[1] Cochin, Mém. inéd., pp. 42, 43.

[2] "Correspondance inédite du Comte de Caylus avec le Père Pacciaudi, Théatin. (1754-1765)," t. i., p. 237, ed. Nisard, 1877. Pacciaudi was librarian to the Duke of Parma. Diderot's resentment may be measured by the satisfaction with which he congratulates himself and others, in the Salon of 1765, on having been delivered by death from the "plus cruel des amateurs." Yet his debt to de Caylus, whose teaching had cleared the way for his own, was large. See E. Müntz, "Un précurseur et un ennemi de Diderot" (Rev. Bleue, 29 Mai, 1897).

The
Comte de
Caylus
and the
great
"Ama-
teurs."

Caylus both as an archæologist and engraver were seconded, it is true, by "plus de zèle que de talent," but they sustained him throughout the agony of his mortal illness[1]—as they had throughout his life—and gave to his figure a consistent dignity and consequence of which there is no example amongst the many "gens du monde" who followed in his footsteps. Claude-Henri Watelet,[2] born to great wealth,[3] employed his riches to make his collections perfect and to lead an easy life with a picked circle of friends. "He likes," says Mariette, "to paint, to draw, to engrave, and to all these talents he adds another and superior, that of versifying and writing elegantly in French."[4]

His early journeys with Leroi de Saint-Agnan in Germany and Italy, his long stay in Vienna, and still longer stay at Rome, where he remained as a sort of amateur student of the Ecole de France, encouraged the development of tastes and friendships which became a part of his life. On his return, Watelet was naturally regarded by de Caylus as a promising disciple. These expectations were heightened by the successive publication of various sets of "Vases" engraved by Watelet, after drawings by Pierre, or by Pierre and Vien, one of which was dedicated to Madame Geoffrin.[5]

Watelet had, however, no intention of sacrificing any of the advantages and pleasures that exceptional fortune and position could secure. He was pleased to busy himself with music, or painting, or engraving; but he lived for the world, in the Salons of Madame Geoffrin and Madame Tencin, in the pleasant company of the reigning favourite, for whom he engraved Cochin's portrait of her young brother, Abel Poisson, the future Marquis de Marigny, or the even more agreeable society of Madame Le Comte, whose

[1] Le Beau says: "Il supporta avec le plus grand courage des opérations douloureuses. . . . Dès que la plaie fut fermée, il se rendit avec empressement à nos occupations. Il n'avoit point interrompu ses études; il reprit son train ordinaire; il visita ses amis, les savants, les artistes, dont il alloit animer les travaux, tandis qu'il mouroit lui-même. Porté entre les bras de ses domestiques, il sembloit laisser à chaque lieu une portion de sa vie. Combien de fois ne l'avons-nous pas vu en cet état assister à nos séances et se ranimer à nos lectures."

[2] 1718-1786. Honoraire associé libre, 1747.

[3] He succeeded his father, who was "receveur général des finances" for the "généralité d'Orléans," at the age of twenty-two.

[4] Mariette, A. B. C. Dario. His chief performance was "L'Art de Peindre," but he also published one or two tragedies and comedies, an "Essai sur les jardins," and the first two volumes of a "Dictionnaire des beaux arts," which was re-edited with additions in 1792 by Lévesque.

[5] "Raccolta di Vasi intagliate dal suo amico Watelet," 1749. A similar set is dedicated to "la Signora illustrissima Duronceray nel arte del' intagliatura dilettante virtuosissima"—a thoroughly unmerited eulogium.

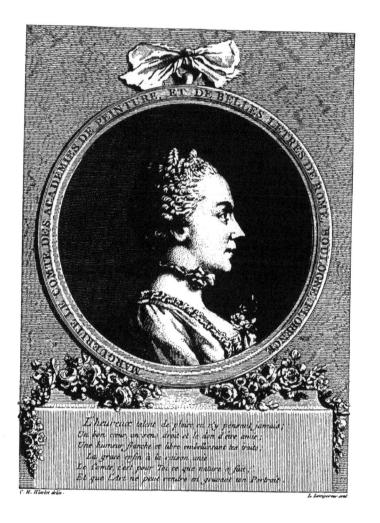

PORTRAIT OF MARGUERITE LE COMTE.
(CLAUDE-HENRI WATELET, AFTER COCHIN LE FILS.)

portrait in profile, also after Cochin, was engraved by him in 1753.[1]

In 1754 Watelet, who had been received as an *associé libre* by the Royal Academy in 1747,[2] signs a " Suite de dessins peints et gravés par Watelet du cabinet de Madame Le C . . ." This initial indicates the lady of whom he has left us this engaging portrait, and whose relations with Watelet and the fashion after which they were accepted by the world are as incredible as anything recounted concerning Voltaire and the divine " Emilie."

George Sand, in her " Lettres d'un Voyageur," draws a senti-mental picture of Watelet, " an etcher superior to any of his day," and Marguerite Le Comte as two poor old people etching together, and thus consoling themselves for the narrow poverty of their lives by their common love for art.[3] It is true, indeed, that Watelet not long before his death was embarrassed by the flight of a dis-honest subordinate, who carried off considerable sums due to the State, the payment of which, exacted strictly and promptly by the abbé Terray, straitened the resources of the unfortunate *receveur général*; but in 1754, thirty years earlier, when he is supposed to have found in the wife of the *procureur*, M. Le Comte, the woman to whom by a rare conformity of tastes and pleasures he became indissolubly attached, the source of Watelet's wealth was untouched, nor can the fortune of M. Le Comte and his wife be regarded as inconsiderable. Le Moulin-Joli, a beautiful property near Argen-teuil, was actually bought by Watelet as a retreat for himself and Marguerite Le Comte, in which they might enjoy each other's society in the company of trusted friends, and he certainly lavished great sums on making it a perfect *maison de plaisance*.

Watelet's social successes were crowned by his election to the Academy, and the journey to Italy which he undertook with Madame Le Comte in 1763 was a sort of triumphal procession. The couple—chaperoned by Watelet's complaisant old tutor, the abbé Coppette, and carrying in their train Savalette de Buchelay and the Swiss landscape-painter and engraver Weirotter [4]—were

[1] A second portrait of the same lady, in full face—an example of which is cited by Portalis and Béraldi as in the collection of Baron Pichon—was also engraved by Watelet.

[2] P. V., September 30th, 1747.

[3] "Il y avait un bon artiste qu'on appelait Watelet, qui gravait à l'eau-forte mieux qu'aucun homme de son temps. Il aima Marguerite Le Comte et lui apprit à graver à l'eau-forte aussi bien que lui. Elle quitta son mari, ses biens et son pays pour aller vivre avec Watelet. Quarante ans après on découvrit aux environs de Paris, dans une maison appelée *Moulin-Joli*, un vieux homme," etc. (" Lettres d'un Voyageur," ed. 1869, p. 142).

[4] 1730-1771. Mariette says of Weirotter : "Nous l'avons vu à Paris, et s'y

The
Comte de
Caylus
and the
great
" Ama-
teurs."
everywhere magnificently received and entertained. At Turin
they were welcomed by His Majesty of Sardinia; at Rome the
Pope and the ambassador of France combined with Natoire and
the *élèves* of the Ecole de France to do them honour.[1] In a letter,
written it has been supposed to M. Le Comte, from Rome,[2]
Watelet, after giving directions as to the arrangement of their
rooms at the Moulin, adds: " Nous nous portons au reste à mer-
veille. Mme. Le Comte est toujours comblée de politesses, de
prévenances et d'attentions sur tout et en toute occasion. Elle
auroit été logée sur la route de Naples dans tous les palais qui sont
sur ce chemin et reçeue dans cette ville par ce qu'il y a de plus
grand. Il y a ici un cardinal Albane qui l'a prise dans la plus sin-
gulière amitié ainsi que la princesse Borghèse." Nowhere, indeed,
do we find any hint of the sacrifices generously suggested by George
Sand as having been made for her lover's sake by Marguerite Le
Comte.[3]

There is, however, an even more suggestive picture of this
curious society in later years, by Mme. Vigée Lebrun, who was
herself one of the privileged guests of " Le Moulin-Joli." In her
amusing " Memoirs " she writes of " that *élysée* which belonged to
a man of my acquaintance, M. Watelet, a great lover of art, a dis-
tinguished man of a sweet and attaching character who had made
many friends. In his enchanted isle, I found him in keeping with
all his surroundings : he received there with grace and simplicity
a small but perfectly well-chosen set. A friend, to whom he had
been attached for thirty years, lived in his house. Time had
sanctified, so to say, their tie, to such a point that they were every-
where received in the best company, as well as the lady's husband,
who, drolly enough, never left her."[4]

The abode of this curious household, " La maison de Mar-
guerite Le Comte, meunière du Moulin-Joli," is the subject of one

distinguer par des desseins de paysage faits d'après nature, où il mettoit beaucoup de
goût et peut-être trop de manière. Etant dans cette ville, il en a gravé plusieurs qui
méritent d'être estimés. Il étoit un esprit inquiet et qui ne pouvoit demeurer en
place. Il suivit M. Watelet en Italie " (A. B. C. Dario).

[1] They published a little book entitled "Nella venuta in Roma di madama Le
Comte e dei Signori Watelet e Copette, componimenti poetici di Luigi Subleyras
colle figure in rame di Stefano della Vallée-Poussin, 1764." The cuts, which show
Watelet arriving with his sketch-book under one arm and his lady on the other, are
excellent comedy.

[2] This letter is quoted by MM. de Portalis and Béraldi, t. iii., pp. 643-645.
From its style it is more probable that it was written by Watelet to his *caissier*,
Roland, than to M. Le Comte. See Wille, Mém., Sept. 3rd, 1767.

[3] See note 3, p. 11.

[4] "Souvenirs de Madame Vigée-Lebrun," ed. 1835, t. i., pp. 151, 152.

of Watelet's happiest attempts, and here he produced by far the The Comte de Caylus and the great "Amateurs." greater part of the three hundred etchings which bear his name.[1] Unfortunately one can only say, even of the best, that they show the good intentions of the intelligent amateur, and in that respect are about on a level with the literary efforts which, culminating in his versified and illustrated " Art de Peindre," opened to him the doors of the Academy.[2]

" M. Watelet," wrote Collé, " receveur général des finances, est un amateur des arts, mais qui, dans aucun n'a montré ni un génie ni un talent décidé. Il sait peindre, il sait graver, il a fait des vers, mais tout celà dans un degré si médiocre que le moindre des artistes est infiniment au-dessus de lui." The criticism is, indeed, painfully true not only of Watelet but of all that busy crowd of *gens du monde* who were pleased to have a talent for the arts.

On one of my first visits to Chantilly, the Duke d'Aumale sent me off with M. Gruyer to look over the drawings of one of the most widely celebrated—Carmontelle.[3] The opportunities which Louis Carrogis dit de Carmontelle enjoyed as Reader to the Duke de Chartres, and which he cultivated by means of his excellent address and social talents, were employed by him to make that extraordinary collection of curious, full-length sketches of his contemporaries in which, as Grimm observed, he has seized the air, the bearing, the essence as it were of each person rather than their actual features. The interest which his drawings excite is independent of any artistic value; it is simply that of a chronicle of things and people out of sight.[4] This is the sole merit which accrues to him in connection with the famous engravings by Delafosse, one of which represents " La Malheureuse Famille

[1] Portalis and Béraldi say "son œuvre gravé dépasse 300 pièces," t. iii., p. 648. His work is by no means remarkable, but it had a great social success. Wille writes, March 29th, 1766: "J'ay chargé M. Huber d'obtenir de M. Wattelet son œuvre pour le Cabinet électoral."

[2] This poem, which was published by Guerin and Delatour in 1760, was ornamented by Pierre with vignettes. It excited the ire of Diderot. " If it were mine," he wrote, "I would cut out all the vignettes, frame and glaze them, and throw the rest into the fire." The vignettes are not much better than the text.

[3] 1717-1806. He was the son of a shoemaker named Carrogis, whose shop was at the corner of the rue des Quatre-Vents. It is supposed that he took his second name in order not too constantly to recall that of the shop. See the notice by Mme. de Genlis to " Proverbes et Comédies Posthumes de Carmontelle."

[4] He kept all his drawings, and the collection now at Chantilly is supposed to include the 520 portraits from his hand, sold in 1831, at the sale of La Mésangère, to an English purchaser. One drawing, that of the Calas family, is historic. Grimm tried in vain to induce Wille to engrave it, and it was handed to Delafosse. See Wille, Mém., April 20th, 1763.

The
Comte de
Caylus
and the
great
"Ama-
teurs."

Calas,"[1] whilst in the other deeply interesting if less sensational work we see the seven-year-old Mozart at the spinet, accompanying his little sister Marianne whilst their father plays the violin. Both these works had sketches by Carmontelle for their basis. The few portraits which he etched himself show that their author might easily have rivalled Watelet, and that is all.

The only amateur whose execution rises above this level is Antoine de Marcenay de Ghuy,[2] and he is an exception proving the rule, for though always reckoned as an amateur, he appears to have no title to this indulgence except good birth. He regularly sold his work in order to eke out his income,[3] and his abortive attempt, with the help of Wille, who had already solicited for him the "patent" of the Imperial Academy of Augsburg, to get himself received as an associate by the Royal Academy indicates an essentially professional ambition.

" J'ay fait mes visites," writes Wille, on July 20th, 1761, "aux officiers et membres de l'Académie royale ayant voix, pour les prier de m'accorder leurs suffrages lorsque je présenterai le portrait de M. le marquis de Marigny, que j'ay gravé pour ma réception. Ces prières sont d'usage. M. de Marcenay m'accompagna et fit ces visites avec moi et prières pour des suffrages aux mêmes personnes ; car il désire être agréé le jour que j'espère être reçu, qui sera vendredy prochain 24 de ce mois." Unfortunately, when the day came, Wille has to enter together with his own unanimous reception the discomfiture of his friend, who " n'ayant pas le nombre de voix pour lui qu'il lui auroit fallu, fut refusé."

As the justification of his pretensions, de Marcenay submitted to the Academy " quatre tableaux "—probably those which he hastened to exhibit with the *maîtres* in 1762—but it is probable that had he even been able to show the best of his etched work, the portraits of Marshals Saxe and Turenne, or the medallions of Stanislas Leckzinski, the result would not have been different.[4] These were, however, all executed after his rejection by the Academy, and show that de Marcenay, in his least pretentious things, does best. As a rule, in large work he gets thick and heavy when trying for force, and " woolly " when he wants an

[1] This work is shown hanging in the alcove of Voltaire's bedroom, in Denon's "Déjeuner de Ferney."

[2] 1724-1811.

[3] See Louis Morand, "Antoine de Marcenay de Ghuy, peintre et graveur. Catalogue de son œuvre, Lettres inédites," etc.

[4] Turenne, d'après Ph. de Champagne, 1767. Le Maréchal de Saxe, d'après Liotard, 1766, et Stanislas-Auguste, roi de Pologne, d'après Mlle. Bacciarelli. Demarcenay inv. et sc. 1765.

effeᏟ of delicacy. Possibly the check to his ambition, by disgust-
ing him with painting, threw him back on the praᏟice of an art
for which he had more aptitude, and in which he could appeal to
Wille for praᏟical counsel and guidance.

From his close association with this great engraver, de Marcenay doubtless drew a certain strength, just as his years with
Fragonard and Hubert Robert fortified the taste and talent of the
abbé Richard de Saint-Non,[1] whose zeal and devotion to the great
work on which he spent his fortune entitle him to be regarded as
the most distinguished amateur of the second half of the century.
He had inherited artistic tastes from his mother—daughter and
grand-daughter of painters of the family of Boullogne. He became
an abbé and a *conseiller au Parlement* for family reasons, but took
the first opportunity that offered of quitting his place, the sale of
which supplied the means for his stay in Italy, whence he returned
in 1761, bringing Fragonard with him, and, says Mariette,
"quantité de desseins qu'il lui a fait faire, et parmi lesquels j'en ai vu
plusieurs représentant des veues de Rome, dont la touche et le faire
m'ont beaucoup plu."

He was a member of the set received by Watelet at Moulin-
Joli, and six views of the enchanted isle—in one of which Marguerite Le Comte is seen with her academician in a boat on the
lake—are amongst the earliest of the abbé's performances.[2] On his
return from Italy, the publication of those "Vues de Rome et de
ses environs," which he etched—with, in some instances, brilliant
success—from drawings by Fragonard and Hubert Robert, betray
the charaᏟer of the impressions which seem to have given a new
direᏟion to his life.

This attempt was followed up by the series of "Fragments de
peintures et tableaux les plus intéressants des palais et églises
d'Italie," engraved by Saint-Non after his system of "eau-forte
complétée de lavis"[3] which closely resembled the method perfeᏟed by Le Prince. Already he had begun to plan the great
work to which he dedicated his fortune and his life, the "Voyage
pittoresque de Naples et dans les Deux Siciles." The passion by
which he was inspired communicated itself to others and, at first,
he found zealous co-operation on the part of all whom he approached concerning the preparation of this costly work.

[1] 1727-1791. Honoraire associé libre, December 6th, 1777 ; amateur, February
26th, 1785.
[2] The first date found on his work is that of 1753 on "Vue des Environs de Poitiers," an etching executed by its author during the exile of the Parliament at Poitiers.
[3] Reference will be made to this and to the various other processes which came
into fashion at this date in Chapter X.

The
Comte de
Caylus
and the
great
"Ama-
teurs."

Amateurs opened their purses ; a long list of subscribers guaranteed a prosperous undertaking ; artists explored Sicily and Calabria under the guidance of Vivant Denon ; the chief engravers of Paris, Duplessi-Bertaux, Choffard, Saint-Aubin, Daudet, Martini, Marillier, were busied with the illustrations, and the text was entrusted to distinguished specialists.[1] De Saint-Non himself undertook with admirable unselfishness the least attractive duties on the perfect discharge of which the perfection of a great undertaking of this sort must depend. Proof-reading, careful critical examination of the text, were the least of the actual drudgery which devolved on him, and, in this respect, as well as in the distribution of the subjects of the illustrations to the engravers—whom he treated with an open-handed generosity—he showed the same devoted temper of self-abnegation, reserving for his own execution only the simpler ornaments at the foot of the page, in which figured antique vases or groups of fruit and foliage.[2] Magnificent success seemed certain to crown this great enterprise, which, begun in 1778, went steadily forward till, in 1786, it was complete in five great folio volumes.

Complete also was the ruin of its creator. Subscribers had become weary of the drain on their funds, and in order to keep his engagements de Saint-Non had been compelled to throw into the gulf not only his own fortune but that of his brother.

Throughout this desperate struggle with adverse circumstances, de Saint-Non was sustained by the fire with which he pursued his unselfish ends. His character in this respect presents a remarkable contrast both to the epicureanism of Watelet and to the formal dignity of de Caylus. All three men are types of their century in its successive phases of development. The whole attitude of de Caylus, with its manifest assumption of authority, is reminiscent of the traditions of the Grand Siècle ; Watelet personifies the lighter philosophy by which they were replaced, but the spirit of de Saint-Non had been stirred by the breath of the coming revolution. His friends were Rousseau and Franklin ; he had generous illusions which consoled and fortified him in disaster and the hour of death. He closed his eyes in the firm faith of a great national renewal ;[3]

[1] Faujas de Saint-Fond, the geologist, and Dolomieu (de Gratet de Dolomieu), were amongst those who undertook special portions of the book.

[2] His work never rises above that of a gifted amateur. The figure subjects are usually the worst, though there is an etching by him of a woman in bed chatting with another seated at the foot, that has "come" very well and has a real air. One may also mention "Vue prise dans les jardins de la Villa Barbarini, Rome" (Saint-Non sc. 1770, Robert del.).

[3] His last words were "Et le patriotisme, se soutient-il ? "

knowing also that, by the conscientious perfection of the work to which he had sacrificed his all, he had himself in a certain measure co-operated with those who were engaged in the great attempt to bring the sincerity of truth to bear on the whole domain of knowledge.

CHAPTER II

MARIETTE AND BASAN

IN the bond which closely united de Caylus and Bouchardon, Pierre-Jean Mariette had always made a third. Cochin describes Bouchardon as " très-despote chés lui ... mais comme cela n'auroit pas réussi dans le monde, il y a apparence que c'est ce qui l'a engagé à se répandre peu, et à ne manger que très-rarement hors de chés lui, si ce n'est chès M. Mariette[1] qui, pour ainsi dire, étoit toujours à genoux devant lui."[2]

To Mariette, Bouchardon, on his deathbed, gave the letter by which—in direct opposition to the wishes of de Caylus—he appointed Pigalle to carry on his unfinished work.[3] " Il fit," says Cochin, " conjointement avec M. Mariette, cette lettre, lui ayant confié son idée sous la promesse du plus grand secret. M. Mariette le lui garda et s'en justifia comme il put dans la suitte auprès de M. de Caylus."[4] Mariette's position in this conjuncture was one of great difficulty, and the fact that his close and intimate relations with de Caylus remained undisturbed, in spite of what might have been regarded as unfriendly conduct on his part, goes to prove that Mariette was no such slave to de Caylus as has been pretended,[5]

[1] 1694-1774.
[2] Mém. inéd., pp. 39, 85. "M. de Caylus ... et M. Mariette faisoient très assiduement leur cour à M. Bouchardon. Le premier donnoit par là bonne opinion de son goust, et le second en tiroit de la considération et presque touttes les contré-preuves de ses desseins."
[3] See "French Architects and Sculptors," p. 79. [4] Mém. inéd., p. 55.
[5] "M. Mariette," says Cochin (p. 33), "libraire et marchand d'estampes, devenû fort riche par ces deux commerces réunis, et considéré en conséquence, étoit fort amy de M. le Comte de Caylus et fort susceptible d'en recevoir les impressions, et de ne voir que par ses yeux." Again we find in another passage (p. 118) an even more decided statement: "M. de Caylus étoit un homme partial ... quant à Mariette ce n'étoit que son écho."

nor was de Caylus himself as intolerant of all opposition as Cochin would have us believe.

There is indeed no hint, except in Cochin's pages, that the friendship existing between these men was ever troubled,[1] and Mariette, when writing to Bottari (October 12th, 1765) of de Caylus's death, added the kindly words : "il est dur, à mon âge, de voir partir un ami qui avait, depuis quarante ans, autant d'attache- ment pour moi que j'en avais pour lui."[2]

The tie between Mariette and de Caylus had grown out of common interests and diversity of gifts. Each found in the other qualities in which he himself was more or less lacking. The varied acquirements of de Caylus, his tendency to dogmatic system and theoretic speculation were a stimulus to the intelligence of Mariette, who, inheriting narrower traditions and special training, was inclined towards the exhibition of pure connoisseurship, backed, it is true, by an amazing store of exact learning. The influence which they combined to exercise on their contemporaries was of incalculable importance. Just when superior direction was failing, de Caylus erected a standard of attainment which was of the highest character : when the passion for prettiness and fantastic graces threatened to blind men to the larger virtues of art, Mariette, strong in the immense authority of his unrivalled collections which formed, as it were, an incontrovertible body of doctrine, called their attention to the work of men who had won the heights, to the great periods which have left us the masterpieces of the arts.

These collections had been to a great extent amassed by the father and grandfather of Pierre-Jean, whom he had succeeded as printseller and publisher at the sign of the Colonnes d'Hercule, rue St. Jacques, with the motto "Haec meta laborum."[3] The

[1] "Ceux qui ont bien connu M. de Caylus . . . n'ont pas douté que, malgré tous les beaux semblans . . . il n'eut été intérieurement très refroidi pour lui. J'ay encore été confirmé dans cette idée par l'aveu que j'ay entendu faire à M. Mariette que, malgré le long attachement qu'il avoit témoigné à M. de Caylus il avoit aperçu que ce n'étoit point pour lui un véritable amy" (*Ibid.*, pp. 55, 56).

[2] *Apud* Dumesnil, " Hist. des plus célèbres amateurs français," p. 214.

[3] This house, in which Pierre-Jean Mariette died, was reconstructed out of three by his father and mother. (See Appendix B.) The sign of the "Colonnes d'Hercule" is coupled with the name of a Mariette for the first time in 1644 (Le livre original de la Pourtraicture pour la jeunesse tiré de F. Boulogne. à Paris, chez Pierre Mariette le fils, Rue St. Jacques, aux Colonnes d'Hercule, 1644.). It appears to have come into the family from Langlois dit Chartres, who died in 1647, leaving a widow who married Pierre le fils. Delatour, in error, gives her to Denys, whose wife was Justine Abonnenc. The original sign of the Mariettes appears to have been "à l'Esperance," and in a dispute over the house bearing it, in which several of the

family were closely united and belonged to the proudest and best
type of the great Parisian middle class. Their traditions were
preserved with noble dignity by Pierre-Jean, and one may see,
even from chance references made by Cochin, how strictly he
kept to his own class—married in it, lived in it, sought alliances
for his children in it—at a time when his close relations with the
great and powerful would have enabled him to gratify less worthy
ambitions. "M. Mariette," writes Cochin, "avoit marié une de
ses filles à M. Brochan,[1] marchand d'étoffes; cette famille étoit
très-considérée dans la paroisse St. Germain tant à cause de son
opulence, qu'à cause de ses mœurs les plus honnêtes et les plus
respectables dont elle faisoit profession. Ils n'entendoient rien
aux arts et regardoient M. Mariette comme un aigle en ces
matières."[2]

In this respect, the family gave proof of better wit than Cochin,
whose judgement was distempered by the rejection of the proposals
made by his friend Slodtz for the decoration of the choir of
St. Germain l'Auxerrois, and who resented the influence which
he supposed to have been exercised by de Caylus on the Brochant
family, through Mariette, in order to procure the commission for
Vassé. On such a point Mariette might now be held to have been
wrong. The weakness inherent to the position taken up by himself
and de Caylus was that it led to a doctrinaire assumption of the
merit of all work—no matter how poor in quality—executed ac-
cording to certain canons of taste, and to the condemnation of all—
no matter how graceful and brilliant—in which these canons were
not respected. No doubt they quite honestly preferred the feeble
elegance of Vassé to the vigorous bravura of Slodtz, neither of
whom, however, was in the least likely to have felt the beauty
of the structure they were proposing to decorate.

As regards taste, even in his own special province, the judge-
ments of Mariette have not always been confirmed by posterity. It
is, indeed, impossible, even for one as brilliantly endowed as he,
not to be biassed occasionally by some capricious fancy or strain of
personal prejudice. Mariette, who wrote of Lionardo, "il étoit
lui-même une lumière qui devoit servir de guide à tous ceux qui

family were interested, Pierre is described as "marchand de taille-douce" (MS. in
possession of Mr. Percy Mariette, whom I have to thank for these details).

[1] A M. Brochant left a collection of engravings, drawings and pictures, etc., etc.,
sold in 1774. He may have been of the same family, but is not the Sieur Claude-
Jean-Baptiste Brochant, marchand, fournisseur de la maison du Roy, who married
Angélique-Geneviève Mariette and figures with her in 1776 in the "Acte de partage,"
etc., by which her father's affairs were wound up. (See Appendix C.)

[2] Mém. inéd., p. 35.

viendroient après lui,"[1] is the same Mariette who writes to Bottari,[2] "J'ai une prédilection pour les ouvrages de Carle Maratte. J'ai plusieurs de ses desseins que je met au rang de tout ce que je connois de plus beau,"[3] and who accepted the attribution to Michael-Angelo of the somewhat coarse and violent drawing of a hand which now figures under the name of Annibal Caracci in the Louvre.

Condivi, in his "Life of Michael-Angelo," had related that when Cardinal Santo Giorgio sent to the sculptor to ask whether a statue of Cupid, sold to him as an antique, were not really by him, Michael-Angelo took a pen and drew a hand in proof of his claims.[4] The drawing brought from Italy by Evrard Jabach,[5] was supposed to be the one in question. It passed from Crozat to Mariette, and Mariette was convinced of its authenticity. He refers to it with unmeasured admiration in the notes published by Gori in the first volume of his edition of Condivi, which appeared at Florence in 1746. "C'est peut être," he says, "le plus beau dessin qu'il eut [Crozat] . . . et je le conserverai précieusement toute ma vie."[6]

This drawing, which appears to us but a sorry makeshift for a masterpiece,[7] imposed on Mariette because it was accredited by a

[1] See the article on Lionardo in the A. B. C. Dario, which is followed by the "Lettre sur Léonard de Vinci, Peintre Florentin," addressed by Mariette to Caylus, and intended to accompany the "Recueil de Caricatures" engraved by de Caylus after da Vinci. (See also Nos. 192-195, Chal. du Louvre.) The letter first appeared in 1730 without the names of either Caylus or Mariette; it was translated into Italian in the "Lettere su la pittura," and finally was reprinted with corrections and additions, and accompanied by the engravings, in 1767. It will be found again reprinted by the editors of the A. B. C. Dario, vol. iii., pp. 139-164. The sixty drawings were acquired by Mariette. See No. 787 of his Catalogue.

[2] 1689-1775. He formed the Cabinet des Médailles of the Vatican Library. In 1737 he published "Sculture e Pitture sacre estratte dei cimiterj di Roma," and in 1754 "Raccolta di lettere sulla pittura, scultura e architettura, scritte da' i più celebri professori."

[3] See letter of 15 Février, 1757, "Courrier de l'Art," August 22nd, 1884.

[4] "Prese una penna . . . e con tal leggiadria gli dipinse una mano, che ne resto stupefatto" (Condivi).

[5] See A. B. C. Dario, Mariette, t. i., p. 207.

[6] A. B. C. Dario, Mariette, t. i., p. 213, and Dumesnil, ut supra, pp. 95-97.

[7] In 1732 Gaburri wrote to Mariette asking him to send him the engraving by Caylus of this drawing, and saying, "Je sais bien que M. Crozat possède un très-grand nombre de dessins tous beaux et rares, mais n'eût-il que cette seule main, elle suffirait à elle seule pour le rendre célèbre, comme il l'est dans le monde entier, parce qu'elle est véritablement un trésor" (Bottari, t. ii., No. xcix., p. 359; apud Dumesnil, p. 96). Eight years later, on the death of Crozat, the drawing now in the Louvre became the property of Mariette, whose admiration for its quality withstood even the comparison with important and authentic work by the master of which he was possessed.

probably apocryphal legend and backed by the names of the
famous collectors who had been its previous possessors. "Je l'ai
acheté," he says, "à la vente qui vient de se faire après la mort
de M. Crozat."[1] He saw in it the virtues that he wished to
see. On this one occasion his habitually direct judgement was
warped by the desire which constantly betrays the ordinary col-
lector—the desire to recognize unique importance in his own
possessions.

The one slip made by Mariette is conspicuous only by contrast
with the innumerable proofs of his consummate connoisseurship,
which constitute his claim to take a higher place than can be
conceded to any other amateur. His special distinction consisted
in the fine taste which led him instinctively to the work of great
periods, and which rendered him insensible to the caprices of
fashion. "On compte," he writes in 1769, "les curieux qui,
comme moi, donnent la préférence aux ouvrages des maîtres
Italiens, sur ceux des peintres qu'ont produit les Pays Bas. Ceux-ci
ont pris un tel crédit qu'on se les arrache et qu'on y prodigue l'or
et l'argent, tandis qu'un tableau ou qu'un dessein d'Italie n'est
regardé qu'avec une sorte d'indifférence. Cela ne m'empêche pas
de suivre mon goût, aussi n'est-ce point une exagération de vous dire
que ma collection, formée dans cet esprit-là, est peut-être la plus
complette et la mieux choisie qui soit en Europe."[2]

Mariette's natural gifts had been fostered by circumstances
from his earliest days. He was born to great opportunities. Not
the least of these was offered by the collections formed by his father
and grandfather, who seem to have carried on their business with
the object of reserving for their own portfolios everything that they
thought to be of exceptional interest or beauty. Trained by daily
contact with the treasures stored in his own home, Mariette was
ready, at an age when most men are but at the threshold of life, to
take advantage to the full of the relations which his father had
acquired in the conduct of his affairs.

On the 30th November, 1718, Prince Eugène wrote from
Vienna to Baron von Hohendorff: "La satisfaction que j'ay des
travaux du jeune Mariette m'engageront [sic] avec plaisir de récom-
penser les soins et attentions, qu'il s'est donné de seconder et
favoriser les desseins, qu'il a de faire un tour en Italie par telles
lettres de recommendations, dont il pourroit avoir besoin et de luy
procurer par ces moyens tous les agrèmens, et facilités que sa

[1] A. B. C. Dario. See under the heading "Buonaroti."
[2] Letter to Temanza, 12 Dec., 1769. See "Lettres de Mariette à Temanza,"
"Les Archives des Arts, Recueil, etc.," edited by E. Múntz, 1890, p. 133.

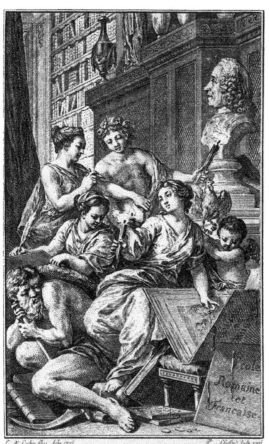

C. N. Cochin filius delin 1756. P. Chofford Sculp 1776.

te

FRONTISPICE: "CATALOGUE MARIETTE."
(PIERRE-PHILIPPE CHOFFARD, AFTER COCHIN LE FILS.)

louable curiosité et gran désir de se perfeĉionner dans sa sphère peuvent mériter." [1]

At this date Mariette, who had spent two years in Vienna, was about twenty-four, and we learn from the "Note sur la Famille de M. Mariette," drawn up by "M. Delatour, successeur de M^r Mariette," [2] that he had started in business with his father, Jean, in 1714. He was, says the writer, "libraire en 1714 . . . imprimeur en 1722, il acheta conjointement avec son père d'Antoine-Urbain Coustelier moitié du privilège de l'ouvrage des historiens des Gaules et de France, colleĉion volumineuse dont le premier volume in f° n'a paru qu'en 1738." [2] The friends made during the stay in Vienna, [3] the letters of introduĉion, due to the friendship of Prince Eugène, which brought him into relations with all those whom he most desired to know during his Italian tour, laid the foundation of Mariette's prosperous and distinguished future. "Ses grandes relations," writes the author of the "Note" already quoted, "le mirent à mème d'étendre son commerce de la manière la plus brillante et de pousser sa fortune jusqu'où elle pouvait aller; on peut dire qu'il réalisa dans son état la devise que son père [4] avait adoptée."

His early debt to the Prince was faithfully recalled by Mariette when at the height of his success, and when his fortune had reached its period of exceptional brilliancy. Special mention is made in the "Partage des biens de la succession" of a "diamant jaune qu'il avait reçu de M. le Prince Eugène," and he requests his eldest son to keep it as a "marque des bontés que ce prince avait eües pour luy et comme une marque honorable pour leur famille." [5]

Mariette's relations with the Prince had not ended with his stay in Vienna and his Italian tour. [6] From letters written in Paris in 1728, we find that his services were in demand, not only for the choice of drawings and engravings, but for the seleĉion of "ouvrages de bronze doré d'or moulu"; for the biddings to be

[1] Letter published by M. Eugène Müntz, "Courrier de l'Art.," April 11th, 1884. See also von Arneth, "Prinz Eugen von Savoyen," t. iii., p. 70.
[2] See Appendix B.
[3] Amongst these may be especially noted Antonio Maria Zanetti (1680-1767), who was a lifelong correspondent, and Pietro Santi Bartoli. In writing to Temanza (15 Avril, 1768) Mariette mentions "Bertoli, habile dessinateur que j'ai connu personnellement dans le séjour que j'ai fait à Vienne" ("Arch. des Arts," 1890, p. 115).
[4] This is an evident allusion to the motto "Nec plus ultra," which I learn from Mr. Percy Mariette was not the motto of his great ancestor.
[5] See Appendix C.
[6] See letter of the Prince to Mariette, July 27th, 1724, Haus arch., von Arneth, "Prinz Eugen," etc., t. iii., p. 522.

made at the sale of the "bibliothèque de M. Colbert," and for the purchase of a "Recueil de quatre cent vingt-cinq plantes dessinées ou pour mieux dire imprimées par le moyen d'un nouveau secret."[1] In 1732 he says in a letter to Gaburri: "J'ai eu par le moyen du prince Eugène, les quatre gravures des tableaux du grand-duc qui me manquaient."[2]

Mariette's letters, whether they treat of business or learning, are mostly dull reading, though saved by the perfect simplicity of their style from any touch of pedantry. Every page gives evidence of that exceptionally exact knowledge and wide experience which, as Delatour puts it, "le mirent dans le cas de mériter la confiance des personnages les plus distinguées et de plusieurs souverains." Although, however, they must be consulted—especially the series addressed to Temanza[3] and Bottari[4]—by anyone who wishes to follow the development of Mariette's interests and pursuits, that which we find in them and in other writings by him is but as dust in the balance if compared with that monument of learning, to which we turn even now day by day for information, the famous Abecedario.

In undertaking this vast enterprise Mariette had the advantage of a forerunner. The mistakes and errors of the Père Orlandi,[5] a writer "sans méthode et sans exactitude," provoked Mariette, as he has himself told us, into jotting down day by day the corrections which occurred to him. "La fine, régulière et juvénile écriture que l'on retrouve sur certains feuillets de l'Abecedario, et qui y recopie des extraits de livres italiens ou des *addita* d'éditions nouvelles d'Orlandi, nous permet de reporter vers 1730 les plus anciennes notules qui se trouvent sur l'exemplaire qu'il avait fait interfolier de l'édition de 1719."[6] Thus writes M. de Chennevières, to whom, aided by M. de Montaiglon, we owe

[1] See "Lettres inédites de P. J. Mariette," published by M. E. Müntz, "Courrier de l'Art," April 11th and 18th, and May 2nd, 1884.
[2] "Lettres extraites de la Correspondance de Mariette," Dumesnil, *ut supra*, p. 299.
[3] 1705-1789. First Architect to the Venetian Republic. The autographs of Mariette's letters to him, eighteen in number, were found by M. Müntz at the Musée Correr, and published in the "Archives des Arts," 1890. They were previously known only in the Italian translation given by Ticozzi, "Lettere pittoriche" (Bottari, t. viii.).
[4] Various letters to Bottari have been published by M. Müntz in the "Courrier de l'Art," July 4th and 11th, August 1st and 22nd, 1884; January 2nd and 9th, 1885.
[5] "L'Abecedario pittorico de' professori più illustri in pittura, scultura ed architettura" (Bologna, 1704). The edition of 1719 was dedicated to Crozat, "excellent et magnifique amateur et dilettante de peinture, sculpture et des autres beaux arts dans la royale ville de Paris." This edition was the basis of Mariette's great work.
[6] De Chennevières, "Un Amateur français du XVIII. Siècle," "L'Œuvre d'Art," Oct. 15th, 1897.

the publication of this work. When, however, we read in Mariette's letter to Bottari[1] his angry condemnation of Orlandi's carelessness, it is impossible not to reflect that it is far easier to correct old blunders and add new facts when someone else has brought into shape, however clumsily, the great body of the materials to be employed. It does not diminish the honours of the great French amateur to point out that Orlandi, hasty and uncritical as he was, furnished him, by the publication of his "Abecedario pittorico," with the ground for his own work.[2] "Tous les jours, malgré nous, ne remontons-nous pas encore à l'*Abecedario* du moine de Bologne."[3]

His warm attachment to de Caylus is dated by Mariette from 1726, but it is certain that their acquaintance must have begun in earlier years. Mariette had known Rosalba Carriera at Venice, during his Italian tour, and when she came to Paris in 1720, she visited him and his mother in the rue Saint Jacques.[4] Mariette was also often in her company at the hôtel in the rue de Richelieu, where Pierre Crozat offered a splendid hospitality to the Venetian pastel-painter and her companions. From the journal kept by her during her stay[5] we get not only an entertaining picture of the crowd of fine ladies and gentlemen by whom she was besieged,[6] but an exact notion as to the regular guests of the house. Amongst these one of the most assiduous was de Caylus, who busied himself, as we have seen, with the reproduction of the magnificent collection of drawings which Crozat had himself brought back from Italy in 1714.

"M. Crozat," says Mariette, "n'aimait point ses dessins pour lui seul; il se faisait, au contraire, un plaisir de les faire voir aux

[1] 11 Août, 1764.

[2] When Mariette sent corrections to Bottari for his edition of Vasari, 1759-1760, Bottari replied: "Il semble qu'il y ait une malédiction qui s'attache aux écrivains qui traitent les beaux-arts ; car tous ont commis et commettent journellement des erreurs incroyables. Je le dis en me citant moi-même, qui me suis trompé sur des noms que je connais aussi bien que mon nom. La même chose est arrivée à Vasari et à ceux qui sont venus après lui " (Bottari, t. v., p. 433, No. clx.).

[3] De Chennevières, " L'Œuvre d'Art," Oct. 15, 1897, p. 178.

[4] Her message to Madame Mariette in the letter of September 18th, 1722, and other letters to Mariette, show a most affectionate intimacy. Dumesnil, *ut supra*, pp. 31-32.

[5] "Diario degli anni 1720-1721 scritto di propria mano in Parigi, da Rosalba Carriera, 1793." A French translation, " Journal de Rosalba Carriera," by M. Sensier, appeared in 1865.

[6] For example we find, February 21st, 1721 : " Venuti da me, con madama la duchessa et la principessa di Clermont, due altre duchesse e cavalieri . . . Venne purè M. Quelus, di nascosto, e per ordine dell' altra principessa sorella, disposta anche ella di venirci alle sei della mattina seguente . . ."

amateurs, toutes les fois qu'ils le lui demandaient, et il ne refusait pas même d'en aider les artistes. On tenait assez régulièrement toutes les semaines des assemblées chez lui, où j'ai eu pendant long-temps le bonheur de me trouver ; et c'est autant aux ouvrages des grands maîtres, qu'on y considérait, qu'aux entretiens des habiles gens qui s'y réunissaient, que je dois le peu de connaissances que j'ai acquises." [1]

To his collaboration with de Caylus we owe not only Mariette's excellent letter on Lionardo [2]—which is a remarkable performance for its date—but the descriptions of " Peintures Anciennes," which accompanied the reproductions by Pietro Santi Bartoli, to which a letter was prefixed by de Caylus. Mariette was, also, it may be noted, the publisher of this costly work,[3] but the printing business in which he had engaged two years before his marriage [4] was abandoned in 1750, when it was sold to Louis-François Delatour, the writer of the not always accurate note on the family of Mariette already quoted.

M. de Chennevières rejects Cochin's assertion that the Academy could not receive Mariette as " honoraire associé libre " until he had given up his printing business as a " petitesse," [5] but look-ing to the kind of standard maintained by that body in these matters it seems as if Cochin were probably right. The same writer also quotes Mariette's proud saying, " I wish no other title than that of *libraire-amateur*," but that was made only in repudiation of the " quality of painter " with which Gori had enriched him in the notes to his edition of Condivi's life of Michael-Angelo.[6]

It is more than probable that Mariette cared nothing for the honours of the Academy but that his friends de Julienne and de

[1] " Avis de Mariette, mis en tête du Catalogue Crozat," p. xj ; *apud* Dumesnil, *ut supra*, p. 13.

[2] See p. 21, note 1.

[3] In Wille's journal, under the date March 7th, 1762, is the entry : " Répondu à M. Usteri de Neuenhof. Je lui marque que M. Mariette m'a remis le volume d'*Antiquités*, peint pour lui. Cet ouvrage lui a été fait présent par M. le Comte de Caylus qui n'a fait imprimer que trente exemplaires. La dépense pour peindre et colorier ces estampes est de trois cents livres, et la reliure dix-huit livres." There is a note on the drawings given by Caylus to the Bibliothèque saying that the plates had been broken up. An edition of the work was published by Didot in 1783.

[4] " Imprimeur 1722," writes Delatour. In the second and somewhat fuller MS. note which is appended to the first the date of Mariette's marriage to " Angelique-Catherine Doyen, fille de Louis Doyen, notaire," is given as 1722, but M. de Chennevières quotes it as " 15 mai, 1724," and this date is accepted by the family as correct (" L'Œuvre d'Art," Oct. 15, 1897, p. 177).

[5] " Dès que le fils (P. J. Mariette) eut quitté ce commerce, l'Académie s'empressa de l'admettre dans son sein " (" L'Œuvre d'Art," Nov. 15, 1897, p. 198).

[6] See the note by Mariette reproduced by Dumesnil, *ut supra*, p. 92.

Caylus were anxious to have the guidance of his incomparable taste
and judgement at their sittings and were unable to carry their point.
The Academy remained unmoved even by the example of the
Academy of Florence, which had done itself the honour of receiv-
ing Mariette as a member in 1733;[1] it remained indifferent to the
fine performance of his " Description sommaire des dessins des
grands maîtres du Cabinet de feu M. Crozat,"[2] to the Catalogue of
the Cabinet Boyer-d'Aguilles;[3] in short, Mariette—even though
rumour declared that his most important work, " Traité des pierres
gravées," had won the favour of Mme. de Pompadour—did not
exist for the Company until " il se démit de son imprimerie et de
la pratique de la police, en faveur de L. F. Delatour."[4]

As soon as he had also sold his printing business and reduced his
publishing to a mere share in the great work of the " Historiens de
France," Mariette received the compliment that had long been his
due, and which would doubtless have been paid many years earlier
had he been as apt to intrigue as were most of his contemporaries.
His purchase in 1752, " avec l'agrèment et l'estime du chef de la
magistrature . . . d'un office de secrétaire du Roi, contrôleur
général de la grande chancellerie de France,"[5] no doubt added to
his position and consideration in the world. I have seen it suggested
that he was not one of Mme. Geoffrin's set, but Cochin, no friendly
witness, mentions his name as present at one of her famous dinners
in 1760, and adds that he drove away afterwards with de Caylus
in Marigny's coach to look at the Catafalque by Slodtz. A year or
two later Cochin again mentions his presence at Mme. Geoffrin's
" bureau des amateurs," when the quarrel had arisen between Betzky
and Daullè over the engraving of the portrait of the Princess Anas-
tasia,[6] and does so in terms which show that, at that date, the learned
author of the " Traité des pierres gravées " was one of the regular
guests of the Monday dinners instituted by de Caylus.[7]

Evidence that a very considerable fortune was amassed by
this great publisher and dealer before he sold his business is not
wanting. From a reference in Wille's journal (February, 1769)

[1] Dumesnil, *ut supra*, pp. 53, 54.
[2] This Catalogue, which was accompanied by " des réflexions sur la manière de
dessiner des principaux peintres," is perhaps the best known of Mariette's works. It
bears his name both as author and publisher, " Pierre-Jean Mariette, rue Saint-Jacques,
aux Colonnes d'Hercule, 1741." The first " Description " in one volume appeared
in 1729. See " Crozat," A. B. C. Dario.
[3] This appeared in 1744. The short preface written by Mariette will be found
under the name of Boyer-d'Aguilles in the A. B. C. Dario.
[4] See Appendix B. [5] See Appendix B.
[6] See Chapter IV. [7] Mém. inéd., p. 77.

we find that Mariette—who had then been promoted by the Academy to the rank of Amateur [1]—was attending the Gaignat sale [2] in much state and comfort. "J'y fus toujours," he writes, "accompagné par M. Daudet . . . je revenois cependant plusieurs fois dans le carosse de M. Mariette car le temps étoit fort mauvais."

The driver of this "carosse" is mentioned in that "Acte de partage," the clauses of which bear witness to the prosperity of the house. The "Cocher Pelletier" figures with Mlle. La Croix and Mlle. Le Blane—the first and second maids of Mme. Mariette— the *domestique* Belleville and the gardener of the country place at Croisy, which is mentioned by Mariette in his letter to Temanza of the 18th June, 1768: "Je reçois," he says, "votre lettre à la campagne, dans une maison que j'ai à quelques lieues de Paris, et que j'habite pendant la belle saison." [3]

Mme. Mariette survived her husband and the arrangements made during her lifetime as to the employment of her fortune when the four children of the house were married and dowered [4] seem to have been answerable for the sale of the unique collection which was the glory of Paris. It was felt by the small group of connoisseurs who continued the traditions of the *Grand Siècle* that the treasures accumulated during more than a century by three generations of *iconophiles*—the last of whom was the most illustrious known—ought not to be allowed to leave the country.

A movement was set on foot to secure for the Bibliothèque Royale this priceless collection and so realize the wishes of one who had in his lifetime patriotically refused the brilliant offers made by the Empresses of Austria and Russia, the King of Prussia and the Elector of Saxony. [5] Joly, then at the head of the "Cabinet," was keenly alive to the necessities of the situation. [6] "Mémoires" were addressed to the "ministre de la maison du

[1] P. V., Oct. 31, 1767.
[2] In his letter to Temanza of the 8th August, 1767, Mariette says: "Il s'est fait ici depuis peu une vente très considérable de tableaux précieux, de desseins, d'estampes et de toute espèce de curiosités. Elle a produit plus de 530,900 lt. Jugez de ce que se [*sic*] pouvoit être. J'y ai eu pour ma part un nombre de desseins qui ne dépareront point ma collection" ("Arch. des Arts," Müntz, 1890, p. 109).
[3] *Ibid.*, 1890, p. 116.
[4] See Appendix C.
[5] Delaborde, "Le Département des Estampes," p. 92. See also "Documents sur la Vente du Cabinet de Mariette," N. A., 1872, pp. 346-370.
[6] He writes to Malesherbes: "On ne pourra jamais, même à prix d'argent, rassembler un cabinet de dessins et d'estampes tel que celui de M. Mariette." "L'assemblage de ces richesses est un prodige. Ce prodige a enfanté un second, celui d'avoir transmis pendant près de deux siècles, la même fortune, le même goût épuré et le même savoir éclairé dans la personne du citoyen dernier possesseur de cette superbe collection."

roi," setting forth the "raisons puissantes pour acquérir le cabinet de feu M. Mariette et le réunir à celui de Sa Majesté." For a while there seemed to be some hope of success. Pierre, Cochin and Lempereur were told off to negotiate with the heirs, but their expectations had been raised by the large sum—69,000 l. —obtained at the first sales of duplicates[1] and they rejected the offer of 300,000 l. made in the King's name for the complete group of drawings and engravings, reckoning on obtaining a larger sum by a sale at auction. Their expectations were disappointed; the sale of November 15th, 1775, only realized a sum inferior by 11,500 l. to that which they had refused.

Joly, in the bitterness of his defeat, may have found some satisfaction in this circumstance, but he had himself had the pain of watching, hour after hour, the acquisition by others of the inestimable treasures for ever lost to France. The credit of 50,000 l. finally wrung from Turgot came too late—not until the eighth day of this memorable sale was past.[2]

When Crozat's great collection was dispersed the sale had been directed by Mariette; the weight and colour of every word in his description had added value and character to the whole event; the unrivalled collection of Mariette found no such competent handling. The famous dealer, publisher and expert of the rue Serpente, Pierre-François Basan,[3] to whom the treasures amassed by the house of Mariette were entrusted, lacked the necessary qualification for his task, not having the scholarship which had rendered the Catalogue of the Cabinet Crozat a work of the highest form of teaching. "Basan était loin d'avoir l'érudition aussi sûre que celle de Mariette, et Mariette lui-même eût seul pu donner de son cabinet le catalogue qu'on attendait."[4]

Basan had shown remarkable aptitude as an engraver and had

[1] For details of the first sale of duplicates see C. Blanc, "Trésor de la Curiosité," t. i., pp. 256-304.

[2] There were a few pictures, gems, coins, etc. (see Wille, May 17th, 1775), but the enormous importance of the collection consisted in the unrivalled perfection of the sets of the work of all the great engravers of every school and the incomparable beauty and rarity of the drawings, the chief portion of which had been in the hands of Crozat. The prices, though not realizing as much as the heirs expected, went beyond the expectations of the outside world. "Répondu à M. Dittmer, à Ratisbonne," writes Wille, "je lui fais voir l'impossibilité où je me suis trouvé (par rapport aux prix que son ami, M. l'Assesseur Hartlaub, m'avoit marqués pour divers articles dans la vente de M. Mariette), d'acquérir ce que M. Hartlaub auroit désiré" (27 Mars, 1776).

[3] 1723-1797. See "Abrégé historique" prefixed to the "Catalogue raisonné du Cabinet de feu Pierre-François Basan père."

[4] De Chennevières, "Un Amateur," etc. ("L'Œuvre d'Art," Nov. 15, 1897, p. 199).

received lessons, at an early age, from Etienne Fessard,[1] who was a member of his own family. Prompted as it would seem by the desire of gain, he abandoned his art and devoted his energies to dealing. He put into the trade which he developed and carried on in his hôtel, rue Serpente, the zeal, the devotion, the passion even, which Mariette displayed in the service of learning and of art. Basan, in short, represents the temper of that later generation of dealers, who have seen in the knowledge of and care for beautiful things mainly the means of making money and who have valued the knack of anticipating their market beyond any interest or pleasure to be derived from the intrinsic value of the works in which they dealt.

Mariette by his personal taste, by his traditions, by his wonderful power of recognizing good work under the most varied or unaccustomed aspects, by his fine qualities of judgement raised the standard of the *libraire-amateur* to a point which it has never attained before or since and actually exerted a direct influence on the formation of that opinion which determined the classic reaction, which coloured the art of Prud'hon and contributed to form the talent of David.

In Basan we have the prototype of the successful dealer of our own day: his commercial instincts had been sharpened by his early stay with Etienne Fessard, a pushing, unscrupulous man, whose ability was greatly inferior to his ambition and his presumption. Under him Basan necessarily became familiar with all the courses of profitable advertisement. If Fessard engraved a work, there was the dedication in favour of which money or credit were to be won. He contrived to stand so well with great people that all Cochin's wit and wisdom were needed to support Marigny in his refusal to grant Fessard the exclusive privilege of engraving with his facile burin the "Tableaux du roi," and he succeeded in extracting a "pourboire" of 600 lt. for each volume of his poorly illustrated edition of the "Fables de la Fontaine" (1765-1775), on the strength of dedications inserted after every title-page to the "Enfants de France"; he could not even suffer the slight of rejection at the Salon without making capital out of it by a vigorous appeal to Marigny himself.

From Fessard, Basan went, we are told,[2] to Daullè, a master

[1] 1714-1777.

[2] Basan gives only a few lines to his own name in his "Dictionnaire des graveurs." The chief source of our information concerning him and for all these details is the "Abrégé historique" prefixed to the "Catalogue raisonné" of his collections, to which reference has already been made.

1

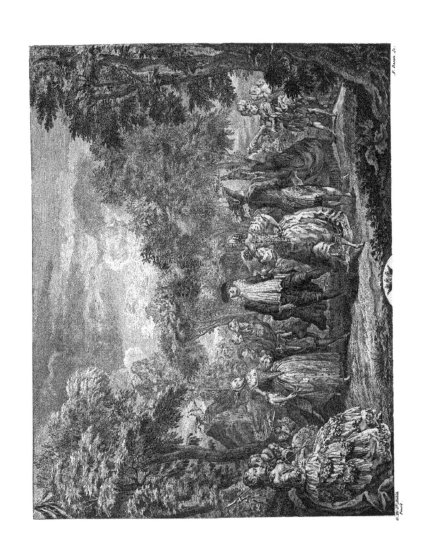

whose laborious life is represented, as we shall presently see, by an immense series of portraits, very unequal in value, and whose pupils must often have learnt from example that it is better to do quickly than to do well. When Basan left Daullé, he was determined on making money. He bought a few good plates, engraved a few himself, and collected round him various young engravers, whom he employed and housed under his own roof.

Italy did not tempt François Basan but, noting the passion for little Dutch pictures of the class skilfully manipulated by Wille, he had resort to Holland, to Flanders and to England[1] for the establishment of a connection. Mariette, with whom he was on friendly terms, may have served him in this part of his business. Meanwhile the manufacture of engravings was steadily kept going in Paris, and in 1760 the public were invited to buy a " Recueil de cent estampes de sujets agréables et paysages, gravées d'après les meilleurs maîtres des Pays-Bas et de l'Ecole Française par François Basan, ou sous sa direction."

Very few, if any, were wholly executed by his hand ; but as one turns over the pages signed by Le Veau, Cochin, Lucas,[2] Sornique,[3] Pierre Aveline,[4] Daullè, Flipart or Beauvarlet, one gradually recognizes a bright, intelligent, exceedingly summary rendering in certain prints which bear the name of Basan : it is, I think, quite obvious, even when, as in the " Hameau de Flandre," after Teniers,[5] we find the name of Basan coupled with that of another. The kind of technique, clear and effective as far as it goes, if not too scrupulously honest, is just of the order which necessarily appeared most desirable to Basan for the setting out of the series of subjects after Flemish and Dutch painters which were to find their market " à Amsterdam chez Fouquet junior, à Paris chez Basan graveur, rue St. Jacques."

For himself alone, Basan claims work such as the " Cordonnier hollandais" after " Skowmann,"[6] the " Ouvrière en dentelle "

[1] He made more than one visit to London. Wille mentions that Basan was away, in London, in August, 1770.

[2] " Le Traitant," after Dumeril, is signed " Lucas sculp." There were two engravers of this name.

[3] 1722-1756 (?). Basan says " a gravé l'Enlevement des Sabines. m. p. en t. d'après Luca Jordano, pour le Recueil de Dresde. Sornique ayant laissé, en mourant, cette planche imparfaite, elle a été terminé par Beauvarlet."

[4] 1697-1760. A. 1737. In 1757 he exhibited three works engraved for the " Galerie de Dresde."

[5] In February, 1761, Wille buys at the sale of the Count de Vence " un tableau de Teniers que M. Basan a gravé."

[6] Schouman (Arthur), 1710-1792.

31

after van Mieris, and the "Femme en courroux" after Zick,[1] the friend of David Röntgens. His title to the execution of these has been contested, but it is clear from the special characteristics of the work that if Basan did not do it he had at least a very clear idea as to how it was to be carried out under his direction. To this class belong also the reproductions of the sketches of Oudry— "'Le Mouton' et 'Le Chat Panterre,' peint d'après nature à la Ménagerie du Roy."

The selection of a subject by Zick was probably dictated by Wille, with whom Basan was on terms of the closest intimacy. Wille seems to have had frequent business relations with Basan. "Livré les épreuves à M. Basan, au nombre de quarante-huit, des planches que M. Zingg[2] m'a gravées d'après M. Vernet," he writes on the 4th November, 1760, a date at which Basan was engaged in the publication of the first "Recueil." In 1762 came out the second collection, followed by four other sets at different intervals, the last appearing in 1779, and thus, if we include a variety of independent work, we reach the enormous total, filling the six heavy folio volumes which we find as " L'Œuvre de Basan " in the Print Room of the Bibliothèque Nationale.

Before going to the rue et Hôtel Serpente, where we find him (No. 14) in 1776,[3] Basan had two other addresses. He lived first, I suppose, in the rue St. Jacques, where he would have received in 1754 the encouragements of his neighbour, Mariette; then in the rue du Foin[4] near St. Severin, until the great extension of his trade forced him to seek larger quarters. His domestic troubles may also have contributed to make him desire the change. "M. Basan," writes Wille, January 31st, 1768, "depuis sa séparation d'avec sa femme, a soupé la première fois chez nous. Il me fait bien de la peine, car il ne mérite pas ce qui lui est arrivé." Mlle. Basan, however, soon comes on the scene,[5] the business prospers and develops, visitors are taken to the shop as to a great sight,[6] and Wille's journal shows a constantly increasing friendly intercourse

[1] See "French Decoration and Furniture, etc.," p. 187 and note 4, p. 190.

[2] A Swiss employed by Wille.

[3] This address is given in the Almanach des Artistes for the year, with a note to the effect that Basan is the Paris dealer doing the largest business.

[4] The engraving by Daullé of Drouais' portrait of Mlle. Pélissier is inscribed "se vendent à Paris chez Basan, graveur rue du Foin."

[5] Mém. Wille, January, 1770. There is no explanation given of the "séparation." The writer of the preface to the "Catalogue" says only that "Basan avoit épousé Marie Drouet, qu'il perdit après trente-sept années de mariage." She certainly returned to her husband long before her death.

[6] Mém. Wille, November 16th, 1768.

between the families accompanying the increasing consequence and importance attached to Basan's position.

He plays the host at suppers and dinners of which it is always recorded that there was much laughter and good cheer, Boucher dines with him to meet Wille[1] and on another occasion he entertains the whole Wille family, the Chèreau and M. de St. Aubin l'aîné,[2] whose name reminds us that the two most interesting engravings with which Basan's name is connected are from drawings by that most delightful artist.[3] Business did not suffer from this jovial existence; on the contrary, it would seem to have been a means of extending and cultivating useful relations and we soon begin to hear something of the project regarding the publication of that edition of the " Métamorphoses d'Ovide " which was one of the most harmoniously beautiful books of the century.[4] Grimm, who was no lover of illustrations and who had been rightly disgusted by the wretched performance of Fessard's " Fables," prophesied evil concerning the undertaking, but draughtsmen and engravers made a combination of admirable perfection. Boucher, Moreau, Gravelot, Eisen, Monnet, Choffard were interpreted by Le Mire, de St. Aubin, de Longueil, Simonet, Masquelier and Baquoy.

The enterprise was, however, the cause of a serious quarrel between Basan and Noël Le Mire, who finally appealed to Wille and three other experts to compose their differences. On the 12th August, 1771, the entry occurs in Wille's journal: " M. Basan m'avoit invité pour être médiateur, avec trois autres, entre lui et M. le Mire, qui se sont séparés d'intérêts dans leur entreprise des ' Métamorphoses d'Ovide.' M. Basan reste actuellement seul propriétaire, en donnant dix mille six cents livres et douze exemplaires complets à M. le Mire, et tout le monde paroît content."

To have carried out this remarkable work reflects the greatest honour on Basan as a publisher. It places the credit of his taste and judgement on a level with his reputation as a brilliant man of business, and Mariette himself may well have given his approval to its pages. It is, indeed, not impossible that the beauty of the work contributed to determine the selection of Basan to deal with the sale of Mariette's collections. In the notice prefixed by Basan to the Catalogue he frankly acknowledges his debt to the twenty

[1] Mém. Wille, February 13th, 1770. [2] Ibid., June 5th, 1770.
[3] " La Guinguette, Divertissement pantomime du Théatre Italien, par le sieur de Hesse," and " Le Ballet dansé au Théatre de l'Opéra dans le Carnaval du Parnasse, Acte Iᵉʳ, gravé par F. Basan." See Chapter IX.
[4] See Chapter VII.

33

years of friendship with which Mariette had honoured him, and speaks proudly of the "choix qu'il a bien voulu faire de moi pour l'arrangement de son cabinet après sa mort."

As an engraver-publisher Basan had affirmed his reputation when he brought out the famous Ovid; the sale of Mariette's collection gave him the opportunity by which his standing as the great expert dealer of the second half of the century was equally established. Neither before nor after had he anything to handle of like importance.[1] The names of Bouchardon, Van Loo, Marigny, Cochin and Wille illustrate the interminable list of sales which were arranged by him, but the great event of his career was, undoubtedly, the dispersion of the Cabinet Mariette.

With the sale of the collections of an amateur of Amsterdam named Neyman, Basan—encouraged probably by the success of the set of little engravings which accompanied the sale of the collection of the Duke de Choiseul—inaugurated the system, since popular, of illustrated catalogues. The Neyman and Poullain sales seem to have decided Wille to sell all his pictures and such drawings as he had in portfolios. "M. Basan," he says (October, 1784) "destiné à en faire la vente, est venu tous ces jours-cy pour prendre notes des uns et des autres, notes nécessaires pour composer le catalogue." The catalogue was allowed to circulate for a month, four days were allowed for arranging everything at the Hôtel Bullion and the sale, which began on December 6th, 1784, lasted four days.

It probably answered Wille's expectations, for the "bon repas" given on the 2nd February, 1785, to M. and Mme. Basan (whose reappearance receives no comment), M. and Mme. Poignant[2] and others may be connected with the final settlement of the operations at the Salle des Ventes. It was certainly no ordinary occasion, for the host adds: "Nous étions en tout douze personnes très-joyeuses et de bonne humeur. Tous ont également soupé le soir, et nous sommes restés ensemble jusqu'à minuit," after which Basan pays his debt by inviting the party to his country house at Bagneux.[3]

There was a certain uneasiness already creeping over the men who were concerned with affairs and Basan decided Wille to part with the greater part of his fine collection of engravings. The re-

[1] "Dans le nombre des catalogues qu'il a publiés, on distingue ceux des cabinets Bouchardon, Rumpré, Slodtz, Quarré de Quintin, Fabre, les Vanloo, Mariette ci-dessus nommé, Neyman, Latour d'Aigues, Marigny, Cochin et Aliamet" (Catalogue Basan, p. iv).

[2] Poignant had married Mlle. Basan, and was associated with her father. in his business.

[3] Mém. Wille, June 4th, 1785.

... have been as satisfactory as those of that by which it was
...ed. "Sur bien des estampes," writes Wille, "j'ay perdu, sur
...tres j'ay gagné, comme il arrive ordinairement." No pains,
...owever, had been spared, Basan himself having "composé et fait
...prim... le catalogue." It was the ... noteworthy ...le in which
... ...tely participated. In 1787 he figured as an expert in the
"...inte en escroquerie de Coutant contre Martin, marchand de
...bleaux,"[1] and a few years later he decided to give up business.
...n 1790 Schmuzer, writing to Wille as to the sale of an engraving,
...s told that he must not count on Paris printsellers, for " les prin-
...ipaux, qui étoient MM. Basan et Chéreau, avoient quitté le
...ommerce."[2]

Basan died in In December ... the following year
...egnault-Del... ...r organized the sale of ... collections which
...ad made the old hôtel of the rue Serpente one of the sights of
...aris. Mariette had lived his life, as it were, to himself; we are
...old that he hid his treasures as a miser would his gold[3] and did
...ot willingly open his portfolios except to those whose taste and
...udgement he respected—a sentiment which appeals to every
...llector; for who has not suffered anguish at seeing damp thumbs
... ...ed on bronze medals; prints handled by the wrong ends, and
... ...ks pulled from their shelves and laid open with a display of
...tal ignorance as to the constitution of their backs!

To such distresses Basan, whose house was genially open to
...ry visitor, must have been continually exposed. No words of
... ...n better the picturesque description of his life and surround-
... ...ven in "Les Graveurs du XVIII. Siècle" by MM. de
... et Béraldi. They speak of the great sale-room on the
... ...oor, where Basan left on view the pictures, prints and
... ...the atelier
...he engravers w... ...is the atelier
... himself—the gallery, shown us in a little engraving by
... where he hung all his collections of engravings, paint-
... drawings. "C'est un va-et-vient continuel," they say.
... graveurstout cela des corre-
... à l'étranger, ... à expédier par toute

...
[1] Mus...
[2] See "...
[3] This is theon in the catalogue of his sale
... is represented surrounded byand ... by Mercury, the
... of commerce."

35

Cul de Lampe from the "Métamorphoses d'Ovide," 1767-1771.

sults of the sale, which opened on the 11th December, 1785, do not seem to have been as satisfactory as those of that by which it was preceded. "Sur bien des estampes," writes Wille, "j'ay perdu, sur d'autres j'ay gagné, comme il arrive ordinairement." No pains, however, had been spared, Basan himself having "composé et fait imprimer le catalogue." It was the last noteworthy sale in which he actively participated. In 1787 he figured as an expert in the "Plainte en escroquerie de Coutant contre Martin, marchand de tableaux,"[1] and a few years later he decided to give up business. In 1790 Schmuzer, writing to Wille as to the sale of an engraving, is told that he must not count on Paris printsellers, for "les principaux, qui étoient MM. Basan et Chéreau, avoient quitté le commerce."[2]

Basan died in 1797. In December of the following year Regnault-Delalande organized the sale of the collections which had made the old hôtel of the rue Serpente one of the sights of Paris. Mariette had lived his life, as it were, to himself; we are told that he hid his treasures as a miser would his gold[3] and did not willingly open his portfolios except to those whose taste and judgement he respected—a sentiment which appeals to every collector; for who has not suffered anguish at seeing damp thumbs pressed on bronze medals; prints handled by the wrong ends, and books pulled from their shelves and laid open with a display of total ignorance as to the constitution of their backs!

To such distresses Basan, whose house was genially open to every visitor, must have been continually exposed. No words of mine can better the picturesque description of his life and surroundings given in "Les Graveurs du XVIII. Siècle" by MM. de Portalis et Béraldi. They speak of the great sale-room on the ground floor, where Basan left on view the pictures, prints and curiosities entrusted to him; on the first floor they note the atelier of the engravers working for the house, and near to it the atelier of Basan himself—the gallery, shown us in a little engraving by Choffard,[4] where he hung all his collections of engravings, paintings and drawings. "C'est un va-et-vient continuel," they say, "d'acheteurs, de graveurs . . . au milieu de tout cela des correspondances arrivant de l'ètranger, des envois à expédier par toute

[1] N. A., 1873, pp. 408-437 and 457-466.
[2] Mém. Wille, May 26th, 1790.
[3] See "Raisons puissantes, etc.," Dumesnil, *ut supra*, p. 387.
[4] This is the allegorical engraving which figures in the catalogue of his sale. Basan is represented surrounded by all his works and encouraged by Mercury, the god of commerce.

l'Europe, des catalogues à rédiger, des graveurs à diriger, des voyages auxquels il faut se préparer, du commerce à surveiller, des amateurs à conseiller et souvent à instruire; et Basan, 'mélange de vivacité et de froideur,' trouve moyen de faire face à tout et, sans rien négliger, de rédiger encore un ' Dictionnaire des Graveurs,' bien sommaire du reste." [1]

From the short notice written by himself in this " Dictionnaire," taken in conjunction with that prefixed to the catalogue of his sale, we are able at any rate to glean facts which not only complete the story of Basan's life, but which set it in a light that shows us the salient points of difference between the great amateur dealer of the past and the great dealer of later days. If one dwells on the character and interests of Mariette, who traded and published and made fortune as his fathers had done before him, one is struck by its dignity and the immense services rendered to art by his sincerity and erudition; if we turn from Mariette to the men who handle beautiful things now, there is a great gulf. It is bridged by Basan.

By his clever substitution of intelligence for personal taste, by his dexterity in business, his quickness to feel the pulse of the public and take advantage of the market, he may be rivalled but can scarcely be outdone by his successors of to-day.

[1] Portalis and Béraldi, t. i., p. 108.

36

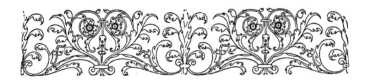

CHAPTER III

LE CHEVALIER COCHIN

THE social successes and the enormous power which Cochin fils[1] exercised through his relations to the Court, to Mme. de Pompadour and to her brother, the Marquis de Marigny, make his life profoundly interesting, because it became the centre of so many other lives and ambitions. He came of a family of engravers. His first lessons were received from his father and mother, for Cochin père[2] had married Louise-Madelaine Horthemels, and she—as did her two sisters, Mme. Tardieu and Mme. Belle—worked regularly with her husband.

Cochin père had an admirable tact in seizing the spirit and style of the very dissimilar masters after whom he engraved. Whether his "sujets des ouvrages en gravure" represent Watteau[3] or Chardin[4] or de Troy, he displays the same quick-witted powers of sympathetic apprehension; but his "Pompes funèbres : Celle de Madame, Première Dauphine, à Notre-Dame. Celle de ladite Princesse, à S. Denis. Celle du Roy d'Espagne, à Notre-Dame,"[5] must reckon amongst his best work, and from these we may single

[1] 1715-1790. A. April 29th, 1741; R. November 27th and December 4th, 1751. From the Catalogue of his work by Jombert, we learn that he gave (P. V., Oct. 31st, 1761) as his diploma work the drawing of "Lycurgue blessé dans une sédition," which is at the Musée du Louvre. See Salons of 1761 and 1769. He also gave on May 31st, 1766, a portrait of Pope Benedict XIV., by Subleyras.

[2] 1688-1754. R. August 31st, 1731, on portraits of Lesueur and Sarrazin, Chal. du Louvre, Nos. 2273, 2279. He exhibited at the Salons of 1737, 1739, 1740, 1743, 1746 and 1750.

[3] The best after Watteau is his "Mariée de Village."

[4] His engravings of "L'Ecureuse" and "Le Garçon Caberetier" (sic) were exhibited in 1740.

[5] Ex. 1750. Chal. du Louvre, Nos. 4051, 4052, 4053.

37

out his very remarkable rendering of the "Pompe funèbre" of
Polixène de Hesse-Rhinfels (1735), on account of its extraordinarily
brilliant effect of space and air. In like manner, the chief successes
of Cochin fils were won in the delineation of those court cere-
monials such as the "quatre Fêtes du premier mariage de M.
le Dauphin," which were engraved by the father from his son's
drawings, and exhibited together with those which commemorated
the funeral obsequies of the "Première Dauphine."

Brought up to handle the point and the burin from the cradle,
Cochin fils showed from the first a brilliant and inexhaustible
facility. Under his name is grouped an innumerable variety of
book-illustrations, fashion plates, trade cards, ornament, book-
stamps and portraits of all the celebrities of the century.[1] His
friend Charles-Antoine Jombert,[2] the publisher and bookseller, to
whose industry and zeal we owe catalogues of the work of
Sebastian Le Clerc and of Belle, prepared that of Cochin during
his lifetime. In the letter which he wrote with the copy sent
to Marigny, Jombert says : " Comme j'ay l'avantage d'avoir été
son camarade dès l'enfance, et que je ne l'ai guère perdu de vue
depuis ce tems, personne n'étoit plus à portée que moi de donner
quelque ordre au nombre considérable de pièces qui forment son
œuvre depuis quarante-quatre ans qu'il a le burin à la main.
J'ay donc tâché de débrouiller le cahos de la quantité d'ouvrages
qu'il a fait."[3]

The letter is dated December 16th, 1770, and, in a note,
Jombert says that the total of Cochin's work, exclusive of his
etchings, already amounted to 1,262 pieces. If, however, we
could add to the list all the work which he produced during the
last twenty years of his life we should reach a more startling figure.
His first engraving was, Jombert tells us, made at the age of
twelve, and he adds that he had preserved a set of sketches,
"Diverses charges des rues de Paris," which had been executed
by Cochin when a boy of sixteen. He had been placed at that
time with Restout to complete a training and discipline which
seem to have been sufficiently severe under his father's roof, and

[1] " Recueil de portraits, etc.," Paris, 1755-1775. See also " Bulletin de Souscription
au portrait de Louis XV, par C.-N. Cochin fils," 1779. N. A., 1880-1881, p. 131.
[2] 1712-1784. See letter from Jombert to Marigny, with a copy of his "Cata-
logue de l'Œuvre de Ch.-Nic. Cochin fils, écuyer, chevalier de l'Ordre du Roi,
censeur royal, garde des Desseins du Cabinet de Sa Majesté, secrétaire et historio-
graphe de l'Académie royale de peinture et de sculpture. Par Charles-Antoine
Jombert. A Paris, de l'imprimerie de Prault, MDCCLXX." (N. A., 1874-1875,
p. 316).
[3] N. A., 1874-1875, p. 320.

L'Ouvrière en Dentelle :
"Diverses Charges de la Rue de Paris."
(Pierre Aveline, after Cochin le fils.)

from the studio of Restout Cochin fils slipped away to the work-
shop of Le Bas. As he went to and fro he made sketches in the Chevalier
street, and so doing developed that marvellous facility of rapid Cochin.
and accurate observation which served him well when he came to
discharge his official duties as "dessinateur et graveur du Cabinet
du roy."

In early work founded on these lessons of the street—such as
the series representing the trades of the men and women of Paris[1]—
Cochin seizes on gestures and manners with the same agility and
vivacity as distinguish his treatment at a later date of the actors
in court pageants, his delineations of which are alive with minute
suggestions of significant detail.

His first great popular success was achieved by the brilliant
rendering of "La Décoration de l'illumination et du feu d'artifice,"
organized by Servandoni at Versailles, in honour of the marriage
of Madame Première with Don Philip of Spain.[2] Cochin fils
had, however, given earlier proof of an almost equal skill and
wit. In 1735, the year in which his father was engraving the
"Pompe funèbre" of Polixène de Hesse-Rhinfels, Queen of Sar-
dinia—in concert with the Slodtz, by whom it had been carried
out in Notre Dame—Cochin fils was engaged on the reproduction
of a sketch by Dumont le Romain of the illumination given by
Cardinal Polignac in 1729 on the Piazza Navona, in honour of
the birth of the Dauphin. This work, which was finished by his
mother, seems to have led to his employment on an engraving in
commemoration of the entertainment given at Meudon to the
little Dauphin, in December, 1735, by the Duke of Orleans.[3]

This commission, as well as that of engraving the "Pompe
funèbre" of another Queen of Sardinia, Elisabeth-Thérèse of Lor-
raine[4] (September 22nd, 1741), seems to have been due to the in-
fluence of the Count de Bonneval, the contrôleur des menus, for Cochin
tells us that it was to him that he had "l'obligation d'avoir travaillé
pour le Roy dès l'âge de vingt ans, honneur," he adds, "dont
j'étois flatté, ne prévoyant pas que je serois toujours fort mal payé
dans ce district et que je perdrois toutte ma jeunesse sans profit à
leur service."

Under a strong sense of obligation to Bonneval, and probably
with an equally strong sense of his own interest, Cochin had made
a present to him of his superb drawing of the "Réception par

[1] "Le Tailleur pour femmes," "L'Ouvrière en dentelle," etc.
[2] The fête took place on August 21st, 1739. The engraving was exhibited at
the Salon of 1741. Chal. du Louvre, 4014. Sept. 25th is given by Portalis and Béraldi.
[3] Chal. du Louvre, No. 4013. [4] Ibid., No. 4050.

Louis XV de Saïd Mehemet pacha, ambassadeur du grand Turc, 1742." "It cost me," Cochin says, "a considerable time, and was countermanded exactly when it was already sufficiently advanced for me to want to finish it, the more so as I saw that it might be a credit to me. . . . As soon as it was finished, I showed it to M. de Bonneval, then *controlleur des Menus-Plaisirs du Roy*. He seemed to want it so keenly, he who was cold and undemonstrative, that I gave it him." [1]

Afterwards, we are told, the Duke d'Aumont "eut envie de ce dessein," and as Bonneval did not dare refuse him, Cochin was called in to find a pretext for resistance, but he took Bonneval's part to his own hurt; in any case, as Bonneval resigned his post, the gift to him of the drawing in question was a pure loss. It was exhibited in 1745, and it is interesting to find that it attracted the notice of Bouchardon. "J'ay eu aussi l'encouragement," writes Cochin, "qu'il voulût bien trouver du talent dans un dessein que j'avois exposé au Salon, qui représentoit l'audience de l'ambassadeur turc à Versailles, et il est certain que cette marque de contentement de sa part me fit plus de plaisir que tous les éloges du public et même des autres artistes." [2]

Until Sebastian and Paul-Ambroise Slodtz [3] were placed in command at the Menus Plaisirs, very little was done there. It was not, as Cochin tells us, until 1745 that the expenditure on royal shows became considerable. To the Slodtz fell the conduct of the splendid fêtes which then signalized the Dauphin's marriage with his first wife, Marie-Thérèse d'Autriche, and Cochin gives us lively pictures of the ceremony in the chapel at Versailles; of the *jeu du roi*; of the masked ball which took place in the grand gallery; of the gala representations given in the theatre which had been arranged in the riding school, and of the no less splendid show of the state ball. [4] The masked ball—of which the original drawing is preserved in the Louvre—is the most striking of the set, each one of which has great interest as showing the immense importance attached to these costly royal pageants and the brilliant talent lavished on their production.

[1] See pp. 105 and 106, Mém. inéd. This magnificent drawing was one of the most important of the Mühlbacher collection, and was admirably reproduced in the catalogue of the sale (No. 101).

[2] Mém. inéd.; Bouchardon, pp. 93, 94.

[3] In the Salon of 1757 we find "Trois portraits en Médaillons. Messieurs Slodtz. D'après les Desseins de M. Cochin. Par M. Cars." On the death of Michel-Ange in 1765 Cochin wrote a short biography of the three brothers, entitled "Lettre aux Auteurs de la Gazette Littéraire" (Œuv., t. ii., pp. 228-240).

[4] Chal. du Louvre, Nos. 4029-4033.

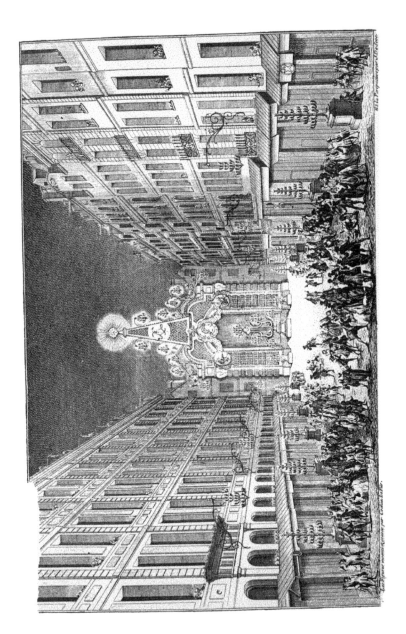

VUE PERSPECTIVE DE L'ILLUMINATION DE LA RUE DE LA FERRONNERIE, EXÉCUTÉE
29 AOUT 1739 PAR LES SOINS DE MESSIEURS LES SIX CORPS DES MARCHANDS
À L'OCCASION DU MARIAGE DE MADAME I^{re} DE FRANCE ET DE
L'INFANT DON PHILIPPE II^e.

(COCHIN LE FILS AND J. DE SÈVE.)

It was a year, Cochin says, in which "chacun fit assés bien sa main : M. de Bonneval, cadet d'une famille de financiers, n'ayant rien, ou très peu de chose, . . . ce M. de Bonneval en resta riche." Plentiful details as to other indecent fortunes made in the "tripot des Menus-Plaisirs" follow on this statement, and his obligations to M. de Bonneval do not hinder the writer from revealing that the said *Contrôleur* "avoit une petittesse de gloriole assès singulière : sur mes planches dont j'avois fait les desseins, il faisoit mettre *De Bonneval invenit*; on en rioit, personne n'en étoit la dupe, mais il étoit content."[1] This absurd practice was established before Cochin was brought into the *Menus*, for we find "De Bonneval invenit" on the "Pompe funèbre" of Polixène, Queen of Sardinia, which is supposed to have been drawn as well as engraved by Cochin père. De Bonneval seems to have considered that every representation of court ceremonial which was "sous sa conduitte" ought properly to receive this stamp.

In the decorations for the Dauphin's marriage fêtes the Slodtz had surpassed themselves. Everything after that date of a similar character was absolutely entrusted to them, and Cochin's share in the performance had no less serious consequences as to his future, for it brought him directly under the notice of the Court. He had, however, to suffer in more than one way from the ignorance and carelessness of his superiors. Anxious as to the effect of his work, he had selected the printer to be employed by de Bonneval: "je l'avois prévenu," he adds, "que c'étoit un des plus habiles, mais qu'il avoit besoin d'être veillé." No notice was taken of this caution. The printer got drunk and set an incompetent subordinate to do his work, with the result that before a hundred proofs were pulled, the plates, which had been delicately engraved by Cochin père, were worn out.[2]

The consequences of this disaster are to be felt at the present day, for good impressions of the *Fêtes* are exceedingly rare. Engravings of the "Mariage" and the "Comédie," together with Cochin's drawings of "Le Roy tenant grand appartement" and of the "Illuminations des deux grandes Ecuries," were exhibited at the Salon of 1750. Cochin had then left for Italy, for his drawings had not missed their due effect; they had brought him the favour

[1] Mém. inéd., pp. 135-137.
[2] " J'en avertis plusieurs fois," adds Cochin, "inutilement ; il les servit donc de manière à mériter punition. Le bon M. de Bonneval lui fit donner une pension. Ce qu'il y eut de plaisant, c'est que l'imprimeur qui avoit imprimé mon ouvrage, qui avait mal servi, fut bien payé et récompensé, et que moy je fus mal payé et n'eut aucune récompense " (Mém. inéd., p. 139).

of the reigning favourite. "Il se fit connoître," writes Mariette, "de Mad. la Marquise de Pompadour, qui, ayant résolu de faire faire à son frère M. le Marquis de Marigny, pour lors appelé simplement M. de Vandières, le voyage d'Italie, pour y prendre le goût des arts, et se mettre en état de remplir dignement la place de directeur des bâtiments du roi, qui lui étoit destinée et voulant lui former une compagnie qui le servît utilement dans ce projet, jetta en particulier les yeux sur M. Cochin." [1]

The story of this journey, which lasted nearly two years, has been often told. Soufflot and the abbé le Blanc, who were also of the party, contributed a stock of sober learning, which was a barely sufficient makeweight for the more lively parts of the "petit Cochin." [2] He had rebelled from the earliest days of his youth against the restraints imposed by his father's training, and on more than one occasion he found relief from the tedium of copying the works of the great engravers of the previous century [3] in the reproduction of *sujets galants*. The scarcity of his engraving of Pierre's version of "Le Villageois qui cherche son veau" is accounted for by the story that his father angrily broke the plate before it was even entirely finished.

Madame de Pompadour could have chosen no more delightful companion for her brother than Cochin. He was not only full of wit and talent, but he had the manners which made him possible at Court and he knew a good deal. Not indeed very exactly, as a curious passage in one of his letters from Italy bears witness. "Je me souviens," he writes, "d'avoir autrefois lû dans un traitté sur la peinture (je crois de Paul Lomasso) des regles dont il dit que le Poussin faisoit usage"—forgetting apparently that Lomazzo died at least two years before Poussin was born.

The letter is in other respects full of interest, for the writer criticises chiefs of the contemporary Italian school:—Della Mura at Naples; Ercole Gratiano at Bologna; Tiepolo and Piazzetta at Venice, and regrets "la couleur outrée dans la quelle les Venitiens sont tombèz." He regrets too—and a vision of Watteau rises before us as Cochin notes—that he has not yet had "occasion de

[1] A. B. C. Dario, Mariette.

[2] Lettres de Madame de Pompadour.

[3] Amongst these it is said that Cochin père gave to his son "Le Christ couronné d'épines de Bolswert." It is described by MM. Portalis and Béraldi as "d'après Rubens" (t. i., p. 504), but would seem to be the same engraving referred to by Wille, March 16th, 1775: "J'ay acheté à la vente d'estampes de la succession de M. Mariette le 'Couronnement d'épines,' gravé par Bolswert, d'après Van Dyck. Superbe épreuve. Elle m'a coûté deux cent trente-neuf livres dix-neuf sols. Il y avoit longtemps que je désirois posséder une parfaite épreuve de cet ouvrage magnifique."

voir la *ros'alba*, elle a perdue la vue et on assure qu'elle n'aime point a ètre vûe dans cet état."[1]

There is no hint by which we can identify the personage to whom Cochin writes with so much freedom combined with the deepest respect, but as he suggests that Cochin's remarks might furnish the matter for a conference at the Academy, he was probably a leading *amateur-honoraire*. The letter is full of so much detail that it might indeed be a leaf fallen from the note-book out of which Cochin put together on his return the three volumes of his " Voyage d'Italie." [2]

The return of the party to Paris brought renewed strength to the classic reaction. " La véritable époque décisive," writes Cochin, "ç'à été le retour de M. de Marigny d'Italie et de sa compagnie. Nous avions vu et vu avec réflexion. Le ridicule nous parut à tous bien sensible et nous ne nous en tûmes point. Nos cris gagnèrent dans la suite, que Soufflot prêcha d'exemple. . . . J'y aiday aussi comme la mouche du coche." [3]

This sensational arrival put the finishing touch to the success of a most successful expedition. The discovery of de Troy's mal-administration and the illness of Soufflot had scarcely ruffled the sense of uninterrupted satisfaction. Cochin, who had succeeded in capturing the goodwill of Marigny and placing himself on a footing of friendly intimacy with him, must have felt that his " petites espérances " were in a fair way of realization, and the next step in his good fortune brought him the letters patent by which he was ennobled, together with the cordon of a " chevalier de l'ordre de St. Michel," obtained for him by the all-powerful mistress of the King.

To a man so assured of court favour nothing could be refused, and the Academy hastened to receive Cochin, although his diploma work was still in abeyance. On the 27th November, 1751, Coypel informed the Society that the work which their associate, M. Cochin, had been obliged to take in hand for the King, and specially his tour in Italy with M. de Vandières, having hindered him from completing his diploma work, he found him-

[1] See A. de l'A. fr., t. i., pp. 169-176. The letter is preserved in the Egerton MSS. at the British Museum.
[2] " Voyage d'Italie, ou recueil de notes sur les morceaux d'architecture, et sur les ouvrages de peinture et sculpture, qu'on voit dans les principales villes d'Italie." 3 vols. In-8. 1754. Cochin also published, in 1755, " Observations sur les antiquités de Herculanum, avec une dissertation sur les morceaux de peinture et de sculpture trouvés dans cette ville souterraine." In-12. See " L'Œuvre de Cochin," par Jombert. N. A., 1874-1875. There are various editions of these works.
[3] Mém. inéd., p. 142.

self thus deprived of the enjoyment of the instructive *conférences* which the Academy gave " sur les différentes parties des Arts qu'Elle cultive; qu'il supplieroit donc la Compagnie, en attendant qu'il satisfasse à ses engagemens, de lui accorder la grâce d'assister aux assemblées."

Thereupon all rules were cast to the winds. Cochin was on the spot received Academician without any diploma work, and simply contented himself with giving a lecture in the following spring (March 4th, 1752) on the advantages of an Italian tour. Coypel seems to have been prompted by something like a touch of gentle irony when he replied that all depended on the person : " Convenons que pour se rendre un tel voyage parfaitement avantageux, il faut, comme vous, s'ètre préparé dès longtemps."

This picture of Cochin's aplomb is amusing if we contrast it with his reply to the suggestion made by the unknown correspondent to whom he writes the letter preserved in the Egerton MSS. " Vous me flattéz, Monsieur, que mes foibles remarques pourraient ètre la matiere d'une conference a l'Académie. Je n'ay point cette vanité, et n'ay assurement rien a dire que tout le monde ne sache mieux que moy. D'ailleurs je ne croy pas que je pûsse jamais surmonter la timidité (qui m'est naturelle) jusques a ce point." Coypel, who had alluded with so much delicate humour to the evident advantages of an Italian tour, died shortly after,[1] and was immediately succeeded by Cochin in the vacant post of " garde des dessins du roi."

Two years later Lépicié, " secrétaire et historiographe " of the Academy, also died and Cochin was at once selected to fill his place. His fellow members felt that they could not have a better representative. He himself was so deeply touched by his appointment that he was obliged to read instead of speaking his thanks and acknowledgements : " Dans les premiers moments de ma nomination," he says, " il ne m'eut pas été possible de vaincre la timidité qui saisit naturellement toutte personne obligée de paroistre pour la première fois au milieu de vostre respectable Compagnie." Mariette, commenting on Cochin's special qualifications, says he was worthy to succeed Lépicié " tant parce qu'il a le talent d'écrire, que parce qu'il a de la souplesse dans l'esprit, et, s'il faut le dire, du manège."

A hint of something of this character seems to be given in Coypel's speech on Cochin's election, and his immense social popularity would in itself suggest " du manège." At Court or in the town Cochin was equally welcome. The " bureau d'amateurs "

[1] June 14th, 1752.

44

at Madame Geoffrin's adopted him as one of their leading counsel; his close intimacy with Madame de Pompadour, whom he advised as to all her purchases and commissions, placed a large amount of patronage in his hands, and the influence which he had acquired over the young Abel Poisson gave Cochin, when his friend came to power, the actual administration of the fine arts for over forty years.

Mariette, whilst observing that, as far as concerned the Academy, Marigny did nothing except what Cochin told him, adds that this flattering position had its disadvantages, for it induced Cochin to sacrifice his special gifts: "depuis cette époque," he says, "il n'a presque plus manié la pointe ni le burin. Il s'est contenté de dessiner et d'affecter dans ses dessins d'y mettre ce qu'on appelle de la grande manière. Mais il y a des gens qui regrettent celle qu'il s'étoit faite autrefois, et qui, pleine de gentillesse, paroissoit lui avoir été dictée par la nature seule." In justification of this criticism he cites the noble drawing of the "Réception de l'ambassadeur turc," and compares it with the allegorical compositions designed by Cochin for the illustrations of President Hénault's "Histoire de France." [1] We have but to look at these or at any of the tiresome allegories, which form so great a proportion of Cochin's later work,[2] to feel that an Italian tour in the company of archæologists is not always an unmixed advantage.

After his return from Italy, but before he ceased to engrave, Cochin undertook, in concert with M. de Montenault, the publication of the "Fables de la Fontaine,"[3] with 276 illustrations after the drawings which Oudry "avoit gribouillé à ses heures perdues." M. de Montenault, of Aix in Provence, was a man of parts who had wasted his fortune. He had attached himself to Darcy the banker, and had induced him, as well as one of his confrères, to finance the undertaking.

To these there joined himself a M. Bombarde, of whom Cochin tells us that he was simply "un important riche, de ces gens qui font les entendus en tout, sans que l'on sçache au juste

[1] Twenty-nine "estampes de l'Histoire de France de M. le Président Haynaut," drawn and engraved by Cochin, were exhibited in 1750. Other drawings for this work appeared at the Salons of 1765, 1767 and 1773.

[2] See the allegorical drawings engraved by Gilles Demarteau l'ainé: "La France témoigne son affection à la ville de Liège," "La Justice protège les Arts," etc.

[3] "Fables choisies mises en vers par J. de la Fontaine," 1755-1759. It is said that the frontispiece only is etched by Cochin fils, and that the other engravings signed C. Cochin are all by his father. I note, however, that Cochin père died in 1754.

pour quoy, qui cependant viennent à bout de persuader aux gens
en place . . . qu'on ne peut rien faire de bien sans leurs conseils."[1]
Called to attend the meetings which took place at his house,
Cochin put in an appearance unwillingly: "Je fus chargé," he
says, "de rectifier les desseins où il y avoit des figures qu'Oudry
estropioit à merveille. Mon affaire étoit rangée, il n'en étoit
pas question. Mais la partie tipographique étoit importante, et
M. de Montenault, l'éditeur (du moins celui qui paroissoit, car
il n'étoit pas le véritable bailleur de fonds), n'auroit pas cru rien
faire de passable, sans la direction de M. Bombarde."

Montenault it seems knew how little the man was worth, but
he knew also how important it was to have " les prôneurs bavards
pour soy "; so meetings were held and attended by Berryer,[2] then
Lieutenant de police, and Malesherbes,[3] the son of the Chancellor.
" Never," says Cochin, " did I hear so much serious talk about
nothing . . . the best of it was that after many conferences at
which nothing was decided, we remained and politely made our-
selves masters of the edition, wisely enough or we should never
have finished. The smallest printer knew more than they did."

At the same time that Cochin was engaged on this enterprise,
for which he etched the delightful frontispiece of " Esope montrant
le buste de la Fontaine," which was finished by Dupuis, he found
time to help Massé, who was then absorbed by his magnificent
reproduction of the paintings and decorations by Le Brun in the
"Grande Galerie" of Versailles.[4] The fine "développement" which
opens the series, giving the scheme of the interior decoration and
the paintings of the ceiling, was drawn, re-touched and partly
etched by Cochin;[5] nor could Massé have found anyone more
admirably competent to handle work full of expressive movement
on a minute scale.

The incessant demands on Cochin's time, the necessity for the
strict fulfilment of official obligations, forced him to seek for some
one who could not only give him efficient help in his profession
but take charge of his house. On the death of his father he had

[1] Mém. inéd., p. 71.
[2] René Berryer, a *protégé* of Madame de Pompadour, who made him Ministre de
la Marine.
[3] The famous Malesherbes who defended Louis XVI.
[4] "Je profiterai de cette occasion, pour vous entretenir des gravures de *la gallerie
de Versailles*, dont l'illustre M. Massé vient d'orner le sallon " (Cochin, "Lettre à un
amateur, en réponse aux critiques qui ont paru sur l'exposition des tableaux," Sep-
tembre, 1753, Œuv., t. ii., p. 49, note). See also " Eloge hist. de M. Massé," t. iii.,
pp. 283-323. The work was begun in 1723 and ended in 1753.
[5] "Développement de la décoration intérieure et des peintures du plafond de la
Galerie de Versailles." Chal. du Louvre, No. 1018.

given shelter to his aged mother and others dependent upon him in his lodgings in the Louvre, where they lacked the attention they required, until Cochin found in the young engraver, Simon Miger,[1] one who was exactly suited to the place.

Miger, whom Wille speaks of as "mon élève," had been employed by Montenault on his edition of the "Fables" both as secretary and superintendent of the printers and engravers. He had, in fact, relieved his employer of all serious responsibility, but there arose between them a mysterious quarrel, and Miger only consented to remain with Montenault until the completion of the work out of deference to the combined authority and influence of Madame Darcy and Cochin. In June, 1760, when the last proof had passed, Miger took his leave with inexpressible joy, and settled down in the galleries of the Louvre as the "commis" of Cochin with a salary of 200 lt. yearly.[2]

The household of which he found himself in charge was extraordinarily incongruous. "La maison de mon maître," he writes, "se composait de M. Cochin; de sa mère, agèe de 80 ans; de sa sœur, personne de 40 ans; d'une cousine de 50 ans: trois femmes bien dévotes, et jansénistes pardessus le marché; d'un domestique femelle pour ce trio, et d'un laquais pour le chevalier." Cochin put in an appearance at this cheerful table scarcely once a month. Miger, therefore, had to do the honours regularly for those whom his master had christened "les sempiternelles":[3] he never went out except on Sunday to dine with Madame Darcy, where he usually found Cochin, who was incessantly engaged with Marigny by day, and spent his evenings and supped with a circle of friends.

This last allusion points to the house of Madame Geoffrin, for, as Alexandre Tardieu tells us, "Cochin fils fut l'oracle du

[1] 1736-1820. R. January 31st, 1778, on the engraving of "The Satyr Marsyas," after Carle Van Loo: on February 24th, 1781 he presented the plate of the portrait of Michel Van Loo painting his father, Jean-Baptiste (Chal. du Louvre, Nos. 1299, 2213). His "Billet Doux," after Boucher, is a pretty example of his work.

[2] See Emile Bellier de la Chavignerie, "Biographie et Catalogue de l'œuvre du graveur Miger," p. 19.

[3] Cochin's mother died in 1767. Wille writes on the 4th October of that year: "J'assistay aux convoy et enterrement de Madame Cochin, née Horthemels, mére de M. Cochin, chevalier de l'ordre de Saint-Michel, graveur du roi, secrétaire de l'Académie royale de peinture et sculpture, et garde des desseins du Cabinet du roi. Elle demeuroit avec M. son fils, aux galeries du Louvre, et fut enterré à Saint-Germain-l'Auxerrois, sa paroisse. Un monde infini, outre l'Académie, accompagnait le corps de la défunte. Elle étoit d'une grande douceur et avoit beaucoup et fort bien travaillé dans la gravure. Elle avoit quatre-vingt sept ans, et il y avoit bien vingt-sept ans que je la connoissois et estimois infiniment."

salon de Madame Geoffrin et l'âme des soupers qu'elle donnait à
la meilleure compagnie de Paris, soupers si recherchés plus pour
ce qui s'y disait que pour ce qu'on y mangeait."

Yet, whilst playing a conspicuous part in this brilliant society,
Cochin's activity in various directions was incessant. If we look
only at the innumerable portraits which he drew, we feel that
they might represent the labour of a lifetime. Not a celebrated
man, nor charming woman of his day, has escaped the delicate
pencil which records their features for us—generally in profile—
with a sincerity invariably tempered by kindly sympathy. The
work which he did for Marigny in connection with his adminis-
tration of the Fine Arts was onerous and often ungrateful. He
had to " ménager les Anti-Caylus " in the Academy and at the same
time he tells us that he had to remain neutral " et à me garder de
leurs conseils qui m'auroient mal poussés et m'auroient fait com-
mettre quelques imprudences." Cochin went, moreover, in some
fear of his friend Marigny, who was not the man to allow himself
to be directed by " les conseils d'Amateurs."

Cochin's work in connection with the post he held in the
Academy also made heavy claims on his time, yet he contrived
to draw incessantly. He put his own hand to nine of the fine
series—" Les principaux évènements du règne de Louis XV par
médailles "—commissioned by the King.[1] The number of other
illustrations, vignettes and portraits by him are not to be counted,
for on all sides so many applications were made to him, that he
ceased to use either point or graver and contented himself with
giving drawings only.[2] As we run over the list of his contribu-
tions to the Salons, we see that from 1777 they consist almost
wholly of engravings for which he has given the drawings. We
pass from Delaunay, Augustin de Saint-Aubin, Miger, Ponce,
till we come, after his death, in 1793, to " la cit. Cernel "—the
lady concerning whose married life Sergent made indiscreet revela-
tions to Restif de la Bretonne.

As we follow the lines of Cochin's brilliant activity we must
not lay stress on his masterly delineations of court pageants to the

[1] Four were exhibited in 1755. Cochin refers to this series as the ground
on which he thought himself entitled to succeed Bouchardon as "dessinateur des
médailles du Roy." It was secured for Vassé by Caylus (see "French Architects and
Sculptors," p. 88), greatly to Cochin's disappointment. "Je ne voyois," he says,
"guères d'autre manière d'avoir aussi un petit bien-être que par le moyen de cette
place" (Mém. inéd., p. 49). The work was never finished, and in his will Cochin
leaves to the "Cabinet des dessins" the allegorical drawings "qui se trouvent faits
pour l'histoire métallique du feu roy" (Mém. inéd., p. 149).
[2] His work in the Cabinet des Estampes fills six large folios.

exclusion of the great share which he had in the transformation of the illustrated book. In addition to the many volumes the illustrations of which are mainly due to him, innumerable are those in which we find unexpected traces of his hand.

His illustrations of " Le Lutrin," exhibited in 1742,[1] are of inimitable wit and spirit : the fat Bishop rolling out of bed when aroused by the angry *chantre*; the Canons and the *Grand chantre* furiously destroying the offending *Lutrin*; the meeting of the *Grand chantre* and the Bishop at the battle of the books on the steps of the Sainte Chapelle, are of an amazing liberty of execution, free also from the influence which might naturally have been exercised by the previous designs of Bernard Picart[2] for the same poem. Compared with these transcriptions from the very life, the allegorical compositions which complete the series are sadly inferior, although they are less mannered than the same class of work executed from Cochin's designs at later dates.

From amongst these we may take, for example, the illustrations of " L'Origine des Graces,"[3] which show a lamentable want of distinction; but even in his best years Cochin is not really interesting when he is busied either with allegory or the classics. How inferior is his " Virgil "[4] to the " Lutrin," or to the exquisitely dainty trifling of the cuts in the " Pastor Fido"![5] Although this book did not appear until 1766, the illustrations had been executed by Cochin in 1745, and are worthy, such is their elegance, to reckon amongst the triumphs of that famous year : the year which saw Cochin designing and engraving the miraculously pretty ticket of admission to the " Bal Paré, porte et gradins à gauche,"[6] and setting the great subject of the " Bal " itself in the framework of flowers and flights of airy Loves which has so much to say to the general beauty of the effect.

The truth is that Cochin was great in handling scenes of his

[1] There is a great difference between the beauty of the impressions in the early copies. These may be known by the transposition of the vignettes by Eisen at the head of Satires VIII and IX.

[2] " Œuvres de Boileau," Amst., 1718, fol.

[3] By Mlle. Dionis Duséjour, 1776. There are six illustrations engraved by Augustin de St. Aubin, Simonet, Née, Masquelier, Delaunay and Aliamet. It is noticeable that some are signed " Cochin filius " and one " Cochin eques."

[4] The drawings were exhibited in 1742.

[5] " Il Pastor Fido. Tragicom. Pastor. del Cav. Guarini. In Parigi. Appresso Prault. M.DCC.LXVI." The title-page, which is an extremely beautiful work by Moreau le jeune, is dated and signed " J. M. Morea [*sic*] Le j. 1766." The six cuts are all signed by Cochin with the date 1745. All are engraved by Prévost, and on two he has added the date 1765.

[6] Chal. du Louvre, No. 2556.

own time with the superb courtliness he loved. Of classic story and
mythology his conceptions were vague and unmeaning; he had
no more imagination than Boucher; but let him only touch the
pulse of those who breathe the same air as himself and he receives
instant inspiration. No better proof of this can be given than is
to be found in the admirable drawing of the Life School, ex-
hibited in 1767, which shows the students competing for the
Prix d'Expression founded by de Caylus. Every head is drawn
with as much care as if it were the subject of independent study,
such as that bestowed in 1787 on the masterly portrait of Fenouillot
de Falbaire,[1] now in Mr. Heseltine's collection, where we also
find the superb coloured portrait of the famous littérateur, Antoine
Thomas,[2] in the execution of which Cochin has employed and
balanced red and black chalk with surprising dexterity and skill.

Great were Cochin's opportunities for amassing fortune. The
speculation into which he entered with Le Bas[3] for the repro-
duction of the "Ports de France," after Joseph Vernet, had a
complete commercial success, but Cochin remained poor. Wille,
who always had an eye to business, writes on the 11th October,
1760: "J'ay retiré six exemplaires des marines que MM. Cochin
et le Bas ont gravées d'après M. Vernet. J'ay souscrit de nouveau
pour six exemplaires des quatre planches suivantes."

Twenty subjects were originally promised to the subscribers
but only fifteen were completed when Cochin took the matter so
much to heart that he started for Havre (1776) to see what he
could himself do. "Vous connoissés," he writes to Descamps,
"les Ports de France de M. Vernet, hé bien, je vais faire un
essay pour tenter de les continuer. Vous pensés bien que je n'ay
pas la sottise d'imaginer que je feray des Vernets, ce ne seront tout
au plus que des Cochins, mais peut-être s'en contentera-t'on faute
de mieux."[4] One subject was successfully completed by Cochin
at Havre and engraved by Le Bas for the Salon of 1781. Two
others, giving different views of the port and town of Rouen,
were also executed by Cochin, but the engraving of one, at least,
was not finished when he died, for in his will, dated April 28th,
1790, the day before his death, special provision was made for its
completion.

"Je charge mon exécuteur testamentaire," so runs the clause,

[1] The author of "L'honnête Criminel" and "Le Fabricant de Londres," both of
which are illustrated by Gravelot.

[2] 1732-1785.

[3] See the Scellé of Le Bas, 1783. N. A., 1885, p. 153.

[4] Letter cited without reference, Portalis and Béraldi, t. i., p. 529.

BILLET DE BAL PARÉ À VERSAILLES POUR LE MARIAGE DE MONSEIGNEUR
LE DAUPHIN, LE MERCREDI, 24 FÉVRIER 1745.

(COCHIN LE FILS.)

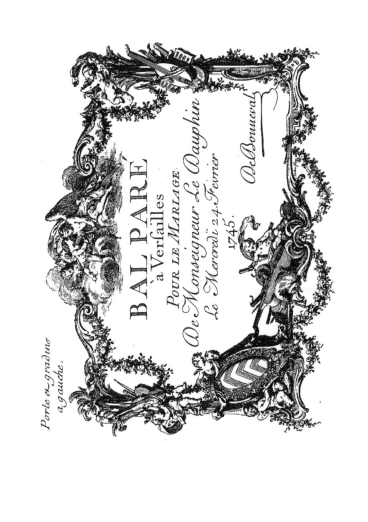

BAL PARÉ
à Versailles
POUR LE MARIAGE
De Monseigneur Le Dauphin
Le Mercredi 24 Février
1745.

De Bonneval

Porte et gradins
a gauche.

"cy-après nommé, de faire achever et perfectionner par M. Le Chauffard, graveur, la planche du port de Rouen, qui m'appar- Chevalier tient."[1] Some difficulty•attached to the execution of Cochin's Cochin. wishes, and Wille writes on August 14th, 1790: "Je devrois ètre un des juges et M. Bervie devoit l'ètre également, par rapport à deux planches non achevées représentant deux vues de Rouen que feu M. Cochin et M. Hecquet,[2] avocat, faisoient graver en société. Cette société étant rompue par la mort de M. Cochin, les héritiers de celui-cy sont en dispute avec M. Hecquet, qui veut avoir l'argent avec l'intérêt. MM. Bervic, Hecquet, Bel, avocat des héritiers, Basan et un autre s'étoient rendus chez moi pour l'arrangement de cette affaire, mais rien ne put être décidé." To this passage the conscientious editor of Wille's MS., M. Duplessis, has appended a note to the effect that these two *planches* were probably never finished; that there is no mention made of them anywhere; and that in spite of every search he has been unable to find a single proof.

They were, however, most certainly finished and exhibited. The catalogue of the Salon for 1793 contains entries of "Vue du Port et de la Ville de Rouen, prise de la pointe de l'Isle de la Croix," and "Vue du Port et de la Ville de Rouen, prise de la petite chaussée." They are described as drawn from nature by C. N. Cochin and engraved under the direction of Le Bas and Choffard. The two engravings are, we are told, the Nos. 17 and 18 of the collection of the "Ports de mer de France, d'après Vernet, et se trouvent chez Basan."[3]

The enterprise, to the conclusion of which Cochin attached so much importance, and which so anxiously occupied his last hours, although it had an immense popular success, provoked from the first the hostility of Diderot. He did not love Cochin, perhaps because he owed him so much. The Chevalier Cochin, says Alexandre Tardieu, was the regular source of all Diderot's technical information, but again and again he goes out of his way to abuse him. In the Salon of 1763 he taxes Cochin with being "homme de bonne compagnie qui fait des plaisanteries, des soupers agréables, et qui néglige son talent." In 1767 he goes farther, and brands the two engravers of the "Ports de France"

[1] Mém. inéd., p. 149. The reason for this anxiety is to be partly found in Cochin's indebtedness to Descamps, who had advanced money to him which was to be paid out of the profits to be made after the completion and publication of the "Port de Rouen." He had stayed with Descamps at Rouen.
[2] Probably a member of the Abbeville family to which Pierre Hecquet, the celebrated doctor, belonged.
[3] See Appendix D.

51

as " deux habiles gens dont l'un aime trop l'argent et l'autre trop le plaisir."

Diderot seems to have been prejudiced from the first against the style in which the subjects were reproduced, admirably fitted though it is to render the light facility of Vernet's work. The engravings are of unequal merit, but some are very happy. I never look, for example, at the " Vue de la Ville et de la Rade de Toulon " without the most lively admiration for the amusing groups of figures by which it is peopled, and without recalling Mariette's reference to Cochin's work on the " Ports de France": " il a arrètè sur le cuivre le trait de toutes les figures qui y entrent; c'est la seule part qu'il ait à ces planches parfaitement bien exécutées."

Cochin's own letter to Desfriches in 1781 shows merely the regret that most men of fine intelligence feel when they have taken life too easily. " Beaucoup d'affaires, des maux d'yeux, des soupers en ville, on se couche tard, on ne se lève pas matin, des dessins à faire qui sont pressés, ou l'on emploie les parties de la journée qu'on ne passe pas à table, car vous savez que qui veut se livrer à la société de Paris ne manque pas d'occasion de gueule; ainsi se passe la vie et après cela on se plaint qu'elle paraisse courte."[1]

The pleasures which Cochin loved had no ugly side. Brilliant talk and good company did no such injury to his art as was inflicted by the pernicious classicisms and allegories which he brought back from Italy. They were more probably necessary to its perfection. In the myriad groups of pleasure-seekers who figure in Cochin's representations of royal ceremonies—dancers, sightseers, busy gamesters at the table of the *jeu du roi*—we find a freedom, an ease, a style, a liveliness of air which show perfect familiarity with the ways and customs of those whose pomps and vanities were the subject of his pencil. It is this intimate acquaintance with the manners of good company, with the shades of bearing which differentiate the various elements which make a Court and which distinguish the actors from the onlookers, that gives to Cochin's work such brilliant interest.

It is probably this feature that impressed M. de Chennevières when he asserted that Cochin had never been equalled, not even by Moreau, for " la liberté, la fine expression, l'aisance, le galant, l'esprit, la variabilité infinie des mouvements et des poses de ses petites figures." Their faces are inexpressive, but every gesture, every movement has been caught from life, and we feel that

[1] See letter cited, Portalis and Béraldi, t. i., p. 545.

wherever Cochin may have been—in Madame de Pompadour's closet, under the eye of royalty, escorting Marigny [1] or Clairon on their visits to studios, making one of a party of *confrères* to dine with de Livry and visit the pictures at Versailles,[2] or fulfilling his official duties—he was equally alert and observant, no indication of character, or humour, or habits escaped him ; the changing pictures of the life about him were food for his admirably suggestive art.

Cochin's last years were darkened and embarrassed by the treacherous robbery of which he became the victim. " Ce qui m'a le plus poignardé," he says, " c'est l'horrible ingratitude de ce monstre," and he seems to be referring to a young cousin whom he had taken into his rooms out of charity. "Je l'amois, je cherchois à le former à tous égards. Il estoit à ma table même quand j'avois compagnie. N'en parlons plus, le sang me bout de rage, cependant je n'ay point porté plainte. Je ne veux point me préparer de nouveaux chagrins tels que ceux de M. Pierre lorsqu'il a fait pendre l'élève qui l'avoit volé."

For eight months the cousin had secretly conveyed from Cochin's lodgings in the Louvre everything that he could lay hands on. Eight to nine hundred proofs of the " Ports de France " —unlettered proofs worth 30 l. apiece—had been sold by the thief for 9 l. each ; a quantity of proofs of the " History of France," which Cochin was bringing out with Prévost, had also disappeared ; and worst of all was the loss of all the proofs which, during an active professional life of forty years, had been presented to Cochin by the engravers, his friends—" touttes choses," he writes piteously, ." devenues rares et de prix." By a lucky chance, for which, he adds, " I cannot sufficiently thank God, he has touched nothing belonging to the King."

" You know," he continues, " that I have in my care about a million drawings of the royal collections ; judge of my state, being eaten up with this anxiety, all the time that it took to make sure that nothing was missing. However, in this respect I have lost nothing. It is true that I keep these things more strictly than I do my own goods." The letter concludes with a wish that the

[1] See Chap. V., p. 79. Marigny seems to have always required the attendance of Cochin when making visits to studios. He probably looked to his companion for protection against the weakness of his own judgement.

[2] This visit was possibly the result of Cochin's previous work for Massé's " Grande Galerie de Versailles," for we find in Wille's journal on July 29th, 1761, the following entry : " J'allai à Versailles avec M. Massé, M. le chevalier Cochin, mes anciens amis, et Mme. Basseporte, du jardin du roi. C'était pour diner chez M. de Livry."

vention of the Queen. "On leaving the Assembly," concludes
Wille, "I went to our district."

Our district was that of the Cordeliers, presided over by
Danton, of whom we get a glimpse in the journal a day or two

[1] Letter to Descamps, July 12th, 1786, cited by Portalis and Béraldi, t. i., p. 548.
[2] Mém. inéd., p. 147 *et seq.*
[3] François Dumont de Luneville. R. May 31st, 1788.

earlier, when the deputies of other districts presented themselves to give in their adherence to certain resolutions which laid down that "le Châtelet ne devoit pas se mêler de connoître des crimes de lèse-nation," and Wille remarks that the president had thanked them with "éloquence, fermeté et politesse."[1] When there was such entertainment as this to be had, the death and ruin of brother Academicians was a matter of little moment.

[1] Mém., April 24th, 1790.

CHAPTER IV

THE DREVET AND JEAN-FRANÇOIS DAULLÉ

THE influence of the great amateurs, backed by the great publishers, could not fail seriously to affect those who worked for them, but the contemporaries of de Caylus and Mariette had been nourished like themselves in great traditions. They were men who had learned their lessons in the school of Edelinck, of Nanteuil or of Gérard Audran, and the severity of their training made possible the achievements of a later day—the triumphs of Choffard's fairy-like point and the miniature excellence of Gaucher or of Ficquet. The variety of purpose which claimed the services of the engraver as the years went by demanded variety of method, but the training of the elder school gave to the elegances of later eighteenth-century work that irreproachable distinction which is not the least of its claims to consideration. That is why it is well here to mention the Audran, and although much of their work belongs in truth to the days of the " Grand Monarque," not to forget either Pierre Drevet or his even more gifted son.

The masterly execution of Gérard Audran—the engraver of the " Batailles d'Alexandre "—calculated with admirable economy of resource, had given perfect expression to the formal and rhetorical art of the " great century."[1] Gérard's nephew and pupil, Jean,[2] shows also something of this skill in the engravings after Jouvenet,[3] which he presented to the Academy in 1726, together with those of the graceful " Twelve Months," after his brother Claude,

[1] See " Art in the Modern State," pp. 180 and 182.
[2] 1667-1756 (see P. V., June 26th, 1756). R. June 30th, 1708.
[3] Chal. du Louvre, Nos. 981 and 982.

the famous decorator for whom Watteau worked at the Luxem- bourg. The same qualities are even more marked in the " Seven Sacraments," after Poussin, by that third brother, Benoît,[1] who was also sent by his father to his uncle Gérard, at the age of seventeen; but Benoît is better known as the engraver of the drawings attributed to the Regent in the " Daphnis and Chloë " of 1718, although in this much overrated book, as in his later work, he sinks almost to the level of his nephew, Benoît II.[2]—a very inferior artist.

The teaching of Gérard Audran was better assimilated by his pupil, Pierre Drevet,[3] than by any member of his own family. No better work of its kind exists than the superb series of portraits which Pierre Drevet engraved after Rigaud[4] and Largillière. Beginning with that of Maximilien Titon and the young Duke de Lesdiguières,[5] we pass to those of Félibien des Avaux and of Colbert, archbishop of Rouen, which are even superior to the two celebrated portraits of Louis XIV.[6] or to that equally remarkable work, the portrait of Louis XV.

The most complete account of the family of engravers to which Pierre Drevet belonged was given by M. Ambroise Firmin-Didot when he published the " Catalogue raisonné " of their work, which is still the best we have, although we owe fresh documents to M. Rolland, *greffier de paix à Givors* "—whose " arrière-grand'-mère " was the niece of Claude Drevet.[7]

" Vous remarquerez," writes M. Rolland, " d'après les actes dont vous avez la copie, que la famille Drevet de Loire a été de tous temps une des premières familles du pays." They were, he says, men who tilled their own land and were in possession of their little " tuilerie et à temps perdu, et surtout les jours de pluie, ils fabriquaient de la tuile."[8] At Loire, Pierre Drevet was born.

[1] 1661-1721. R. July 27th, 1709. He lived in the Luxembourg with Claude.

[2] 1700-1772. He was the son of Jean Audran, who lived at the Gobelins. He began, like most young engravers, by doing portraits for Odieuvre, but we find his name on various prints after Watteau. See N. A., 1885, p. 18.

[3] 1663-1738. R. Aug. 27th, 1707.

[4] When Rosalba was staying with Crozat, Rigaud gave her a collection of portraits engraved after him by Pierre Drevet, and sent the rest on to her at Venice ("Diario della Rosalba," p. 67).

[5] No. 242, Galerie Lacaze, Musée du Louvre.

[6] In the *inventaire* of Oudry we find "une estampe représentant *Louis XIV*. gravée par *Drevet* d'après *Rigaud*, sous une glace et dans une bordure de bois doré" (N. A., 1884, p. 207). The picture itself is No. 475, Musée du Louvre. No. 96, Musée de Reims, is a duplicate.

[7] Arch. des Arts, 1890, pp. 186-193. See also Jal, usually a trustworthy source of information.

[8] " La terre de ce pays est très propre à ce genre de fabrication et de tous temps

The son of "honneste Estienne Drevest et de dame Catherine Charnou" was a delicate child, and we find that he received, on the 16th August, 1663, the complement of the ceremonies of Holy Baptism, having been christened "à la maison *propter imminens mortis periculum*" on the 20th of the preceding July.[1]

A weakly constitution probably retarded the development of Pierre Drevet's remarkable powers. His training, which had begun under Germain Audran at Lyons,[2] was completed in the school of the famous Gérard Audran in Paris, but he was forty when we first find his name on the books of the Academy. Up to that time his situation must have been rather uncertain, yet, amongst the engravings executed by him, under the protection of Gérard Audran, there are several that must rank with his best work.[3]

Portraits have always held a prominent place in French art. At the beginning of the century a special impulse was given to their production by their selection as the subject for the diploma works of engravers. "MM. les graveurs" had appealed against the varied tasks at first imposed upon them, and Drevet was one of the first to avail himself of the permission to engrave portraits only.

He had presented himself on the 28th September, 1703, and was obliged to claim the protection of the Society, two years later,[4] against the vexations of the *imprimeurs en taille douce*, who were unwilling to recognize the freedom of an *agréé*. In spite of this need for protection there was an immense delay before Pierre Drevet fulfilled his obligations. The portrait of Robert de Cotte, after Rigaud—proposed in 1703—he undertook to engrave in 1707, but it was not delivered by him until fifteen years later.[5] Meanwhile he had left in pledge with the Academy the plate engraved by Edelinck after Largillière's portrait of Le Brun, together with one hundred proofs, but he was not allowed to withdraw the plate except on condition of pulling a second hundred proofs from it as a gift.[6]

il y eut des tuileries; c'était là qu'étaient les tuileries des Romains de Vienne" (Rolland, "Arch. des Arts," 1890, p. 189).

[1] Rolland, "Arch. des Arts," 1890, p. 191.

[2] There was a family connection with the Audran of Lyons (*ibid.*, p. 193). Germain (1631-1700) was the son of Claude le père and brother of Gérard, but an indifferent workman who never left Lyons (A. B. C. Dario, Mariette).

[3] The portraits of the Duke de Lesdiguières and of his mother, those of Keller, with the equestrian statue in the background, of Mme. Keller and of that delightfully insolent old lady "Marie par la grace de Dieu, Souveraine de Neuf-châtel et Vallangin, Duchesse de Nemours," all belong to this period.

[4] P. V., Jan. 31st, 1705. [5] P. V., Feb. 28th, 1722.

[6] P. V., July 30th and Aug. 27th, 1707; Feb. 28th, 1722.

The same obligations were imposed on Drevet le fils,[1] when he in his turn presented himself. On the 30th December, 1724, he was directed to reproduce the portraits of Rigaud and Barrois and, although his engraving of de Boullogne's picture of " The Puri- fication " was accepted from him in June of 1726, he received a few months later, in company with Larmessin, reiterated instruc- tions respecting the two portraits still due as his diploma work.[2]

Pierre Drevet found in his son, Pierre-Imbert, his own rival. In the great series of their work it would be difficult to separate that of the father from that of the son, or that of either from that which they produced together, were it not for the evidence of dates and signatures. Throughout his life the father had had the command, as engraver, of all the most important work that was produced in France. His son had, therefore, before his eyes, from his earliest days, examples of a class calculated to stimulate his re- markable talent. As Mariette tells us, he received from his father daily lessons, not only in skill but in unwearying patience and conscientious devotion to his exacting art. If he could only attain his ends, he counted as nothing the time and the labour— often mere drudgery—which he had to give to his work.

Pierre-Imbert, thus trained, distinguished himself at an age when others are but feeling their way. At twenty-six he had already produced his superb portrait of Bossuet,[3] a work which shows all the quality of his father's admirable handling of the graver. There is the same brilliancy, the same economy of means, the same freedom and breadth in the treatment of the voluminous draperies—in which his model, Rigaud, delighted—and the same delicate precision in the rendering of head and hands. These admirable characteristics distinguish his even more celebrated portrait of Adrienne Lecouvreur, executed in 1730. She had died on the 20th March in that year. On the 24th Mathieu Marais writes : " I keep for the last the death of Mademoiselle Lecouvreur, who was ill but three or four days, who died in the arms of the comte de Saxe, who loved her no more ; and not having had the time to renounce the stage, it was impossible to obtain a little earth to bury her."

Coypel had painted her in the character of Cornelia, weeping over the urn in which she carried the ashes of Pompey and

[1] 1697-1739. He was succeeded in his lodgings in the Louvre by his cousin Claude, who was an indifferent character and produced very little. He died in 1781 (N. A., 1885, p. 129), having squandered almost the whole of the fortune amassed by his uncle and cousin ("Arch. des Arts," 1890, p. 190).
[2] P. V., Dec. 30th, 1724 ; June 13th and Nov. 9th, 1726 ; March 6th, 1728.
[3] This portrait of Bossuet by Rigaud is in the Musée du Louvre, No. 477.

it was decided to engrave this portrait as a tribute to her memory. Had it been a less remarkable work, the pathetic nature of the circumstances under which it was produced would no doubt have given to this engraving a great popular value : even now one can only dare to suggest that it is—and perhaps properly so—less virile and splendid than the Bossuet, which remains one of the finest, if not the finest work of Pierre-Imbert Drevet ; it is, indeed, finer even than his magnificent reproduction of Rigaud's portrait of Samuel Bernard.[1]

No happier phrase can be found to describe the peculiar quality and charm of the Bossuet than that used by Mariette, who had made a collection of everything executed by these two engravers. "Son burin," he writes of Pierre-Imbert, "est d'une couleur extrêmement douce et brillante et l'on ne peut regarder sans étonnement les recherches dans lesquelles il est entré, et avec quelle légèreté, quelle précision, il a exécuté chaque objet suivant le caractère qui lui convenoit."[2]

Something of the wonderful success of the Bossuet engraving must be credited to the extraordinary pains taken by Rigaud to ensure the perfect reproduction of this portrait. One usually expects to find that the engraver has himself made the drawing from which he has worked, but, in this instance, the painter performed this task, and performed it as Rigaud alone was capable of doing. Wille, the engraver, who was known to Rigaud, and who is certain to have understood what he was writing about, tells us that on the 2nd of January, 1762, he is exhibiting at his own house the original drawing made by Rigaud "pour la gravure du beau portrait de Bossuet, évêque de Meaux, chef-d'œuvre de gravure de M. Drevet, le fils. J'ay fait l'acquisition," he says, " de ce magnifique dessein en vente publique, provenant de la succession de M. Rigaud," and adds that his purchase was keenly contested ; that he had been offered 300 lt. for it, but that he would not take double the money, because of the pleasure it gives him.

The portrait of Adrienne Lecouvreur was the last important work of Pierre-Imbert Drevet. As far as the dates can be pieced together, it was in 1726 that he suffered the sunstroke, during a fête at Versailles, which for a time deprived him of reason and from which he never completely recovered. If this is correct, then this fine portrait must have been executed, with the help possibly of his father, during an interval of suffering.

His madness was not, we are told, "une folie complète, mais

[1] Described as by Pierre Drevet sometimes, but it is signed " Pierre-Imbert Drevet."
[2] A. B. C. Dario, Mariette.

bien une imbécillité intermittente," and when at Loire he would
often have himself rowed out to the middle of the Rhône. There,
with a glass, he drank water dipped from the midstream, believing
that it would bring him back his wits.[1] If, as they say, he was
but twenty-nine when this happened, we have to count thirteen
terrible years of conscious suffering before Pierre-Imbert was
released by death.

With him the last representative of what one may call the
fixity of style which was a mark of the school of Gérard Audran
passed away, nor can one speak of any who succeeded him as
showing the same faith in and perfect intelligence of the resources
of pure line. François Chéreau,[2] the best of Pierre Drevet's
pupils, died nine years before his master. The learned and
decisive execution of his fine series of portraits after Rigaud—
amongst which the masterly "Nicolas de Launay" may be cited
as an example—give him a serious claim to notice, for they show
admirable dexterity in handling the burin, and this dexterity, like
his drawing, is devoted to the exact rendering of his subject.
His brother Jacques[3] sustained the traditions of his training by his
fine engraving of Van Loo's portrait of Marie Leckzinska, but the
third pupil of the Drevet, Simon Vallée, was carried away by the
attractions of the etching needle.

Simon Vallée was not the only one in whom at this date a
certain impatience of the long labour imposed by work in pure
line declared itself. The use of the process of etching for the
preparation of the plate had had the authority of Gérard Audran,
but gradually the temper of the day sought out more adventurous
methods. The Academy even discussed the possibility of imitating
with the graver the picturesque values and lively character proper
to an etching. Nicolas Dupuis[4] took up the challenge and
engraved "Enée sauvant son père," after Carle Van Loo—which

[1] "Arch. des Arts," 1890, p. 189. See also Didot, "Les Drevet," pp. xviii, xix.
[2] 1680-1729. R. March 26th, 1718, on the engraved portrait of "de Boullongne le jeune": he died without having executed the second, which should have been that of Alexandre, after Louis de Boullogne (A. de l'A. fr., t. ii., p. 363).
[3] 1688-1776. He does not seem to have been received by the Academy, having left France for England, where he joined Dubosc, Beauvais and Bernard Lépicié. He assisted to engrave the cartoons of Raphael at Hampton Court; his name appears also on a print of George I., after Kneller, which was probably executed by him during his stay in London.
[4] 1696-1771. R. June 28th, 1754. Curious details of his agreement to engrave the Louis XV. monument by J. B. Lemoyne at Rennes are given in A. de l'A. fr., t. vi., pp. 113, 123, 124-126, 131. He exhibited this engraving, together with his portrait of de Tournehem in 1755, and in 1759 sent to the Salon another after Lemoyne's "Statue equestre du Roi, élevée dans la Place de Bordeaux."

he exhibited in 1751—on this fashion, and his friend Gaucher [1] assures us that, " although this engraving is wholly executed by the graver, one can recognize the wit, lightness and happy audacity of a skilled needle."

Other work by Dupuis is not unattractive—if one does not ask too much—as, for example, " Le Glorieux," after Lancret, which he sent to the Salon of 1741 with " Le Philosophe Marié," engraved by his brother Charles. In the small portraits, such as that of Wouvermans—pictor Batavus—which he framed in ornamental borders, his work is often slight but always intelligent, and the remarkable engraving of " Le Roi gouverne par lui-même," which bears his name in the " Grande galerie de Versailles," justified Massé in urging Dupuis to present himself at the Academy, where he was received on the portrait of de Tournehem after Tocqué, which is one of his best works. This fine print, dignified and sound in execution, has yet a somewhat commonplace aspect if one sets it beside the work of either of the Drevet.

It is amazing to learn that Rigaud, who had been so brilliantly interpreted by the father and son, should have cooled towards them in his later years. He imagined, it is said, that they ceased to pay him as much respect and to serve him with as much zeal. Whilst he was in this state of irritation, it so happened that a proof of the engraving by Jean Daullé [2] of Mignard's portrait of his beautiful daughter, the Countess de Feuquières, fell into his hands. He was enchanted by the facility and brilliancy of Daullé's execution, and at once decided to put his work for the future into his hands and make him his engraver. [3]

Daullé had arrived from Abbeville, that nursery of great engravers, fairly skilled in his art. Hecquet, [4] who was his countryman, gave him food and lodging, and set him to engrave large " planches de thèses." Under his direction Daullé acquired extraordinary practical facility and Hecquet, it would seem, both procured him the portrait of Mme. de Feuquières to engrave and arranged that it should be seen by Rigaud, of whose coolness towards the Drevet he was probably aware.

[1] 1740-1802(?). R.A. Lond. A pupil of Le Bas. See Renouvier, "Hist. de l'art pendant la Révolution," t. ii., p. 328. He was not only a remarkable engraver, but knew a great deal about his art. He contributed to the " Dictionnaire des Artistes " of the abbé de Fontenai, from which the above passage is cited, and exhibited at the Salon of 1793 " Portraits gravés," " Portraits dessinés " and " Estampes d'après différens maitres."

[2] 1703-1763. R. June 30th, 1742. Mariette gives date of birth 1711 ; Portalis and Béraldi, May 18th, 1703. See Jal.

[3] Mariette, A. B. C. Dario. [4] Ibid. See also p. 51, note 2.

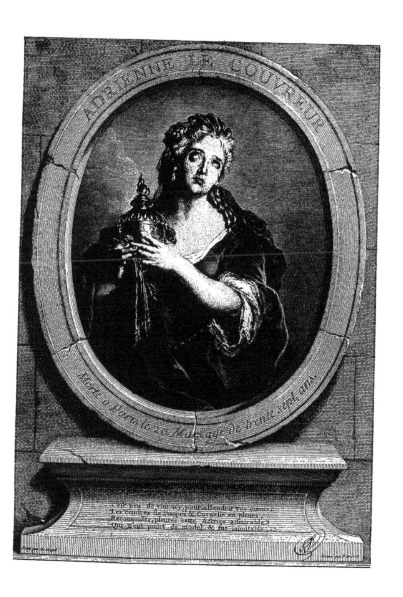

ADRIENNE LE COUVREUR

Morte à Paris le 20 Mars, age de trente sept ans.

The " Comtesse de Feuquières " bears date 1735 and was therefore executed about four years before the death of the younger Drevet, who had engraved Rigaud's fine Bossuet; his father must have witnessed the preference given to Daullé and seen his first success with the portrait of Gendron, the oculist, which he completed, after Rigaud, in 1737.[1] In the execution of this fine work, as in others produced during Rigaud's lifetime, Daullé no doubt enjoyed the enormous advantage of the painter's direct and skilled supervision. " Sous la conduite," says Mariette, " d'un peintre si intelligent, Daullé fit plusieurs chefs d'œuvre, qui lui méritèrent une place dans l'Académie royale de peinture et de sculpture." [2]

The work which Daullé engraved for his reception is well known. No more taking subject could have been found than that in which Rigaud has represented himself painting the portrait of his wife, Elisabeth de Gouy.[3] It is not, however, without some surprise that we find that the painter who had been so fascinated by Daullé's talent was actually employing Wille, at the same time, to also reproduce this picture.[4] As Rigaud died in 1743, it is probable that he never saw the plate engraved by his special *protégé*, and the work has a certain lack of accent in the treatment of the heads—especially in that of Rigaud—which compares unfavourably with the handling of the portrait of Gendron. That is perhaps the best of Daullé's portraits, if we except his charming "Comtesse de Caylus," [5] though even in that we find some weakness in the character of the head, which is not the best part of the work.

De Caylus himself had probably commissioned the engraving of this portrait of his mother at not too high a price, and it enjoyed a success which again may have owed something to the attractions of the original. It contributed to cause that press of work which obliged Daullé to seek for outside help in order to fulfil his engagements. Fortunately, he found in Jean-Georges Wille, the famous engraver of the " Satin Gown," an assistant whose style of execution bore the closest likeness to his own.

Wille, who had not been long in Paris, was leading the usual student's life, getting his daily bread from Odieuvre,[6] who, he says, did not pay much, but did pay. In his own time he worked on the engraving—from which he hoped to build up

[1] Ex. Salon, 1742, together with "Mme. de Feuquières " and "Rigaud et son épouse."
[2] A. B. C. Dario, Mariette.　　　　　[3] Chal. du Louvre, No. 2271.
[4] N. A., 1884, p. 57 ; " French Painters, etc.," p. 141.
[5] See pp. 4 and 5.　　　　　[6] See Chapter V,

his own future—of the portrait of the Duke de Belle-Isle, which had been entrusted to him by Rigaud. In this conjuncture Daullé, says Wille, came to see him and entreated him to come to his rescue by helping to engrave the portraits of "the Pretender and his brother the Duke of York." Wille was to do everything but the heads, and he seems to have felt aggrieved at the arrangement. "Je dois observer ici," he adds, " que M. Daullé s'étoit réservé la gravure des têtes de ces princes ; et les ayant finies, il mit son nom sur des planches ainsi fagotées, et dont je pouvois ètre jaloux."[1] His irritation did not, however, prevent him from again accepting the same sort of work from Daullé, at a later date, on the portrait of Maupertuis, in which we have another example of the usual defect of his portraits, even when executed wholly by himself, for the furs and other accessories strike the eye more forcibly than the head of the man who wears them.[2]

It is clear from the way in which Daullé divided labour with Wille that no want of confidence in his own powers led him to abandon his work on portraits and to take up the engraving of subjects. "He was yet," says Mariette, "in the prime of life when he became disgusted with the style of portraits, which appeared to him to require a slavish constraint." He began with some prettily arranged subjects after Boucher, such as " Les Amours en gayeté," dated 1750,[3] and one of a couple referred to by Mariette as having been engraved by Daullé from drawings by Jeaurat, after Poussin, is to be identified with the " Nymph and Love asleep, surprised by Satyrs," which belongs to the National Gallery.

These are not works which can add to Daullé's reputation. Many show an incredible carelessness, and even the best, such as the subjects which he engraved for the " Galerie de Dresde,"[4] betray something of his lack of that *science du dessin* without which no man, however skilfully he may " cut the copper," can become

[1] The two portraits in question appear to be the pair, Nos. 112 and 113, Portalis and Béraldi. Daullé had previously executed one of the " Pretender " on a larger scale. No. 111, *ibid.*

[2] Maupertuis, on his return from his journey to the Arctic regions, had his portrait painted in the costume which he had worn in Lapland. Ex. Salon, 1743.

[3] There are also the " Elements," which appear to have been executed about the same time. They are dedicated to the Count de Brühl. " Les Amours en gayeté " appeared at the Salon of 1750, together with the " Naissance et triomphe de Vénus d'après l'esquisse de M. Boucher."

[4] This magnificent collection of engravings after the finest works in the Gallery was undertaken at his own expense by Heinecken, the secretary to Count de Brühl, after he was made, in 1746, Director of the Gallery at Dresden. He would have been ruined had not the King (Augustus III. of Poland) come to the rescue.

a great engraver. The portraits—of which not all the best were produced under the keen eye of Rigaud—will always be the better part of Daullé's title to remembrance.

"Daullé, Gaillard, Tardieu," suggests Wille in 1759, when refusing to himself engrave, for the second time, the portrait of the Duke de Belle-Isle:[1] and although there was an unfortunate episode in 1761 regarding the portrait by Roslin of " S. A. S. Mme. Anastasie, landgravine de Hesse-Hombourg, née princesse Troubetskoy,"[2] it can hardly have put an end to Daullé, as Mariette affirms—" c'est par où il a fini sa triste carrière "—since his fine portrait of La Peyronie was executed two years later. Mariette is, most likely, rather hard on Daullé, who had reason to complain of the terms for the engraving of the portrait of " Anastasie." These had been the subject of one of those arrangements by his friend de Caylus which excited the wrath of Cochin and the indignation of those who were trapped into accepting them.

The circumstances of Daullé's bad bargain were so disastrous that Cochin selects it as an example " entre plusieurs marchés dont j'ay eu connoissance de la façon de M. de Caylus." The work was first offered to Wille,[3] but as Cochin puts it, " M. Ville dont la vuë . . . finissoit, ne vouloit point se charger de grands ouvrages, à moins que ce fût pour lui des coups de fortune. . . . M. Ville donc demanda d'abord un prix exhorbitant, trente mille livres ; mais enfin il se restraignit à seize" ; but this price was still too high for General Betsky,[4] at whose cost the work was to be done. Cochin describes M. de Caylus as furious, as abusing Wille, and as seeming to think that the purse of the Russian ought to be spared even at the expense of French artists. Then, says Cochin, de Caylus went off to Daullé and bullied him until he managed to get from him a written undertaking to engrave the picture for 4,000 lt.

When the work approached its termination, nobody was satisfied. Daullé had soon discovered that, even working as hastily and as slightly as he could, it was impossible not to be a loser.

[1] See Chap. V.
[2] This princess was the friend of the Empress Elizabeth, whom she accompanied on the night of her attack on the Emperor Ivan. See " French Architects and Sculptors, etc.," p. 125.
[3] He had already refused to engrave work for Roslin himself. On June 27th, 1759, he writes : " M. Roslin, peintre de notre académie, me proposa deux portraits à graver ; mais je fus obligé de les refuser, ayant trop d'occupation."
[4] The Director-General Betsky. See for his treatment of Falconnet " French Architects and Sculptors, etc.," p. 110. His portrait by Roslin was engraved by Nicolas Dupuis.

He therefore demanded some sort of compensation. The General, supported by de Caylus, appealed to the terms of the agreement. Finally Mariette was put between the two to see if it were not possible to arrange the matter. The print was brought to Madame Geoffrin's, where, as Cochin says, sat " le bureau d'amateurs." Even then it was not easy to find a way of conciliation amidst so many conflicting interests. Betsky, who had doubtless intended to pay his court to the Empress Elizabeth by a flattering image of her friend, found fault especially with the head of the figure, whereupon Cochin, ever ready to oblige, offered to retouch the proofs, hoping probably that if Betsky and the bureau of amateurs were content, Daullé might obtain some satisfaction.

On this point Cochin found Caylus deaf to all entreaties. He insisted on holding Daullé to the original agreement, although, as Daullé said, it had been extorted from him. In vain Cochin proved to him that thirty years earlier the price of such work would not have been less than 6,000 l., and that the " prix de l'industrie devoit être augmenté " in proportion to the rise in the price of every article of food. " I was met," he says, " by that contempt which, I know only too well, is felt by men of birth, in spite of their fine seeming politeness, for all who are, like artists, but of the bourgeoisie." [1]

Whether or no Daullé obtained any " gratification " such as he well deserved Cochin cannot say, but he reports that Betsky, though a good sort of man, did not seem inclined to be generous, and he conjectures that when Daullé died, in the spring of 1763, he was still pleading in vain for the payment of such a sum as might indemnify him for the loss of his time on the plate. [2]

He died of a putrid fever which carried him off on the ninth day of his illness, and left his family but ill-provided for; and on May 20th Wille tells us that the sale began, " chez madame Daullé, des effets délaissés par feu son mari, qui étoit mon ami, l'ayant déjà fréquenté, il y a plus de vingt-quatre ans,[3] dans ma grande jeunesse, et lequel est mort il y a environ un mois. Sa mort

[1] Cochin wound up with: " Si vous voulés que Daullé ne mange que des harangs sores, j'y consens, mais au moins songés que, lorsqu'on payoit deux mille écus, ils ne valoient que deux liards et qu'à présent ils valent au moins dix-huit deniers."

[2] Mém. inéd., pp. 75-78.

[3] There is only one allusion—with the exception of that referring to the portrait of the Duke de Belle-Isle—in Wille's journal to his relations with Daullé. It is on January 3rd, 1762. The Academies had paid their New Year's visit to the Marquis de Marigny. " Au sortir de là," writes Wille, " M. Daullé, graveur, MM. Challe, l'un peintre, l'autre sculpteur, vinrent avec moi, et nous dînâmes chez Lendel, rue de Bussi."

PORTRAIT OF COCHIN
(JEAN DAULLÉ, AFTER COCHIN LE FILS.)

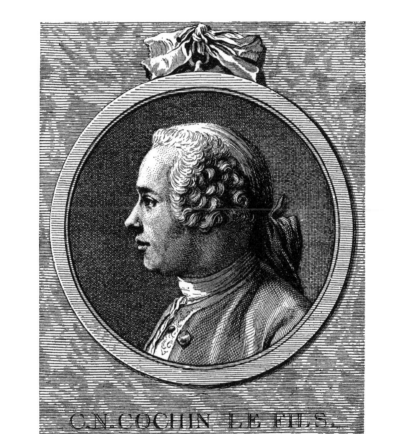

C.N. COCHIN LE FILS.

Dessiné par Luy Même

Gravé par J. Daullé 1764

m'a véritablement attristé, et je plains la veuve et ses deux filles, d'autant plus qu'elles ne sont pas bien à leur aise."

Wille, whose own talent was of a character analogous to that of Daullé, had a high opinion of his powers, which is worth citing because it gives us the measure of his ability from a purely technical point of view. He notes admiringly that Daullé was never ill and was an extremely rapid worker; then adds that his work reckons nearly three hundred pieces, amongst which are many of great reputation, well-executed and much sought after. " C'est dommage," he concludes, " que sa grande facilité dans l'exécution l'ait quelquefois emporté à n'être pas assez difficile," but he goes on to say that Daullé must, in justice, be reckoned in the number of good engravers in his day, and to cite the portraits of Gendron and of the Countess de Feuquières, together with the " Quos Ego," [1] the " Magdalen " [2] and the " Children of Rubens " —the last three for the " Galerie de Dresde "—as works which must carry Daullé's name down to posterity.

I know that it is usually said that Daullé's point is cold and brilliant. I recognize the force of this criticism as applied to a certain class of his work, such for example as the " Berger Napolitain " engraved after Boucher, impressions of which, when as fine as that in the Print Room of the British Museum, may well deserve the epithet brilliant. When, however, one turns to Daullé's portraits—and one must remember that it was the promise of his portraits that took Rigaud's fancy—one would be inclined to describe their air as rather soft than brilliant, and their execution seems to show a tiresome tendency to mechanically dexterous repetitions of line, and in the display of this elegant dexterity the engraver seems to have found a more lively interest than in the forms which his line should express.

Let us take " Hiacinthe Rigaud, Ecuyer, Chevalier de l'ordre de S. Michel, ancien Directeur, et Recteur de l'Académie Royale de Peinture et de Sculpture, avec son Epouse, peint par lui-même," and set this celebrated print beside the " Samüel Bernard, Chevalier de l'Ordre de Saint-Michel," engraved by Pierre-Imbert Drevet, or the " Nicolas de Launay," by François Chéreau. The impression we receive from the engraving " Rigaud painting his wife " is that of grace and skill, and even loving finish. Daullé cannot be accused in this instance of haste, or of having scamped his work in order to get the better of a bad bargain, but the moment we look at the

[1] Ex. Salon, 1753, " 'Départ de Marie de Médicis,' appelé communément le ' Quos Ego'; d'après Rubens."
[2] Ex. Salon, 1753.

man's head, and compare it with that of Samuel Bernard, or of de Launay, we recognize the science and power which have enabled Drevet and Chéreau to seize on the very heart of their subjects and put into their features a vitality that grips us as if with the real presence of the men.

Nicolas Dupuis had something of the secret, as we may see in his lordly " Lenormant de Tournehem," but Wille puts no such insistent force of life into his portraits. Nor, indeed, are any later works of this class, on the same scale, worthy to be compared with those of the Drevet and François Chéreau. We must come to the marvellous miniatures of Ficquet, such as the amazing La Fontaine and equally amazing Eisen of the " Contes," before we find their equal.

Under the magnifying glass we see that the method of execution in these microscopic *chefs-d'œuvre* is identically the same as that employed by the great masters of line. The heads of the portraits in the " Contes " are modelled by the simple sweep of curved lines divided by other broken lines running between them.

That is exactly how Drevet has rendered the superb character and expression of his Samuel Bernard : in like manner François Chéreau has treated his de Launay and Cardinal Fleury, and Nicolas Dupuis, even in his slighter works, does not lay his lines otherwise. Daullé works differently. He is, as it were, preoccupied by his own skill ; his lines succeed each other with marvellous mechanical regularity, and his calculated excellence of craft is so obvious that one might almost suppose that this alone detracts from the importance of the head in all his portraits, even in those done under the direction of Rigaud. For the true reason of Daullé's inferiority we must, however, look beyond any mere question of execution ; " il pêchoit," says Mariette, " par le dessin." That is to say that Daullé's training was defective on the most important side.

The painter may possibly appeal to us by colour, but no amount of *métier* can justify the etcher or engraver who is wanting in what has been described as " la probité de l'art." This charge of something like want of honesty may also be extended to another point. Daullé and men of his type took no exact account of the difficulties they encountered. Should a fold of drapery demand an inconvenient exercise of skill it was " fudged " without scruple. The pure sincerity of their great predecessors was unknown to them.

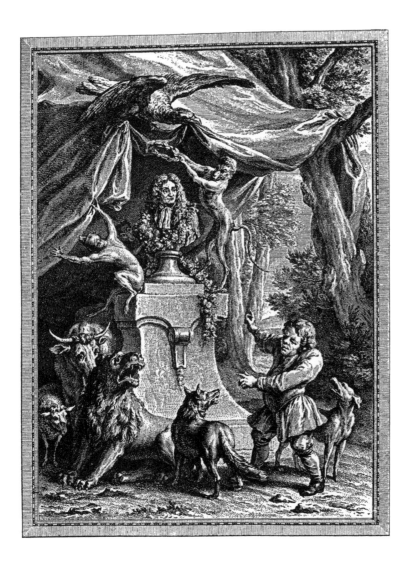

CHAPTER V

WILLE AND HIS PUPILS

JEAN-GEORGES WILLE[1] was a lad of fifteen when Pierre Drevet engraved his Adrienne Lecouvreur. A Hessian by birth, he came to Paris—as did his friend Georges-Frédéric Schmidt[2]—so young that his training was practically French, and, having assimilated all that the school could then teach, he exercised in turn an extraordinary influence over his teachers, becoming the master of the masters of the modern school.

In early years, the inconstancy of his interests, the vivacity with which he pursued diverse occupations, gave no promise of that serious devotion to a profession which he afterwards displayed. A series of ventures, in which he exhibited great intelligence and an even greater love of change, culminated in his departure for Paris, where he amused himself with delighted curiosity until he found that he had wholly exhausted his resources. To his appeals for help his father turned a deaf ear. " Enfin mon fils," he replied, "tu es donc sorti de ta patrie sans me consulter et même sans m'en avertir, je dois donc croire que tu te trouves en état de te soutenir sans mon intervention, et si j'avois la foiblesse de t'envoyer de l'argent, je ferois une faute capitale ; je connois ton inclination de briller partout, je veux et je dois t'empêcher de faire des dépenses sans nécessité et sans utilité. . . . Au reste, mon fils, n'abandonne jamais le chemin de la vertu que je t'ai enseigné, . . . fais voir en toute occasion que tu es le fils d'un honnête homme."[3]

[1] 1715-1808. R. July 24th, 1761, on portrait of Marigny after Tocqué, No. 2236, Chal. du Louvre.
[2] 1712-1775. R. July 30th, 1744, on portrait of P. Mignard after Rigaud, No. 2245, Chal. du Louvre.
[3] Mém. Wille, t. i., p. 63.

The letter took effect as old Wille knew it would. His son, finding that his father would give him nothing but rebukes and advice, promptly raised money from a "bon juif" on some very fine silver medals which he had brought with him from Germany.[1] Reassured by the possession of funds, with which "l'inclination de briller partout" at once reappeared, the young Wille dressed himself in his best and boldly presented himself at the magnificent hôtel of Largillière, to whom he explained that his desire to see one so celebrated was the only justification for such a step.

Largillière, adroitly flattered, lent him a picture to copy, and after its return would have lent him another, only Wille, foreseeing that he must shortly do some remunerative work, ingeniously declined the offer on the ground that he meant to give up all the winter season to drawing—a pretext which, of course, elicited from Largillière the strongest approbation.[2] Not, however, until winter drew on, and all the resources obtained from the "bon juif" were exhausted, does Wille seem to have decided that he must work. A friend, to whom he had brought a letter on his arrival in Paris, and who knew that he had, as a youth, been employed in the engraving of ornament on guns, found him a place in the shop of an *arquebusier* on the Pont Marie. That quarter was, however, too dull for a young gentleman who went constantly to the Comédie Française, where Wille knew several actors who had given him his *entrées* gratis.

Another move was accordingly made to the shop of M. Bletterie, in the same street as the theatre. Even then Wille does not seem to have been quite decided as to his occupation. "Une idée," he says, "mal conçue, plus mal digérée, m'écartoit pendant quelque temps de la route que je m'étois tracée, preuve de ma légèreté ou de mon inconstance. Enfin, je désirois travailler dans l'horlogerie." It seems that he had supposed that a watch from the beginning to the end of its construction, including the chasing and engraving of the case, was the work of a single man; so after having spent weeks doing nothing but turn pieces of steel of the thickness of a hair, he gave up his new trade in disgust.

At this point the real career of Wille begins. "I went back," he says, "to my little room, where I drew a fictitious portrait. This I engraved on a small plate, and had printed. I showed a proof of this to a printseller, who had a great deal of work done and paid very little; he was called Odieuvre, and lived on the quai de l'Ecole, opposite to the Samaritaine of the Pont Neuf." Odieuvre instantly recognized the value of Wille's work.

[1] Mém. Wille, t. i., p. 64. [2] *Ibid.*, p. 66.

" Ça n'est pas mauvais," he said, and added the offer of employ-ment—at the rate of twenty francs a plate—on the series of profiles of the Kings of France which he was then in the course of publishing.

The payment was not liberal and the reception by Odieuvre of those he employed far less so. Wille has described how, when he brought in his first commissions, Odieuvre—not having enough money in his drawer to make up the required sum—called to his wife, who, old, bent and deaf, was sweeping the kitchen: "'Ma poule, n'as-tu pas quelque argent dans les poches de ton tablier, car je veux payer ce jeune homme qui travaille pour la boutique.' ' Oui, mon ange,' répondit-elle, et mit sur le comptoir ce qu'elle avoit, dont il me paya en gémissant et disant toujours : ' Hélas ! que l'argent s'en va promptement!' "

It took Wille nearly three weeks, he tells us, to engrave a couple of these heads, with which Odieuvre kept him incessantly supplied. The work was too intolerably wearisome, so that when he found some copies of portraits by Largillière, in the room which Schmidt had invited him to occupy on Eckhardt's[1] departure for England, he at once began to engrave that of Largillière himself, and also, on a larger scale, that of his daughter.[2] These he presented to Largillière, and at his suggestion offered to his son a proof of his sister's portrait in a gilt frame, a civility which was rewarded by the gift of " quatre louis d'or." [3]

Wille's next step was to get Schmidt—who was engraving Rigaud's portrait of the Count d'Evreux[4]—to present him to that famous painter. He had never lost sight of Schmidt, to whom he had attached himself at Strasburg on his way to Paris, and had frequently visited him when he was working for Larmessin on the 1738 illustrations of the Contes de la Fontaine.[5] With that naked

[1] (?)-1779. Jean-Georges Eckhardt was born at Darmstadt, but settled in England, where he acquired a considerable reputation as a portrait-painter.

[2] This engraving is dated 1738. Another portrait of Marguerite-Elisabeth painted with those of her mother and himself is one of Largillière's best known works. See " French Painters, etc.," p. 145.

[3] Mém., t. i., pp. 70, 71.

[4] Second son of the Duke de Bouillon and Colonel général de la Cavalerie. He married Mlle. Crozat. See "French Decoration and Furniture, etc.," pp. 29, 30.

[5] Mém., t. i., pp. 51, 62. Larmessin had undertaken to engrave as a uniform collection various subjects from the " Contes," painted by Boucher, Lancret, Pater, Vleughels and others. Larmessin reserved for himself those by Lancret, and on these he was helped by Schmidt. Crayen in his Catalogue of Schmidt's work goes farther, and gives to Schmidt "Nicaise," "Le Faucon" and "A femme avare, galant escroc," the lover in which last is said to be a portrait of Schmidt, the husband that of Lancret's brother.

frankness which makes Wille's "Mémoires et Journal" such amusing reading, he would probably have said of Schmidt as he did of his own father, "son amitié m'étoit précieuse et nécessaire," for he certainly had a liking for his friend, fortified though it was by a strong alloy of self-interest.

With his engravings after Largillière in his hand and backed by the kindly Schmidt, who was four years his senior, Wille came before Rigaud, who, after a prolonged examination of his work, remarked: "Vous méritez bien, monsieur, à être encouragé"! Wille seized his chance, and at once declared that he would be only too happy were he permitted to engrave a single portrait after one of Rigaud's paintings, even if it were at his own expense.

Rigaud was completely conquered; he held out his hand to Wille with a royal compliment. "Je veux vous être utile," he continued; "voicy le portrait du duc de Belle-Isle sur ce chevalet, auquel je dois retoucher quelque chose; ça sera bientôt fait, venez me voir au bout de huit jours, en attendant je tâcherai d'obtenir de M. le duc la permission de vous remettre son portrait, afin que vous l'exécutiez soigneusement en gravure; et ce seigneur ne doit-il pas en être flatté?"

In my brief account of Rigaud,[1] I have already referred to the exact record of scenes and even words given in Wille's "Memoir." He takes us back with him again to learn from Rigaud that the desired permission is obtained; we see him seize on the picture, desiring to carry it off on the instant; we hear Rigaud remonstrate, "Doucement, la vivacité est bonne, mais un peu de patience l'est aussi quelquefois; voicy mon valet de chambre qui apporte le café, nous le prendrons ensemble, si vous le voulez bien"; and the breakfast hour passed with such certain assurance of protection that Wille—though his pockets were empty—returned to his own rooms in perfect confidence as to the successful accomplishment of the task he had undertaken.

It must be understood that the execution of an important engraving such as that of the portrait which Wille proposed to reproduce was—if we consider only the time which it required— a very costly matter. When Schmidt came to him as to the portrait of the Count d'Evreux, Rigaud's first thought was to inquire whether he had "les moyens d'entreprendre un ouvrage de longue haleine." Wille, who had no regular employment, was obliged to make money at once by selling to Odieuvre, for a humble sum, the plate of the portrait which he had engraved after

[1] "French Painters, etc.," pp. 138-142.

72

LES REMOIS: "CONTES DE LA FONTAINE," 1738.
(NICOLAS DE LARMESSIN, AFTER LANCRET.)

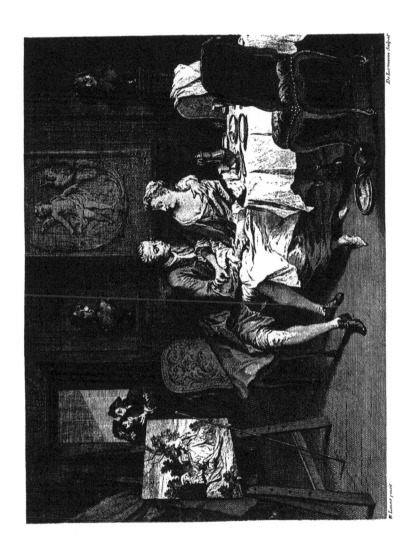

Largillière, and could only obtain that by undertaking to execute two others—Cromwell and the Prince of Dessau—at the same price. He received, however, some moneys from his father, to whom he had sent a proof of his portrait of Largillière in that expectation, but they were soon spent. A portion went on the purchase of fine medals, but the most was squandered by Wille on eating and drinking and smart clothes, including the purchase of a silver hilt to his sword. He was incited to the possession of this last elegance possibly by rivalry with Schmidt, who was the proud owner of the uniform of a Prussian bombardier.

The two friends, who had for some time occupied the same lodgings, now parted company. The success obtained by Schmidt's "Comte d'Evreux" led to his admission—though a Protestant—into the Academy by royal command.[1] This was in May, 1742, and he at once told Wille that he must have rooms suited to his new dignity, in which he could fitly receive his fellow academicians.[2]

This date gives us the exact time at which Diderot was, as he tells us, living in an attic with Preisler[3] and Wille.[4] The move made by Schmidt had disturbed Wille, who went about looking for other lodgings, and presently he was joined by Preisler and another friend in a house of the rue de l'Observance, where lived "un jeune homme fort affable qui, dans la conversation, m'apprit qu'il cherchoit à devenir bon littérateur et encore meilleur philosophe s'il étoit possible . . . ce jeune homme," adds Wille, "étoit M. Diderot, devenu célèbre par la suite."[5]

The date, 1740, given by Wille (p. 90) for this encounter is obviously wrong, for the circumstances by which it was preceded were a consequence of Schmidt's "agrément" by the Academy in May, 1742. It has some importance, because it enables us to fix the year in which Wille was employed by Daullé, who came to him in the rue de l'Observance with the proposal that he should prepare his portraits of the "prétendant et le duc d'York, son frère."[6] It shows us too why Wille, though disliking it, decided to take the work. He was still dependent on Odieuvre, and obliged to accept anything he could get in order to maintain him-

[1] See the letter from Orry of May 3rd, 1742. P. V., May 5th, 1742.

[2] Mém., t. i., p. 82.

[3] 1715-1794. Born at Nuremberg; came to Paris, 1739; called to Denmark in 1744. One of his best works is the engraving of the equestrian statue of Frederick V. erected at Copenhagen by Saly. See "French Architects and Sculptors, etc.," pp. 112, 114, 196.

[4] Diderot. Salon, 1765. [5] Mém., t. i., p. 91.

[6] Ibid., pp. 98, 99. See Chap. IV.

self whilst he engraved the portrait lent to him by Rigaud. Not
until a third change, to the rue de la Harpe, had lodged him
absolutely to his liking did Wille begin to work " très-sérieuse-
ment " and feel sure enough of himself to insist on being better
paid.

The story of his struggle with Odieuvre, who would have had
his engraving of Antoine Pesne's portrait of Frederick II. of
Prussia at the same price—24 lt.—as that of Professor Wolf of
Marburg; the sale of the plate behind Odieuvre's back to Petit;[1]
Odieuvre's comical rage on discovering that he had overreached
himself—all these things are written down by Wille in his
"Memoir," and so we arrive at the year 1743 and the comple-
tion at last, to Rigaud's full satisfaction, of the portrait of the
Duke de Belle-Isle.

"A few days after," writes Wille, "when all was ready, he
gave me a letter to M. Duplessis, *officier-général* and friend of the
said *seigneur*. Thus fully equipped with all I required for this
expedition, I went with the portrait in a gilt frame to this *officier-
général*, who received me with civility, read M. Rigaud's letter,
saying that this great artist had been long his friend, and finally
introduced me to the duke, who received me with the most
encouraging politeness, and whilst holding his portrait in his
hands he talked familiarly with me, making me compliments on
my talent taking into consideration my youth. Finally he said :
'You have paid me a compliment with which I am enchanted, it
is fair that I should pay you one in my turn, in showing you my
gratitude ! Go, my dear Wille, to my treasurer, who will be
delighted to see you and will treat you well.'"

When Wille arrived with Duplessis at the apartment of M.
de la Monce, the treasurer, he saw in the anteroom a crowd of
people, "dont les uns demandoient de l'argent pour telle et telle
fourniture, et d'autres pour des travaux exécutés par ordre et livrés
exactement. M. de la Monce les écoutoit avec bonté et les prioit
de patienter encore quelque temps, et que le tout seroit acquitté
avec justice ; mais non ; ils s'écrièrent presque à la fois : 'Ce ne
sont pas des paroles, mais de l'argent que nous demandons.' Des
prétensions aussi brusques et aussi peu mesurées étourdissoient
M. de la Monce, si bien qu'il ne trouvoit rien de plus efficace

[1] Gilles-Edme Petit, the brother-in-law of Jacques Chéreau, under whose direc-
tion he engraved several prints. He has signed several portraits and reproductions
of work by Lancret and Boucher. "Le Soir" or "La Dame allant au Bal," one
of the "Quatre parties du jour" after Boucher, is a good example of Petit's popular
work.

dans sa sagesse que de donner à tous des congés si absolus et si bien
articulés, qu'ils décampèrent les uns après les autres."

This painful exhibition impressed Wille only with fear for himself, and his relief was great when de la Monce, carrying him off to his own room, opened his coffers and counted out 600 lt., saying, "Prenez, Monsieur, cette petite somme. . . . Hélas! si nous n'avions pas été obligés de faire des dépenses si énormes à Francfort pendant l'élection de Charles VII à l'empire germanique, vous auriez été bien plus magnifiquement récompensé."[1] To the 600 lt. de la Monce added other 300 lt. in payment of one hundred proofs of the portrait which Wille, who went off with his bag of money under his arm, delivered the same day. His visit to Rigaud was paid the following morning, and the "Memoir" prefixed to the pages of Wille's journal here breaks off on the words "il m'embrassa en me disant qu'il seroit content. . . ."

I conjecture that the unwritten words concerned Rigaud's intention to secure the reception of his *protégé* by the Academy at an early date. Wille certainly expected this distinction to follow on the completion of his "Maréchal duc de Belle-Isle," seeing that Rigaud had procured the admission of Schmidt as soon as he had successfully terminated his "Comte d'Evreux." Any schemes for the achievement of this envied honour by means of Rigaud's good offices were, however, cut short by the death of the kindly painter, and Wille found himself once more without a protector. He was probably stimulated by his loss to more active exertions, but we know nothing—at any rate from himself—of the steps by which he attained the remarkable position which he succeeded in filling with much authority till the close of the century.

When Schmidt left Paris for Berlin, in 1744, his decision was perhaps affected by the growing consequence of Wille. He had refused the offers made to him by von Knobelsdorf in 1740, but it was then possible to hold Wille—who was four years his junior —cheap, and his own situation, supported by the favour of Rigaud, was one of singular promise. To his fine portrait of the "Comte d'Evreux" had succeeded an equally fine and even more popular portrait of Saint-Albin, Archbishop of Cambrai,[2] the appearance

[1] On this occasion Voltaire says that "Le maréchal de Belle-Isle . . . semblait être plutôt un des premiers électeurs qu'un ambassadeur de France. Il avait ménagé toutes les voix, et dirigé toutes les négociations ; il recevait les honneurs dus au représentant d'un roi qui donnait la couronne impériale. L'électeur de Mayence, qui préside à l'élection, lui donnait la main dans son palais, et l'ambassadeur ne donnait la main chez lui qu'aux seuls électeurs, et prenait le pas sur tous les autres princes" ("Précis du Siècle de Louis XV," ed. 1808, p. 57).
[2] Saint-Albin was the son of the Regent by Florence, an actress. His nomination

of which no doubt also contributed to bring this clever German engraver the exceptional favour which he seems to have enjoyed with those in power.

Neither of these portraits is equal to the remarkable reproduction of the portrait of Mignard, by Rigaud, which Schmidt executed as his diploma work.[1] It was presented by him on the 30th July, 1744. Two months later, in spite of all the efforts made to retain him, he had left France for Berlin. Wille's "Mémoire," from which one would expect some light on this decision, breaks off, as we have seen, in the middle of his last interview with Rigaud and—as a volume has been lost—the "Journal" does not begin till the 31st May, 1759. We are, therefore, left with a gap of sixteen years, during which all we know of Wille's life is to be reckoned by the dates on his engravings. It is, however, certain that his friendly relations with Schmidt had not been disturbed, for Schmidt's name appears on one of the earliest pages,[2] and recurs again and again till we come (March 26th, 1775) to the entry of the letters written by Wille in reply to correspondents who have announced the death of his "ancien ami."[3]

Schmidt, on his side, had preserved a grateful memory of his days in Paris, " car il avoit de l'esprit et surtout le goût fin." Crayen, the Leipzig dealer, to whom we owe the record of his work, tells us that Schmidt died of apoplexy at the moment when "il songeoit à faire son testament en faveur de plusieurs de ses anciens amis, et dans l'intention de léguer tous les objets qui concernent les arts à l'Académie royale de peinture de Paris." His life in Berlin had not been so full of satisfactions that it could efface the impressions of that joyous youth of which Wille says: " Nous étions tous de jeunes artistes, peu sujets aux inquiétudes, quoique souvent sans pécune, mais toujours prêts à nous réjouir honnêtement, selon les circonstances, et sans que nos études en souffrissent."[4]

Common studies had brought about a close resemblance in the work of the two friends, both as to their merits and defects.

to the see of Cambrai was one of the scandals of the day (Mém. Mathieu Marais, t. ii., pp. 50, 51, 139; t. iii., p. 36).
[1] Chal. du Louvre, No. 2245.
[2] This entry on January 4th, 1760, shows that Wille was selling Schmidt's engravings for him: "j'ay les 'Amours des Dieux,' par Schmidt, à quatre-vingt-dix livres."
[3] These were "C.-L. Troschel, conseiller du roy de Prusse et avocat à Berlin," and "B. Rode, peintre du roy de Prusse à Berlin."
[4] Mém., t. i., p. 79.

Pure line, with rare exceptions, is employed by both, and both show the same treacherous dexterity. In his best work—and I take it that we may reckon as such his superb " Maurice de Saxe " after Rigaud, his " Prince de Galles " after Tocqué, his " J. B. Massé " and his " Marigny " [1]—Wille achieves a marvellous brilliancy. Schmidt, on the other hand, has better feeling for colour, and he draws, I think, better.[2] Yet, just as Wille uses the graver as a witness of skill rather than as a means of expression, and gets sometimes a metallic effect for which not even his brilliancy can atone, even so Schmidt makes free with his subjects, treating them as a means for the display of his command over his tools, and the glitter of his work is to me often very unpleasant.

We may leave on one side the poor vignettes which this great engraver—carried away by the fancy of the day—produced in his last years,[3] but his etchings, some of which are of value, cannot be passed over. They show, nevertheless, that Schmidt was hampered in their execution by the mechanical excellence of his habitual practice. There is not the slightest trace of the hand which engraved Lancret's " Nicaise " in the " Contes " with such splendid brilliance. Long after Schmidt had left for Prussia, Wille notes that a friend, M. Esperendieu, coming from Berlin, had brought him two engravings from M. Schmidt *de sa façon*, the one a portrait of a St. Petersburg doctor,[4] which was good, the other " le buste d'une vierge dédié au comte d'Esterhasy, mais qui n'est pas bien . . . selon moi," [5] and if we look at this print we see that Wille probably recognized in another that failure to reproduce with simplicity the aspect of his subject that was his own besetting sin.

" C'est l'air brusque et dur de Wille," says Diderot of the famous portrait by Greuze, now in the collection of Madame André, " c'est sa riche encolure, c'est son œil petit, ardent, effaré." [6] This roughness, harshness and ardour are reflected in his work, and gave him an immense influence over his numerous pupils.

[1] Ex. 1761.

[2] Many of his engravings are from his own drawings, as, for example, his portrait of the abbé Prévost, " dessiné à Paris d'après nature, et gravé à Berlin, par Schmidt."

[3] The *fleurons* and *culs de lampe* of the " Mémoires de Brandebourg, Berlin, 1767," are by Schmidt.

[4] Probably drawn on his visit to Saint Petersburg, where Schmidt was called by the Empress Elizabeth in 1757.

[5] Mém. Wille, Sept. 10th and Nov. 10th, 1764. This work represents the Sassoferrato of the Esterhazy Gallery.

[6] Salon, 1765. This portrait was exhibited at Paris in 1888.

He had the great force of unreasoning conviction and the best men went to him. Jean Massard,[1] one of the best interpreters of Greuze, the engraver of " La Cruche cassée," " La Dame bienfaisante," " La Mère bien-aimée," owed his training to Wille; so did Pierre-Alexandre Tardieu,[2] whose " Marie-Antoinette, archiduchesse d'Autriche, reine de France," begun, after Dumont, in 1792, was finished in 1815.[3] To him is due, also, the partially completed engraving of David's " Lepelletier de Saint-Fargeau mort," which is the sole record of a work which, it is conjectured, was hidden or destroyed by the family, to whom the story of Lepelletier's career was a cause of shame. Avril,[4] " fervent adepte du genre ennuyeux," and Berwic,[5] the acknowledged master of the men of our own time, went forth from the workshop of Wille.

With Berwic, as with nearly all his pupils, Wille maintained relations of the most friendly intimacy. We find in his journal, under the date of February 24th, 1788, note of a dinner given in honour of Berwic's marriage. " Ce jour j'ay donné," writes Wille, " un repas à M. Bervic et à sa jeune et aimable épouse. Je l'ay fait avec plaisir, d'autant plus que M. Bervie est un de ceux de mes élèves qui m'ont fait le plus d'honneur, et qu'il est d'un caractère franc et sans détour. Il est instruit et son esprit est solide." Berwic—whose real name was Charles-Clément Balvay—was, in fact, the most important pupil taught by Wille. He worked with Le Prince, the inventor of the *gravure au lavis,* but after much study of Nanteuil devoted himself unreservedly to pure line, and his " Louis XVI.," after Callet, exhibited in 1791, is as brilliant and certainly as interesting as anything done by his master.

Wille himself had at first given to the engraving of portraits

[1] 1740-1822. He worked also on the " Œuvres de Voltaire " (1768); " Les Graces " (1769); Anacreon (1773); Ovid (1767-1771). He engraved " Le Lever," after Baudouin, in 1771.

[2] 1756-1844. His " Lord Arundel," after Vandyck, is a fine piece of interpretation.

[3] Chal. du Louvre, No. 2232. It represents Marie-Antoinette costumed as a vestal virgin, standing by an altar and holding a branch of lilies in her hand. The heavy Austrian type of the features is accentuated by these inappropriate surroundings.

[4] 1756?-1823.

[5] 1756-1822. A., 1784. His " Cléopatre," after Netscher, closely follows the style of Wille in the satin of the gown (" Corres. litt.," t. i., p. 246). He exhibited only in 1785, 1791 and 1798. The " grand prix de gravure en taille-douce " was founded by him. See his letter to Rosaspina (N. A., 1877, p. 365, and " Not. hist.," t. i., p. 254). He engraved " Le Serment," after Fragonard, with feeling as well as skill.

the most important place in his work. In 1755, as we have seen, he executed one of his best, that of Jean-Baptiste Massé, after Louis Tocqué, and he engraved later—for his reception by the Academy—that of Marigny, after the same painter.[1]

Shortly after this date, Wille decided to devote himself to what he called historical engraving. In June, 1759—although he was then probably at work on the Marigny portrait—he sends M. le Cat, of Rouen, to Ficquet, declaring that he himself cannot possibly do a portrait. He next tells us that he has been requested to engrave that of a great personage of Holland, but "je me suis excusé en recommandant M. Tardieu"; and finally he refuses even crowned heads. "Replied," he notes on October 20th, 1761 —only six months later than the visit of Marigny—"to M. Ziesenis, painter to his Britannic Majesty in Hanover, who offers me the portrait of the Queen of England. . . . I have said that I do no more portraits, but will get it done, and he can, if he likes, send me the picture."

Even Mlle. Clairon, who came, escorted by Cochin, to solicit Wille in person,[2] was firmly refused. "Ils firent," he says, "tous deux, tout ce qui est possible pour m'engager à faire le portrait de cette fameuse actrice dans la grande planche que grave M. Cars,[3] d'après M. Vanloo, où elle est représentée en Médée,[4] et dont la tête a déjà été effacée quatre fois. Je me suis défendu longtemps, malgré les discours séduisants et les éloges de l'un et l'autre. La planche resta chez moi, mais le lendemain j'allai chez M. Cochin lui représenter qu'il m'étoit impossible de faire la tête, à cause de ma vue trop courte, pour pouvoir atteindre au haut de cette planche, et le résultat fut que je lui envoyai la planche au retour de chez moi."

The excuse made by Wille to free himself from the importunity of Mademoiselle Clairon and her friends may have had some foundation, but it is just as likely to have been a pretext, though Cochin seems to have believed that Wille's sight was really at fault. At the same time we must remember that other work was more lucrative. The publication of "La Liseuse"[5] from the painting by Gerard Dou, which had been lent to Wille by de Julienne, had an enormous success. He had executed it as a companion to "La Dévideuse," engraved many years before, and

[1] These two engravings are Nos. 2236 and 2239, Chal. du Louvre. Wille was in close relations both with Tocqué and Massé. See his journal, July 7th, 1759, and July 29th, 1761. See also Chap. III., p. 53, note 1.

[2] February 2nd, 1763.

[3] See Chap. VI.

[4] See "French Painters, etc.," p. 46.

[5] Ex. 1763.

he notes that more than three hundred proofs had been taken up on the same day.[1]

This success encouraged him to devote himself exclusively to a class of work in which he was without a rival. The vogue which his interpretations of popular masters enjoyed in Paris was outstripped abroad. Schmuzer,[2] a young engraver coming from Vienna—sent, in fact, by Kaunitz that he might study under Wille —informed him that prints of " La Tricoteuse " and " La Dévideuse," [3] which were sold by him in Paris for 3 lt., were fetching 15 lt. apiece in Vienna; that " Le petit Physicien " [4] and " La Ménagère "—sold in Paris for 2 lt.—reached as much as 13 lt. 10 sols., and finally that Kaunitz himself had paid seven louis d'or for a proof of Wille's portrait of Saint-Florentin—a fine early work.[5] To a suggestion from Kaunitz, received a few years later, we owe the fine print after Terburg, " L'Instruction paternelle " [6] —sometimes called " The Satin Gown " [7]—which Wille dedicated by his directions to the Dowager Empress of Austria, from whom he received in acknowledgement a superb diamond ring.[8]

It became the rule for all " patrons of the arts " and " people of taste " to call on Wille when they visited Paris. The Duke de Deux-Ponts—in German, as Wille reminds us, " Zwey-Brücken " —not only visits him but joins a party for sketching in the country; he is presented to the Prince of Monaco by the abbé de Grimaldi, who is a frequent visitor; the sons of Kaunitz, Count and Countess Harrach, arrive from Vienna; Prince Poniatowski and Prince Czartoriski represent Poland; Count Moltke, Denmark; Prince Galitzin, Russia; the names of Gluck and Goldini jostle those of the unfortunate Struensee, of the Prince d'Ysembourg, Count Reuss XLIII., the Princess Kinski, the Prince of Saxe-Weimar and the Margrave and Margravine of Baden-Durlauch.

[1] Mém., July 16th, 1762.

[2] Wille writes, November 19th, 1762: "Aborda chez moi, vers le soir, M. Schmuzer, graveur de Vienne . . . Il me fit en entrant bien des révérences gothiques, me voulant baiser le bas de ma robe de chambre, me nommant tantôt Votre Excellence, tantôt *Ihre Gnaden.* J'étois honteux de toutes ses civilités."

[3] These two prints were exhibited, together with "La Ménagère," in 1757.

[4] Ex. 1761.

[5] Mém., Nov. 19th, 1762. This portrait was engraved in 1749, and after thirteen years the plate—so injured by verdigris that it had to be reworked—was brought to Wille, in order that he might pull 160 prints from it for the town of Marseille (*ibid.*, March 15th, 1763).

[6] Ex. 1767. See Mém. Wille, March 14th and April 27th, 1766.

[7] "J'ai rendu justice au burin de M. Wil et à sa manière unique de rendre les étoffes" ("Lettre de M. Raphael," Salon, 1769, "Œuvres de Cochin," t. ii., p. 308).

[8] Mém., July 27th, 1766.

The honours paid to Wille by all these exalted personages and
their frequent visits did not make his intercourse with his brother
craftsmen less close or constant. Not only did he live on the best
terms with the chief men of the French school, but his journal
shows his friendly relations with strangers and especially with the
English. He was present when Robert Strange, "né dans l'Isle
de Pomone, l'une des Orcades," was *agréé* by the Academy.
Strange—by whom he sends letters to Winckelman and Mengs [1]
—is described by Wille as "an old friend and a brave worthy
man." After Strange comes Woollet, "excellent graveur," [2]
Vivares,[3] Ryland and Smith [4] are his friends, and Byrne became
his pupil.[5] Of Ryland [6]—"graveur du roi d'Angleterre "—who
was afterwards hanged for forgery, Wille tells us that he had a
commission to buy for the King "mes pièces historiques ; mais des
premières et magnifiques épreuves, et je les ay fournies comme
pour un roi." In 1787 Basan calls on him with Alderman Boydell,
who brings with him his daughter and his niece. The daughter,
Mrs. Nicol, is married to a bookseller, and when Wille dines, on
the 20th September, with the party, he notes : " C'est dommage
que Mme. Nicol ne sût pas le françois, celà n'empêcha pas qu'elle
ne me fît mille caresses."

Dealers, in every town, were his regular correspondents, and
he bought and sold for them. Sometimes their commissions were
embarrassing. M. Gier de Bordeaux, he notes, " has sent me some
gouaches by Mlle. Dietsch, to sell, but . . ." The *but* is ex-
pressive, and one is not surprised to find that Wille—after some
hesitation—excused himself, telling Gier that " les petits tableaux
de l'espèce qu'il m'a envoyés ne sont pas rares à Paris." He even
bought for these correspondents at sales as well as for himself.
No great sale, such as that of an amateur like de Caylus, or de
Julienne, or of brother artists such as Surugue,[7] took place with-

[1] August 31st, 1760, and December 31st, 1764. Strange (1723-1792), who was
then a student with Cooper in Edinburgh, followed Charles-Edward in 1745, took
refuge in Paris after Culloden and became a pupil of Le Bas.
[2] November 6th, 1769 (1735-1785).
[3] June 27th, 1763 ; November 18th, 1763 ; July 4th, 1776 (1712-1782).
[4] September 1st, 1787.
[5] October 10th, 1769.
[6] April 18th and May 9th, 1765. Wille dines Ryland and says that he is " fort
à son aise. Il a cinq mille livres de pension de son roi, qui lui paye non seulement
généreusement les ouvrages qu'il lui commande, mais lui fait aussi présent de l'ouvrage
même, lorsqu'il est fini. Chose sans exemple ! "
[7] 1686-1762. R. July 30th, 1735, on the portraits of Christophe and Boullogne
père. Exhibited at the Salon from 1737 to 1761. He had spent some time working
for Bernard Picart at Amsterdam, but married and returned to Paris in 1715, and

M

out his attendance. Of the latter he writes: "I have spent all my time lately at the sale of prints belonging to the late M. de Surugues [*sic*] in the house of his son. I have bought many for myself *pour ma curiosité*." Minor occasions, however, were not neglected, and Wille could spare an hour even to visit the sale of the pictures in the collection of the "Comtesse de Farvaques," though he regretfully remarks: "Je n'en ay pas acheté un seul, car je n'aime pas les croûtes."

It is to be wished that his taste had always shown itself equally severe, for Wille, whom his friends delighted to hail as the greatest *buriniste de l'Europe*, often applied his skill to the reproduction of work not of the first class, such as that produced by his friend Dietrich of Dresden,[1] or—betrayed by paternal affection —those equally unworthy subjects which were furnished by the work of his son Pierre-Alexandre.[2] In spite of the long life in Paris, in spite of his French marriage and surroundings, Wille always remained intensely German. His atelier, his household, his manners retained this stamp—"l'honnête logis," say the de Goncourt, "l'aimable école d'art, la bonne franc-maçonnerie allemande que le n° 29 du quai des Augustins,"[3] but there is a reverse to the medal. When Wille arrived in Paris he accepted French direction, French teaching, French influence, but, as he built up his own position, his self-confidence returned, and when he became the acknowledged head of his profession his choice of subject suffered from it.

His journal, whilst it shows that his talent had placed him in contact with all that was most distinguished and most interesting in Paris, shows also how incapable the writer was of profiting by his unrivalled opportunities, how limited was his scope of interest, how narrow his field of vision. Wille is absorbed in his commissions, his purchases, his dinners, his excursions and the details of his family affairs. The engagement of Basan's old cook, Thérèse, cramp in the calf of the leg and the consequent inconvenience of falling asleep on the edge of the bed, whilst holding on to the

established a printselling business. He died at Grand-Vaux, near Savigny-sur-Orge. His son was Pierre-Louis Surugue, 1716-1772. R. July 29th, 1747, on the portraits of Guillain and Frémin. Some of his best work is after Chardin, and he was the engraver of the enchanting "Mme. de * * * en habit de Bal," after Coypel, in 1746 (Scellé, N. A., 1885, p. 36). He exhibited at the Salon from 1742 to 1761.

[1] Chrétien-Guillaume Dietrich or Dietericy, 1712-1774. He was protected by Count v. Brühl and was painter to Augustus, King of Poland.

[2] 1748-(?). A., June 25th, 1774. His simple studies, such as that known as "La Femme à la Tulipe" (see illustration), engraved by his father in 1774, are best.

[3] In a note by Wille he gives the number of his house as 35.

offending member, these are matters to be set down minutely, undisturbed by any public calamity or private sorrow. He notes, it is true, on the 10th May, 1772, the arrival in Paris of the news that the "comtes de Struensée et Brandt avoient été exécutés à mort à Copenhague," but he immediately adds, "Je marque cecy icy parce que j'ay connu personellement le comte de Struensée."

For his excellent wife, Marie Deforge, the old engraver seems to have had something like real affection. "Ce jour, 29 d'octobre 1785," he writes, "a été le jour le plus fatal et le plus malheureux de ma vie.—Ma femme, la plus excellente femme possible, s'est endormie avec la ferme confiance en la bonté de son Créateur.— Dieu! que de larmes me coûte cette séparation!" His attachment to her seems, however, to have caused him some surprise. In February, 1787, he notes: "Depuis le mois de décembre 1785, je n'ay presque rien écrit dans ce Journal, ayant toujours eu la tristesse dans le cœur à cause de la perte de ma très-chère femme, qui je ne saurois jamais oublier. Et nous voilà au moi de mars de 1787." But even as one reads these words one remembers that he had told us on an earlier page how deeply he loved his brother, yet when the widow wrote to say her husband was dead (June 24th, 1769) Wille allowed nearly seven weeks to elapse before he acknowledged the announcement. Of his own sister he says —when dating a letter to the cousin with whom he usually corresponded—that she is the only one of his relations whom he remembers, adding: "Je prie mon cousin de dire à cette sœur que ses lettres n'ont nul agrément pour moi, et qu'elle feroit bien d'employer son papier et sa peine à autre chose." [1]

After this, the reader is prepared to find that the most tragic events of the Revolution cast no shadow on the pages of this "phlegmatique buriniste allemand." On the 21st January, 1793, he writes: "Toujours incommodé, je ne suis pas sorti de chez moi, mais je voyois passer . . . devant ma maison les bataillons des diverses sections pour se rendre à la place de la Révolution (cy-devant de Louis XV), où Louis XVI fut exécuté avant midy." Nine months later he was so busy making a list of his "patents" as member of a dozen Academies, all of which were to be sacrificed as contrary to principles of true civic virtue, that he forgets even to note the death of the Queen.

[1] May 27th, 1790.

CHAPTER VI

LAURENT CARS, BEAUVARLET, FLIPART AND LE BAS

LAURENT CARS[1] has left work which places him in the same relation to the " gravure d'histoire " as that in which the Drevet, father and son, stand to the " gravure de portrait." Bachaumont says of him, " il a presque abandonné la gravure pour faire le commerce des estampes." Cars—who was born at Lyons in 1699—had, however, inherited his print-selling business from his father, who, two years after the birth of his son Laurent, transferred his establishment from Lyons to Paris.[2]

Cars père had engraved portraits—local celebrities—before leaving Lyons; Paris encouraged him to higher flights, and his best work is represented by his Cardinal Polignac, after Rigaud. He did not depend for his living on the engraving of portraits; his real business is shown by a " Catalogue de sujets de thèses," which were his stock-in-trade.[3] In their preparation the help of numerous assistants was required, whose services naturally passed with the business from father to son. Amongst those whom he

[1] 1699-1771. R. Dec. 31st, 1733, on the portrait of Michel Anguier, after Gabriel Revel, and that of Sébastien Bourdon, after Rigaud. Nos. 2099, 2117, Chal. du Louvre.

[2] The declaration of the nephews of Laurent Cars, in 1771, to the effect that their uncle had then died aged about seventy-two, and the inscription on a portrait of Louis XIV., signed and dated as engraved at Lyons, and sold at Paris by Cars père in 1701, are the basis for these statements. See Portalis and Béraldi, t. i., p. 301.

[3] These were bought at the death of Laurent Cars by Babuty, the father of Mme. Greuze. There appeared also prior to this date a "Catalogue in 4° des Estampes formant le fonds de Laurent Cars." See Scellé de Laurent Cars, N. A., 1885, p. 4.

employed Laurent Cars found more than one brilliant pupil,[1] but the school under his direction never attained the general influence or commercial importance of that which was conducted by Le Bas. The aptitudes of a great artist do not often lend themselves to the formation of a school, and Laurent Cars was a great artist.

"L'un de nos meilleurs graveurs," writes Mariette, and his commendation is justified by the intelligence with which Laurent Cars interpreted the spirit and manner of those whose work he reproduced. Mariette's encomium is amplified and specialized by another contemporary who says, "un très bon graveur et notre meilleur pour l'histoire." Yet his best work can hardly be classed as "historical." Striking as one must find that series of remarkable engravings after Le Moine, which opens with "Hercule et Omphale," reveals a youthful freshness and charm in "Iris entrant au bain," and displays equal spirit and force in "Persée délivrant Andromède," not one of these—not even the proud "Louis XV donnant la paix à l'Europe"[2]—seems to me equally distinguished with his brilliant and original rendering of "Les Fêtes Vénitiennes," by Watteau, and the "Camargo dansant," after Lancret.

Next to the "Fêtes Vénitiennes" must stand the fine series engraved by Cars after Boucher in illustration of the plays of Molière. I never turn them over without admiring afresh the expressive character of the drawing and the masterly intention with which—as in the "Malade imaginaire"—the suggestion of the whole situation is given by the movement of the hands. We see the fruits of those severe studies in the Academy of St. Luke, to which Gaucher calls our attention in the article on Laurent Cars contributed by him to the "Dictionnaire" of the abbé de Fontenai.

"Every time," writes Gaucher, "that there was a medal competition, he competed and carried off the first: but several years having elapsed without any being distributed, the Academy, having too many crowns to award, decided that all those who had gained a first prize should compete together, and one only

[1] The conditions of an engagement between the engraver and his assistants or pupils are indicated in the "Contrat (1759, 11 Septembre) entre le graveur Laurent Cars et Pierre-François Martenasie, par lequel celui-ci s'engage à travailler pour le premier pendant toute sa vie, à certaines conditions" (see N. A., 1885, p. 315). Martenasie was a pupil of Le Bas (see p. 93). He engraved the illustrations of Eisen for the "Eloge de la Folie" and those of Gravelot for the "Boccacio" (*sic*) of 1757.

[2] Chal. du Louvre, Nos. 1153, 1155 to 1163. Laurent Cars engraved a composition by Le Moine for the theological thesis sustained by Armand, prince de Rohan-Ventadour. See also P. V., March 1st, 1738, and Nov. 4th, 1752.

Laurent
Cars,
Beau-
varlet,
Flipart
and
Le Bas.

should be the winner. Cars returned to the lists and triumphed over all his rivals."

The execution of both Laurent Cars and Le Bas recalls in some measure the picturesque touch and manner of their master, Tardieu père,[1] as seen in his delightful engraving of Watteau's "Embarquement pour Cythère." Each seems to have accentuated the qualities akin to his own temperament. Le Bas developed, through extreme facility, a licence of execution which often obscures his real intelligence and talent; Cars, on the other hand, drew to himself all the science with which Tardieu mingled his ingenious use of the point with the graver—a science which, transmitted by Cars to his pupil Beauvarlet,[2] was by him abused.

The co-operation of Beauvarlet with his master in the celebrated portrait of Mlle. Clairon as Medea—engraved by royal command from the picture given to Clairon by the Princess Galitzin—established his reputation. As soon as the print was published, it became the rage. Bachaumont says: "Tout le monde court après la nouvelle estampe de mademoiselle Clairon; ... on sait qu'elle est représentée en Médée."[3] Then, when the first excitement wore off, criticism was heard. "L'estampe de mademoiselle Clairon représentant Médée," writes Grimm, "est publique depuis quelques jours. A mon gré, celà n'est rien moins que beau! ... d'ailleurs, c'est Beauvarlet qui a gravé la figure de Mademoiselle Clairon et Cars le reste du tableau et la différence des deux burins jette dans toute l'exécution une discordance qui fait mal aux yeux. Partant, nous condamnons cette estampe à passer la thèse d'un bachelier."[4]

The last words "passer la thèse" refer to the practice of decorating "thèses" with engravings, and have the specially spiteful intention of belittling the work of an engraver whose family business was that of executing the ornamental subjects used as headings to these exercises. As to the whole statement, if there is some truth in it, there is more exaggeration. The only criticism which I should venture to make is that the plate has

[1] 1674-1749. R. Nov. 29th, 1720. He exhibited at the Salons of 1738, 1741, 1742, 1743, 1745, 1747 and 1748. Amongst his most important work is a series of the "History of Constantine," after Rubens.

[2] 1731-1797. R. May 25th, 1776, on the portrait of Edme Bouchardon, after Drouais, No. 2111, Chal. du Louvre. Beauvarlet came of the Abbeville school. He worked in Paris first with Hecquet, then with Charles Dupuis, the inferior brother of Nicolas Dupuis, then with Laurent Cars. See "Le graveur Beauvarlet et l'Ecole Abbevilleoise au XVIII. Siècle."

[3] Aug. 19th, 1764.　　　　　　　　　[4] Sept., 1764.

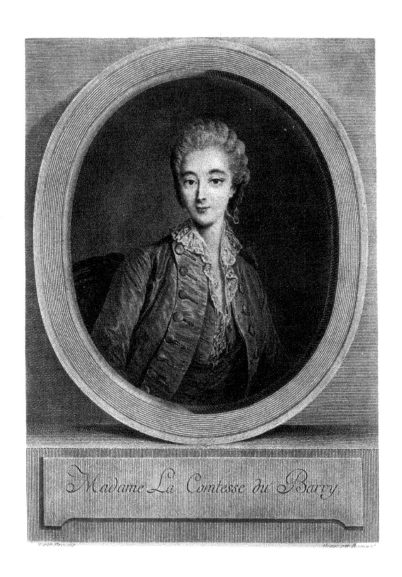

Madame La Comtesse du Barry

Madame Dubarry en **habit de chasse**.
(Jacques-François Beauvarlet, after Drouais.)

probably been overworked at the last in the effort to bring the whole together and reconcile "la différence des deux burins."

Beauvarlet had but recently been *agréé* by the Academy,[1] showing, probably, the four engravings after Jordaens, which he exhibited in 1763. These do not give us as favourable an impression of his ability as his work after contemporary masters such as "La Toilette" and "Le Retour du Bal," after de Troy,[2] or "La Lecture" and "La Conversation Espagnole," after Van Loo,[3] though even in these we may note the tendency to make too free translations in a popular sense from the masters whom he professed to reproduce, which was a weakness of the least unworthy pupil of a considerable master.

Not defects of skill but defects of temper seem to have delayed his reception by the Academy. Wille records that on May 25th, 1776, he attended the election of Beauvarlet, by his own request. Beauvarlet was received, but he had no less than seven black beans. The portrait of Bouchardon which he then presented he had been ordered to carry out on July 24th, 1772. This portrait, if not as attractive as his popular Madame Dubarry in hunting dress, or as famous as that of Mademoiselle Clairon, is a good specimen of the class of work by the execution of which he seems to have amassed the fortune to the possession of which his three marriages[4] probably contributed, and the inventory taken at his death bears witness.

In addition to Beauvarlet, Augustin de Saint-Aubin[5] and other pupils, such as Chedel,[6] Jardinier[7] and Pasquier,[8] excellent artists but of less note, there is one who was formed by Laurent Cars and whose talent responded brilliantly to the direction of the master. Whether he were translating the "Tempêtes" of Vernet, the

[1] P. V., May 29th, 1762.
[2] These were reproduced in the "Gazette des Beaux Arts," April, 1899. Beauvarlet also engraved after de Troy various scenes of the "Story of Esther," of which the best is the "Evanouissement d'Esther." See Salons of 1775, 1777, 1781, 1783, 1793.
[3] The drawings for these were exhibited in 1765, the engravings in 1769 and 1773. He also engraved after Van Loo "La Confidente" and "La Sultane" (see Salon of 1775), the latter of which M. de Marigny pronounced to be the best portrait of his sister.
[4] From the notice prefixed by Regnault-Delalande to the catalogue of Beauvarlet's sale, we learn that on the death of his first wife, the stepdaughter of Madame Langlois, he married his stepmother-in-law. His most distinguished pupil was Porporati, who also went to Wille, but Malœuvre, the two Voyez, Elluin, Dugourc, Hubert and Audouin may be added to the list. A pupil named Jogan placed with him by Mariette (see "Acte de partage," Appendix C), when Beauvarlet was his tenant in the Maison de la Croix d'or, seems to have made no mark.
[5] See Chap. IX. [6] 1705-1763. [7] 1726-1774. [8] 1718-1785.

Laurent
Cars,
Beau-
varlet,
Flipart
and
Le Bas.

"Chasse au Tigre" or the "Chasse à l'Ours" of Boucher and
Van Loo, or the masterpieces of Greuze, Jean-Jacques Flipart[1]
showed remarkable powers of assimilation which are the more
astonishing when we recollect that he is said to have developed
very slowly. He was no longer a youth when he became the
pupil of Laurent Cars[2] and it was not until after he had spent
some months under this master that his talent became evident.
Cars himself, we are told, had failed to recognize the ability of
Flipart. Cochin, on the other hand, detected the signs of power
and induced Michel-Ange Slodtz to entrust him with the en-
graving of one of the frontispieces of the "Description des Fètes
données pour le second mariage du Dauphin." Flipart was then
about twenty-eight;[3] he carried out the commission alone and it
brought him the unmixed satisfaction of the assertion by Cars
that, of all his pupils, he alone had understood his lessons.

The notice of Flipart written by Gaucher expresses, in each
turn of phrase, the deep feeling of admiration with which the art
of this engraver inspired every competent judge. The vagrant
Perronneau from the first set high value on his powers and these,
coupled with his high character, actually gave him some influence
in the Academy. Greuze was no doubt sincerely attached to
Flipart, who returned his friendship, with the result of that great
series of admirable renderings of all his sentimental subjects, such
as "L'Accordée de Village," which has done enormous service to
the popularity of the painter.

Flipart's first Salon (1755) had consisted only of work for the
"Gallerie de Dresde," six "little bits" after Boucher and Cochin,
and an "Adam and Eve" after Natoire. In 1757 he exhibited
two engravings after Chardin, one of which was the "Jeune
Dessinateur," and, seeing this perfect interpretation of a perfect
master, one cannot but regret that Flipart abandoned Chardin so
soon for his friend Greuze. Except for the two fine "Tempests"
after Vernet, exhibited in 1765 and 1773, and a necessary civility
paid to Vien in 1765 — when he engraves "La Vertueuse

[1] 1719-1782. A., June 7th, 1755. He was the master of the two Ingouf. The
elder (1746-1800) displeased Wille. The younger, François-Robert, was the better
artist. See his portrait of Crébillon after La Tour, "Œuvres Complettes," 1785.

[2] He went to Cars from the house of Nicolas Tardieu. Mariette, under that
master's name, mentions "La St Vierge assise, apprenant à lire à l'enfant Jésus,
ce qui excite l'attention de St Joseph, qui, appuyé sur un baton, est assis sur la
droite de la Vierge. Gravé d'après Maratti, par Flipart, chez N. Tardieu, dans le tems
qu'il apprenoit de ce maitre la gravure."

[3] The age "thirty-two" given by MM. Portalis and Béraldi is evidently a mistake
as the date of his birth is correctly given as 1719.

Concours pour le Prix de l'Expression fondé dans l'Académie royale de peinture par le Comte de Caylus. Mademoiselle Clairon, assise au-dessus d'une table, sert de modèle aux jeunes artistes.

(Jean-Jacques Flipart, after Cochin le fils.)

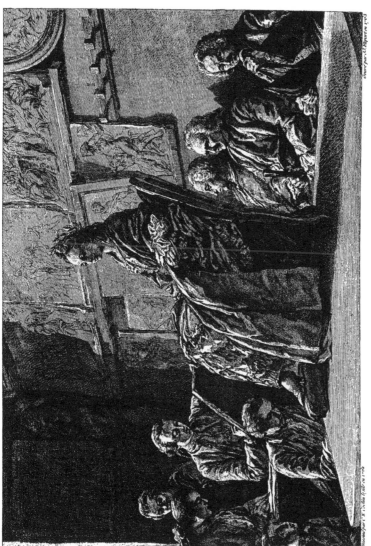

Athènienne" and her companion "La Jeune Corinthienne"[1]— Flipart devotes himself wholly to Greuze. The "Gâteau des Rois" ends in 1777 the series which began in 1763 with "Une jeune fille qui pelotte du coton, d'après M. Greuze."

Laurent Cars, Beau-varlet, Flipart and Le Bas.

I had almost forgot to recall by mention here a work to which I have already referred—the famous "Chasse au Tigre," that powerful version of "le tableau de F. Boucher du Cabinet du roi." It is difficult to remember that Flipart, fresh from re-producing "L'Accordée de Village" with all the softness and brilliancy which the heart of Greuze could desire, handled the violence of the "Chasse au Tigre" with a restraint in which Laurent Cars, had he been still alive, would have found a final proof that Flipart had indeed mastered his lessons. But Cars was dead and all the young men were crowding to the studio of Le Bas.[2]

If Basan made no pupils, we may say, with some slight exaggeration, that Le Bas—who had set Basan the example of combining his art with business—made nothing else. The charm of his character lives in every page of the MS. notice of his life which is prefixed to the volumes which contain his work in the Cabinet des Estampes, and as one reads one feels the attraction which drew to him so many of the younger men of his day and made his workshop the most brilliant school in Paris.

Here, when he could escape from the disciplinary engraving of sacred subjects after Bolswert,[3] Cochin took refuge and found himself in that pleasant company, of which Le Bas—by eight years only senior to Cochin—was the leading spirit. "Il eut des pensionnaires, des externes et beaucoup d'élèves qu'il logeoit, nourrissoit et instruisît gratuitement . . . le persiflage étoit l'arme la plus acérée dont il se servit," writes Joullain fils,[4] the author of the MS. notice, which bears every sign of having been dictated by Le Bas himself.

Before he arrived at this brilliant situation, Le Bas passed through narrow straits. His mother taught him to read and, at at the age of fourteen, having placed him with Hérisset, an architectural engraver, left him to his own resources. It is not to

[1] This print, which was dedicated to Prince Christian of Denmark, seems to have inspired the travesty by Dumont of Marie-Antoinette "en Vestale." See p. 78.

[2] 1707-1783. A., Oct. 29th, 1735. See P. V., Dec. 30th, 1741 ; Jan. 5th, Jan. 27th, 1742. R. Feb. 23rd, 1743.

[3] See Chap. III., p. 42, note 3.

[4] His father (1697-1779) is described by Mariette as a "disciple de Gillot"; he ceased to engrave and began to sell about 1730-1733. The son gave himself up specially to work as an expert.

Laurent
Cars,
Beau-
varlet,
Flipart
and
Le Bas.

be supposed that a lad as happily endowed as Le Bas would be
long in finding his way to better teaching. This he obtained from
Nicolas Tardieu and his work soon brought him the generous
encouragements of Crozat.[1]

Before he was eight and twenty, he married the beautiful,
quick-tempered Elizabeth Duret, and the account of his wedding
as given by him to Joullain is not the least interesting page of his
story. "When I was married," said he, "I played the young
man. I gave laces, diamonds and fine clothes. The next day I
had no money. That made me serious. Without saying a word.
I took the diamonds and the laces in the top of my hat; I sold
everything. On returning home, I showed all my money to my
wife, saying to her: '*Ma bonne amie*, I have sold your ornaments,
but I have got some silver and I am going to buy some copper.
Be patient; keep up my courage; I only ask of you the time
necessary to engrave a few plates and publish them, and I will
promise to give you back with interest that of which I deprive
you to-day.' I kept my word. I shut myself up. *J'ai pioché le
cuivre* [these, says Joullain, were his words]. Mme. Le Bas helped
my zeal by her economy. She was her own servant and swept
her own stairs. In a short time I was able not only to give her
back all that I had taken from her before she had enjoyed it, but
to have her waited on and to procure for her all those comforts
which are proper to decent income."

The story shows us all the kindliness, the ready ability, the
brave and flippant humour which, seconded by the genial house-
keeping of his wife, made the atelier of Le Bas so great a centre,
and it gives also indications of that careless getting and spending
which entailed bitterness on the last days of this generous, brilliant
and hardworking man. .

As soon as his means permitted Le Bas to organize his atelier
it rapidly filled, and the attraction was such that the provoking
treatment received at his hands by incompetent or self-satisfied
pupils was no check to his popularity. "Should a young man,"
says Joullain, "much in love with his own work, as is often the
case, offer Le Bas a drawing or an engraving which he thought
less good than ought to have been done by this pupil: 'You
deserve,' he would say, 'that I should embrace you,' and rising in
the most matter-of-course manner, he would actually embrace him.
The youth who received the first kiss of the sort went back to the
atelier much pleased with himself. His fellows disabused him and

[1] "Le Midi" and "L'Après-diné" were engraved by Le Bas after Berghem,
dedicated to M. le Baron de Thiers and exhibited in 1742.

PORTRAIT OF LE BAS.

(Louis-Jacques Cathelin, after Cochin le fils.)

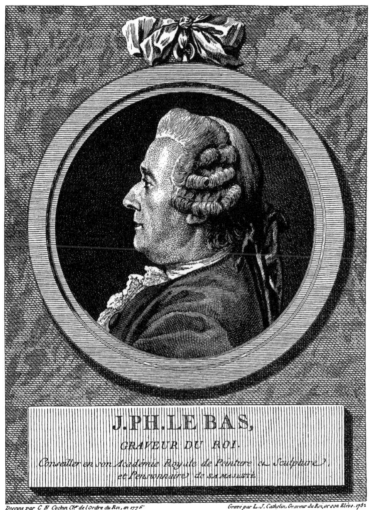

J. PH. LE BAS,

GRAVEUR DU ROI.

Conseiller en son Académie Royale de Peinture et Sculpture,
et Pensionnaire de SA MAJESTÉ.

Dessiné par C. N. Cochin Cher. de l'Ordre du Roi, en 1776. *Gravé par L. J. Cathelin, Graveur du Roi, et son Elève. 1782.*

soon fear of being laughed at . . . induced him to redoubled Laurent Cars, Beauvarlet, Flipart and Le Bas. exertions in order to avoid the embraces of the master."

By handling them with this mixture of jovial familiarity and mockery Le Bas obtained boundless popularity with the pupils who passed through his workshop. Their number and the consequent enormous output of Le Bas cannot be rivalled by any other master, certainly not by Laurent Cars. It is said that Cars was checked in the exercise of his profession by his devotion to business. There may have been other reasons. The splendid qualities of his work were not the qualities then coming into vogue. The breadth and freedom, the large and luminous vitality which distinguish the great pages in which he took the compositions of Le Moine for his theme are common characteristics with the famous engravers of a previous century. The splendid virility of his translations from Boucher in the Molière series may have seemed an inconvenient force to those who were co-operating in the production of the delicate vignettes required for the popular work of the day.

Le Bas, on the other hand, was not only disposed to follow passing currents but adapted himself to them without losing any of his pleasant skill. Through his numerous pupils and his own sympathies he was closely in touch, throughout the great span of his life—which coincided with the most essential period of the century—with all the various developments of his art, from the "estampe galante" to the most delicate caprices of the vignette. Cochin, Ficquet, Eisen, Le Mire, Aliamet, Choffard, de Longueil, Née, Cathelin, Martini, Gaucher, Moreau le jeune and Masquelier, Godefroy and Malbeste are all to be reckoned as having profited by his teaching. Foreigners such as Ryland and Strange were drawn by the reputation of the house, and Rehn,[1] the young *protégé* of Tessin, quitted his "régiment de Royal-Suédois" to work under Le Bas.

Rehn, however, on returning to Sweden abandoned the practice of engraving, not without much opposition from Le Bas, who saw in this decision not only the loss of the credit to be expected from a promising pupil but of a fresh opening for those commercial relations of which he never lost sight. In January, 1746, he admonished his late pupil to see whether it would not be possible

[1] The grandson of Rehn, the Baron de Hochschild, communicated to M. de Chennevières some interesting details as to the life of this Swedish draughtsman and architect, who died in 1793, having for some time filled the post of "surintendant des bâtiments de la couronne" ("A. de l'A. fr.," t. iii., p. 118 *et seq.*). These details are accompanied by passages from two of four letters from Le Bas to Rehn.

Laurent
Cars,
Beau-
varlet,
Flipart
and
Le Bas.

to set up a shop in Sweden for the sale of prints : " Cela donneray beaucoup de gout au vulgaire, ay vous auray cette obligation et nous procureray du commerce."

A hint of the easy family relations which marked the life of the household is given in the message sent to Rehn by Mme. Le Bas. " Mon épouse," writes her husband, " vous remercie de vos politesse, et monsieur Darcy,[1] en atendant ces manchon de vostre gout que vous avé promis à ces dames." The muffs were, however, forgotten, and winter went by. Le Bas was bidden to remonstrate and begins his letter : " Mon épouse a eu bien froid cette hiver, le manchon n'a pas parue que vous luy aviez promis de vous mesme ; cest ce quis letonne ; elles vous fait mil compliment et parle de toutes nos partie de campagne sans cesse disant que vous etiez un charmant garçon et quel desireray bien vous voir ; cela merite quelqun de vostre souvenir, vous luy avé promis ce n'est pas ma faute."[2]

To stir the memory of the young Swede for whom he had so much affection, Le Bas was, it seems, in the habit of sending him sketches of the domestic scenes with which he had once been familiar. The letter of the 10th January, 1746, contains a reference to a previous one of which " le dessins et la diction " had not been such as Le Bas would willingly have had shown by Rehn to the Count de Tessin.[3] He therefore implores his correspondent, to whom he sends the drawing of a " segonde feste," not again to betray him : " Epargnez-moi," he writes, " de montré cela." The drawing, however, seems to have been a light and graceful pencil sketch, worthy of all admiration. It takes us, we are told, into the salon, where, the day's work done, pupils and friends are dancing—Le Bas himself opposite to his wife ! The sketches were not, indeed, always in this key, for that which accompanies the letter in which Rehn is reminded by Darcis and Mme. Le Bas of his failure to send the promised muffs is in a vein of pure caricature.

" On one line," says M. de Chennevières, " getting larger and

[1] Darcis was the engraver of various prints stippled after the manner of Bartolozzi, amongst which may be mentioned " L'Accident imprévu " and " La Sentinelle en défaut " after Lavreince. " Il en fit de moins sérieuses," writes Renouvier, " et qui ne pouvaient, malgré le relâchement du temps, affronter le Salon." His chief successes were, however, obtained in work after Carle Vernet such as " Les Incroyables " (Renouvier, " Hist. de l'Art pendant la Révolution," t. i., p. 222).
[2] " A. de l'A. fr.," t. iii., p. 123.
[3] Le Bas was known to Tessin, when he was ambassador in Paris. " Le Sanglier forcé," engraved after Wouvermans by Le Bas and exhibited in 1741, was dedicated to " M. le Comte de Tessin."

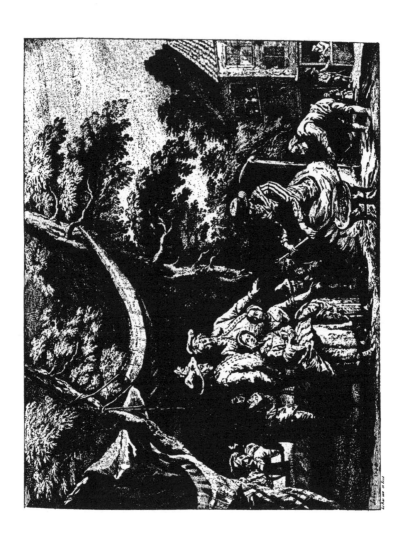

La Marchande de Beignets.
(Jacques-Philippe Le Bas.)

larger, from left to right are the caricatures of Chenue[1]—Pitre[2]—
Bachelay[3] with his slippers—Lemire Normant—Tailler Halle-
mant. And in the background the long visage, stiff and thin, of
Mademoiselle Manon Manchelard, probably his servant."[4]

Laurent
Cars,
Beau-
varlet,
Flipart
and
Le Bas.

Le Bas himself, although every little engraving on which we
find his signature testifies to his wonderful skill in delineating
physiognomy, could do no portraits. It is on record that in 1741,
when, after much difficulty, he managed to produce those of Cazes
and Le Lorrain, which had been imposed on him for his diploma
work, they were, on their presentation to the Academy, "rejettès
pour vice de médiocrité à la grande pluralité des voix," nor was it
until two years later that he obtained the official consecration of
his talent by the "Conversation galante" which he had engraved
after Lancret.[5]

The bright and sparkling effect of this work, coupled with a
certain air of distinction, justifies those who urged Le Bas to devote
himself wholly to engraving. Bachaumont says, somewhat curtly,
"Il néglige beaucoup la gravure pour le commerce."[6] The very
character of his exceptional natural gifts, the wit and intelligence
which he brings to bear upon a page of "Manon Lescaut," the
wonderful *finesse* with which he has rendered the head of Don Juan
in the Molière illustrated by Moreau, his excellent interpretations
of Lancret[7] indisposed the public to accept that sacrifice of his
professional distinction to his commercial interests which was
dictated as much by the necessities of his family as by his love of
free expenditure.

The "shop," at least, did not stand in the way of full pro-
fessional honours, for Le Bas was yet a young man when received
by the Academy ; he became "graveur du Cabinet du roi" in
1744, and in 1771 was not only elected "conseiller" but succeeded
to the pension of 500 lt. which had been previously enjoyed by
Laurent Cars.[8]

Le Bas, to whom Diderot assigned the unenviable distinction
of having given the death-blow to "la bonne gravure,"[9] was driven
to the employment of expeditious methods in order to deal with
the enormous quantity of work that he undertook at a low price.

[1] 1730-1800 (?). [2] Pitre, Martenasie, 17 . .-1770 (?).
[3] 1712-1781. [4] A. de l'A. fr., t. iii., p. 123.
[5] No. 986, Chal. du Louvre. P. V., Feb. 23rd, 1743. It was exhibited in the
same year, together with two subjects after Teniers and the "Courrier de Flandres"
after Bott.
[6] Mém. Wille, Appendix, and note, t. ii., pp. 22, 23.
[7] "Le Maître galant," "Le jeu de pied de Bœuf."
[8] P. V., April 27th, 1771. [9] Salon, 1765.

Laurent
Cars,
Beau-
varlet,
Flipart
and
Le Bas.

In 1758 we find de Caylus using the most persuasive eloquence to induce Le Bas to engrave "pour la moitié moins qu'elles ne valoient" the plates of Le Roy's two volumes on " Les Ruines des plus beaux Monuments de la Grèce." The terms were accepted on the understanding that further payment would be made should the book sell well. It did sell well, but no further payment was received—"Aussi M. Le Bas, qui sçait très bien compter, et qui n'est pas mal attaché à ses intèrests, s'en est-il toujours plaint." [1]

Love of money was the crime imputed to Le Bas by Diderot when criticising the " Ports de Mer " of the Salon of 1767,[2] but, if he were keen to get, Le Bas was equally keen to spend. There is a sharp distinction to be drawn between the love of gain which feeds a magnificent generosity and that which only satisfies the miserable cravings of a selfish avarice. By this distinction Le Bas has a right to profit. His worst crime would seem to have been that, generous and free-handed, he lived careless of the next day.

If not " âpre au gain," it is certain that Le Bas was extraordinarily quick to seize on any chance of making money. He unveiled or professed to unveil the mysteries of Freemasonry in a curious set of engravings—one of which, representing " L'Entrée du récipiendaire dans la Loge," I have here reproduced—and, whilst courting the profitable advertisement of a little scandal, discreetly sheltered himself behind the apocryphal statements, " Dessiné par Madame la Marquise de . . ." and " Gravé par Mademoiselle de . . ."

The conduct which, in later years, aroused the anger of Le Prince went, however, beyond the bounds of pleasantry. The continued vogue of the Russian subjects which he treated after his return to France in 1763 inspired Le Bas with the desire to profit by the occasion. It is only necessary to look over the list of his contributions to the Salon to see that all the great collections were open to him.[3] He had, therefore, no difficulty in finding what he wanted and, in 1777, exhibited his engraving of a " View of the Port and Citadel of St. Petersburg on the Neva, . . . after the

[1] Cochin, Mém. inéd., p. 79. These engravings were exhibited in 1759, and dedicated to Marigny.

[2] See Chap. III., pp. 50-52. In this connection it may be noted that in 1769 Cochin, in the character of " M. Raphael, Peintre, de l'Académie de Saint Luc," writes of " la précision de M. le Bas," exactly the quality which was denied by Diderot at preceding Salons ("Œuv. Cochin," t. ii., p. 308).

[3] Amongst the names of those who permitted Le Bas to engrave the pictures belonging to them we find those of the Elector of Saxony (King of Poland), the Dukes de Choiseul, de Cossé, de Praslin and de Nivernois, the Prince de Condé, the Count Baudouin and the Marquis de Brunoy.

Les Francmaçons : L'Entrée du Récipiendaire dans la loge.

(Jacques-Philippe Le Bas.)

Laurent In
Cars, ir
Beau-
varlet,
Flipart
and
Le B

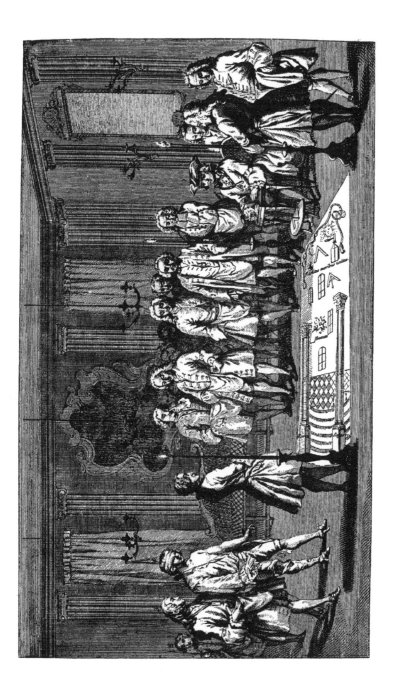

painting by M. Le Prince belonging to Mme. la Marquise de Laurent l'Hôpital," adding the announcement, "elle doit être dédiée à Sa Cars, Majesté l'Impératrice de toutes les Russies." When Le Prince, varlet, whose permission had never been asked, not unnaturally declined Flipart to be satisfied with the present of "a proof and an explanation," Le and Bas chose to consider himself the injured person. Yet his breach with Madame de Pompadour proves that Le Bas, in his own case, would brook no breach of etiquette or want of courtesy, even on the part of those to whom he looked for patronage.

He had dedicated to the all-powerful lady the first of a series of "Fêtes Flamandes,"[1] engraved after works by Teniers in the collection of her faithful and attached friend, the Duke de Choiseul. She was at her toilet, Joullain tells us, surrounded by men of the Court, when Le Bas came to her and presented his engraving. She received him well and praised his work with judgement, but either from absence of mind or because she did not know exactly what to do, she waited until he had left her rooms before asking him for his bill. "Dites à Mme.," replied Le Bas, "que je ne suis point apothicaire, que je ne donne jamais de mémoire, qu'elle pourroit trouver trop fort celui que je lui fournirois et que je ne connois personne en droit de le régler"—a reply which cost him not only the present reward of his labour, but all hope of any future recompense.

The spirit which Le Bas displayed over this incident in the days of his prosperity never forsook him. He lost his wife, he had to leave the house which had sheltered him and his for more than forty years. His resources were drained by the cost of those " Figures de l'histoire de France ; Ouvrage proposé par souscription," from which he had hoped to make great profit, being fully justified in this expectation by the success attending the issue of the " Ports de France" engraved by him after Vernet " en société avec M. Cochin."

The first fourteen of the " Ports de France " had appeared in rapid succession and were received with enthusiasm ; then came a check, which permitted Le Bas to produce his engravings of sixteen " Conquêtes ou Cérémonies Chinoises," after the drawings of the Jesuit father Castillon for the Emperor of China.[2] It was not until twelve years later, when Le Bas had actually undertaken

[1] The first was exhibited in 1750, four others appeared at the Salon of 1771.
[2] See Salons of 1769 and 1771. Grimm says in his " Correspondance littéraire " that the engraving of the drawings cost over a hundred thousand crowns, and adds that in these battles not one of the Chinese is killed or wounded, the draughtsman having had express orders to that effect.

Laurent
Cars,
Beau-
varlet,
Flipart
and
Le Bas.

his "Histoire de France," that Vernet furnished his fifteenth subject, the "Port de Dieppe." It was the last received from him. Cochin—as we have seen—attempted to complete the set, but he and Le Bas had both passed away before the engraving of his second drawing was finished. On the 2nd February, 1783, Le Bas took to his bed, having been at work as usual on the preceding day. To the last he retained his unfailing flow of spirits and malicious gaiety. He played tricks on those who watched him, on the priest whom his old servants had called to his bedside, and died after a short illness as bravely as he had lived. "Voici," he cried, on the morning of April 14th, "voici, l'édifice qui s'écroule!"[1]

The fate of Le Bas' last enterprise, as far as he himself was concerned, had been little short of disastrous. After the exhibition, in 1779, of the first set of drawings, he called Moreau le jeune to his aid and two years later thirty-five "sujets de figures" drawn by Moreau were exhibited, with the intimation that six books had already appeared, each containing eighteen engravings, and that the seventh was actually on sale. He also sent to the Salon a frame enclosing several others, "gravées sous la direction de M. Le Bas à qui ils appartiennent."

It is said that Moreau, highly paid for these drawings by Le Bas, played with the work until the old man died and then—having given out that no more drawings for the series would be executed by him—succeeded in obtaining the proofs, together with the plates already engraved, for a nominal sum at Le Bas' sale. The next step was to replace the early designs of Lépicié and Monnet by drawings of his own and complete the work. This done, the publication was started by Moreau on his own account, the motive alleged for so much double-dealing being that he desired to reap the credit due to the carrying through of a great "historical" performance.[2] Whether this were so, or whether Moreau were actuated by the purely sordid object of gain, there seems no doubt that his conduct was responsible for much of the distress and misery in which the last years of the unfortunate Le Bas were brought to a close. As we shall see, however, when we come to write of this matter in connection with the career of Moreau himself, his treacherous scheme brought him neither the profit nor the credit which he may have expected to reap from it.

[1] MS. notice by Joullain, Cabinet des Estampes.
[2] "M. Moreau jeune, Graveur, Agréé de l'Académie . . . suplie l'Académie d'accepter le 13ᵉ livraison des figures de l'Histoire de France, ouvrage qu'il continue depuis le décès de M. Le Bas" (P. V., Dec. 4th, 1784).

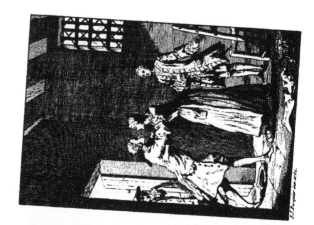

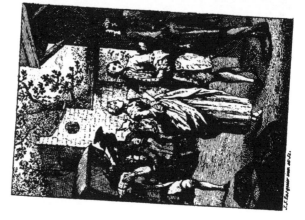

"LE DÉPART POUR PARIS" AND "MANON EN PRISON": "MANON LESCAUT," I

(JACQUES-JEAN PASQUIER.)

CHAPTER VII

THE PUPILS OF LE BAS AND THE ENGRAVERS OF
THE VIGNETTE

ALMOST all the best-known engravers of "estampes galantes" and of illustrations for books were pupils of Le Bas or of men who had worked for him. The "graveurs de livres" are almost a class apart. When we come to them, we quit the groups to whom we owe the execution of magnificent enterprises such as the "Galerie de Dresde,"[1] the "Galerie de Florence," the "Galerie de Dusseldorf,"[2] the "Galerie de Versailles"[3] or the imposing achievements of "historical engraving" and find ourselves amongst other men and other intentions.

There is, of course, no hard and fast line between the two sets. Nicolas de Larmessin[4] executed portraits and worked after Raphael for the "Recueil" published by Crozat, but he engraved also after Watteau, gave us fine versions of the Four Seasons and the Four Ages after Lancret and will always be remembered by his masterly renderings of designs by Lancret, Boucher and others in the "Contes de la Fontaine" of 1738. The engraver of the great print also turned—as did Laurent Cars—now and again to the

[1] See p. 64, note 4.
[2] The "Galerie de Dusseldorf" was a venture of Christian de Mechel, of Bâle. He made offers to young engravers, who mostly, like Carl Guttenberg (1744-1790) came back to Paris weary of the work and its editor. Guttenberg was much employed by Wille. His brother Henri engraved "La petite laitière," after Baudouin.
[3] See Chap. III., p. 46.
[4] 1684-1755. R. July 29th, 1730. He was a pupil of his father, who was sent to the Bastille for caricaturing Louis XIV. and Madame de Maintenon. Schmidt on arriving in Paris became his assistant. See p. 71, note 5.

The
Pupils of
Le Bas
and the
Engravers
of the
Vignette. pages of the book, but there is a distinction to be traced and the same distinction may be seen governing the size and shape of the book itself. The folio practically becomes extinct; even the quarto loses favour. The octavo reigns supreme, but the supremacy of the octavo is itself disputed by the seductive attractions of the duo-decimo. The volume in the pages of which the "traitant" should read himself to sleep had need be light and easy to the hand. In the print engraved by Lucas after Dumeril and published by Basan we are shown that this was indeed the use of the book to the man of money. At the *guichet* seen through the open door, his *commis* faces the anxious questioning crowd; the *traitant* himself, stretched on his couch, begins to slumber and his book—perhaps the famous edition of "Manon Lescaut" which bears date 1753[1]—is slipping from his relaxing fingers.

It would of course be absurd to pretend that the easily-handled little illustrated book was a creation of the eighteenth century, but it had so fallen out of fashion that the "Gil Blas" of 1735,[2] the Molière of 1739[3] and the "Contes de ma mère l'Oye" of 1742 appeared as novelties, which remind us of the pocket editions of Ovid, of Æsop, of Petrarch and Boccaccio which the engravers of Lyons, in the sixteenth century, decorated with microscopic woodcuts for Rovillio or Jan de Tournes.

What is really the point to note is that whereas, during the earlier part of the century, credit and reputation were won by the bringing out of works of great size, fashion, during the latter half, carried the little book to the front. It no longer waited modestly behind the ponderous volumes which had been the publishers' glory, but took the first place, just as the *estampe galante* of the same date shouldered out of sight historical engraving.

The illustrations of all the most remarkable of the small books of the second half of the century were engraved almost without exception by men from the school of Le Bas. If we examine their work closely we shall find how admirably his method was fitted to ensure their success in this direction, provided they had the intelligence to seize on the intention of his teaching. Its influence penetrated even beyond the circle of those who actually worked with or under him. We can trace it even in the work of

[1] "Histoire du Chevalier des Grieux et de Manon Lescaut. Amsterdam (Paris), MDCCLIII."
[2] The frontispiece and eight vignettes in this volume, published by Jacques Des-bordes at Amsterdam, are by Fokke, who engraved after Coypel "La poltronnerie de Sancho à la chasse" in the "Don Quichotte" of 1746.
[3] See "Œuvres de Molière. Nouvelle édition. A Paris. Chez Huart l'ainé, à l'entrée de la rue Saint Jacques, à la Justice. M.D.CCXXXIX."

a man such as Louis-Simon Lempereur,[1] an engraver who was, I believe, no pupil of Le Bas, but who formed in Delaunay,[2] the master of the *estampe galante*, a talent as conspicuously brilliant as any of those who issued from the school of Le Bas himself.

The change in method, for which, I imagine, Le Bas was mainly responsible, becomes evident if we compare work—such as the "Henriade" of 1728,[3] or even the "Don Quichotte" of 1746[4]—done before his school became efficient with that which was executed at a later date by the men whom he had trained. Take, for example, the famous edition of the "Fables de la Fontaine," the illustrations of which were prepared by Cochin from Oudry's drawings. The four volumes of this fine work, published by Jombert in 1755, 1756 and 1759, mark, after a certain fashion, the parting of the ways. Whether we take the illustrations actually engraved by Le Bas himself, by his numerous assistants or by his imitators, it is impossible not to be struck by the absence, on the whole, of any attempt to give a complete pictorial rendering of the subjects, such as we find in the "Don Quichotte," to the engraving of which Picart was so large a contributor.

The engravers, if we except Cars and Flipart, seem, for the most part, to have intentionally indicated the story to be told by

[1] 1725-1796 (Biog. Univ., 1728-1808). R. March 2nd, 1776. See Nos. 2196 and 985, Chal. du Louvre. He is to be specially remembered as the master of Nicolas Delaunay. Huber classes him as a better engraver, or rather as engraving in better taste, than his master, Pierre Aveline. If we compare the work of the two we shall find the distinction unfounded. Take, for example, "Les Plaideurs," engraved by Lempereur in the de Sève Racine, and set it beside "Le Chameau et les Bâtons flottans," engraved by Aveline in the Oudry La Fontaine—the difference is in favour of Aveline.

[2] 1739-1792. R. August 28th, 1789. In addition to his fine work on the Molière (1773) and the Rousseau (1774) should be named his admirable interpretations of Fragonard, "Les Hasards heureux de l'Escarpolette," "La bonne Mère," "Dites donc s'il vous plait," "Cachette découverte," "L'heureuse Fécondité." He engraved several frontispieces for the publications of Cazin, who employed Delvaux and made a speciality of prohibited literature, for which he was twice "destitué de la qualité de libraire."

[3] The illustrations after de Troy, Le Moine and Wleughels are reproduced by C. N. Cochin, Louis Surugue, Tardieu, Jeaurat, Charles and Nicolas Dupuis. The vignettes which head each canto, with two exceptions, are designed by Micheux and engraved by Desplaces, de Poilly and Lépicié; the exceptions, one of which is the "Queen Elizabeth" intended for the English subscribers, were given to Henry Fletcher.

[4] The engravers of this volume, to the illustration of which Coypel, Boucher, Tremolières, Le Bas and Cochin fils contributed, are, if we except Bernard Picart (1673-1733) as of French origin, all Dutch. Picart, born in Paris, lived in Holland, where he settled as engraver and printseller at Amsterdam. He is best known in England by his fine edition of Boileau (1718), which is accompanied by a remarkable portrait of Queen Caroline after Kneller.

The
Pupils of
Le Bas
and the
Engravers
of the
Vignette.

a little firm work on the figures of the foreground, and this telling of the story once secured, they put in just as much on the etched background as was necessary to help the general effect. Le Mire, then at the height of his powers, a fine draughtsman and endowed with a most delicate sense of values, gets a harmonious result with these slight means, but others less skilful—such, for example, as Lempereur and his wife, Elisabeth Cousinet—fail to give us more than the suggestion of the situation: they tell the story as might the illustrator of a comic paper, taking no account of any other elements in the scene.

Before Noël Le Mire[1] joined, with his young brother, the group working on the " Fables de la Fontaine," he had made his mark by engraving the vignettes with which Eisen had illustrated in 1751 the " Eloge de la Folie." In that year Le Bas wrote to Rehn, "notre normant Le Mire gagne par jour ses dix-huit livres. Il a pour une petite figure debout qu'il fait en six jour cent livre. Le temps a bien changé depuis que vous étiez à Paris." [2]

The " Fables " were actually in course of publication when Noël Le Mire was called to take an overwhelming share [3] in the engraving of the illustrations of the famous Boccaccio,[4] with which the name of Gravelot is especially associated, although Boucher, Cochin and Eisen also count amongst those who designed the subjects which ignorance of Italian has distributed with a puzzling want of reference to the text. If Gravelot's name must stand almost alone as the author of these illustrations, so should that of Le Mire as their engraver, not only because of the quantity due to him, but because of the peculiar excellence of his interpretation of the drawings. Flipart touching these miniature scenes becomes too heavy, Lempereur is confused, Pasquier[5] commonplace, but Le Mire—always alert, always delicate, always intent on getting the full pictorial value of his subject—prepares us for the final development of his brilliant and personal talent. The wit and certainty with which he handles

[1] 1724-1801. He only exhibited once at the Salon—1799, " L'Annonciation, d'après Solimen," and " Le gouverneur du sérail, choissisant des femmes."

[2] *Apud* Portalis and Béraldi, t. ii., p. 620.

[3] See Jules Hédou, " Noel Le Mire et son Œuvre."

[4] " Il decamerone di Giovanni Boccacio." Londra (Paris), 1757. Five vols. in 8vo.

[5] 1718-1785. He engraved " Les Graces " after Van Loo and various other prints, but was concerned chiefly with the vignette. MM. Portalis and Béraldi state that the eight illustrations of the " Manon Lescaut " of 1753 are " gravées par Le Bas " after Gravelot and Pasquier. Only two are contributed by Gravelot, those two only are engraved by Le Bas ; the six others bear " J.-J. Pasquier Inv. et sc."

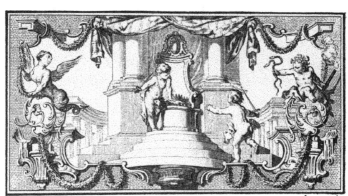

De Sere inv. Baquey Sculp

...pter, and the distinction with which he endows their baby faces, show the same remarkable gift for fine of the ... de which Le Mire displayed when, in 1762, he produced his most important work and engraved the ten designs of Eisen for the "Temple de Gnide."[*]

The influence of the brilliant vignettes by which the "Decameron" was enlivened is immediately apparent in the pages of the de Sève Racine,[*] which appeared in 1760. Each play has its heading and its tailpiece, in which children mimic the passions of tragedy. Two of these compositions are here reproduced, and it will be seen that they have a less enticing air of originality than that which distinguished the groups designed by Gravelot for the text of Boccaccio, but they are engraved by Charles Baquoy[*] with the same spirit and delicate emphasis as he shows when working by the side of Le Mire.

Whether Baquoy had any ... atelier seems doubtful, but ... he has something of ... signing "Les C......... edition of the "Contes plate on which we ... "Eisen inv." To this m.. sense may be said to have espe.. pretation of Eisen—contributed whole. Amongst the earliest in d............................... Minutolo" and "M.........," on both 1762. The more celebrated, the "B...................

(Jean-Charles Baquoy, after J. de Sève.)
Cul de Lampe, "3." Acte, d'Alexandre," Racine, 1760.
En tête de la "Thébaïde."

En tête de la "Thébaide."
Cul de Lampe, "3me Acte d'Alexandre": Racine, i
(Jean-Charles Baquoy, after J. de Sève.)

the fairy-like groups of Loves and children by which Gravelot
has commented the text of the "Decameron" at the close of every
chapter, and the distinction with which he endows their baby
forms, show the same remarkable gift for fine treatment of the
nude which Le Mire displayed when, in 1762, he produced his
most important work and engraved the ten designs of Eisen for
the "Temple de Gnide." [1]

The influence of the brilliant vignettes by which the "De-
cameron" was enlivened is immediately apparent in the pages of
the de Sève Racine,[2] which appeared in 1760. Each play has
its heading and its tailpiece, in which children mimic the passions
of tragedy. Two of these compositions are here reproduced, and
it will be seen that they have a less enticing air of originality than
that which distinguished the groups designed by Gravelot for the
text of Boccaccio, but they are engraved by Charles Baquoy[3] with
the same spirit and delicate emphasis as he shows when working
by the side of Le Mire.

Whether Baquoy had any special training outside his father's
atelier seems doubtful, but he worked often with Le Mire and
he has something of his manner and execution. We find him
signing "Les Cordeliers de Catalogne" in the Fermiers Généraux
edition of the "Contes de la Fontaine"[4]—it is, I think, the only
plate on which we read, together with the engraver's name,
"Eisen inv." To this magnificent work Le Mire—who in a
sense may be said to have especially attached himself to the inter-
pretation of Eisen—contributed an enormous proportion of the
whole. Amongst the earliest in date of execution are the "Richard
Minutolo" and "Mazet," on both of which we read the figures
1759. The most celebrated, the "Rossignol," is dated, as is "Les
Quiproquo," 1761—the year in which Le Mire was engraving
Gravelot's designs for the "Nouvelle Héloïse."[5]

On the preparation of all his work for the "Contes de la

[1] MM. Portalis and Béraldi describe amongst the riches of the collection made by
M. de Lignerolles a copy of which they say that it contains "en face des lumineuses
eaux-fortes de Le Mire qui les traduisent, les suaves mines de plomb d'Eisen." See
t. ii., p. 622.
[2] "Œuvres de Racine," Paris, 1760. 3 vols. Nothing is at present known about
de Sève except his work, but he is supposed to have belonged to a family of the same
name connected with the Gobelins.
[3] 1721-1777. He engraved chiefly after Eisen, but also after Gravelot, in the
"Contes Moraux" and "Œuvres de Corneille."
[4] "Contes et nouvelles en vers par M. de La Fontaine." Amsterdam, 1762.
2 vols.
[5] "Lettres de deux amans habitans d'une petite ville au pied des Alpes." Amster-
dam, 1762.

The
Pupils of
Le Bas
and the
Engravers
of the
Vignette.

Fontaine" Le Mire employed Le Veau,[1] also a pupil of Le Bas, who had a great power of seizing signs of character and expression which are evidenced in his "Alix malade" and "La Confidente sans le savoir," on which we find his signature; but the man whose contribution to the two volumes stands next in importance to that of Le Mire is Joseph de Longueil.[2]

If he does not reach the delicate brilliancy of Le Mire—and even that is hard to say in the face of a good proof of "Le roi Candaule" or "Le Mari Confesseur"—he may be compared to his advantage with Delafosse, the engraver of "Le Faucon" and "La Coupe enchantée," and he loses little if we set his work beside the more vigorous graver of Flipart in the "Juge de Mesle" or "Les Troqueurs."

This famous book has owed much of its renown to qualities other than those which make its real beauty and value. The suggestions which are pointed out as furnishing matter for scandal are not there for their own sake, but as an aid to free story-telling in which morality and immorality are illustrated with equal jesting indifference. What we have to look at in these volumes is the perfection of the art with which they are carried out: the exquisite beauty of the page, the harmony between the letterpress and the illustration calculated so that text and picture balance each other with nice exactness and, moreover, the admirable harmony of the illustration in itself. M. Bouchot has well put it: "Sincèrement, et en dépit de cette note un peu aphrodisiaque et banale, les Contes édités par les fermiers généraux méritent leur célébrité. C'est un tout merveilleux où l'on ne sait quoi admirer le plus, ou des figures hors texte, ou des fleurons, ou même de la typographie supérieure."

In the de Sève Racine the ornamental designs are more delicate than the rather commonplace subjects of the engravings; in the Molière illustrated by Moreau, heavy woodcuts—such as might have adorned the leaves of a volume in the previous century [3]—face the most delicate work of the "vignettiste."

[1] 1729-1785. Born at Rouen in circumstances of terrible poverty and suffering, he owed his start in life to Descamps. Amongst the prints engraved by him are ten "marines" after Vernet and "Le Juge ou la cruche cassée" after Debucourt.

[2] 1730-1792. He seems to have done his best work on the "Contes." On July 18th, 1792, Wille notes: "Ce jour, M. de Longueil, graveur, principalement pour la vignette, fut enterré. Il avoit été mon élève il y a quarante-deux ans ou environ. Sa disposition pour la gravure étoit égale à celle qu'il avoit pour la débauche." The romance which gathered about his sudden death, which was attributed to fright at a hostile denunciation, has been dispelled by the publication of authentic documents in Panhard's "Joseph de Longueil : sa vie et son œuvre."

[3] The little blocks in the Molière are of this character, though signed and

However good such blocks may be in themselves, however fine in style, the attempt to incorporate them in work of a totally different character is to be condemned. They remain out of relation—as in the " Baisers " of Dorat and the " Graces " of du Querlon—with the rest of the work and the eye which has been resting on the delicate lines of Le Mire or Delaunay is hurt by the transition to ruder virtues.

The necessity—for the production of the perfect book—of a close alliance between the ornament and the illustration had been a cardinal point with all the great publishers of the sixteenth century; we recognize its force in those editions of the seventeenth in which the red and black title-page is composed with a lost art; then a moment comes in which taste seems less sure. Finally the perfect type of the eighteenth-century "livre de luxe " is produced in the two small volumes of the " Contes," in which not the least of the honours claimed are due to the ornament by Choffard.[1]

" Monseigneur le prince de Nassau-Saarbrück," writes Wille on March 2nd, 1761, " has asked me to engrave his arms. I laughed and excused myself by giving him M. Choffard." [2] The prince no doubt gained by the substitution. We are, though, scarcely prepared for Choffard's truly marvellous execution in the " Contes " by his exercises on the " Fables de la Fontaine " or by the frontispiece engraved by him for the Gravelot "Decameron." The brilliant " culs de lampe " of the " Contes " are most justly famous, and above all the others must stand that marvel of beauty and delicacy which serves, at the close of the " Rossignol," as the frame of his own portrait. The bird in his cage, the flowers of the wreaths and ornament on either side are indicated with a spirit and precision which take nothing from the exquisite lightness of the work; every detail contributes to the luminous effect of the head in the centre, which is treated as a gem might be set by the hands of a skilful goldsmith.

dated " Papillon, 1770." The best work of Jean-Michel Papillon (1698-1776) is in the tailpieces of the " Fables de la Fontaine." There is a large collection, in four volumes, of his work and that of his family in the Cabinet des Estampes.

[1] 1730-1809. He appears only at the Salons of 1785 and 1793. At the first his portrait of Barathier, Marquis de Saint-Auban, Lieutenant-Général des Armées du roi, etc., was engraved by Miger; at the second his name figures with that of Le Bas in connection with the engravings of the two views of Rouen prepared by Cochin to replace those not completed by Vernet for the " Ports de France." He was the pupil in the first instance of Babel.

[2] A specimen of this class of work by Choffard is in the Print Room of the British Museum (1861, 8, 10, 72, 73), armorial bearings and supporters executed in pen and wash. There is also a good sketch by Choffard in red and white chalk of a man on his knees to a girl, seated, in a gallant undress (1865, 10, 14, 370).

The
Pupils of
Le Bas
and the
Engravers
of the
Vignette.

The originality of Choffard's wonderful work is rendered the more apparent if we turn the pages and examine the portraits of La Fontaine and Eisen by Etienne Ficquet,[1] after Rigaud and Vispré, in the same volumes. These are engraved with as much care, as much minute detail as if they were on a great scale. Nothing is suggested, everything is set down with a precision and veracity which speak of the sure hand which enabled him to work directly on the copper from his subject without preparation, and remind us that before he went to Le Bas, Ficquet had been trained under Wille's friend, Schmidt.

Thanks probably to this originally severe training Ficquet, in spite of his irregularity in work and fantastic humour, surpassed all those—not excepting Grateloup[2]—who devoted themselves to the task of engraving in miniature. His strong, definite, unswerving graver, tempered to a miraculous exactness of touch, expresses qualities exactly opposed to those which we see in Choffard's brilliant little portrait. If Ficquet gives the very letter of his text, Choffard breathes its very spirit.

· The original beauty of this work seems to have had some influence on the execution, in 1767, of the wonderful miniature of Marie Leczinska, engraved by Etienne Gaucher after Nattier, for the dedication to that Queen by President Hénault of his "Abrégé de l'Histoire de France." This portrait, framed by Choffard in a garland of lilies and roses, is unsurpassed by any of Gaucher's later achievements and is barely equalled by his charming "Madame Dubarry" (1770) or by the "Joseph II." and "Marie-Antoinette," which he engraved after Moreau for the "Annales du Règne de Marie-Thérèse." Gaucher is, however, most popularly known by a later work, for he is the engraver of the sensational "Couronnement du buste de Voltaire sur le Théatre Français," the drawing for which by Moreau le jeune is now in the collection of Lord Carnarvon.[3]

[1] 1719-1794. He at first worked for Odieuvre, under the direction of Schmidt, and whilst with Le Bas became a close friend of Eisen. If we may judge from a postscript written by Ficquet on a letter from Le Bas to Rehn (de Chennevières, "Port. inéd. des Artistes Français," 3rd pt.), they amused themselves with more energy than they worked. Many of his portraits (thirty-four) for Odieuvre are good, as are also some of those executed for the "Vies des peintres Flamands" by Descamps. See Faucheux, "Catalogue raisonné de toutes les estampes qui forment les œuvres gravés d'Etienne Ficquet, de J.-B. de Grateloup, etc."
[2] 1735-1817. His work consists of nine portraits, all engraved before his sight was injured by cataract at the age of thirty-five. Of these his "Bossuet," after Rigaud, is a remarkable work. See Faucheux, "Cat. rais., etc."
[3] Formerly in the possession of M. Henry Lacroix. Reproduced in "Les Moreau," p. 93.

MARIE-LECZINSKA: EN TÊTE DE LA DÉDICACE DU NOUVEL ABRÉGÉ CHRONOLOGIQUE
DE L'HISTOIRE DE FRANCE DU PRÉSIDENT HÉNAULT, 1767.
(CHARLES-ETIENNE GAUCHER, AFTER NATTIER AND CHOFFARD.)

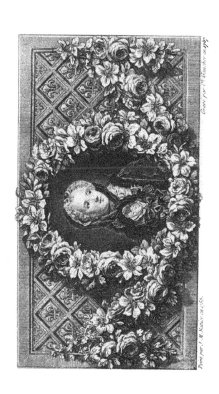

His close friendship with Flipart and his collaboration with Choffard lead us to expect the name of Gaucher amongst those who illustrated the most famous edition of the "Contes," but though he produced one or' two bits of ornamental work after Marillier [1] and Monnet which take very high rank, his preferences seem to have led him to devote himself to small portraits.

Names from the brilliant group by whom the "Contes de la Fontaine" were illustrated are to be found, in 1765, signing the reproductions of Gravelot's delightful illustrations to the "Contes Moraux" of Marmontel. Le Mire and his assistant Le Veau reverse their positions, for Le Veau—preparing with exquisite care his little plates—takes a principal share in the work. Nearly all those which give us pictures of the social movement of the day under its most engaging aspect are signed by him. If only the text were anything like as good as the art for which it serves as a pretext, these three volumes, further enriched by a graceful frontispiece engraved by C. Boily [2] and a pleasant portrait by Augustin de Saint-Aubin after Cochin, would be entitled to take an even higher place than they now claim on the shelves of the bibliophile.

This is the weak spot in many of the most lovely books of the day—their text is not in any sense literature. It is a relief to find publishers who have been ready to venture on a classic, even a classic as familiar as Ovid. It is, however, true that no other presents a store of fables equally rich in pictorial incident and inexhaustible because capable of the most various interpretation. The translation of the abbé Banier, though both chill and formal, was in itself a classic, having first appeared at Amsterdam in 1732 accompanied by the engravings of Bernard Picart. Other editions followed, and their success was such as to inspire Le Mire and Basan with the project realized in the four quarto volumes published at Paris in 1767-1771.

Choffard signs the title-page,[3] but this work is somewhat

[1] 1740-1808. He engraves not too well in the Banier Ovid but etched "La Famille du Fermier," after Fragonard, pleasantly. It was "terminé au burin" by Romanet, a pupil of Wille (Mém., t. i., p. 350). The five frontispieces to the "Héloïse" published in 1788 are designed by Marillier and accompany the reductions engraved by Vignet from Moreau's illustrations in the quarto edition. His most important work is to be found in the "Fables de Dorat."

[2] 1736- . . . ? He was a pupil of Lempereur.

[3] The full title is "Les Métamorphoses d'Ovide. Gravées sur les dessins des meilleurs Peintres Français par les soins des Sʳˢ Le Mire et Basan. A Paris chez Basan. rue du Foin S. Jacques. Le Mire rue S. Etienne des Grés." The dedication to the Duke de Chartres, engraved by Choffard, is signed by Basan and Le Mire and dated 1767.

The
Pupils of
Le Bas
and the
Engravers
of the
Vignette.
heavy in aspect and cannot be compared in rivalry with the
fairy-like decoration which he lavished on the pages of the
" Contes " of La Fontaine. Wreaths and garlands have lost the
fragility which is the secret of much of their charm. The illus-
tration, as a whole, is of unequal merit; it opens well with half-
a-dozen pretty subjects by Eisen, daintily rendered by Le Mire,
de Longueil and Le Veau, whose vignette of " Le Printemps " is
a masterpiece. Some pages such as " Apollo and the Python," by
Le Veau after Gravelot, " Europa," by Augustin de Saint-Aubin
after Boucher, " Thetis and Proteus," by Le Mire after Monnet,[1]
and " Dejanira," by Le Veau after Moreau, realize to perfection
the qualities most desirable in this class of work. They are
not only delicate engravings of graceful compositions, but they
lie well on the page, taking the eye pleasantly without over-
weighting the text. In this respect others are less happy:
the skill of Masquelier,[2] Née,[3] Ponce,[4] Baquoy and Delaunay
maintains a high average, but the two contributions made by
Basan himself after Monnet are not remarkable achievements,
whilst with Binet,[5] Louis Legrand[6] and Rousseau[7] we reach a
lower level of excellence, superior, nevertheless, to the dull per-
formance of Miger[8] in the " Philemon and Baucis " after St. Gois.
Admirable as is all their work in these volumes, Le Mire, De-
launay and Le Veau never seem to reach their highest level in
the execution of allegorical and classical designs, although Le
Mire, in virtue of his splendid drawing of the nude, is often
triumphantly excellent. Ponce and Simonet,[9] on the other hand,
seem, in this direction, to do their very best. The " Leucothea
and Apollo " by Simonet, after Monnet, is, in good proofs, as

[1] 1732-1816. A., July 22nd, 1765.
[2] 1741-1811. His most important work is in the " Galerie de Florence," 1789.
[3] 1735-1818. Worked for the " Galerie de Florence," but, like Masquelier, was
above all a " vignettiste."
[4] 1746-1831. Exhibited 1791, 1793, 1796 and 1799. Pupil of Delaunay. His
work on the Ovid is unequal, on the " Fables de Dorat " invariably good. Of his
larger prints the place of honour must be given to the " Enlèvement nocturne " after
Baudouin, but " La Toilette " with a frame by Cochin, is also a pretty thing. His
learned tastes sometimes led him to engrave duller subjects.
[5] 1744-1800(?). [6] 1730- . . . ? [7] 1740- . . . ?
[8] See Chap. III., p. 47.
[9] 1742-18 . . ? His brilliant work on the Ovid is equalled by his execution of
" Le Triomphe des Graces " after Boucher, and " Les Graces Vengées " (see illustration)
after Moreau in illustration of du Querlon's " Les Graces " (Laurent Prault, libraire,
quai des Augustins, à la source des Sciences: et Bailly, même quai, à l'Occasion, 1769).
His engravings after Baudouin of " Le Modèle honnête," " Le Couché de la Mariée,"
" Le Danger du Tête-à-Tête " and " La Soirée des Thuileries " are famous, but
Moreau is said to have been chiefly responsible for the " Couché de la Mariée."

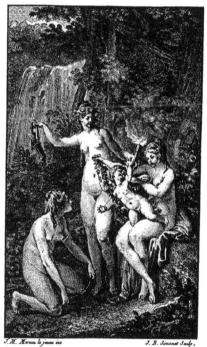

J. M. Moreau le jeune inv J. B. Simonet Sculp.

bright and happy in expression as any of the subjects rendered by Le Mire after Eisen, the draughtsman whom he seems to have specially reserved to himself. In comparing the work of this brilliant and original engraver with that of those whom he selected as his associates, the most noticeable thing is the immense advance made by his pupil, Le Veau. This fact was evidently appreciated by Le Mire when he confided to Le Veau one of the series by Eisen with which the work opens. In dealing with these Le Veau first makes proof of that peculiarly incisive point which distinguishes his reproductions after Gravelot and Moreau and continues to differentiate his work to some extent from that of his master. From this time forward he stands in the front rank of the most accomplished of all the "graveurs de livres."

The admirable execution by Le Veau of many of the little scenes in the "Contes Moraux" is unsurpassed even by his famous contributions to the Molière, illustrated from the drawings of Moreau le jeune in 1773.[1] In the "Fourberies de Scapin" and the "Georges Dandin," Le Veau has interpreted Moreau's conception of the situations with a lightness and delicacy which take nothing from the play and vivacity of the expression. Not even the masterly engraving of the "Festin de Pierre," by which Le Bas himself takes his place at the head of the group engaged on these volumes, can claim conspicuous precedence. The company includes de Ghendt[2]—the pupil of Le Bas' pupil, Aliamet[3]—who shows much of the brilliance of Le Mire in his treatment of "Les Fâcheux"; Helman,[4] who in "Le Malade imaginaire" gives us an excellent example of the discreet use of the "pointillé"; Masquelier, who takes "L'Ecole des Maris," whilst Née, with whom his name is constantly associated, engraves no less than six subjects, and, of those less directly connected with Le Bas, Baquoy, Simonet, Duclos[5] and Delaunay.

Of the six engraved by Née, two—"Le Mariage forcé" and

<hr />

[1] "Œuvres de Molière. A Paris. Par la Compagnie des Libraires Associés. 1773."

[2] 174.?-1815. A set of figures after Eisen for the "Pygmalion" of Rousseau bear the signature of de Ghendt with "Aliamet direxit." Except for the "Quatre Parties du Jour" which he engraved after Baudouin, he confined himself entirely to book-illustration: his name appears on the plates in du Rosoi's "Les Sens" ("Les Sens. Poëme en six chants. A Londres. 1766."), Baculard d'Arnaud's "Epreuves du Sentiment" (see p. 127) and on a title-page of the second volume of Poinçot's edition of the "Nouvelle Héloïse" (1788), etc., etc.

[3] 1726-1788. [4] 1743-1806.

[5] 1742-....? He was an excellent engraver of vignettes and best in reproducing work by Augustin de Saint-Aubin. He exhibited at the Salon of 1795 "Deux têtes d'études" and "Deux gravures."

The
Pupils of
Le Bas
and the
Engravers
of the
Vignette.

"L'Avare"—are specially noticeable for a silvery delicacy of
effect, but the style of the delicate work is injured in the second
example by the coarse effect of the woodcut heading on the
opposite page. Baquoy treats "L'Amour Médecin" with bril-
liance and "M. de Pourceaugnac" with power; Simonet, unlike
most of his fellows, is at his best when handling allegorical fan-
tasies such as "Psichè." He plays with them, showing a freedom
and elegance which he does not exhibit in "Le Tartuffe" or
"L'Etourdi." Duclos is mannered and over emphasizes the features
of his actors.

I have left to the last the "Comtesse d'Escarbagnas" and "Le
Cocu imaginaire," both of which were engraved by Delaunay.
"Le Cocu imaginaire" especially, which he has signed and dated
1772, is in many respects supremely excellent. In point of ex-
pression, grace, piquancy and admirable unity of general effect it
appears to me to be simply perfection. One is indeed loth to
criticise any point in the aspect of an edition which is illustrated
by so much beautiful work, amongst which must also be reckoned
the famous engraving by Cathelin[1] of the head of Molière. This
brilliant portrait exemplifies to admiration that wonderful skill in
giving dainty details of lace and watered patterns of silk[2] which
Cathelin brought to perfection under the eye of Le Bas and
which contrasts in his work with the decision and firmness shown
in handling flesh—the quality which, in his rendering of Cochin's
"Louis XV.," after Van Loo, justified the choice made of him
to complete the work which Tardieu had left unfinished.[3]

In the same year that saw the publication of this edition of
Molière appeared the "Fables de Dorat." The text has but the
slightest claim to be classed even in the lower degrees of literature,
but the illustration—engraved chiefly by de Ghendt, who wins his
greatest triumphs in translating Marillier—is of the most brilliant
quality. All de Ghendt's little pieces in this volume are miracles
of microscopic delicacy. With de Ghendt were joined Masque-
lier and his associate Née, who were not far behind him in
delicate art. Delaunay left the task on which he was engaged
for the works of Rousseau to engrave the full-page subject of
"Time and Truth," which figures in the first volume of the
"Fables"; Arrivet, Le Beau,[4] Baquoy, Lingée,[5] Le Veau, Gode-

[1] 1736-1804. R. April 26th, 1777.
[2] This is even more remarkable in his "Abbé Terray," after Roslin.
[3] See the letter written by Cochin, cited by Portalis and Béraldi (t. i., p. 326) as
given by Dumesnil, "Hist. des plus célèbres amateurs français."
[4] 1744-18 . . ? See Basan, "Dict. des Graveurs." [5] 1751(3?)- . . ?
108

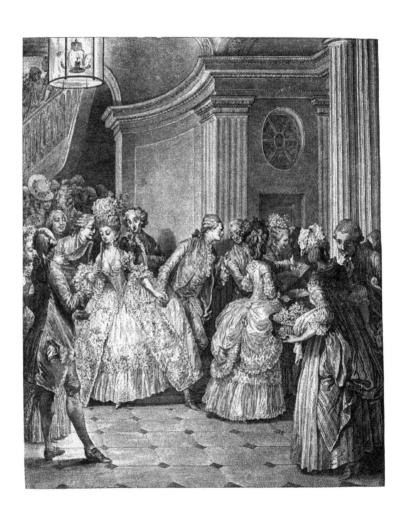

Le Mariage, ou la Sortie de l'Opéra :
" L'Histoire des Modes et du Costume," 1776.
(Georges Malbeste, after Morfau le jeune.)

froy[1] and Le Grand each contributed subjects, Le Gouaz[2]— for whom the plumage and movement of birds had a special charm—was entrusted with several, in one of which, " L'aiglonne et les paons," he shows us how much less of an artist he is than Née, who treats the same royal bird in the tailpiece to the " Silphe et le pigmée."

To the co-operation of Masquelier and Née we owe not only in large measure the beauty of the " Fables de Dorat " and the creation of many other illustrated books of a different type, but the continuation of the famous " Chansons de la Borde."[3] The last three volumes are as inferior to the first as the designs of Moreau le jeune are superior to those by Le Bouteux, Saint-Quentin and Le Barbier, who were employed as cheaper substitutes to carry out the work which he had begun, but the perfect art of the engraver has succeeded in enabling the continuation to pass muster.

Whilst Née and Masquelier were completing the abandoned work, a great group of artists were employed by Prault in reproducing the famous designs made by his brilliant son-in-law, Moreau, for the " History of Costume."[4] This costly and splendid publication is not only the most vitally real, but, in certain aspects, also the most dignified representation of the days of Louis XVI. If Trière[5] shows himself somewhat inferior to his task, we can find no more magnificent example of the work of others engaged than the " Déclaration de la grossesse " by Martini,[6] the " C'est un fils, Monsieur," by Baquoy, and the " Mariage " or " Sortie de l'Opéra " by Malbeste.[7] The last named in a fine state is, I think, the gem of the series.

The brilliant art of these men rises to a splendid excellence in these remarkable pages which make us turn impatiently from the

[1] 1743(8?)-1819. He was a pupil of Descamps and Le Bas, and was the engraver of Moreau's drawing, " Trait d'humanité de Mme la Dauphine."
[2] 1742(?)-1816.
[3] " Choix de chansons mises en Musique par M. De La Borde. Ornées d'Estampes par J. M. Moreau. Dédiées à Madame la Dauphine." Paris, de Lormel, 1773.
[4] " Seconde et troisième Suites d'Estampes pour servir à l'Histoire des Modes et du Costume en France dans le XVIII. siècle. Année 1776. A Paris, de l'Imprimerie de Prault, imprimeur du Roy, 1777-1783." See Bocher, p. 487.
[5] 1756-18 . . ? For his work in this publication see p. 142, notes 1 and 2. He also engraved " Le Lever de la Mariée," after Dugourc, and many vignettes for illustrated works ; amongst others for the Kehl Voltaire, the " Gerusalemme liberata " of Cochin, " Les Liaisons dangereuses," the Crébillon (after Marillier) of 1785.
[6] 1739-1800. He worked much for Le Bas in the preparation of his plates. His four engravings in the above series constitute his most important claim to notice.
[7] 1754-.. ? The above is his most important work. See also p. 140, note 2.

slighter and more exquisite graces of volumes more popularly
representative of the press of the day. The light needle which
François-Antoine Aveline[1] brings to sketch in Eisen's headings
to the " Satires " of Boileau; the even more fairy-like grace with
which Prévost[2] handles the slender fancies spun by Cochin's early
genius about the fable of that " Pastor Fido " dear to the heart of
Wilhelm Meister; the delicate work spent on the foolish "Origine
des Graces";[3] all these, triumphs of art in their way, we may
weary of, but the " Monument de Costume " remains a work to
which one turns with never-ceasing delight.

[1] 1718-1762 (?).

[2] See p. 49, note 5. Benoit-Louis Prévost (c. 1735-18..) was a pupil of Le Bas'
pupil, Ouvrier. We find his name on many vignettes, amongst others, on those
designed by Cochin for the Terence of 1770, which he engraved together with
Choffard and Saint-Aubin.

[3] See Chap. III., p. 49, note 3.

En tête and Cul de Lampe of "L'Abeille justifiée":
Fables de Dorat, 1773.
Emmanuel de Ghendt, after Pierre-Clément Marillier.)

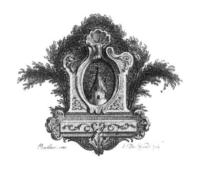

CHAPTER VIII

GRAVELOT AND EISEN

SO far we have been dwelling on the influences which went to the shaping of the art of the century and on the achievements of men who for the most part reproduced the works of others: the portraits of Drevet, of Daullé, of Wille; the great collections published by men such as Basan; the engravings of Laurent Cars after Le Moine, those by Beauvarlet after Van Loo; and the great enterprises of Le Bas. With Hubert-François Bourguignon dit Gravelot[1] we leave the engravers proper and come to the designers for illustrated books.

The execution of cuts that should enliven the text of books of dimensions such as could be easily held in the hand was quite a different matter from the illustration of great folio volumes, which meant the execution of engravings that would show as well or better on the walls of a cabinet. There was also another and noteworthy point marking difference and change which is directly connected with the genius of Gravelot. It is the treatment of matter furnished by the life of the day in the pages accompanying the text of the novel or romance. The modern novel is, in fact, the creation of the eighteenth century and Gravelot was, perhaps, the first to show what might be done in the way of illustrating the subjects treated in its pages.

Cochin, it is true, gave designs for hundreds of small books and showed—in his famous drawings of the great Versailles Fêtes—

[1] 1699-1773. He belonged to no Academy. His "éloge" is to be found in the *nécrologe* for 1773. It was, says Mariette, carefully compiled from notes furnished by his brother d'Anville, the famous geographer. Walpole, in his "Anecdotes of Painting," has a short article on "Henry Gravelot." This error is replaced by another in the footnote, where he figures as "François-Hubert D'Anville."

an immense power of making records of the passing day, but his tendencies towards a veracious accuracy in that direction were strangled by the foolish passion for allegory which attacked him in the most exaggerated form after his Italian tour.

If compared with the work of other designers of illustrations that of Hubert Gravelot takes the most honourable place. " Not much known as an engraver," writes Walpole, "but was an excellent draughtsman." Not even Moreau le jeune can surpass the tact and skill, the firm and admirable draughtsmanship of Gravelot. "Dès ses plus tendres années, il montra," it is said, "un goût décidé pour le dessein,"[1] but his early training owed little to that steady direction by which his contemporaries were drilled in their craft and was further disturbed by a long absence from France. The promise of excellence shown by him when the pupil of Restout[2] encouraged his father—who, a tailor by trade, nourished high ambitions for his sons—to send him to Rome, but the project did not succeed, and finally Gravelot was despatched to St. Domingo with the Chevalier du Roche-Alard[3] and "y fit sous Frézier les fonctions d'ingénieur," which reminds us of Dugourc's employment when he went with M. de Gribeauval to Nancy.[4]

Before long Gravelot returned to France, but although he received encouragement from Boucher, he left Paris[5] for London, having had an invitation from Dubosc,[6] who employed him on the English edition of Picart's " Cérémonies religieuses de tous les peuples" (1732-1737). Whilst in England he spent, says Walpole, "some time . . . in Gloucestershire, drawing churches and antiquities." Gravelot was, he adds, "a faithful copyist of ancient buildings, tombs and prospects, for which he was constantly employed by the artists in London. He also drew the monuments of kings for Vertue, and gave the designs, where invention was necessary, for Pine's plates of the tapestry in the House of Lords,"[7]

[1] Mariette, A. B. C. Dario.
[2] See "Supplément au dictionnaire des graveurs," F. Basan.
[3] Walpole says : " He had been in *Canada* [?] as Secretary to the Governor, but the climate disagreeing with him, he returned to France."
[4] " French Furniture and Decoration in the XVIIIth Century," p. 74.
[5] It is supposed that his "Cahiers d'Images pour les enfants," "Scènes Enfantines," "Fables de la Fontaine," " Les Sciences," etc., etc., should be placed during this stay in Paris.
[6] Claude Dubosc, who was employed by Sir Nicolas Dorigny to engrave the cartoons at Hampton Court, began upon his own account a set of the Duke of Marlborough's battles—suggested probably by that which appeared in Holland in 1728. He took a shop and sold prints, sending for Gravelot and Scotin to work for him ("Walpole's Anecdotes," ed. 1862, t. iii., pp. 965, 968).
[7] This volume, entitled " Tapestry hangings of the House of Lords," consists of

VIOLA AND OLIVIA: "TWELFTH NIGHT,"
SHAKESPEARE (OXFORD, 1744).
(HUBERT-FRANÇOIS GRAVELOT, AFTER HAYMAN)

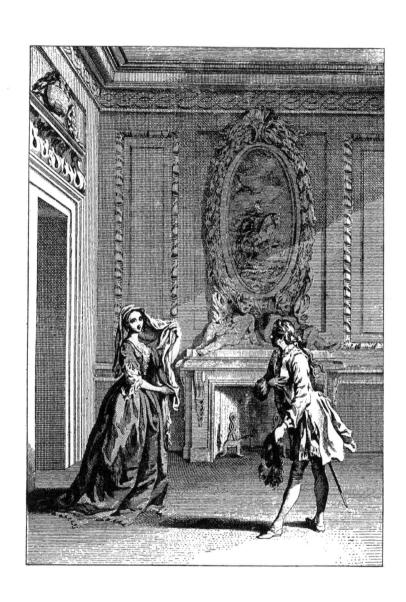

but all this work, by which he got his bread, gave him no opportunity of distinction and is to us small source of pleasure.

In England Gravelot remained about thirteen years, engraving and painting and making an immense quantity of drawings for other engravers. His work at that date shows the greatest variety of style: absurd designs in the *genre rocaille* for goldsmiths,[1] trade-cards for shops,[2] sketches for the headings of ballad sheets;[3] but, above all, series of illustrations for books. The twelve at first executed for "L'Astrée" in 1733 do not show much originality, but the frontispiece to the Kit-Cat Club (1735) is not without character and the headings to the "Songs in the Opera of Flora" are excellent. So are most of those to the edition of Gay's Fables published by Knapton in 1738. In connection with these last Gravelot probably made some of the drawings in pen and sepia, such as the "Dog and Fox," "The Man with the Dog and Cat" and the "Girl feeding a Turkey," which, together with others of a different character, are to be found in the Print Room of the British Museum.[4]

In 1743 Gravelot made a few designs for Godwin's "De Præsulibus Angliæ," and at about the same date we begin to see in the pages of Rapin de Thoyras' "History of England"[5] the formation of a personal way of looking at life. The Blue-coat boys, in one of these volumes, who cap the portrait of Edward VI. are seen with an absolute detachment from any preconceived ideal of what a boy should look like, that makes them very amusing. The same freedom marks Gravelot's sketch of the members of the House of Commons "in 1744½," probably executed when he

a series of sixteen large double folio plates tinted blue. They represent engagements between the British and Spanish fleets at the time of the Armada, and are surrounded by borders, with medallion portraits of the various commanders. (London, 1739.)

[1] One of these described by MM. Portalis and Béraldi shows designs for the case of an *étui*, for the case of a watch, figures, etc., on the same sheet.

[2] In the seventh volume of the collection of Gravelot's work in the Cabinet des Estampes there is a vignette of a man buying and sniffing at the tobacco balanced in the scales before him by a young apprentice. It is accompanied by the announcement: "French manufacture of Rappee snuff by John Lhuillier. Removed from the corner of Little Newport St. to Great Newport St., Leicester Fields . . . also makes and sells Wholesale and Retail all sorts of Scotch Snuff, Smoaking Tobacco, Shag, Pigtail of all sizes."

[3] The popular "Adieu to Susan" and many others of a similar class were thus embellished by Gravelot. They were "printed for John Bowles, at the Black Horse in Cornhill. According to Act of Parliament, 1744."

[4] The set in sepia are eight in number, but others representing subjects such as the "Interior of a Theatre," "A Gravedigger," etc., etc., can have no connection with the "Fables."

[5] London, 1743-1747.

was going to the Houses of Parliament on his work in connection with Pine's publication of the "Tapestries of the House of Lords." In the pretty cuts to the 1742 edition of "Pamela" we get some of the first of Gravelot's book-illustrations, and although it is commonly supposed that those for Sir Thomas Hanmer's edition of Shakespeare[1] were all drawn by Hayman, we find from Walpole that many were designed by Gravelot and all were "of his graving."

It is, however, in the pages of "Tom Jones" that one finds some of the most significant work executed by Gravelot during his stay in London, at the sign of the Gold Cup, King Street, Covent Garden. Of these illustrations of Fielding's great story, we may repeat Mariette's words: "Il y montroit du genie, et entroit assez bien dans le caractère des sujets qu'il avoit à traiter. Aussi étoit-il recherché, et il y trouvoit plus de profit que le meilleur peintre n'auroit fait en produisant de grands ouvrages."

It seems difficult to say exactly when Gravelot left England. He cannot have arrived earlier than 1732, when the first numbers of the "Religious Ceremonies" began to appear weekly. If he went back to Paris thirteen years later, in 1745, he must have returned to London shortly after, unless indeed he continued to furnish from Paris the illustrations of various editions brought out in London.[2] Mariette, in the first article which he wrote on him, says that Gravelot made two visits there and that he spent in all fifteen years in England; this article he, however, afterwards declared to be "fautif," adding: "Il m'avoit été administré par des gens mal informés; il faut s'en tenir à ce qui est marqué ici," that is to say, the statements made in the second article are alone authentic.[3]

Whether he stayed for fifteen or for thirteen years, the country and the people made a profound impression on Gravelot. Again and again we find in his works pages in which the English air and aspect are depicted with that vividness of impression that is granted only to a stranger's eye. "A Conversation with a Romish Priest" could take place nowhere but in England and in the England of that day. Our women would scarcely need to look so furtive at the present moment. The young lady, too, in "Le Lecteur," of

[1] Oxford, 1744.
[2] Palissot de Montenoy, "Théatre, etc.," London, 1763; "Mémoires de Sully," London, 1767.
[3] These details are perhaps necessary, as M. Portalis, in the very full and interesting article on Gravelot in the first volume of his "Dessinateurs d'Illustrations au XVIII^me Siècle," keeps to the date repudiated by Mariette: "Gravelot séjourna quinze ans en Angleterre" (p. 273).

PROMENADE À DEUX.
(DRAWING BY GRAVELOT.)

)

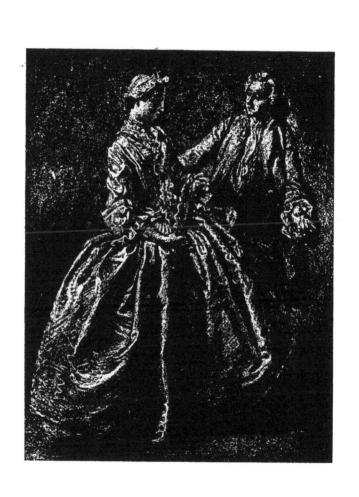

which we are told "Gravelot pinxit—Gaillard sculpsit," does not require the verses inscribed on the engraving to tell us to what nation she belongs.

> "Oui, cette jeune Anglaise a droit de te charmer.
> Et tu lui lis d'amour sans doute l'art d'aimer, . . ."

To look at Gravelot's painting of " Le Lecteur"—which came into Mr. Heseltine's collection from that of Mr. Wornum—must convince us that when M. Portalis writes, "Gravelot a fait aussi de la peinture, mais assez mauvaise, quoi qu'en dise Boucher," he can hardly have seen any authentic work. Gravelot paints, as he drew, with ingenuous simplicity, without pretension or emphasis, and with a most remarkable feeling for the right surroundings of his subjects.

It is not alone in work directly representing the men and women of London that we can trace signs of the way in which Gravelot's sight became impregnated with the essence of English life. We recognize them markedly in his designs for plays and romances: in the figures of the " Galerie du Palais "—engraved by Le Mire in the illustrations to Corneille[1] and named in the English version " The Unlucky Glance " ; in those for Lasalle's " Histoire de Sophie de Francourt," published in 1763 ; in the four which accompany " L'Histoire de Miss Jenny," by Mme. Riccoboni,[2] which appeared the following year ; and in the "Fabricant de Londres," by Fenouillot de Falbaire,[3] published only two years before Gravelot's death.

On the other hand, it is impossible to find anything more sincerely French than a design such as that for the " Ecole du Jardinier-Fleuriste," by Freart de Castel, executed in 1764, or the brilliant series illustrating the " Contes Moraux " of Marmontel,

[1] This edition was that the sale of which was intended to furnish the dower of Mademoiselle Corneille. Bachaumont writes (July 5th, 1762): "On répand dans le public un *prospectus* de la nouvelle édition de Corneille, entreprise par M. de Voltaire. Cet ouvrage sera de dix a douze volumes. Il sera orné de trente-trois estampes, dessinées par M. Gravelot."

[2] Mme. Riccoboni writes (May 15th, 1765): "Monsieur Becket, . . . s'est ruiné avec Miss Jenny . . . Monsieur Hume . . . s'avisa de donner cette malheureuse Jenny à Monsieur Becket, qui en a fait un garde boutique, un fond de magasin pour ses arrière neveux " (" Correspondence of David Garrick," v. ii., p. 436).

[3] See Chap. III., p. 50, note 1. Fenouillot was a personal friend of Gravelot. In an undated letter to Garrick he says: " Je profite, Monsieur, avec le plus grand plaisir, de l'occasion que M. de Fenoüillot me procure de vous renouveller les senti-ments de la plus vive amitié . . . J'y joins mes respects à Madame Garrick dont le souvenir me sera toujours cher . . ." (" Corres.," v. ii., p. 533). Gravelot had illustrated "L'honnête Criminel," an earlier drama by Fenouillot, in 1767, the plates in which were engraved by Delaunay.

which were published in the following year.[1] It is true that
Gravelot loses grip and directness if he has to treat classic or
romantic themes : when he attempts to render sentimental rustic
idylls—"Laurette" or the "Bergère des Alpes"—his illus-
trations become as unreal as the stories they accompany. His
great strength is in dealing with scenes of contemporary life.
In "Le Mari Sylphe," "Annette et Lubin," "Le Connoisseur,"
"Tout ou rien," "L'heureux Divorce" and the admirable "Femme
comme il y en a peu" the art of Gravelot touches a high point.
Of the delicate and peculiar character of these designs, M.
Portalis, to whom students of the art of the eighteenth century
owe so much, has written an admirable criticism. "Qu'ils soient,"
he says, "sous la tonnelle des jardins ou sur les sophas des salons,
ses personnages, dans les costumes les plus gracieux, y sont toujours
élégamment groupés ; quant aux situations dans lesquelles il a à les
peindre, celles qu'il préfère de beaucoup sont les scènes d'amour
et les motifs de galanterie, et personne n'entend mieux que lui les
réticences du crayon, et l'art de ne laisser pas voir ce que le lecteur
devinera sans peine."[2]

It is in this class of work especially that we see Gravelot's powers
at their full strength. There is not a figure nor a group in the
"Exercices de l'Infanterie et des diverses positions du soldat" which
is not drawn with masterly vigour, but his drawing does not help
him except in handling that which he has actually in sight.[3] If
we take up the illustrations to Voltaire's works we find that those
of the Plays alone in which, as in "Narcisse," he had close
touch of the aspects of everyday life are very good. When he
attacks the classics,[4] there is shown a distinct inferiority of every
quality except that of composition. His admirable powers of
design never forsake him and furnish indeed the saving grace of
his weakest and latest work. They give excellence to the fine
"fleurons" of the Terence of 1753 and inspire the quality of his
best designs for the Boccaccio of 1757.[5] Even the miserable

[1] Three vols., Merlin, 1765. The twenty-four drawings for the "Contes
Moraux" were exhibited by M. Germain Bapst in 1888 ("Exposition de l'Art fr.
sous Louis XIV et sous Louis XV").

[2] Portalis, "Les Dessinateurs," t. i., p. 285.

[3] From the "Eloge" of Gravelot written by his brother d'Anville we learn that
he had had made in London three little lay figures carefully padded and jointed.
They were about fifteen inches high and were provided with a considerable ward-
robe, so that they could be dressed according to the characters they had to represent.

[4] Lucain, two vols., 1766 ; Tacite, 1768 ; Horace (Baskerville), 1770 ; Lucrèce,
1768, etc., etc.

[5] See Chap. VII., pp. 100, 101. The publisher requested Gravelot to add to
the illustration subjects containing "des figures libres." M. Portalis quotes (t. i.,

LE CONNOISSEUR.
(JEAN-FRANÇOIS ROUSSEAU, AFTER GRAVELOT.)

LE MISANTHROPE CORRIGÉ.
(NOËL LE MIRE, AFTER GRAVELOT.)

Illustrations of the "Contes Moraux," Marmontel, 1765.

ij

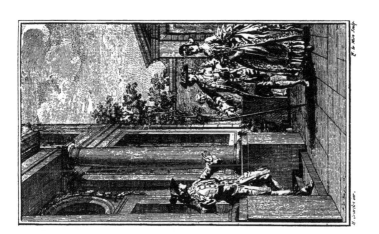

H. Gravelot inv.t.

J. F. Rousseau Sculp.

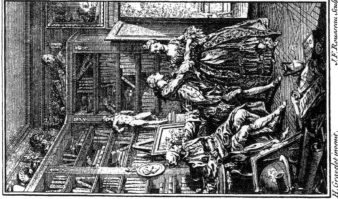

H. Gravelot inv.

E. de Man Sculp.

illustration of the Tasso of 1771 is saved from disgrace by a faint
echo of the taste and skill of earlier years.

The delightful pieces in the " Decameron," the baby groups who mimic every shade of human conduct should be compared with the tiny etching of " Les enfants imitateurs " or the endless procession of childish figures that starts with the "Almanach utile et agréable de la loterie de l'Ecole royale militaire pour l'année 1760." La Honteuse, La Bien Elevée, La Rieuse, La Petite Maîtresse, L'Affairée and others present themselves each with an infant couplet:

> " Que Lise parait occupée
> L'ambitieux et le sçavant,
> A peine le sont ils autant,
> Mais chacun l'est de sa poupée."

Extracts from some letters which have been published by M. Portalis[1] are the most valuable source of our information concerning the facts of Gravelot's private life. They are specially interesting because they throw light on features in his character which explain the character of his work. He loved his art and lived by it, but was without the ambition which might have prompted him to make it his only occupation. He wrote, he wrote verses, he read much and he contrived to live in Paris and to carry on his profession without obtaining the sanction of any Academy, nor does he seem to have suffered in consequence the usual persecutions and summons before legal tribunals.

His very existence seems to have sought hidden ways; he visited no one, not even his brother; he married twice, but " par fantaisie et à l'insu de ses proches." Yet one of these letters, in which he has written of his early hopes, long delayed for want of means, contains a passage of great tenderness : " Nous allons donc être heureux, tous deux," he says, when the day draws near, " par notre amour, par une honnête médiocrité, des désirs modestes, un petit ménage décent, mon crayon, mes burins, mes livres, quelques amis, et, plaise à Dieu ! une bonne santé surtout." The " quelques amis " reminds us that Gravelot, like his distinguished but less eccentric brother, d'Anville, the geographer, reckoned amongst his friends men of the greatest distinction.

p. 276) from the letter written by Gravelot in reply the following passage : "Ce que vous me demandés se peut faire, mais, pour rendre les choses suivant votre idée, cela exige de votre part une explication plus décidée et que je susse bien jusqu'à quel point je dois pousser la gaillardise; car, quoique dans ces sortes de compositions la gentillesse soit préférable à la grossièreté, il y a des gens, comme vous sçavez, à qui il faut des perdrix et d'autres qui aiment mieux la pièce de boucherie."

[1] " Les Dessinateurs," t. i., p. 289.

The position which he had acquired in London was quite different from that which would have been accorded to an obscure young foreigner doing hack-work for publishers and brother artists. Amongst his friends were no less personages than Garrick and his wife. That his relations to them were of the closest intimacy is indicated by every line of the letters published in the "Private Correspondence of David Garrick." Their style, also, gives evidence of the unusual character of the education which both he and his brother had received. It is surely not necessary to suppose that the two young men disguised their origin by assuming names other than their own because that of Bourguignon figured over a tailor's shop. "Je ne puis croire," says Mariette, "que ce fut par un motif de vanité, car le père non-seulement etoit en reputation d'un honnête homme, mais, ce qui auroit dû les toucher davantage, il prit un soin tout particulier de leur éducation." The most likely explanation would seem to be that prudence imposed some such precaution when the father sent his boys to a "collège" chiefly frequented by their "betters."

Gravelot's friendship with the Garricks did not cease with his departure from England. In the "Mémoires secrets" of Bachaumont we find the entry, under the date of January 15th, 1765: "On annonce un fameux médaillon que Garrick a fait frapper pour Mademoiselle Clairon." The medallion, as we learn from the fuller details given later, was struck from a drawing ordered of Gravelot by Garrick.[1] "Les enthousiastes de mademoiselle Clairon," adds Bachaumont, "ont saisi avec avidité cette occasion de la célébrer : on a institué l'ordre du Médaillon, et l'on a frappé des médailles représentant ce portrait, dont ils se sont décorés." [2]

This incident, which so opportunely soothed Clairon's wounded pride at the time of her struggle with Fréron, passes without comment in the letters to Garrick, but there are two letters of the year 1766 which are full of allusions to Gravelot's work. "I have," he writes on the 8th March, "—in order to meet the impatience of

[1] "Mademoiselle Clairon," says Bachaumont, "est représentée avec tous les attributs de la tragédie. Un de ses bras s'appuie sur une pile de livres: on y lit: Corneille, Racine, Crébillon, Voltaire ; et Melpomène est à côté, qui la couronne." The words "Prophétie accomplie" at the top of the drawing referred to Garrick's prophecy of Clairon's future when he had seen her fourteen years previously.

[2] Mém. sec., Feb. 10th, 1765. This is probably a joke. The drawing was engraved. Monnet writes to Garrick, June 15th, 1765 : "Le dessin que vous avez donné à Mademoiselle Clairon est gravé. On le vend et M. de Crébillon est très-fâché de ce qu'on a mis son père après Voltaire, c'est à dire au-dessous du dernier des volumes sur lesquelles Mademoiselle Clairon est appuyé. J'ai jetté la faute sur M. Gravelot " (" Correspondence of David Garrick," v. ii., p. 442).

A Conversation with a English People.
(Gravelot.)

M. de Grimaldi[1] halfway—hastily put together with this year's little almanack[2] some specimens of my work. There are some proofs of the plates for an Italian edition of the 'Secchia Rapita,'[3] as well as some prints for M. Marmontel's prose translation of Lucan,[4] which I am sure will give you much pleasure. . . . These two works are finished as far as I am concerned, and almost as far as regards the engravers. I promise myself some day to send you the two series complete. I am actually attempting Tasso,[5] and at last, I believe, they are going to engrave the Voltaire,[6] which if they do me justice will I hope do me some credit. I have added to the specimens in question good proofs of the comedy of 'La Partie de Chasse de Henri IV,'[7] by M. Collé—a piece with which you are by this time probably acquainted, as it is a fortnight since it was published in print."

Concerning the illustrations to the Voltaire, by which Gravelot hoped to do himself honour, the publisher Cramer wrote to him, as early as 1760, that the author, delighted with his drawings for the Plays, made over to him all responsibility for the engraving of the subjects and the choice of the engravers.[8] Voltaire was possibly glad to free himself from all anxiety as to the " vain et misérable ornement des estampes," which had, however, become an absolutely necessary addition to every work of letters.

Gravelot himself refers to this passion for illustrations in terms equally vigorous when he excuses his unwillingness to look after some vignettes for Colman's Terence.[9] " Nos graveurs," he says, ". . . sont si occupés, la manie des estampes étant actuellement

[1] The "abbé de Grimaldi, de la maison des princes de Monaco," is frequently mentioned by Wille as a great "amateur."
[2] The "Almanach iconologique" was begun by Gravelot in 1765 with the co-operation of Cochin and kept up for seventeen years.
[3] Published by Prault, 1766.
[4] "L'Epître aux poëtes sur les charmes de l'étude" (1760), in which Marmontel specially exalts Lucan, at the expense of Virgil, was a prelude to the publication of this translation.
[5] This work did not appear till 1771: the illustrations are worthless.
[6] The beauty of Gravelot's illustrations for his Plays, for the "Nouvelle Héloïse" (1761) and for the "Œuvres de Pierre Corneille" (1764) inspired Voltaire with the desire to employ him only on the great edition of his works which was completed in 1768.
[7] M. Portalis places the execution of these drawings between 1762 and 1765 ("Les Dessinateurs," t. i., p. 284).
[8] *Ibid.*, p. 280.
[9] I suppose this to be George Colman (1733-1794), best known as a dramatic author and owner of the Haymarket Theatre. He collaborated with Garrick on "The Clandestine Marriage" (see letter of December 14th, 1766, from him to Garrick, "Correspondence of David Garrick," v. ii., p. 209). He was the author of a translation in verse of the "Ars Poetica."

celle de la typographie, que je n'ose me mettre entr'eux et la personne qui voudroit me charger de pareilles entreprises." In the same letter, which is written to Garrick, Gravelot refers also to a "Télémaque," the engravings for which might be put into the hands of a pupil of his—"Grignon,[1] qui a été mon élève, s'il n'a pas dégénéré, a du goût et du mérite"—and returns to the subject of the Voltaire. "On grave actuellement," he says, "mes dessins du Voltaire, qui sont payés cent écus pièce aux graveurs, ceux du Corneille étoient payés sept louis chacun." The phrase with which this letter ends is also worth citing, if only in proof of the strong feeling which bound Gravelot to the Garricks: "A présent, laissons l'essor aux mouvemens de l'amitié. Vos lettres me seront toujours une bonne fortune, et le souvenir de votre chére épouse *a true blessing*."[2]

As we read these words, written in 1766, it must be confessed that some doubt arises as to the truth of the legend which represents Gravelot as fleeing from England before the offensive attitude assumed by those about him after the loss of the battle of Fontenoy. The brilliant success of Marshal Saxe—then at death's door, but so courageous that he had met Voltaire's remonstrance before his departure from Paris with "Il ne s'agit pas de vivre, mais de partir"[3]—had left the English far more angry with General Ingoldsby, to whose disobedience the Duke of Cumberland attributed his defeat, than with the enemy. The coincidence of the date—1745—with that which has been suggested for Gravelot's final return to Paris has probably been responsible for the tale of the terrifying talk by which he was driven from London, and if he did not return, which seems doubtful, his marriage was a sufficient reason, to one of his disposition, for not again leaving his own country.

To Gravelot had fallen the honour in 1761 of " creating " the illustration of Rousseau's " Julie."[4] Rousseau had appeared more than content, but—whether it were that Gravelot was absorbed by his designs for the Voltaire or that the publishers were inclined to make trial of another hand—the designs for " Emile " were furnished in the following year by Charles Eisen.[5] The lavish employment of the vignette had not at first been welcomed by the lover

[1] Grignon is supposed to be, as his name indicates, of French origin, but spent his whole life in London.
[2] "Correspondence of David Garrick," v. ii., p. 496.
[3] "Précis du Siècle de Louis XV," p. 109, ed. 1808.
[4] See Chap. VII., p. 101, note 5.
[5] 1720-1778. R. Acad. St. Luc, 1751.

La Galerie du Palais : Corneille, 1764.
(Le Mire, after Gravelot.)

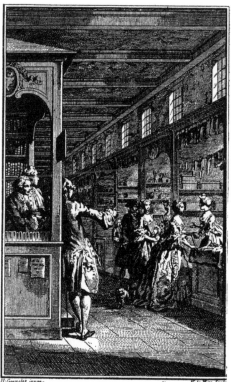

H. Gravelot invon. N. le Mire Sculp.

of books. "J'ai pesté le premier," writes Mathieu Marais to Gravelot and Eisen. President Boubier, " contre les encadrements de nos libraires, qui sont plus sots que des enfants avec des images."[1] But the artists who devoted themselves to the task showed such admirable dexterity and ingenuity that they conquered their public and the vignette soon became the indispensable adjunct to every text. The art of illustration was no longer confined to the decoration of works of romance or poetry, or to the pointing of serio-comic studies of life and character, it seized on treatises of morals—the most unlikely pasture to nourish the imagination of the designer.

" Emile ou de l'Education," says Bachaumont, " by Jean-Jacques Rousseau, citizen of Geneva ; such is the title of four volumes in 8vo which have lately appeared. This work, long announced and expected, excites so much the more public curiosity since the author joins to great wit the rare talent of writing with as much force as grace . . . the four volumes are admirably printed and ornamented with the prettiest cuts."[2] These cuts, engraved by Pasquier,[3] de Longueil and others after Eisen, do not, however, show that profuse book-illustrator to advantage. The enticing airs of his women, their mincing manners and wanton fluttering ways are as evident in the cuts which adorn the first edition of " Emile " as in the famous series of the " Contes de la Fontaine," but so also is Eisen's insufficient drawing.

Born in 1720, at Valenciennes, of Belgian parents,[4] Eisen on coming to Paris was brought into relations with the *maîtres*. His father exhibited, in 1762, two little pictures of the " Fuite " and " Le Repos en Egypte "[5] at the Salon of " Messieurs de l'Académie de S. Luc," but this was a tardy compliment, for his brilliant son had been received on " Un tableau, représentant Icare et Dédale," eleven years before. At the Salon of 1751, when he made his first appearance, Charles Eisen showed, amongst other work, " Plusieurs dessins et esquisses sous le même Numéro," which probably represented his designs for the " Eloge

[1] Letter of January 2nd, 1726. He writes in reference to the edition of the " Contes " to be published at Amsterdam in that year.

[2] May 22nd, 1762. The first edition, "La Haye, 1762," contains five cuts by Eisen. Before the month was out Bachaumont notes that " Le livre de Rousseau occasionne du scandale de plus en plus. Le glaive et l'encensoir se réunissent contre l'auteur." Early in June he adds : " L'*Emile* de Rousseau est arrêté par la police. Cette affaire n'en restera pas là."

[3] See Chap. VI., p. 87, note 8.

[4] Jal, " Dictionnaire critique."

[5] Two subjects " par Eisen père " were engraved by Halbou (1730-18 . . ?) for Basan: " L'Amour en ribotte " and " Les dragons de Vénus."

de la Folie,"[1] which appeared in that year. He must have been already in communication with the " canal des grâces," for at the Salon which was held by the *maîtres* in 1752 at the Arsenal Eisen, who is called " conseiller," exhibited two drawings commissioned by Madame de Pompadour, " dont l'un représente une Automne, dessinée d'après un Bas-Relief d'yvoire qui lui appartient, et l'autre un Printemps dessiné et composé par le sieur Eisen. Ces deux dessins," we are told, " sont gravés par Madame la Marquise de Pompadour." A further indication of his friendly relations with Cochin is given by Eisen's employment on the tailpiece for the " Oraison funèbre de Madame Henriette de France."

The illustration of the " Eloge de la Folie" was the first important work of its kind executed by Eisen, who, whilst yet in the house of Le Bas,[2] had been forced by a hasty and ill-assorted marriage[3] to devote himself to the readiest means of making money. He engraved and designed a great variety of subjects—some religious—all more or less commonplace in character, from which may be distinguished the headings and tailpieces with which he ornamented the Boileau edited by Saint-Marc in 1747, but neither in this work nor in the " Eloge de la Folie " do we realize that Eisen is about to give us his famous series of drawings in illustration of the " Contes de la Fontaine."

Some of these were exhibited in 1753, together with others for the " Christiade," for a new edition of Puffendorf's " Histoire de l'Univers," and for a curious work dedicated to the Marquis d'Argenson and intended for the use of " différens Artistes, Architecture, Sculpture, Ciselure, Orfévrerie, que l'auteur fait graver pour lui."[4] The miniature portrait of a young lady, painted in oil, the size of a snuff-box, which Eisen exhibited the same year, reminds us that he was then engaged on the small portraits which

[1] The plates are fourteen in number.
[2] He came to Le Bas in 1742. M. Portalis (" Les Dessinateurs," t. i., p. 191) cites an amusing sketch of a lanky youth, lost in his cloak, beneath which Le Bas has written " M. Esin, peintre, en redingote."
[3] Charles Eisen, whose full name is Charles-Dominique-Joseph, married on September 20th, 1745, Anne Aubert, his elder by thirteen years. She was the mother of a boy, who had been baptized under the names of Christophe-Charles, October 4th, 1744, and this child was acknowledged by Eisen and his wife as theirs on their marriage (Jal, " Dictionnaire critique ").
[4] It is to this work that Jal refers as a " recueil de dessins, gravés d'après Eisen et publié en 1753," in which one finds that—although his address is given in the Salon catalogue as " rue du Foin "—Eisen was then living " rue de Bièvre, au petit hôtel de Braque, Place Maubert." He shortly afterwards moved to the " quai de la Tournelle, à côté de la manufacture de fayence, chez M. Mazois " (" Dictionnaire critique "), and then to the " Quay des Miramionnes," where he remained for some years (Salons de l'Acad. de St. Luc, 1756 and 1762).

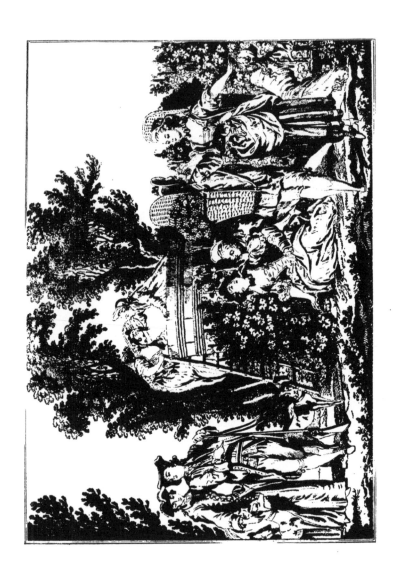

LES VENDANGES OU L'AUTOMNE.

(EMMANUEL DE GHENDT, AFTER EISEN.)

Préparation en eau-forte for the Engraving by de Longueil.

illustrate Descamps' "Vies des Peintres," the drawings for which were nearly all made by him.

Eisen was then "adjoint à professeur" at the Academy of St. Luke and "professeur de dessin dé M. M. les chevau-légers de la garde du Roi,"[1] posts which conferred on him a somewhat settled position. Admission to the Royal Academy remained out of the question; if his acquirements had equalled his genius, there would still have been difficulties, it is hinted, on account of the irregularities of his life. His marriage—which, under the circumstances, one must reckon to the credit of a kindly heart—did not obtain the sanction of his father's presence, but he evidently had some very good friends of the soberer sort. Le Bas—in whose atelier he had worked—stood godfather to the son who was christened in 1747, when his father was living in the "rue des Noyers, au coin de la rue des Anglois," and the excellent Madame Wille was godmother to another in 1749, when the family had moved to the "rue du Foin."

The diary of Wille for 1743-1759 is unfortunately lost, so we do not know what entertainment Madame Wille received at the christening, nor what present she was obliged to make. The intimacy, if ever there were any, cannot have been lasting, for the name of Eisen never occurs in his pages. Words which passed in the curious quarrel which took place between Eisen and Le Mire in 1759 over, it would seem, some of the illustrations to the "Contes de la Fontaine,"[2] imply that there already existed a strong feeling of sympathy for Eisen's wife and children in which Eisen himself had no share. He appeared at seven o'clock in the evening of the 2nd December before the *commissaires du Châtelet*, who discharged in the eighteenth century the functions of the *commissaires de police* of our day, to complain that Le Mire had that afternoon at five o'clock brought him some work which he had given him; that he had pointed out some faults in his work, whereupon Le Mire, instead of thanking him for his hints and representations, had abused him violently, had insulted him, had requested him to come down and fight it out, and had actually used these words: "Si je ne respectois pas ta femme ainsi que tes enfants, je te passerois mon épée au travers du corps, et je te rejoindrai."[3]

[1] Jal, "Dictionnaire critique."
[2] I do not think that there is any work by Le Mire after Eisen bearing the date of this year, but they were then most certainly occupied with the illustrations to the edition of the "Contes de la Fontaine dite des Fermiers généraux" which came out in 1762. Eisen, as we have seen, had begun to prepare the drawings in 1753.
[3] "Bulletin de la Société de l'Histoire de l'Art français," 1875-1878, b. iii. 5-6.

Le Mire was, as his rough treatment of his assistants shows, an excitable, passionate man. On this occasion, it is likely that he had considerable justification for his anger. The compositions which Eisen designed with incomparable facility, grace and spirit, were too often drawn with a careless and slovenly hand. If one puts beside an engraving by Le Mire the drawing which it reproduces and that drawing be by Charles Eisen, the advantage is by no means invariably to the account of the draughtsman. The fault-finding, the hints and representations which Le Mire took in such ill part had, quite possibly, but little justification, and it is clear from the tone of the reference to Eisen's wife and children that his conduct as a husband and father was already notoriously bad.

The brilliant series of Eisen's illustrations to the "Contes,"[1] even more than his later work on the "Métamorphoses d'Ovide,"[2] must always remain his chief title to fame. In many respects this fine series—the most important that he produced—is superior to any other of his work. The proportions of the figure, often faulty in Eisen's designs—as in the vignettes to the "Eloge de la Folie" or the headings to the "Satires" and the "Héros de Roman" in the Boileau of 1747—are, in the "Contes," often of rare beauty and elegance. The pose and proportions of the beautiful queen in "Le roi Candaule" have a fine reminiscence of the Diane of Jean Goujon; nor is this figure the only example of a similar character. Even when Eisen's art offers us a less delicately poised elegance, his wit, his facility of invention, his power of touching with piquancy every expression and pose carry off the necessary freedom of his treatment of themes essentially free, for the light touch of his pencil is exquisitely appropriate to the airy mockery of vice and folly with which the witty story-teller entertains his readers.

We may take with these volumes "Les quatre parties du jour" and "Les quatre Saisons,"[3] charming compositions engraved by de Longueil, in which Eisen has given us of his best. They represent the sort of work which one should expect from the illustrator of the "Contes," but it is not without surprise that we discover, from the list of Eisen's contributions to the Salon of the

[1] These drawings are in the collection of Madame James de Rothschild, by whose kindness I am able to give a reproduction of that of the "Trois Commères" together with the engraving by Le Mire.
[2] See Chap. II., p. 33.
[3] See Panhard, "Joseph de Longueil: sa vie et son œuvre," pp. 67-69 and 71-73.

LES TROIS COMMÈRES.
(DRAWING BY EISEN.)
In the collection of Baroness James de Rothschild.

LES TROIS COMMÈRES.
(LEMPEREUR, AFTER EISEN: "CONTES DE LA FONTAINE," 1762.)

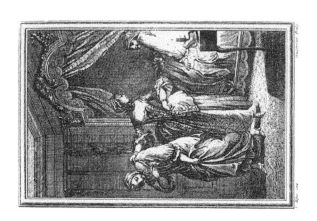

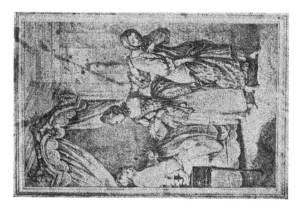

Academy of Saint Luke in 1762, the amount of work of a strictly religious character on which he must have been engaged simultaneously with that of the lightest style. First comes "un projet dessiné pour une Chapelle de Communion," together with "une esquisse du Tableau d'autel de ce même projet, représentant Notre Seigneur qui fait la Cène avec ses Apôtres," and "une autre Esquisse, représentant l'Annonciation de la Vierge, exécutée en grand." Of this last, we are told that it was destined for the collegial church of Douai and was thirteen feet and a half high by ten·wide. Another "esquisse," the subject of which was "The Marriage of the Virgin," had possibly the same destination, and the mere fact of the commission shows not only that Eisen continued in touch with the neighbourhood in which he had lived as a youth,[1] but that the licentious character of much of his work was no bar to his employment by the dignitaries of the Church.

It was not, moreover, the first time that Eisen had been busied with work of this class; he exhibited studies of St. Sebastian for an altar-piece in 1756, and it is clear that the various works which we have just seen figuring at the exhibition of the *maîtres* in 1762 must have satisfied the taste and feeling of some amateur, for two years later "Charles Eisen, professeur," sends to their rooms as his principal contribution "Sainte Genevieve assise dans la campagne, faisant la lecture"—a painting six feet by four which was intended for the chapel of a château. At the same exhibition Eisen showed also various pencil drawings washed with Indian ink, and probably amongst these were his illustrations to the "Zélis au bain"[2] of the Marquis de Pezay. One of these —"Le bain de Zélis"—was in the de Goncourt collection, where also figured Eisen's drawing of "L'Ouïe," reproduced in illustration of du Rosoi's verses on "Les Sens,"[3] which came out in 1766.

The drawings for the edition of the "Henriade,"[4] which was not complete till 1770, were also prepared about 1766-1767, but at this date Eisen had left his wife. He was but forty-seven, she was sixty, and the rupture was so complete that he was not present at the marriage of his daughter Catherine-Justine, which took place on the 4th November, 1767, at St. Nicholas des

[1] He is supposed to have spent his first years at Valenciennes, where he was born: 1742 seems to be the earliest date suggested at present for his presence in Paris. Fine work of the early sixteenth century, such as the polyptych of Anchin by Jean Bellegambe (see A. Preux, "Jean Bellegambe") was probably little valued by the men who commissioned work from Eisen.

[2] "Zélis au bain" by the Marquis de Pezay, 1763 and 1768.

[3] See p. 107, note 2. [4] "La Henriade. Paris, Vᵛᵉ Duchesne, 1770."

Champs, nor, two years later, at that of his son, Christophe-
Charles, who married a girl of fifteen, Adélaïde Thibault, the
daughter of a "contrôleur des fermes," at Ste. Marguerite, the
31st January, 1769 [1]—a match which seems rather better than the
state of his family affairs entitled the young man to expect.

His father was, however, actually producing some of his best
work at this time, and the price of one of his drawings was, we
learn from a receipt given at this very date, 48 l.; [2] but it is
unlikely that his family were much the richer for his earnings.
The drawings for Dorat's " Baisers," now in the collection of the
Baroness James de Rothschild, belong to this date and were closely
followed by those for the " Temple de Gnide." [3] The illustra-
tions in this work are amongst the best of Eisen's designs, and
their beauty is enhanced by the exquisite art of Le Mire, by
whom they were all engraved. This volume has therefore a real
advantage in harmony of aspect over others—such as du Rosoi's
" Les Sens "—in some respects equally beautiful, but the pages of
which are disfigured now and again by the inferior work of Wille
fils,[4] which cannot for an instant support the comparison with
Eisen's facile and accomplished skill.

The rashness of youth can alone excuse the impertinence
which presents us with the ludicrous version of " L'Ouïe " by
young Wille, immediately in connection with the same subject
treated as the frontispiece with that delightfully intangible grace
which was one of Eisen's many gifts. Not even the equal kind-
ness of de Longueil's graver, in which " the quality of mercy is
not strained," can give to the Teutonic sentiment of such draw-
ings as represent " La Vue " and " L'Odorat " anything in common
with the witty gaiety of Eisen's " Le Tact " or " Le Goût," nor
anything of the elegance with which he has handled the subject
of " La Jouissance."

[1] Jal, " Dictionnaire critique."

[2] " J'ay reçue de monsieur d'Arnaux la somme de quarante huit livres pour le
payement d'un dessien quy doit servire de frontispice au lamantation de Geremye fait
par monsieur d'Arnaux, à Paris, ce 24 janvier, 1769 " (N. A., 1872, p. 340): " mon-
sieur d'Arnaux " is Baculard d'Arnaud, the husband of M^{lle} Chouchou, a fashionable
marchande de modes.

[3] " Le Temple de Gnide, suivi de Céphise, par M. de Montesquieu. Lemire,
Paris, 1772." 1 vol. gr. in 8vo. M. Portalis says that the drawings for this work
were in 1877 in the collection of M. Duriez de Verninac (" Les Dessinateurs,"
t. i., p. 212).

[4] Wille fils no doubt profited by the reputation and position of his father. We
find Cathelin engraving with delicate art his ridiculous " Nouvelle affligeante," in
which a lady in full dress and feathers strikes a fantastic attitude of despair, explained
by a detail in the frame, where we see a little ship going down at sea.

Here we are back again at situations such as Eisen treated in the "Contes," such as he treated in "Les Epreuves du Sentiment "[1] and a dozen other volumes of a similar character. By the grace and wit that distinguished his conception of these themes he made his great and very personal reputation. Cochin had something to say as to the composition of his allegorical designs, Boucher's influence may be recognized in his drawing, especially of the heads of his figures, but these things are not of the essence of Eisen's art. His special gift resides in the power to handle indelicate subjects with the most exquisite delicacy. This fine tact never forsook him; no matter how suggestive the situation, Eisen rarely becomes either coarse or vulgar.

His contributions to the exhibitions of the Academy of St. Luke maintained their curiously mixed character up to the last. In 1774 the unfortunate *maîtres* held their final show in the Hôtel Jabach under the auspices of the Marquis de Paulmy.[2] Eisen, then "adjoint à Recteur," sent, in addition to some little paintings of classical subjects,[3] several drawings, amongst which may be noted two "à la sanguine, rehaussés de blanc." These last were a "Sainte Famille, et pour pendant le Songe de Saint Joseph." After this effort the *maîtres* closed their doors, and Eisen, in his official capacity, can have had very little to do. His name appears on some illustrations published in the course of 1775, and then we hear of him at Brussels "rongé de goutte et tourmenté par les maux qu'entraînent le libertinage et la débauche."[4]

At Brussels Eisen died. When his wife appeared, to give notice of the fact (January 13th, 1778), before the *commissaire du Châtelet*, François Bourgeois, she declared that he had gone there "pour ses affaires," and his death had taken place on the 4th January, 1778, according to the letter of the Sr J.-J. Clause "addressée à la dame Saint-Martin, rue Sainte-Hyacinthe, place Saint-Michel, qui vient de la luy communiquer."[5]

The dame Saint-Martin who announces to the dame veuve Eisen the news of her husband's death[6] is, it is said, the woman for whom Eisen had deserted his wife and family thirteen years before.

[1] Paris, Delalain, 1775. 3 vols. in 8vo.
[2] See "French Painters of the XVIIIth Century," p. 12, note 3.
[3] See Appendix D.
[4] De Goncourt, "L'Art du XVIII. Siècle," ed. 1880, t. ii., p. 155.
[5] N. A., 1885, p. 84.
[6] Clause says in his letter to her that the goods left by Eisen in his hands would only about half pay the debts due to him, and he desires her "de faire avertier à son per est à la famille" (*ibid.*, p. 82).

There is not a word concerning them in the letter from which we learn that Eisen "s'a bien converties pour morier," and that he was, on the 6th of the present month "anterés sur la simantier des St. Gudule." One would say that Clause had not even any idea of the existence of a wife and children, for he continues, "les pu trist pour mois, c'es pour avoir ce quy m'es dois, est mes des bours la somme de 376 florain quy fait en argant de France 752 liever, sans le dette quy doit encore au sauter, que la valeur en tous est mil liver."

Whether these debts were ever paid is doubtful. Eisen, we learn from the close of Clause's curious letter, had told him that he would be paid for his outlay by the sale of his furniture and the library which he had in the apartment of "Madame St. Martin" in the "maisson de Monsr Vasselin, à Paris." "Il m'a dis," he says, "ci en cas que je viens troi cours pour mois, que je saire̋s payés de ces meuble de Paris," but they had counted without Anne Aubert, "épouze actuellement veuve de Charles-Joseph-Dominique Eizen, peintre dessinateur du cabinet du Roy et de l'Académie des beaux-arts de Rouen, avec lequel elle demeuroit rue du Faubourg-Saint-Denis."

Not only the "bibelotecque," but everything else that could be removed had been transferred by Eisen to his apartment in the rue Sainte-Hyacinthe. His widow was left in possession of nothing that was not her personal property. The *commissaire*, who accompanied her to her own rooms after setting the seals on her husband's apartment, notes only a screen, a mirror, a picture or two, amongst which were her own portrait and that of the dead man, a couple of candlesticks and one or two other necessary articles of household furnishing. Money was owing on all sides, not only to tradespeople, but to Patas,[1] the engraver from whom Eisen had obtained various sums on account of two drawings which he had never executed or delivered.

The details of the claim made by Patas recall similar incidents in Eisen's earlier career. The curious series of documents printed by M. Guiffrey in the "Courrier de l'Art" for 1884 includes not only two Procès-verbaux of "Saisies" made by the *maîtres* on Eisen's work in 1748 and 1750—both, that is to say, prior to his reception into their body and appearance at their exhibitions—but also the facts as to the dispute between him and Guyon, one of the *fermiers-généraux*. In this case Eisen was taxed with delay in carrying out the illustrations of an unnamed work, which can be no other than the famous edition of the "Contes." He had, according to

[1] 1748-1817.

128

his usual custom, obtained payment in advance, and also, as usual, Gravelot
violently resented any attempt to induce or compel him to fulfil and
his engagements. Eisen.

Eisen had no pupils; it was indeed impossible that the qualities
which give charm to his work should be taught. The special
characteristic of his art was that very personal and delicate facility
and lightness which enabled him to present the most indecent
themes with a gloss of grace and sentiment. Others might indeed
imitate his freedom, but not one could boast the same dexterity
in the avoidance of the commonplace, the foolish and the vulgar.

CHAPTER IX

THE SAINT-AUBIN, MOREAU LE JEUNE, BOILLY, PRIEUR

GABRIEL DE SAINT-AUBIN[1] was one of the most original of all the draughtsmen in whose work may be traced the influence of Gravelot and of Eisen. He was next brother to Germain de Saint-Aubin,[2] the amusing author of " Les Papillonneries humaines,"[3] in which we find an echo of the apish pleasantries of Christophe Huet.[4] The youngest of the family, Augustin, is perhaps the best known, for he is the author of the popular " Au moins soyez discret " and the companion " Comptez sur mes serments," in which he has drawn and engraved a pair of lovers whose charming looks must plead forgiveness for any indiscretion which they may have committed.

The year 1753 marks an epoch in the life of Gabriel. He was then about thirty, and was attending the classes of the Royal Academy and competing, as one destined to the career of an historical painter, for the Grand Prix. He missed it, but obtained the second place. Monnet,[5] whose name we find on so many poor

[1] 1724-1780.
[2] 1721-1786. He was the eldest of fifteen children, and became his father's assistant in his trade as "brodeur." See MS. note by him reproduced by the de Goncourt, "L'Art du XVIII. Siècle," ed. 1880, t. i., pp. 399-401.
[3] These were published "à Paris chez Fessard graveur du roy rue St. Thomas du Louvre la 3ᵉ porte cochère à main gauche en entrant par la Place du Palais Royal." Germain also published a "Recueil de Chiffres inventés par Saint-Aubin dessinateur du roi A. P. D. R." These were engraved by Marillier and published "chez la Vᵉ de F. Chéreau, rue St. Jacques aux deux Piliers d'or." "Mes petits bouquets," another of his publications, were "Dédiés à Mᵐᵉ la Duchesse de Chevreuse."
[4] See "French Decoration and Furniture, etc.," pp. 90-96.
[5] 1730- . . .? A., July 27th, 1765. He was never received.

LE BAIN : "PAPILLONNERIES HUMAINES."
(GERMAIN DE SAINT-AUBIN.)

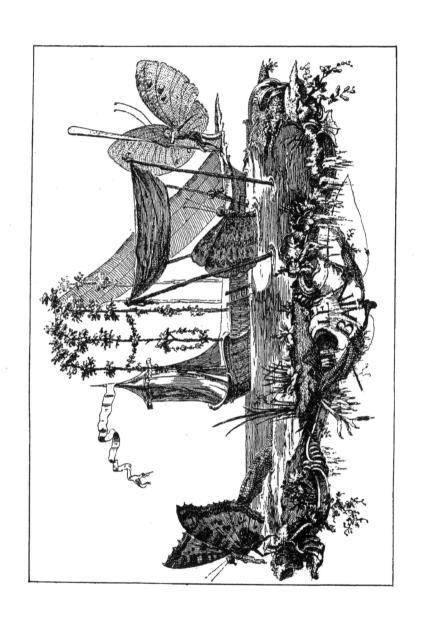

designs for which mythology and allegory have furnished the subjects, was the successful competitor. When it came to painting "Nabucodonosar qui ordonne le massacre des enfants de Sédécias, Roi de Jérusalem, et lui fait ensuite crever les yeux,"[1] one feels sure that Monnet would have the best of it. Such a theme offered no chance to Gabriel de Saint-Aubin for the exhibition of the brilliant and entertaining wit which was the essence of his genius and which he had already displayed in his etching of "Les nouvellistes au café" executed in the previous year.

The astonishing thing is that Gabriel's family should have even wished him to compete for the Grand Prix at this date. The competition was not decided till the 31st August; the Salon, which is commemorated by his marvellous drawing, "Vue du Salon du Louvre en l'année 1753,"[2] had opened on the Saint Louis, five days earlier. It is quite clear from the freedom and beauty of this drawing, the powerful rendering of the movement of the crowd and the delightful ease and insight with which every man and woman is characterized, that Saint-Aubin was in the full possession of his powers. Yet, in spite of this triumph and in spite of the check from Monnet—which followed on a previous failure[3] —Gabriel de Saint-Aubin stolidly returned to his Old Testament exercises. In October of the same year[4] he again entered a competition of which the prize should have been a place as "élève protégé." Fortunately both for himself and us he was again unfortunate. The subject was "Laban seeking his gods" and the successful competitor was Brenet.[5]

Undaunted by his third unlucky essay, more time was again wasted by this delicate and spirited draughtsman on the "Concours pour les grands-prix."[6] He was defeated by young Chardin and accepted the test as final. In the year 1754 he dated the fairy-like composition popularly known as the "Bal d'Auteuil." It is the work of a master. The musicians play, little figures dance with a grace, a gaiety and a freshness that recall the magic thrown by Watteau over these rustic festivals. To paint the

[1] P. V., Aug. 31st, 1753.

[2] His etching of this subject is reproduced by the de Goncourt, "L'Art du XVIII. Siècle," ed. 1880, t. i.

[3] See P. V., Aug. 26th, 1752. M. Moureau notes: "Deux sujets bibliques, datés de 1752 et de 1753, représentant, le premier 'La Réconciliation d'Absalon et de David,' le second, retouché dix ans après, 'Laban cherchant ses dieux,' justifieraient assez mal la faveur qui s'attache aux eaux-fortes de Gabriel" ("Les Saint-Aubin," p. 42).

[4] P. V., Oct. 6th, 1753. [5] P. V., Dec. 29th, 1753.

[6] P. V., April 6th, 1754.

The
Saint-
Aubin,
Moreau
le jeune,
Boilly,
Prieur.

"Ballet dansé au théatre de l'Opéra dans le Carnaval du Parnasse"
was clearly more to his taste than the task of depicting Laban's
unpleasing adventures with his erring daughter.

This work, which was exhibited by Gabriel in the "Salon des
Gràces" at the Colysée in 1776, was engraved by Basan and
dedicated by him to the "Duc de la Valière Pair et grand
Fauconnier de France . . . Capitaine des Chasses de la Capitannerie
Royale de la Varenne du Louvre."[1] The etching was prepared
by Saint-Aubin himself, and its seductive brilliance is such that it
cannot be obliterated even by Basan's graver—a tool which has
not added beauty to the work as prepared by its author. With
the "Bal d'Auteuil" may be grouped the "Dimanches de Saint-
Cloud"[2]—in all the various states which make Gabriel's method of
work so entertaining—the "Réunion dans un Parc," where the
professional bearded old model makes his appearance as a beggar at
one of the tables, and the "Chaises mises aux Thuilleries," with
its companion, "Le Tonneau d'arrosage."

The "Chaises mises aux Thuilleries" is dated 1760: "En
ce temps-là le beau jardin des Thuilleries étoit le rendés-vous de
tout ce qu'il y avoit de grand et d'élégant dans la ville. On n'y
avoit pour se reposer que quelques bancs de bois épars dans les
contre-allées. Ils étoient toujours très occupés et encore plus
désirés. . . . En 1760 le gouverneur du château, Bontemps, fit placer
dans la grande allée quelques milliers de chaises, dont il donna la
ferme à sa maîtresse. . . . Les bancs furent abandonnés; il parut
même ignoble de s'en servir. Le grand concours du monde
occasionnant beaucoup de poussière, les loueurs de chaises firent
faire un tonneau roulant assés ingénieux pour arroser la promenade.
C'est le sujet de la seconde vignette."[3]

These were the scenes in which the bohemian spirit of Gabriel
delighted and he sought them reckless of all but the joy of the
moment: yet he seems to have been visited occasionally by an
uneasy impulse of allegiance to forms of art such as he had been
bidden to admire in the classes of the Academy. We find in his

[1] Impressions of this beautiful etching are, I believe, extremely rare. See Chap.
II., p. 33, note 3.
[2] The drawing of this subject was in the de Goncourt collection and is repro-
duced in "L'Art du XVIII. Siècle," t. i. A fine drawing, the composition of which
recalls that of the "Dimanches de St. Cloud," is in the collection of Mr. Heseltine,
who possesses also the sketch of a group drawing from the life and that of a large
group of dancing figures, both of which were in the de Goncourt collection.
[3] See MS. note on the proof of the "Chaises mises aux Thuilleries" in the
volume "Les St. Aubin" in the Cabinet des Estampes. It has been reproduced in
full by MM. Portalis and Béraldi ("Graveurs du XVIII. Siècle," t. iii., p. 478-479).

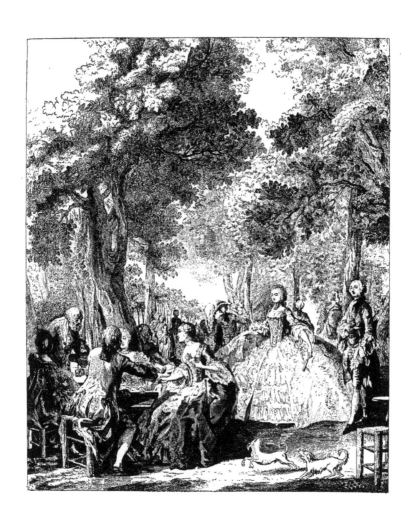

copy of the *livret* for the Salon of 1761—which is full of tiny pen-and-ink sketches—that the most careful note is devoted to Cochin's "Lýcurgue blessé dans une sédition."[1] Nothing amongst the work of Gabriel de Saint-Aubin is more curious than the minute sketches which fill these little books—sometimes, as in that of 1769, washed in with sepia, sometimes simply sketched in pencil and retouched with the pen. They show an ever ready catholicity of interest, and in the margins of the catalogue for 1777 Robin's plafond for the " Salle de Spectacle de Bordeaux " is as carefully noted as " La port et citadelle de Saint-Pétersbourg sur la Neva "—the engraving which involved Le Bas in his quarrel with Le Prince.[2]

Gabriel himself exhibited officially for the first and only time, not at the Salon which he had so zealously frequented, but at the exhibition of the *maîtres* in 1774.[3] He was then " adjoint à professeur," and at the head of his list of contributions stands " Le Triomphe de l'Amour sur tous les Dieux," next to which comes " L'Ecole de Zeuxis . . . l'an du monde 3,564." This is followed by " Effet du tremblement de terre à Lisbonne "[4] and a series of other works, amongst which figure a " Fête de Village et Pendant "—the only entry which suggests that Gabriel had really painted something to please himself. That he could paint, work such as the little canvas exhibited this year at the Guildhall under the title of " Le Nozze di Figaro " bears eloquent witness.[5]

Not one of the works described in the " Catalogue " of the *maîtres* have I succeeded in identifying. It is, however, impossible to believe that their author put into subjects evidently selected with a view to " l'enseignement," as was the bounden duty of a professor, the gaiety and graceful satire which he brought to the rendering of a " Parade aux thèâtres du Boulevard "—the engraving of which is said to be by his brother's pupil, Duclos—or the easy

[1] See Chap. III., p. 37, note 1, and Chap. X., p. 151.
[2] The catalogues cited here are in the Cabinet des Estampes ; others are in the hands of various amateurs. Fourteen were sold in 1808 on the death of Augustin de St. Aubin (" L'Art du XVIII. Siècle," t. i., p. 370). " Salons " found a rival in " Sales." No great sale took place without the presence of Gabriel, and his copies of the catalogues are also covered with innumerable small drawings. In this way he has enriched the pages of those of L. M. Van Loo (1772), de Fournelle (1776), Natoire and Fitz James (1778) and Randon de Boisset. This last is now in the collection of Mr. Heseltine.
[3] He sent works also, as we have seen, to the Colysée, where, after the suppression of their Academy, some of the *maîtres* held a surreptitious exhibition (see Appendix D), which, though it was noticed in the press, had no official sanction.
[4] A fine drawing admired by artists, we are told, and ruined by his own additions and corrections (MS. note on the " Recueil des plantes " of Germain de Saint-Aubin).
[5] No. 117. Lent by M. Warneck.

The
Saint-
Aubin,
Moreau
le jeune,
Boilly,
Prieur.

freedom which distinguishes the fine drawing of " Un grand dîner dans une Orangerie," which formerly belonged to M. Armand, but is now in the collection of M. Valton, together with Gabriel's famous " Ouvrier de fileuses à deux mains "—signed and dated 1777.

This drawing must have been amongst his last work, and amongst his last work we must also reckon the drawings made by him for the " Ouvrage intitulé abregé de l'histoire romaine orné de 49 estampes. Paris, 1789." [1] Many, if not all, of these designs are attributed to Gabriel. The " Pl. 39 " which sets forth the triumphal procession of Pompey in the Forum is signed " Gabriel de St. Aubin del." and " Pelletier sc." In spite of the technical merits of the work, I confess that I would rather possess one such drawing as those in M. Valton's collection, or the wonderful " Séance de Physique à la Monnaie " which the kindness of M. Doucet enables me to reproduce, than all those done in illustration of the history of Rome.

The " Expérience de Chimie," once in the Goncourt collection, is dated 1779, the year before Gabriel's death. He died young, exhausted by the feverish passion with which he gave himself up to every passing caprice and vagrant fancy. The beaten path had no charms for him. He seems to have lived in the street, at the " Café," in the auction room, or wherever his fellow-men happened to have come together.[2] In his haste to be with them every personal care was forgotten. The description of the clothes which he brought with him to his brother Germain's house, when, after suffering for six months, he had himself carried there, " pour être plus à portée de secours," five days before his death, justify his brother's words : " C'est dommage qu'il ait négligé l'ordre et la propreté." [3] An overcoat of striped plush, a dressing-gown, black breeches, an old pair of slippers, a dirty shirt, a woollen nightcap without a lining, a pocket handkerchief—these were " les seuls effets dans lesquels il était enveloppé dans la chaise à porteurs dans laquelle il s'est fait transporter."

On Thursday, February 10th, 1780, Germain, the " dessinateur du roi," sent for the *commissaire* to declare that his brother Gabriel-Jacques de Saint-Aubin, " peintre de l'Académie de Saint-Luc,"

[1] The de Goncourt give the date of 1764 for the drawings prepared by Gabriel for this work (" L'Art du XVIII. Siècle," t. i., p. 373).

[2] See *ibid.*, pp. 374, 375, for the admirable portrait of his activity drawn by the de Goncourt. It is too long to be transferred to these pages, but their mention of Gabriel's sketch of Damiens in his cell, " bouclé sur une grosse pierre," the night before his execution, cannot be omitted.

[3] *Ibid.*, p. 405, note ; MS. note by Germain de Saint-Aubin on an album of drawings.

SÉANCE DE PHYSIQUE À LA MONNOIE.
(GABRIEL DE SAINT-AUBIN.)

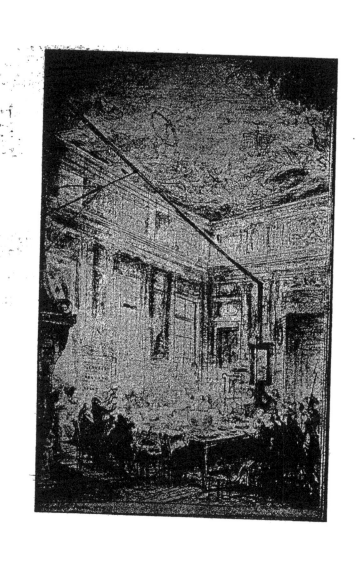

had died at eleven o'clock in the morning of the previous day. The seals were set on the doors of the apartment in which he had lived in the rue de Beauvais, but when it came to making an inventory of his goods the *commissaire* takes note of " le désordre qui règne dans led. appartement et l'impossibilité qu'il y a de procéder à l'inventorié de ce qu'il renferme avant qu'au préalable il ait été fait un arrangement et mise en ordre de tous les meubles et effets, tableaux, dessins, livres et papiers bouleversés et confondus les uns dans les autres." [1]

This note points to an exceptional state of things, which was due only to Gabriel's eccentric habits. Germain, the elder brother, whose trade as *dessinateur pour étoffes* reminds us that the father of this family was a " brodeur du roi," [2] had no lack of means. Even after the losses which he sets down in the autobiographical note to which reference has already been made, servants and money and plate were not wanting in his house, [3] and Augustin, " graveur de la bibliothèque du Roi demeurant rue Thérèze," was also at this date in easy circumstances.

Augustin de Saint-Aubin [4] had succeeded to the post which he then occupied in 1777, on the death of Etienne Fessard. He had been a pupil of Fessard, but fortunately for himself had been first taught by his brother Gabriel. He was but a boy of sixteen when he engraved a ticket for a " Concert bourgeois de la rue Saint-Antoine " and executed a little etching of a party of excited women in a Salon, the title of which is " L'Indiscrétion vengée." The little figures are ludicrously out of proportion, but their attitudes are full of spirit, and have an air that reminds us of Eisen's illustrations to the " Eloge de la Folie," which had appeared in the previous year.

In spite of this early evidence of unusual gifts Augustin was put to the humblest tasks. On the engraving of a " Crucifix with St. John and the Virgin," which opens the series of his work at the Cabinet des Estampes, he writes : " J'ai fait cette drogue la première semaine que je suis entré chez Etienne Fessard en 1755." [5]

[1] Jules Guiffrey, "Scellés et Inventaires d'Artistes," N. A., 1885, pp. 105-106. His heirs were three brothers and a sister, Catharine, who lived with Germain in the rue des Rouvaires, and to whom Gabriel, on his death-bed, gave his gold watch and "sa médaille d'or de l'Académie." Basan was called in to value the engravings and paintings.

[2] Charles-Germain de Saint-Aubin tells us that he conferred on himself the title of "'Dessinateur du Roi' que personne ne me contesta," when he married in 1751 (MS. note, de Goncourt, " L'Art du XVIII. Siècle," t. i., p. 400).

[3] N. A., 1885, pp. 183-184.

[4] 1736-1807.

[5] Portalis and Béraldi mention that Augustin at about this time won a medal at

The
Saint-
Aubin,
Moreau
le jeune,
Boilly,
Prieur.

Matters improved when he reached the *fleurons* of the "Decameron"
and found in the admirable drawings of Gravelot a course of the
highest instruction : the influence exercised on him by this work
may be traced in the brilliant execution of the engraving of the
"Mausolée de M. Languet de Gergy," which he contributed to
d'Argenville's "Voyage pittoresque de Paris."

The "St. Fessard direx." which accompanies the signature
"August. St Aubin del. et Sc. 1757" reminds us that, although his
work may be compared almost to its advantage with that of
Choffard in the same volume, Augustin was still only the assistant
of a master to whom he was greatly superior. There is, however,
little personal character in work such as the series of "Les différens
jeux des petits polissons de Paris" and "Mes Gens"—engraved by
Augustin de Saint-Aubin's fellow-pupil, Jean-Baptiste Tilliard [1]—
as compared with his "Tableau des portraits à la mode" or the
more famous "Promenade des remparts de Paris," both reproduced
by Courtois in 1760. [2]

This was four years earlier than that in which Augustin entered
the atelier of Laurent Cars [3] and married Louise-Nicole Godeau,
whose charming features are, it is said, to be recognized in the
portraits labelled "Louise-Emilie, Baronne de . . .," and "Adrienne-
Sophie, Marquise de . . .," exhibited by her husband in 1779. The
brilliant happiness of this marriage seems to have been saddened
only by the loss of children, and even in later years the features
of the woman who had figured in 1779 as the "Baronne" served
her husband for the popular "Au moins soyez discret," whilst he
revived a companion image of his own youth in "Comptez sur
mes serments."

Laurent Cars was not satisfied to leave his brilliant pupil to the
protection of the *maîtrise*. On the 25th May, 1771, Augustin
was presented by Cochin and *agréé* by the Academy. He re-

the Royal Academy. His name does not occur in the Procès-verbaux, as winning a
medal until Dec. 31st, 1761, but a competition *pour les médailles*, to which all the
students were admitted, took place on October 4th, 1755.

[1] 1740-1812. He was a good workman, whose name is to be found in numbers
of books. He engraved ten subjects in the "Gerusalemme liberata" (1784) after
Cochin, and retouched and signed the little "Place Louis XV" by Moreau. A
portrait of his wife by Augustin is in the collection of Mr. Heseltine.

[2] The set of six "Habillements à la mode de Paris," engraved in red by Gillberg,
dated 1761, were executed for the "Magasin de la veuve Chéreau rue Saint-Jacques
aux deux piliers d'or." A further set of modes containing "Grande robe à la reine,"
"Chapeau à la miladi," etc., signed "St. Aubin del. Dupin fils sculpsit" and bearing
date 1764, were published by Esnauts and Rapilly.

[3] His engraving of "Vertumne et Pomone" after Boucher is dedicated to Cars,
in 1765, by his "élève Saint-Aubin."

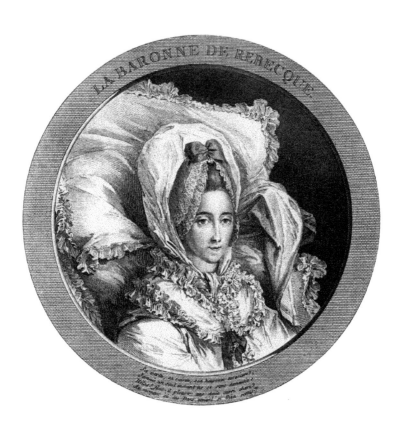

mained content with this position and was never received, for the two portraits which he was ordered to execute were never completed.[1] He had little time for gratuitous work, being then at the height of his professional success, and the climax of his art was reached when he exhibited his remarkable drawings of the "Bal paré" and the " Concert Bourgeois " at the Salon of 1773.[2] To the same Salon Augustin sent, amongst other things, a series of portraits " d'après les dessins de M. Cochin," and the success which they obtained determined the continued production of similar work.

From this time onwards the enormous demand for these portraits, in the execution of which he exhibited—as in the Marmontel at the head of the "Contes Moraux"—his brilliant power of rendering the flexibility and softness of flesh,[3] drew him wholly away from the class of subject which really justifies his reputation. Yet amongst these portraits—many of which, as for example that of Linguet, framed by Choffard,[4] have *ad vivum* inscribed on them—there are not one, nor two, but many which may claim to be *chefs-d'œuvre* of delicacy and of truth. The fine head of Necker,[5] the Mariette after Cochin, the Madame de Pompadour etched in 1764, and even more the wonderful Mme. Radix and Mme. Létine make us forget our regret that we are to have no more " Promenades sur les remparts," nor " Bals parés," nor " Concerts bourgeois." Augustin handled old age as delicately as the years themselves seem to have touched Mme. Létine : in the very folds of her dress there hangs a perfume of faded rose-leaves, and one understands that her son-in-law should have put his hand to this and the companion portrait of himself in order to justify the impertinent inscription " La Live sc."[6]

The Revolution, which was to realize Augustin's happiest dreams, ruined him and ruined his art. Expelled from the atelier which he had occupied since, he says, 1777, when he succeeded his old master, Fessard, as " dessinateur de la bibliothèque du

[1] The two portraits ordered on June 1st, 1771, were those of Le Moyne le père, after Tocqué, and of Louis de Silvestre, after Greuze. Those named on July 24th, 1772, are of Le Moyne le père and Dumont.

[2] These drawings were admirably engraved by his pupil, Duclos.

[3] See Grimm's mention of Saint-Aubin's engraving of the portrait of Diderot after Greuze, " Corres. lit.," January 15th, 1767.

[4] Salon of 1783. He exhibited at the same time a second set of drawings. for the " Pierres gravées antiques du Cabinet de M. le Duc d'Orléans." The first set were shown in 1775.

[5] Exhibited in 1789 : " Portrait de M. Necker. D'apres M. Duplessis. Format in-12, gravé en Juillet 1789." See also the Salon of 1785 and p. 160.

[6] These portraits are included in the collection of his own work made by Augustin himself.

The
Saint-
Aubin,
Moreau
le jeune,
Boilly,
Prieur.

roi,"[1] Augustin was taken on by Renouard to execute the frontis-
pieces and portraits needed for his various publications. In 1789
—if we may identify " Au moins soyez discret " and " Comptez
sur mes serments " with the " Deux demi-figures dans des ovales "
which he then exhibited—he was in the full force of his powers.
Then comes the dull succession of hack-work by which he had, if
possible, to live.

The portraits begin to take on a deadly sameness of aspect : we
get the incessant repetition of little profiles treated in imitation of
cameos, in the same oval medallion set in the same frame, bearing
the same label. Individual character and personal accent dis-
appear; the supple talent of Saint-Aubin is hopelessly crippled
and never regains its spring. The fire and grace which animate
even the little etching of " L'Indiscrétion vengée " have fled the
pencil which decorates the pages of the " Siècle de Louis XIV "[2]
with heads of La Vallière, Montespan and other illustrations of his
Court, in company with wretched drawings from the enfeebled
fingers of the once brilliant Moreau le jeune.[3]

On the 21st April, 1806, Augustin writes pitifully to Renouard
begging for a little money : " You sent me," he says, " only
200 fr. last time, if it is possible for you to give me 300 fr.
this month, it would give me pleasure." Moreau was even
more sadly insistent : " I entreat M. Renouard to help me," he
writes in a letter of February, 1814, " for I do not know where to
turn. I have not a farthing."[4] In the same year he was attacked
by cancer in the arm, and within a few weeks of his death he re-
peated his application. " I am grieved, sir," he says, " to worry
you, but I am forced to do so, being unable to work at present as my
arm is useless. It seems that from now till the end of the year
I cannot hope to use it freely ; having no chance of receiving
money till the end of January, I apply to you to get some as soon
as possible ; I count on you for this week, without fail."[5]

The career which closed thus disastrously had opened with
early and unusual brilliance, prolonged throughout a period of un-
usual productiveness and prosperity. Moreau, who was the son of
a " perruquier de la rue de Buci," was chosen by Le Lorrain, at

[1] He had no lodgings there, only a studio. See his letter to the Minister Paré
(de Goncourt, " L'Art du XVIII. Siècle," t. i., pp. 395-396).

[2] Paris, 1808.

[3] 1741-1814. R. April 23rd, 1789.

[4] Adrien Moureau, " Les Moreau," pp. 132, 133. There is, I think, a catalogue
of Moreau's sale which shows that he had not parted with his collections. It is
possible that they could not be sold except at a great loss.

[5] Ibid., pp. 133, 134.

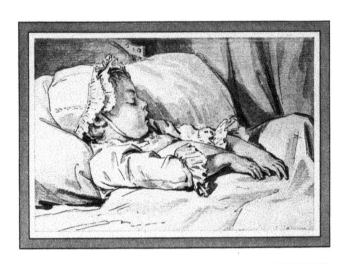

the early age of seventeen, to accompany him to St. Petersburg. There he was appointed—as we learn from his daughter, who became Madame Carle Vernet—" premier professeur de dessin à l'Académie Impériale,"[1] but Le Lorrain died and Moreau returned to Paris eighteen months after he had left it.

In Paris, Moreau found his way rapidly to fortune. He entered the workshop of Le Bas and in 1761,[2] at the age of twenty, he signed his first engraving. This early work has not the beauty or character which soon began to distinguish the execution of his drawings. During the next three or four years he seems to have been wholly occupied in preparing plates for other people. Thus he brilliantly etched, after Greuze, " La Bonne Education " and " La Paix du Ménage," both of which were finished by that unworthy pupil of Flipart, Pierre-Charles Ingouf. The charming " Philosophie endormie," on which we read " Aliamet direxit," was also etched by Moreau. The engraving of " David and Bathsheba," after Rembrandt, which is dated 1763, is entirely by him, but it only shows that, in spite of his extraordinary facility and skill, he has utterly failed in the attempt to work in the manner of that mysterious master.

In 1765 Moreau's marriage with Françoise-Nicole Pineau,[3] the granddaughter of the publisher Pierre Prault, and niece of his successor Laurent, probably determined the bent of his career. Thenceforward we find him incessantly employed in the illustration of books. Miniature editions of the Italian classics were then appearing " In Parigi, appresso Prault," and in the year of Moreau's marriage Prévost was engraving for the " Pastor Fido " of Guarini the vignettes which had been designed for its illustration by Cochin twenty years before (1745). Moreau added the title-page, and though in many others—as in that to the " Tempio di Gnido"—he showed himself a more consummate artist, I do not think that in the whole range of this lovely form of art there is anything more finely touched than the voluptuous movement of the two doves, who, nestling down on the quiver and arrows in the centre, give each other the kiss of love.

[1] " Notice historique par sa fille, M^{me} Carle Vernet " (A. de l'A. fr., t. i., p. 183). See also " Eloge par M. Feuillet " (" Moniteur," 1814, No. 355) and " Eloge par M. Ponce " (" Mercure," June 15th, 1816).
[2] This date is given by MM. Portalis and Béraldi as " 1781," an obvious misprint for " 1761."
[3] Françoise-Nicole was the daughter of Dominique Pineau and Jeanne-Marine Prault. See Emile Biais, " Les Pineau," p. 116. MM. Portalis and Béraldi are, I think, in error when they state that she was the daughter of François Pineau. François-Nicolas Pineau was the brother of Françoise-Nicole. See ibid.

The
Saint-
Aubin,
Moreau
le jeune,
Boilly,
Prieur.

The work on which Moreau was immediately employed after drawing this little gem was the designing and engraving all the tailpieces for Prault's edition of that "Histoire de France," by President Hénault, which was further and most brilliantly adorned by Gaucher's miniature portrait of Marie Leczinska, set in a frame that Choffard alone could have invented. The proof of extraordinary gifts shown in Moreau's work for Prault[1] brought him, from Basan and Le Mire, the proposal to join the band then engaged upon their famous Ovid, whilst Le Bas continued to keep him busy with etching plates which he himself afterwards finished and signed.

In this way Moreau became associated in 1768 with the production of that famous *estampe galante*, the "Couché de la Mariée," which was finished and signed by Simonet after Baudouin. Two years earlier Moreau had engraved after Le Paon—a very inferior draughtsman—the " Revue de la Maison du roi au Trou d'Enfer." I do not know the drawing made by Le Paon for this engraving, but anyone who has seen other drawings by him and noted their peculiar mannerisms must necessarily suppose that there is a great deal less of Le Paon than of Moreau in the work as we now have it. In any case we owe Le Paon a debt of gratitude in that he inspired Le Bas to order of Moreau—as a companion to the "Revue de la Maison du roi au Trou d'Enfer"—the famous drawing of the "Revue de la Plaine des Sablons."[2]

Moreau's nomination in 1770, "sur la présentation même de Cochin," as "dessinateur des Menus Plaisirs"[3] gave him an assured position which permitted the free exercise of his talent and marks the moment when much of his best work was produced. It was the year in which his little daughter, whose slumber he has sketched with so much charm, was born to him— she to whose pious devotion we owe the collection of her father's work in the Print Room of the Bibliothèque Nationale and the short sketch of his life written with the tenderness that befits a daughter much beloved.[4]

[1] Perhaps the finest work of this class by Moreau is "Les Graces," engraved after Moreau by N. Delaunay, in Du Querlon's "Les Graces" (see p. 106, note 9). It is far superior to the other four illustrations by Moreau in the same volume and to his four designs for Imbert's "Jugement de Paris," 1772.
[2] Engraved in 1787 by Malbeste, Liénard and Née. The drawing, one of the finest belonging to the de Goncourt, was sold at their death to M. Chauchard for 29,000 francs.
[3] A. Moureau, "Les Moreau," p. 42.
[4] The notice is written at the beginning of the first volume of the collection of Moreau's work, which fills five volumes, and is signed " F. Vernet, née Moreau, 20 Octobre 1818."

Le Retour de Claire: "Nouvelle Héloïse," 1774-1783.
(Le Mire, after Moreau le jeune.)

it. In any case we owe of gratitude inspired Le Bas to ... Moreau—as a compani "Revue de la Maison d... ... Trou d'Enfer"—the fan ing of the "Revue de la Plaine des Sablons."[2]

Moreau's nomination in 1770, "sur la présentation Cochin," as "dessinateur des Menus Plaisirs"[3] gav assured position which permitted the free exercise of the moment when ... of his best work dated. It was the year in which his little daughi ... ber he has sketched with so much charm, was ... she to whose pious devotion we owe the collection of h work in the Print Room of the Bibliothèque Nation short sketch of his life written with the tenderness th daughter much beloved.[4]

[1] Perhaps the finest work of this class by Moreau is "Les Gr after Moreau by N. Delaunay, in Du Q...lon's "Les Graces" (see It is far superior to the other four illustrations by Moreau in the sa to his four designs for Imbert's "Jugement de Paris," 1772.
[2] Engraved in 1787 by Malb..., Lienard and Née. The drawin finest belonging to the de Goncourt, was sold at their death to M. 19,000 francs.
[3] A. Moureau, "Les Moreau," p. 42.
[4] The notice is written at the beginning of the first volume of th Moreau's work which ... five volumes, and is signed "F. Vernet, n October 1816."

140

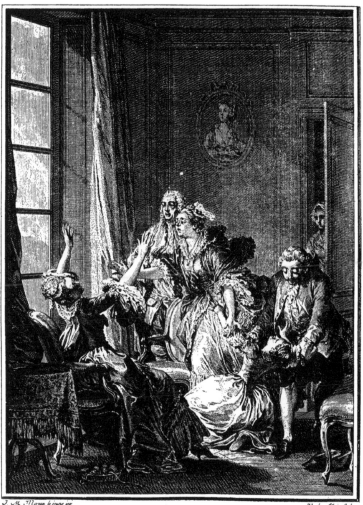

Nothing at this point was wanting to perfect the astonishing good fortune which waited on Moreau's footsteps and brought him fame and honour and prosperity at the age when most men have their spurs to win. That some of his best work was done when he was about thirty is a noteworthy fact. Amongst it we must reckon the twenty-six illustrations which he engraved himself and contributed to the " Chansons," before he quarrelled with Laborde;[1] those which he prepared for the edition of Molière, published in 1773, and the fine plates in the " Nouvelle Hèloïse " produced in the following year.[2] These last are treated with a breadth which one would scarcely expect from the same hand which, in 1772, had given us the four superb miniatures contributed, together with various minor subjects, to Desormeaux' " Histoire de la Maison de Bourbon."

Of these, as of other book-illustrations by Moreau, we may say that those in which he treats personages of his own day, wearing the costumes of his own century or the traditional costumes of the French stage—which were incorporate, so to say, in the daily national life—are invariably the best. Like Gravelot, Moreau seems bored by classic drapery and conventional nudities; his drawings for the " Princesse d'Élide " remind us of those executed for the tragedies of Voltaire,[3] at a date when Moreau's brilliant faculties had begun to fail him, whereas in illustrating a scene from " La critique de l'Ecole des Femmes " or " Les précieuses ridicules " he is brilliantly intelligent and free from the tiresome mannerisms which disgrace the work of many of his rivals, as, for example, Eisen.

In the " Monument de Costume "[4] we find perhaps the finest example of the brilliant sincerity of Moreau's work. He gives us no mere set of fashion plates such as limited the ambition of the publisher Eberts, at whose instance the work was undertaken, but a series of drawings which represent phases of the life of a definite social class. The first illustrate the childish days of the girl, and then Moreau goes on to give us the most intimate details of the

[1] See p. 109, note 3. The drawings, together with those of the other volumes, are at Chantilly. The frame of the dedication, drawn also by Moreau, is engraved by Masquelier.

[2] " Œuvres de Jean-Jacques Rousseau. Londres, 1774-1783."

[3] In the Procès-verbaux of the Royal Academy, February 3rd, 1781, we find the entry of a " Prospectus pour une suite d'estampes, destinée à décorer la nouvelle édition de M. De Voltaire . . . M. Moreau le jeune, Graveur et dessinateur du Cabinet, et Agréé de ladite Académie . . . permission de faire paroître sous les auspices de l'Académie."

[4] See p. 109. The dates on the engravings show that the first were begun in 1776, the last of the second set finished in 1783.

The
Saint-
Aubin,
Moreau
le jeune,
Boilly,
Prieur.

existence of the young married woman. We see her in the stages of her motherhood: "La déclaration de la grossesse" and "N'ayez pas peur, ma bonne amie," are followed by "C'est un fils, Monsieur," and "Les délices de la maternité." Then come her court appearances, her coquetries, her assignations, her walks and rides in the Bois.[1] In the third series Moreau sets before us the youth of a similar class developing through various stages of gallantry and pleasure till he becomes the not much married man. One of this set—brilliantly engraved by Malbeste—is perhaps the most beautiful of all. It has been diversely christened "La Sortie de l'Opéra" and "Le Mariage"; it seems, on the whole, to be more probably "Le Mariage," and as such I have therefore reproduced it here.[2]

At the height of his power there came to Moreau a great opportunity. The office which imposed on him such futilities as allegorical drawings on the recovery of the Countess d'Artois,[3] brought him the great spectacle of the coronation of Louis XVI. His rendering of this subject embodies a moment of exalted vision in the most impressive character. No scene of royal pomp has ever been depicted with greater perfection and fulness of insight and with more exquisite and masterly art. The conception ot the magnificent picture by David of the coronation of Josephine by Napoleon is not of a higher order.

The extraordinary significance of the scene lifts it into a different order of interest from that occupied by the equally brilliant "Louis XV à la Plaine des Sablons," whilst both these works stand infinitely above anything of a similar character afterwards produced by Moreau. The "Sacre de Louis XVI" is the apotheosis of the old *régime* seen in all the blinding glory of royal state and consecrated by the holy magic of the Church. The pictorial effect of the composition is far finer than that achieved

[1] In this set Martini engraves the "Déclaration de la Grossesse" and "Les Précautions"; Trière, "J'en accepte l'heureux présage"; Helman, "N'ayez pas peur, ma bonne amie," "Délices de la Maternité" and "L'Accord parfait"; Baquoy, "C'est un fils, Monsieur"; Baquoy and Patas, "Les Petits Parrains"; Guttenberg, "Le Rendez-vous pour Marly" and "Rencontre au bois de Boulogne"; Delaunay le jeune signs "Les Adieux."

[2] The third set opens with the engraving by Halbou of "Le Lever"; Martini follows with "La petite Toilette"; Trière engraves "La Grande" (repeated by Romanet for the edition as published; see Bocher, p. 493); Guttenberg, "La Course des Chevaux"; Camligue, "Le Pari gagné"; Dambrun, "La Partie de Wisch"; Thomas, "Oui ou Non"; Delignon, "Le Seigneur chez son Fermier"; Patas, "La Petite Loge"; Malbeste, "La Sortie de l'Opéra"; Helman, "Le Souper fin"; and Simonet, "Le vrai Bonheur."

[3] Ex. 1783. The drawing is now in the Musée de Bayeux (N. A., 1874-1875, p. 347).

... the King, there is, indeed, no room for thery which entertains us in the "Bal masqué" or ... du roi," but this is more than compensated by the ...otative character of the various actors.

The drawing and engraving of the "Cérémonie du Sacre" were exhibited by Moreau at the Salon of 1781, together with an immense group of other work, amongst which may be specially noticed the "Dessin de l'Illumination, ordonnée par M. le Duc d'Aumont, pour le mariage du Roi"; the "Dessin représentant Louis XV à la Plaine des Sablons"; many drawings for "L'Histoire de France" — some of which are specially marked as "appartenant à M. Le Bas" — and others for the Brussels edition of the works of Rousseau, in which the kneeling figure placed beside the tomb of Jean-Jacques was obliterated by order of the Censor. Other groups of illustrations are for Metastasio, for the "Henriade," for the "Description générale de la France," but the splendour of the collection was not enhanced by the inclusion of the drawing representing "L'Arrivée de J. J. Rousseau au séjour des Grands Hommes; sur le devant, Diogène souffle sa lanterne," Moreau's first essay in a style which found its most ridiculous expression in "La réception de Mirabeau aux Champs-Elysées" exhibited by him in 1800.

Before we reach that date we have gratefully to remember the four famous drawings of the "Fêtes de la Ville à l'occasion de la naissance de Mgr. le Dauphin" which appeared at the Salon of 1783 in company with "Douze dessins pour les Œuvres de Voltaire, dont la collection est dédiée à S.A.R. Frédéric-Guillaume, Prince de Prusse." Those for the Tragedies, Comedies and "Contes" — eighteen in all — appeared together with the frontispiece in 1785; seven more were exhibited in 1787, together with "Un grand dessin représentant l'Assemblée des Notables. Dessin ordonné par le Roi."

In this year, too, Moreau ... bethought himself of his duties ... the ... The "... " party probably saw in that he should qualify himself to

... ... to be met with and is of ...

... Mount Engraved by Masquelier, 179.

la Rose de V.X.L, Feu d'Artifice, le Festin Royal, ...

... Rupp., G. E. A., 1889. The ...

(X.

(N. A.,

LEAVES FROM A SKETCH-BOOK (MUSÉE DU LOUVRE).
(MOREAU LE JEUNE.)

in any similar work by Cochin. The attention of everyone being The Saint-Aubin, Moreau le jeune, Boilly, Prieur. concentrated on the King, there is, indeed, no room for the amusing byplay which entertains us in the " Bal masqué " or the " Jeu du roi," but this is more than compensated by the representative character of the various actors.

The drawing and engraving[1] of the " Cérémonie du Sacre " were exhibited by Moreau at the Salon of 1781, together with an immense group of other work, amongst which may be specially noticed the " Dessin de l'Illumination, ordonnée par M. le Duc d'Aumont, pour le mariage du Roi "; the " Dessin représentant Louis XV à la Plaine des Sablons " ; many drawings for " L'Histoire de France "—some of which are specially marked as " appartenant à M. Le Bas "—and twenty-nine for the Brussels edition of the works of Rousseau, in which the kneeling figure placed beside the tomb of Jean-Jacques was obliterated by order of the Censor. Other groups of illustrations are for Metastasio, for the " Henriade," for the " Description générale de la France," but the splendour of the collection was not enhanced by the inclusion of the drawing representing " L'Arrivée de J. J. Rousseau au séjour des Grands Hommes ; sur le devant, Diogène souffle sa lanterne,"[2] Moreau's first essay in a style which found its most ridiculous expression in " La réception de Mirabeau aux Champs-Elysées "[3] exhibited by him in 1800.

Before we reach that date we have gratefully to remember the four famous drawings of the " Fêtes de la Ville à l'occasion de la naissance de Mgr. le Dauphin "[4] which appeared at the Salon of 1783 in company with " Douze dessins pour les Œuvres de Voltaire, dont la collection est dédiée à S.A.R. Frédéric-Guillaume, Prince de Prusse."[5] Those for the Tragedies, Comedies and "Contes"—eighteen in all—appeared together with the frontispiece in 1785 ; seven more were exhibited in 1787, together with " Un grand dessin représentant l'Assemblée des Notables. Dessin ordonné par le Roi."

In this year, too, Moreau also bethought himself of his duties towards the Academy. The " progressive " party probably saw in him a useful ally and suggested that he should qualify himself to

[1] The etching for this plate is not unfrequently to be met with and is of extraordinary beauty.
[2] Engraved by Macret. [3] Engraved by Masquelier, 1792.
[4] L'Arrivée de la Reine à l'Hôtel de Ville, le Feu d'Artifice, le Festin Royal, le Bal masqué. See article by M. Germain Bapst, G. B. A., 1889. The drawings were exhibited in 1783, the engravings in 1789.
[5] See the letter concerning the Voltaire to Beaumarchais, July 15th, 1782 (N. A., 1872, p. 385).

The
Saint-
Aubin,
Moreau
le jeune,
Boilly,
Prieur.

vote. A drawing of "Tullie, faisant passer son Char sur le corps de son Père" of which we are told that it was to be engraved "pour la réception de l'auteur" appeared together with the King's drawing of the "Assemblée des Notables." The engraving was delayed by its author's absence from Paris, but a drawing of the same subject appeared a second time at the Salon in 1789, with the note, "C'est le morceau de réception de l'auteur,"[1] and from that date onwards we shall have no more delightful water-colours such as the piquant "Souper à Louveciennes,"[2] that *chef-d'œuvre* of distinguished feasting, but cuts for the Old and New Testament[3] in the commonest taste and plenty of false sentiment in illustration of the "Lettres d'Héloïse et Abailard."[4]

Like all the set to which he belonged, Moreau lost his fortune, his gift and his style in the throes of the Revolution. A change for the worse in the character of his work dates from the tour which he made in Italy in 1785,[5] of which Madame Carle Vernet says that "in less than two years, one saw a new man, as much superior to his old self as he had been previously to his contemporaries." This statement is confirmed by the "Sketch-book" of 1785, which is in the possession of Mr. Heseltine. It is clear from the "academies" of the opening leaves—helmeted heroes straddling behind shields—that Moreau is already on the decline, but he makes two graceful drawings of French landscape, probably on his way south, and at Venice completely recovers himself, and the pages are filled with a series of brilliant studies of the men and women before him. After his return and his reception by the Academy he fell an easy prey to the tendencies of which David was the chief exponent, and became absorbed by the internecine struggles which divided his *confrères*. On behalf of David he even had an active skirmish with Vien during the turbulent meetings of 1790, the sentimental close of which brought tears, we are told, to their eyes.[6] Wille himself was closely allied in all these disputes with Moreau, to whom, shortly before, he had been "parrain" on his unanimous reception as a full Academician.[7]

The temper which Moreau developed may be judged from the

[1] It was engraved by Simonet in 1791. See Bocher, p. 107.
[2] In the Musée du Louvre.
[3] These are dated 1790, 1791 and 1792. Those of the New Testament were exhibited in 1791, others of the Acts of the Apostles in 1796, and eighteen for the "Testament de Saugrain" in 1798, together with the forty-seven drawings for Renouard's edition of Gessner.
[4] Edition published by Didot le jeune, 1796.
[5] N. A., 1878, p. 62. [6] Wille, Mém., Sept. 23rd, 1790.
[7] See P. V. and Wille, Mém., April 25th, 1789.

letter written by him from Paris "ce 27 jenvier 1791" to his brother-in-law François-Nicolas Pineau. "Quand à notre ville," he says, "tout va assé bien excepté le clairgé qui nous tracasse un peut, mes nous en viendrons à bout il faut l'espérer ; mais ces M. M. sieurs sont diablement coriace, mes il trouveron plus dur qu'eux. Hier et avan hier nous avons instaler nos 6 tribunaux ; ce la fei passer a merveille."[1] From this time onwards Moreau's second manner became more and more accentuated. Drawings such as fill the pages of his sketch-book in the Louvre,[2] full of human interest and spontaneous charm, were too trifling for the newly-acquired dignity of *l'homme libre*, and the laboured composition of "Tullia," which, as we have seen, was presented by Moreau to the Academy on his reception, did but open the long series of empty and stilted work by which he paid homage to his new ideals and turned his back on art, which draws vitality from the senses rather than from reason. "Une influence étrangère," as M. Duplessis puts it, "changea tout d'un coup sa manière et sembla paralyser ses facultés."[3]

In 1798 Moreau's fortunes had fallen so low that he was glad to accept the post of Professor of Drawing at the "Ecoles Centrales."[4] Under the Empire he made vain attempts to renew his youthful successes : the tide had turned, and when Louis XVIII., in 1814, compassionately restored Moreau to his old post of "dessinateur du Cabinet du roi" he held it but for a few months before his death.[5]

The companions of Moreau's brilliant past had dropped one by one into poverty and neglect. Choffard—the unrivalled "graveur de l'accessoire" who was never trivial, not even when he was only sketching his own trade-card, or inventing an "ex libris," or drawing the frame for a portrait by Gaucher or by Ficquet—was obliged to occupy his time in writing the "Notice sur la gravure" which he published in 1804. A few years later he too died in poor circumstances, forced to undertake the most inferior work to get a little money for his daily needs.[6] The days were long past

[1] Emile Biais, "Les Pineau," p. 131.
[2] See the article by M. Lafenestre, G. B. A., 1888.
[3] "Merveilles de la Gravure," p. 278. This little book, in spite of one or two inaccuracies, is more original and suggestive than the "Histoire de la Gravure en France," an earlier work by the same author.
[4] See Salon, 1798, in which he is entered as "Moreau jeune, . . . professeur aux Ecoles Centrales de Paris au Palais national des Sciences et des Arts."
[5] See letters of Feb. 8th and March 26th published by M. Emile Biais, "Les Pineau," pp. 134, 135. His last and perhaps worst work is the Crébillon published by Renouard in 1817, three years after Moreau's death.
[6] See letter of the engraver Legrand to Mme. de Charrière (Portalis and Béraldi, t. i., p. 423).

145 U

The
Saint-
Aubin,
Moreau
le jeune,
Boilly,
Prieur. when, as Wille so often chronicled in his journal, publishers, engravers, painters feasted together; when joyous dinners and suppers united the friends and pupils of Le Bas; when Papelier and Eberts entertained Flipart and Choffard, Chardin and Roslin and Vien, or " my wife and I and our two sons " dined with " Delaunay the engraver, to meet M. and Mme. Lempereur, M. and Mme. de Saint-Aubin, M. Choffard and others." [1]

Conspicuous amongst the few men who flourished prosperously both before and after the days of the Revolution was Louis Boilly.[2] In fact he lived so late into the nineteenth century that one is surprised to find that he had nearly fallen a victim to republican zeal for morality in 1794. The licence of certain subjects of his pencil was denounced by a brother artist to the Société Républicaine des Arts, and by that society to the Comité du Salut Public ; Boilly was lost, had it not been that a timely warning enabled him to destroy the offending "sujets de boudoir" and begin a sketch for the "Triomphe de Marat," an achievement which, coupled with the declaration " qu'il expie les mœurs d'une composition un peu libre en exerçant son pinceau d'une manière plus digne des Arts," procured his absolution.[3]

In spite of that incessant activity as a painter of small portraits,[4] and as a draughtsman and lithographer, which was imposed on Boilly by the necessities of his numerous family, it is as a painter of "sujets de boudoir," such as drew on him the thunders of the Société Républicaine, and of scenes from everyday life that he deserves to be remembered, to be consulted and admired. Amongst the most charming specimens of this class of his work are " Le Cadeau délicat," " Les Chagrins de l'Amour," " Poussez ferme " and " La douce Résistance," catalogued by M. Harrisse, together with three other subjects, as in the Wallace Collection, but his talents as a great draughtsman—the equal of the best in his day, which was a day of great draughtsmen in France—are better shown in his drawings and sketches. As an example of a less familiar class may be instanced " L'Arrivée d'une Diligence," in the Musée du Louvre, and his fine composition, " Départ des Conscrits de 1807," in the collection of M. Lehmann.

The qualities which mark these remarkable examples of the

[1] Wille, Mém., Feb. 12th, 1765, and Sept. 25th, 1774.
[2] 1761-1845.
[3] Henry Harrisse, "Louis Boilly, Peintre, Dessinateur et Lithographe," pp. 13-15.
[4] A fine series of these, including the charming "Portrait de femme en robe grise " (belonging to Dr. Piogey), were seen at the Exposition Centennale in 1890. The preface to the catalogue entitled " Un Siècle d'Art " contains some excellent notes on Louis-Léopold Boilly by M. Armand Dayot.

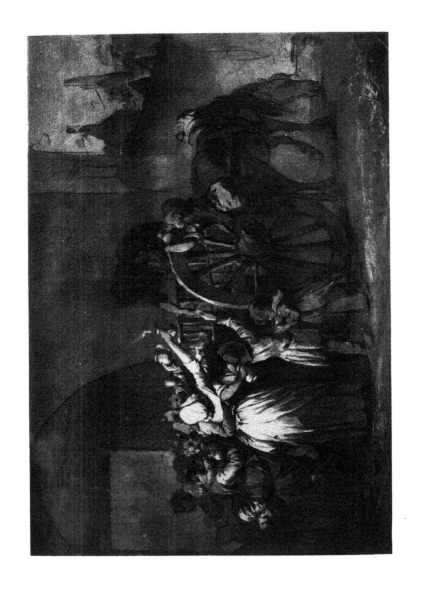

Les
Saint-
Aubin,
Moreau
le jeune,
Boilly,
Prieur.

... Boilly during his early years in Paris are to be
... the beautiful " La Queue au Lait," which is here repro-
... The pure truth of the types and attitudes, the harmonious
... of the very clothes worn by those who are pressing
..., with admirable unity of movement, speak of the perfect
... of hand and eye which distinguished this fine draughts-
man.

It is scarcely possible to overestimate the importance of this
part of Boilly's work in relation to the anecdotic history of the
time. We are at the same time to be congratulated in that, in
his earlier days at least, it presents features of beauty and artistic
value. As a rule the drawings which impose themselves as docu-
ments are barely entitled to attention in any other respect. Those
executed by Jean-Louis Prieur for the "Tableaux de la Révolution
Française" do not belong to this category, but they show us the
progressive deterioration which overtook the work of an artist who
gave himself up to the passions of the Terror. Most of the men
who were affected by the revolutionary movement were inspired,
like Moreau le jeune, by a mild enthusiasm for "l'homme libre"
and classical costume, or followed David into stilted heroics and
the severer duties of citizenship. Prieur went mad with blood.

Of the sixty-eight drawings by him now in the Louvre, the
first were begun in 1789, when Prieur married and settled in the
Faubourg St. Denis. These—numbering thirty-one—are out of all
proportion to the fifteen allotted to the events of 1790; the later
years are still less liberally illustrated, for Prieur became more and
more absorbed in politics, until he was forced to accept, in Septem-
ber, 1793, the fatal post of "juré au tribunal révolutionnaire."
Slipped between the leaves of the text of the "Tableaux de la
Révolution," these drawings, till recently, escaped attention, but
have now been the subject of a very complete study by M. Jean
Guiffrey in the pages of "L'Art." There he has summed up all
that is to be known of Prieur; of the early days ... let us add,
... brought him into connection with François ... and of
... the northeast, the engraver, ... out of all these

style developed by Boilly during his early years in Paris are to be found in the beautiful "La Queue au Lait," which is here reproduced. The pure truth of the types and attitudes, the harmonious expression of the very clothes worn by those who are pressing together, with admirable unity of movement, speak of the perfect certainty of hand and eye which distinguished this fine draughtsman.

If it is scarcely possible to overestimate the importance of this group of Boilly's work in relation to the anecdotic history of the day, we are at the same time to be congratulated in that, in in his earlier days at least, it presents features of beauty and artistic value. As a rule the drawings which impose themselves as documents are rarely entitled to attention in any other respect. Those executed by Jean-Louis Prieur[1] for the "Tableaux de la Révolution Française"[2] do not belong to this category, but they show us the progressive deterioration which overtook the work of an artist who gave himself up to the passions of the Terror. Most of the men who were affected by the revolutionary movement were inspired, like Moreau le jeune, by a mild enthusiasm for "l'homme libre" and classical costume, or followed David into stilted heroics and the severer duties of citizenship. Prieur went mad with blood.

Of the sixty-eight drawings by him now in the Louvre, the first were begun in 1789, when Prieur married and settled in the Faubourg St. Denis. These—numbering thirty-one—are out of all proportion to the fifteen allotted to the events of 1790; the later years are still less liberally illustrated, for Prieur became more and more absorbed in politics, until he was forced to accept, in September, 1793, the fatal post of "juré au tribunal révolutionnaire." Slipped between the leaves of the text of the "Tableaux de la Révolution," these drawings, till recently, escaped attention, but have now been the subject of a very complete study by M. Jean Guiffrey in the pages of "L'Art." There he has summed up all that is to be known of Prieur; of the early days in the Temple, which brought him into connection with Fouquier-Tinville, and of his work for Berthault[3] the engraver, who—out of all those

[1] 1759-1795. He was brought up in the Temple, where his father, Louis Prieur, had taken refuge on account of debt. Condemned to death after Thermidor, he was guillotined at the age of thirty-six. See Guiffrey, "Les Dessins de Prieur, etc." ("L'Art," Oct. 28th, 1901, p. 439).
[2] Renouvier, "Hist. de l'Art pendant la Révolution," t. i., pp. 59-60, and Maurice Tourneux, "Bibliographie de l'Histoire de Paris pendant la Révolution Française," t. i., p. 33 *et seq.*
[3] 1737-1831. See Guiffrey, *ut supra*; also Renouvier, "Hist. de l'Art pendant la Révolution," t. i., pp. 60-61.

The
Saint-
Aubin,
Moreau
le jeune,
Boilly,
Prieur.

engaged on the "Tableaux de la Révolution"—alone died a natural death.

The drawings themselves make a fitting close to the story of this century of art. In them an extraordinary chord is struck which includes all the gaiety, the thoughtlessness, the courtliness of the *ancien régime*. We pass from the enthusiastic " Repas des Gardes du corps " and see the fine air of royal representation that clothes "Le roi à l'hôtel de Ville de Paris, 7 Juillet 1789"; then the fervour of the " Vœu patriotique. Assemblée nationale. 7 Septr 1789," seizes on us and prepares the way for a growing popular excitement: the " Place Louis XV " is strewn with headless busts, and as yet passion may be contented by the ruin of things inanimate. Turn the pages and there is the terrible arrest at Varennes. Royalty huddled in the miserable room of a miserable inn ; the rabble swarming, hustling from the stairs; the King obscured by a countryman's coat, the Queen with a toy hat knocked on one side of her head; both seen with the illuminating vision of hate. Turn the page again and the tumbril rolls along with its terrified burden and the heads are bleeding from the pikes.

The quality of Prieur's work steadily degenerates as he becomes more and more fervent, developing finally into " l'un des suppôts de la Terreur." Moreau lost his individuality—as did most of the men who were then swept clear of the convictions of a lifetime by the popular current. Prieur lost his art. His later drawings are not to be compared for precision, for wit, for variety of incident with those which open the series of the " Tableaux de la Révolution Française." If we wish to think of him as an artist we must turn back to the earlier pages of this series, to the crowds which almost remind us of the inimitable skill of Cochin, to the " Repas des Gardes du Corps " and the " Roi à l'hôtel de Ville de Paris."

LA FÊTE DE LA FÉDÉRATION.

Drawing for "Tableaux de la Révolution" (Musée du Louvre) showing the
Triumphal Arch erected on the Champ de Mars.

(JEAN-LOUIS PRIEUR.)

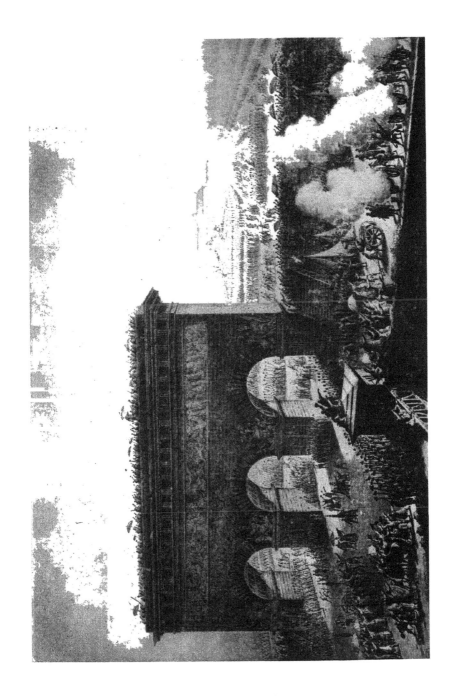

CHAPTER X

THE ENGRAVERS IN COLOUR

ONE of the most popular examples of the work of Augustin de Saint-Aubin, the charming figure in disordered dress crying " Soyez discret," is most popular of all in the coloured version. The existence and renewed popularity of these coloured versions of much work, the beauty of which is scarcely enhanced by this treatment, bear witness to the popular interest in scientific questions, which accompanied the movement of the Encyclopædists and reflected itself in the eager pursuit by engravers of new processes.

The varieties of method which came into vogue were endless. As a first step we have seen that obvious divisions of labour were accentuated. One group were engaged in preparing plates *à l'eau-forte*, whilst others, who only worked with the *burin* or graver, formed a class apart termed *les finisseurs*. Then the graver was taught to affect the picturesque play of the etching needle. The Academy actually deliberated on the subject, and Nicolas Dupuis—as we have seen—in proof of zeal, began and finished after Carle Van Loo the curious print of "Enée portant son père " entirely with the graver, employing it as if it were the point.

To imitate by engraving the effect of a chalk drawing was the next problem to be solved. The attempts made in this direction by Jean Lutma and by Leblond[1] had long been forgotten, when

[1] Mathieu Marais, under the date of April 29th, 1721, notes that Desmaiseaux has sent over to the Chancellor, who has shown to the Regent, specimens of " peinture imprimée " by a Frenchman named Leblond who had withdrawn to England. These specimens comprised portraits of the King, the Queen, etc., etc. Leblond is called an " Allemand " by the de Goncourt, "L'Art du XVIII. Siècle," t. ii., p. 273.

François, a " graveur de vaiselle " at Nancy,[1] presented to Marigny in 1756 six sheets of prints *à la manière du crayon* and received in acknowledgement a pension of 600 lt. and the title of " graveur des dessins du Roi." In the following year he appeared before the Academy with " des estampes qu'il a gravées dans une manière non usitée jusqu'à présent qui imite le maniement large du crayon." He received from them a certificate that his invention would be of service in the reproduction of the drawings of the old masters.[2] To him succeeded Magny and Gilles Demarteau,[3] who claimed attention for another process and was, in his turn, succeeded by Bonnet,[4] Jean and Dagotti Gautier[5] and others, each with some variety of the same invention. The imitations of pastel by Bonnet are remarkable, but the chief place was maintained by Demarteau, who, after having been *agréé* in April, 1766, on a set of his works " dans le genre qui imite le crayon," was received three years later,[6] having meanwhile distinguished himself by an " essay . . . dans lequel il imite le mélange des deux crayons, rouge et noir."

With this " essay " it is recorded that " la Compagnie en a esté satisfaite,"[7] for Demarteau had contrived a " roulette " with which he rendered Boucher's drawings in red chalk so as to deceive at first sight even a practised eye. Amongst the best of these is the " Femme couchée sur le ventre " and her companion " Nymph," both drawings " du portefeuille de M. Nera,"[8] but he made his first appearance at the Salon of 1767 with five subjects of less importance after the same master. These were " Un grouppe d'Enfans ; Une tête de femme ; Deux petites têtes, Imitant le dessin à plusieurs crayons," and "Une Femme qui dort avec son enfant."[9] To this imitation of drawings " à plusieurs crayons" Demarteau returned in 1771, when he showed " Une tête de

[1] M. Portalis, "La gravure en couleur," G. B. A., 1889.
[2] P. V., Nov. 26th, 1757.
[3] 1722-1776. See a pamphlet published at Brussels in 1883, entitled "Gilles Demarteau."
[4] 1743-1793. He applied Demarteau's invention to the imitation of pastel. Regnault says of him, "par des planches repairées parvint à imiter la peinture au pastel" (Avant propos, Catalogue Basan, p, xv, note).
[5] There seems some doubt as to the proper names of these artists. I have followed Regnault (*ut supra*) and Basan (" Dict. des graveurs "), who give the father and son thus. They will, however, be found under "Dagotti" in other works of reference.
[6] Sept. 2nd, 1769. [7] P. V., April 4th, 1767.
[8] See "French Painters," p. 50, note 5.
[9] The other subjects by Demarteau at this Salon were an "Allégorie sur la vie de feu Monseigneur le Dauphin ; La Justice protège les Arts ; Notre Seigneur au Tombeau, d'après le Caravage ; Une Sainte Catharine, d'après P. de Cortonne." "Tous ces morceaux, imitant le crayon, sont gravés," we are told, " d'après les Dessins de M. Cochin." The list is completed by an "Académie" after Carle Van Loo.

vieillard, d'après le Dessin de M. Doyen," but his "Deux Enfans jouant avec un chien," exhibited in 1773, together with "Trois Sujets de Femmes et d'Enfans. Gravés à plusieurs Crayons," and "Deux Enfans jouant avec des raisins. Gravés à l'imitation du Dessin aux trois crayons sur papier gris," exhibited in 1775—all after Boucher—were not executed till after the painter's death.

Of Demarteau's work after Cochin, the best known is the "Lycurgue blessé dans une Sédition,"[1] exhibited in 1769. To the Salon of 1771 he also sent reproductions of a study from life and an allegorical subject: "La France témoigne son affection à la ville de Liège." Two years later he produced another "Académie" after Carle Van Loo and a "Descente de Croix, d'après une Esquisse de M. Pierre"—work which was probably imposed on him by reasons of interest and from the pressure of which he would seem to have relieved himself by his studies after Boucher and by the portrait after "Vandick, à l'imitation du crayon noir et du lavé," all of which he sent, together with "La Laitiere. A plusieurs crayons, d'après M. Huet," to the Salon of 1773.

From the imitation of coloured chalks and pastels the transition was easy to the art of engraving in colour. Jean Le Prince,[2] a skilful etcher, invented a form of aquatint which led directly to this further development.[3] His secret was bought by the Academy, after his death, from his niece, to whom he had bequeathed it as the only provision which he was able to make for her.[4]

The wild life led by Le Prince and his eccentric habits account for the poverty in which he died. He gained money only to waste it, and no advantage could be offered him that he did not promptly throw away. A humble lad at Metz, he had the luck to please the Marshal de Belle-Isle and to be carried by his patron to Paris and placed with Boucher; but when scarcely eighteen he married a woman of forty, and, having spent her money, relieved her of his company.[5] His return to France after five years at St. Petersburg gave him almost as much popularity in Paris then as it might now, and was followed up by a con-

[1] See Chap. III., p. 37, note 1.
[2] 1734-1781. R. Aug. 23rd, 1765. See "L'Art en Alsace-Lorraine" and Hédou, "Jean Le Prince."
[3] P. V., Jan. 28th, 1769.
[4] D'Angiviller insisted that the Academy should take it up, granting to Mlle. Le Prince an annuity of 1,200 lt. as an equivalent. He overruled objections, declaring that he thought the company "aujourd'huy assez riche, tant par la dottation du Roy que par les concessions des Baraques [shops on the Pont Neuf] à son profit."
[5] Another story is that Le Prince returned her money before he left her.

tinuous flow of paintings, etchings and drawings of Russian
customs, ceremonies and scenes. "Il a fait en Russie," writes
Mariette, "des études sans nombre d'après nature, et il en est
revenu avec une ample collection de desseins dont il sçut tirer
parti lorsqu'il se présenta pour ètre agréé à l'Académie."

His "Baptême suivant le rite Grec" did, in fact, secure his
reception, and in the success which it obtained curiosity seems
to have played a certain part. The work had been carried out
with difficulty, " in spite," says Mariette, " of very bad health,"
and thenceforth Le Prince—probably for this reason—relaxed
his efforts and relied chiefly on the interest excited by the un-
familiar aspect of his subjects.

"Si cet artiste n'eut pas pris ses sujets dans des mœurs et des
coutumes, dont la manière de se vêtir, les habillements, ont une
noblesse que les nôtres n'ont pas, et sont aussi pittoresques que les
nôtres sont gothiques et plats, son mérite s'évanouirait."[1] And
this criticism made by Diderot on the series of works sent by Le
Prince to the Salon of 1767 applies to all that interminable pro-
cession of "Concerts Russes, Bonnes Aventures Russes, Reveils
de petits enfants Russes, Cabacks ou Guingettes Russes aux en-
virons de Moscou," in which we find the same exhibition of
magnificent stuffs and ornaments, the splendour of which is ill-
supported by the figures of those by whom they are displayed.
"Si un Tartare, un Cosaque, un Russe voyait tout celà, il diroit à
l'artiste : tu as pillé toutes nos garde-robes, mais tu n'as pas connu
une de nos passions."

When Diderot wrote thus with his usual reckless frankness,
Le Prince was only thirty-three. He was on the eve of perfect-
ing the process " au lavis " destined to have so great a popularity.[2]
In spite of the support which he derived from his situation in the
Academy and the success of his work, his affairs were always
embarrassed and he died at forty-seven in every way a ruined
man.

The famous secret once in the hands of the Academy very
soon became public. The next step was to apply colour in the
place of the wash which Le Prince had laid with a brush on the
varnish by which he covered his etched plate, and this was done
by François Janinet,[3] who describes his little print " L'Opérateur "
as " gravé à l'imitation du lavis en couleur par F. Janinet, le seul

[1] Diderot, Salon 1767.
[2] "En 1768, il a trouvé une manière d'imiter à la gravure le lavis des desseins "
(Mariette, A. B. C. Dario).
[3] 1752-1813.

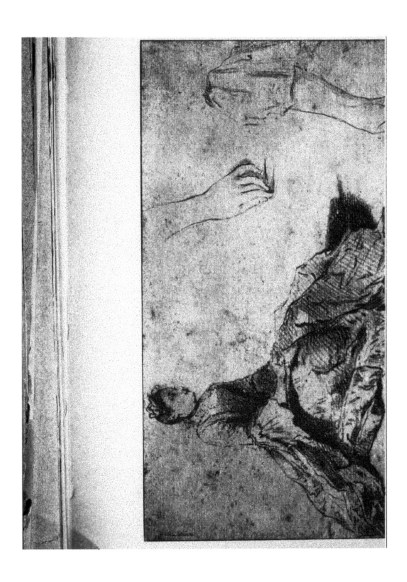

STUDY OF A WOMAN SITTING ON THE GROUND.
(Michael-Angelo.)

From the Suite de Goncourt

qui ait trouvé cette manière." His pretensions, unfortunately for himself, did not stop at the imitation of "lavie en couleur," and his disasters as an aeronaut furnish Wille with the materials for one of his most amusing pages.

"It was," he writes on the 11th July, 1784, "a Sunday devoted to sending up the balloon made by the abbé Miollan and M. Janinet, the engraver. This machine, the largest of all those previously sent up, was to start from the garden of the Luxembourg. . . . As it was a lovely day I proposed to my wife to take her to the Luxembourg itself for three livres a head, to look close on the ascension of this balloon which was one hundred and ten feet high : the two inventors, the marquis d'Arlande and a *mécanicien*, were to go up in it—but she would not agree to risk herself in such a crowd of people as would be there. We therefore went to the new boulevard, to a gardener's of our acquaintance . . . even here there were an infinite number of people. MM. Preisler, Baader, Guttenberg, Madame Guttenberg and her brother were in our party. The machine should have gone up at midday precisely ; but the poor inventors, apparently through ignorance, having been unable to fill their balloon with gas, on the contrary, set fire to it : it was burnt to ashes, and all we saw from where we sat was a thick smoke."

The abbé Miollan and "l'ami Janinet" had to fly for their lives ; the crowd tore down the barrier and threw the planks and rails of which it was composed, together with the chairs on which they had sat, into "le feu ballonique," which raged for four and twenty hours. "The next day," adds Wille, "and throughout the whole week, nothing was sold and sung but satirical ballads on MM. Miollan and Janinet ; at the same time several prints appeared to make them as ridiculous as possible."

The public heard no more of the abbé Miollan. Janinet went back to his engraving in colour which he had already brought to great perfection. His admirable rendering of the "Toilette de Vénus" after Boucher had actually been produced in 1783—the year previous to that in which he made his unfortunate attempt as an aeronaut—and his remarkable portraits of Marie-Antoinette[1] and of Mlle. Bertin, from the opalescent delicacy of their colour, look as if they might belong to an even earlier date. With these, as showing the same beautiful quality, may be grouped the clever reproductions of two medallions after Fragonard, "La Folie" and

[1] In 1781 Janinet reproduced after Huet a design in honour of the birth of the Dauphin. The head of the Queen has no resemblance to the large portrait which I take to be that of the year 1774.

"L'Amour," which are attributed to Janinet on the evidence
afforded by their execution.

It is when dealing with "boudoir-subjects" after Nicolas
Lavreince[1] that Janinet seems to be supremely happy. The
modish marionettes, daintily staged in equivocal situations, who
furnished the painter with his favourite themes, lent themselves
with facility to the skill of the colour-engraver. Lavreince cannot
handle full, strong hues without heaviness, but the white frocks
and blue ribbons, the roses and feathers of the ladies who accept
"Les offres séduisantes" or show signs of "Le Repentir tardif"[2]
are well within his scope. In these suggestive romances the airy
dress or undress of the heroines, the faint blues of their bed-cur-
tains, the violet coats of their lovers afford the very tones which
are the most effectively handled in this medium. Janinet's repro-
ductions of the two gouaches by Lavreince, "La Comparaison"
and "L'Aveu difficile" (1786 and 1787),[3] imitate the execution
of Lavreince in the most deceptive manner and are veritable
triumphs of his graceful and pleasing art. With them may be
ranked the clever print in which Janinet reproduced the portrait of
Mme. Dugazon by Claude Hoin[4] as "Nina, ou la Folle d'Amour,"
which was to be seen three years ago in a state of remarkable
preservation at the sale of the Mühlbacher collection.

"L'Indiscrétion," which Janinet reproduced after Lavreince
in 1788, is not only one of his best, but one of the last amongst
his work which were really successful. He appeared at the Salon
of 1791 with two "Scènes familières, gravées en couleur," but
these were accompanied by a "Vue du Champ de Mars, au
moment de la prestation du Serment Civique, gravure coloriée,"
and his remaining contributions were of a character that betrayed
a change of interest: "Deux dessins et une gravure d'après

[1] Nicolas Laurensen—whose surname is sometimes written "Lafrensen," and was
transformed by the French public into "Lavreince"—was born and died at Stockholm
(1737-1807). Of the works executed by him for Gustavus III. now in the Gallery
at Stockholm, the most interesting are "Tvanne Taflor en gouache, forestallande
Fêter, under Konung Gustaf d. III:s vistande i Paris, år 1784." His art belongs to
the class produced for the "fermiers-généraux" and "financiers" of Paris, towards the
close of the century. Twenty gouaches by him were sold in 1899 at the death of
M. Mühlbacher, in Paris. Two of these were of great importance, "L'Assemblée
au Concert" and "L'Assemblée au Salon" (Bocher, Nos. 5 and 6, engraved by
Dequevauviller, 1763, "Catalogue de l'Œuvre de Lavreince").
[2] Bocher, Nos. 43 and 52. The gouache of "Le Repentir tardif" was in the
Mühlbacher collection.
[3] Bocher, Nos. 12 and 8.
[4] 1750-1817. The gouaches of this Dijon master are often of great brilliance.
He has recently been the subject of an excellent study by M. Portalis, G. B. A.,
1899 and 1900.

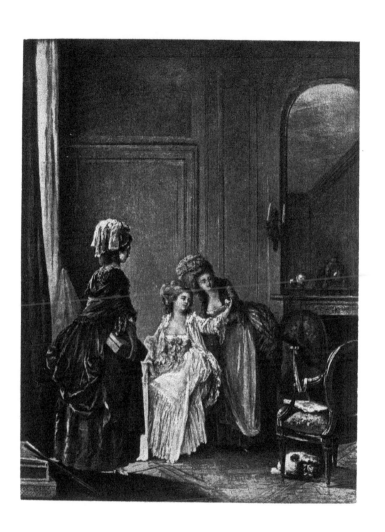

M. Moitte. Frise à l'antique." In 1793 he again returned to the work of this dull pupil of Pigalle's, exhibiting not only some drawings and an engraving of "Le premier pas de l'enfance," but two heavy reproductions of "La conspiration de Catalinat et la Mort de Lucrèce, gravés d'après les dessins de Moite."

Meanwhile the process which Janinet had invented, and the capabilities of which he had for a while illustrated with real charm, had fallen into other and stronger hands. Even before he had become a good citizen and had substituted Moitte as his model in the place of Lavreince, Janinet's methods had been mastered and most brilliantly turned to account by Louis-Philibert Debucourt,[1] who was *agréé* by the Academy on the 28th July, 1781, as "Peintre en petit sujet dans le genre des Flamands." He had exhibited an "Intérieur Flamand" at the Salon de la Correspondance during the same year, and to the Salon of the Academy contributed various works of the same class, if one may judge by titles such as "L'Instruction villageoise,"[2] "La Consultation redoutée" and "Le Juge de Village ou La Cruche cassée."[3]

He exhibited again at the Salons of 1783 and 1785, at the last of which appeared the well-known "Feinte Caresse ou Les deux Baisers," which is rather a "sujet de boudoir" than a *sujet flamand*. As the catalogue tells us, we here see "an old man looking at the portrait of his young wife, whom he is having painted, looking at his own in a locket, whilst she strokes his cheek as she leans on his shoulder and takes advantage of his foolish confidence to slip a note to the young painter who kisses her hand." The sketch for this work—the last exhibited by Debucourt at the Academy—was reproduced by the de Goncourt in "L'Art du XVIII. Siècle," when it formed part of the collection of M. Lion.

This painting seems to have been the point of departure from which Debucourt made his way to a different class of subjects. The "Feinte Caresse" is not "Flemish," neither does it represent precisely the Debucourt who made a name for himself as having imaged with surprising felicity the life and air of his epoch, for there is a touch by which we are reminded of Eisen and the "Contes de la Fontaine." In the following year[4] "La Feinte

[1] 1755-1832. [2] Engraved by Glairon.
[3] Engraved by Le Veau. The subject seems to have been suggested by Tieck's "Zerbrochene Krug."
[4] 1786. Debucourt had published several engravings in colour at an earlier date. The de Goncourt mention "La Porte Enfoncée ou les Amants poursuivis, Suzette mal cachée ou les Amants découverts et La Fille enlevée." All these works of a tentative character bear the date of 1785 ("L'Art du XVIII. Siècle," t. ii., p. 277).

Caresse" was published as a coloured engraving, but at the same
date appeared a work of a very different order—" Le Menuet de
la Mariée," of the black state of which I give an excellent
reproduction.

" Le Menuet de la Mariée" is one of Debucourt's most suc-
cessful and important works in "la gravure-gouache"; it is
superior to "La Noce au Château" (1789)—though this is amongst
his best—and may take equal rank with the famous "Promenade
de la gallerie du Palais Royal," which, apart from its interest as
an historical document, is remarkable for the evidence it affords of
quick powers of observation and taste too delicate, one would
think, to be tempted into caricature such as detracts from its com-
panion, the "Promenade du jardin du Palais Royal."

In the "Promenade du jardin du Palais Royal" we get the
first hint of the effect of the Revolution on Debucourt. The
patriotic fever, even when it was sincere, as it certainly was in his
case, rarely inspired fine work.[1] We may, however, leave on one
side the domestic virtues of republican families and the caricatures
of the strange world thrown up by the waves of revolution which
Debucourt engraved after his friend Carle Vernet. Even his
methods changed ; he lost not only his originality and charm, but
the precious secrets of his excellent art.

The grace and personal accent of the work done by him
during the five years which followed the publication of the
"Menuet de la Mariée" are such that they throw into the shade
engravings as pretty as the "Foire" and "Noce de Village,"
which Descourtis[2] engraved after Taunay.[3] For in Debucourt
we have the "graveur qui crée." Much of the peculiar merit
which renders his engravings still so delightful is doubtless due to
the fact that at first he painted his subjects before he engraved
them, and thus won a double mastery over their expression.

After 1791, in which he dates "La Rose mal défendue," we
seek in vain for any sign of this mastery over his own method. In
fact he abandons it for a "procédé nouveau découvert par l'auteur en
1792," which, if I remember rightly, is the same as that employed
by Sergent, in 1793, for "Il est trop tard."[4] The engravings

[1] See "L'Almanach national," "Le Calendrier de la République Française,"
"Les Droits de l'homme et du Citoyen," etc., etc.
[2] 1753-1820(?). He was the pupil of Janinet.
[3] 1755-1830. A., 1784. Pupil of Brenet and Casanova. See Quatremère de
Quincy, "Not. hist.," t. ii., p. 51.
[4] He exhibited "Il est trop tard, estampe peinte et gravée en couleur," in 1793,
together with two views of Chartres, two engravings of "La Soirée et la nuit de 12
Juillet, 1789," and a "Costume Républicain." In 1798 he exhibited "Portrait gravé

LE MENUET DE LA MARIÉE.
(LOUIS-PHILIBERT DEBUCOURT.)
Black state of the plate formerly in the Mühlbacher coll

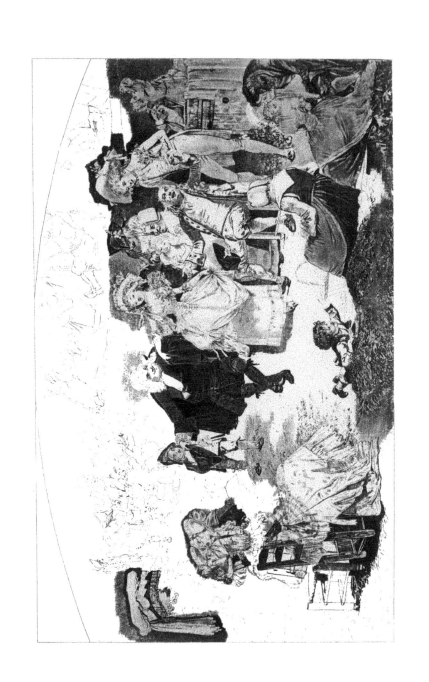

produced according to the new process have no likeness to the early work; they depend for their effect on a stipple of colour about which there can be no illusion.

The change of method was no doubt suggested by the then enormous popularity of stipple engraving. Reserved at first—as one may see in the work of Delaunay and Le Veau in the Molière of 1773—for the young faces only of figures in vignettes, it became the rage in England, where the method, as applied to the whole subject, was skilfully turned to account by Bartolozzi. In France it was employed, on the whole, with greater taste and intelligence both by Copia[1] and his pupil, Barthelemy Roger,[2] nor is it possible to withhold our admiration from the appropriate use of pure stipple to render the "effets estompés" specially character-istic of Prud'hon, though the unfortunate attempt made by Debu-court to apply it to colour-engraving wrought ruin on his entertaining and decorative art.

en couleur du général Marceau, beau frère de l'auteur," and in 1799 a water-colour :—
"Il représente les costumes des filles suisses, etc."
[1] 1764-1799. A German, born at Landau (Salon, 1798). Amongst his best work are the illustrations of "Idées sur le geste et l'action théâtrale." See Renouvier, "L'Art pendant la Révolution."
[2] 1770-1840.

CHAPTER XI

ENGRAVERS AND THE ACADEMY

IN 1752 Natoire, reporting to Marigny as to the *élèves* of the school of France at Rome, suggests that one place should be given to an engraver. This concession he urges on the ground that for the most part engravers cannot draw. He adds that, as they are admitted to the Academy, they will be worthier of the honour if they are put in possession of " un talent si nécessaire." [1]

Nothing came of Natoire's proposal, but the feeling that the training of engravers—except in what may be called the mechanical part of their profession—was insufficient determined a motion brought forward in 1790, at a moment when all other regulations were relaxed, but when, through the influence of Vien and David, the reaction in favour of a severer style and stricter method was daily gaining strength.

"They wanted," says Wille, "at one of our last meetings to make a rule that all engravers who come up to be *agréés* shall show with their engravings academy studies recently executed in the schools under the eye of a professor. This proposal shocked me and I opposed it hotly. I gave my reasons and was supported by other engravers, even by M. Pajou, our president, and the proposal was rejected. I maintained that no one ought to be humiliated, and that artists having various talents ought to be treated equally and without any distinction : that they ought all to add to their works, whether painting, sculpture, engraving, etc., drawings from the life and academies executed by them— even the flower-painters—all was agreed." [2]

[1] G. B. A., 1870, pp. 268, 270. [2] Mém., Sept. 23rd, 1790.

Wille had been chafing all his life at the inferior position which he and his fellows occupied as compared with painters and sculptors in that Academy of which he proudly records that, when visiting Marigny on New Year's Day, its representatives took precedence of the Academy of Architecture, " qui y étoit aussi." [1] The engraver, even within the fold of the Academy, found himself in a position inferior to that of other artists, whilst outside the Society the incessant commercial relations with the public—made necessary by the sale of impressions—tended to relegate him, in general opinion and in that of his fellows, to the ranks of those in trade, and also gave rise to vexed questions not only between engravers and their brother artists but between buyers and sellers. When the Revolution gave the signal for the revolt of the " agréés " against the Academicians, the engravers at once made common cause with them, under the leadership of the sculptor Pajou, and thus seized the opportunity to make better terms for themselves.

In addition to the annoyance that they had always experienced from the half-veiled contempt which accompanied the insufficient protection received from the painters and sculptors, engravers were subject to harassing attacks from printers and publishers, on whose domain they were supposed to encroach. Driven to despair " les graveurs en taille-douce " presented a memorial in 1767 to the unsympathetic Academy, imploring their intercession with Marigny in order to secure a favourable hearing for their petition, entreating his protection " pour conserver la liberté de leur art." [2]

The desired freedom unfortunately led to abuses which are set forth in a letter from Lenoir to d'Angiviller in reply to the complaints brought before him as to the libels on Mmes. Vigée Lebrun, Vallayer-Coster and Labille-Guyard, published in connection with the Salon of 1783. [3] The insults of which they complained are attributed to the abuse of the concessions which had been made to the " graveurs en taille-douce." " What has occurred, sir," writes Lenoir, " is a fresh proof of the abuses which I could have wished to have been more speedily checked. There are many cases in which, by means of line engravers or of engravers of music, violent attacks and obscenities are published contrary alike ' aux bonnes mœurs et à la bonne police,' but under the pretence of freedom, the men of this profession at Paris are not inspected; they put their presses to an ill use. . . ." [4]

[1] Mém., Jan. 3rd, 1762. [2] P. V., Sept. 20th, 1767.
[3] See Portalis, " Adélaïde Labille-Guiard " (G. B. A., Dec., 1901, pp. 483, 484).
[4] Guiffrey, " Expositions du XVIII. Siècle," p. 61.

Troubles as to the rights of reproduction and publication were also frequent. In July, 1719, the engravers presented a petition to the Academy and complained that M. Poilly,[1] in spite of their " pleintes," " contrefait tous leurs ouvrages." On this the company directed their secretary to write to Poilly, so as to give him a chance " avant de se porter contre luy à quelque juste violence."[2] Later in the century no less than six Academicians combined to object to the reproduction of their works—executed " pour le Roy "—by a certain Henriquez, a *protégé* of d'Angiviller. This was simply a protest against the employment of an incompetent hand, but piracy—such as that of which Poilly was accused—was of frequent occurrence. Augustin de Saint-Aubin in November, 1788, attacked Delaunay, his fellow *agréé*, for copying and selling a portrait of Necker, whereby he was injuring the sale of Saint-Aubin's own engraving after the original portrait of Necker by Joseph-Silfrède Duplessis, the pupil of Subleyras.[3]

There were also graver matters than these to be settled. Balechou,[4] a pupil of Lépicié, who is best known to us now by his two spirited engravings after Joseph Vernet, also executed portraits in the manner of his contemporary Beauvarlet, such as his well-known rendering of François de Troy's portrait of Watteau's friend and patron, M. de Julienne. To him had been entrusted the reproduction of that by Rigaud of Augustus III., King of Poland and Elector of Saxony, which was destined to be placed at the beginning of the " Galerie de Dresde."[5] The engagement made with the King's agent, Leleu, was brief: " Nous soussignés," it says, " sommes convenus que moi Jean-Joseph Balechou, m'engage à graver entièrement au burin, le portrait de S. M. le roi de Pologne, conformément à l'original qui m'en a été remis peint par M. Rigaud, sur une planche de cuivre de deux pieds, dans l'espace de deux ans pour le prix de 5,000 lt."

The result was pronounced equal to Balechou's best work, rivalling his achievements in the portraits of Mme. Aved and Mlle. Loizerolles, or that executed in 1750 of the Count de Brühl after Silvestre, which was placed at the beginning of the collection of engravings after works in his gallery. The plate carried out for the King of Poland was, however, soon found to be in a bad

[1] Not to be confused with F. de Poilly, the engraver of the " Vierge au Linge." See " Catalogue de l'œuvre de F. de Poilly." Drevet finished de Poilly's portrait which had been begun by Roullet in 1699.
[2] P. V., July 29th, Sept. 30th and Oct. 28th, 1719.
[3] P. V., Nov. 8th, 1788. See " French Painters, etc.," pp. 155 and note and 157. See also Wille, Mém., t. ii., p. 117 note.
[4] 1719-1764. A., March 29th, 1749. [5] N. A., 1882, pp. 142-210.

condition, and the engraver was accused of having pulled as many as six hundred proofs on his own account. The matter was brought before the tribunal of the Academy, and on April 8th, 1752, that body was called on to consider a series of questions drawn up in a "Mémoire" signed by the "Comte de Loss, Ambassadeur de Sa Majesté le Roi de Pologne, Electeur de Saxe."

Some of these questions seem rather irrelevant, as, for example, No. 8, which runs as follows: "Des épreuves non finies d'une planche peuvent-elles être bonnes à vendre ou à faire des présents à des personnes que l'on considère, et surtout en y joignant la dépense d'un cadre et de sa glace." Others tended to elicit strict limitations of the number of occasions on which impressions might be taken during the progress of the work. These were laid down with laconic precision by the commission, on which sat no less than fourteen engravers.[1]

The deliberations were directed by "M. de Silvestre, Directeur et ancien Recteur et premier peintre du roi de Pologne," and Balechou was found guilty.[2] In spite of the violent opposition of men of good character, such as Daullé,[3] Le Bas and Lépicié, backed by the support from outside of the Dukes of Nivernais and Clermont, the name of Balechou was struck off the register of the Academy and he was expelled from France. The rest of his life was spent at Avignon, then still Papal territory.

The chief witness against Balechou was, it would seem, his printer, and we cannot help suspecting that there was something in this affair of which we are left purposely in ignorance, when we find that on the testimony of this man, "dont le dire variait considérablement, du reste, sur le nombre d'épreuves tirées," the Academy cast out one of the most skilled engravers of the day. No doubt some of his colleagues wished to get rid of him and they succeeded.

"Il y a à Avignon," says Diderot, writing of "Les Ports de France," "un certain Balechou . . . qui court la même carrière et qui les écrase."[4] He refers, probably, in this sentence to the two engravings after Vernet, "Le Calme" and "La Tempête," the second of which seems one of Balechou's best works, though I do not think that it is really a truthful interpretation of Vernet. He himself was, however, not ill pleased with the free translation

[1] Duchange, Audran, Lépicié, Massé, de Larmessin, L. Surugue, J. Moyreau, J. Daullé, L. Cars, Tardieu, Le Bas, Cochin, Cochin fils, Surugue fils.
[2] P. V., April 8th, 1752.
[3] See Delinières, "Jean-François Daullé." [4] Salon, 1763.

and strokes of unauthorized force and effect which the engraver has substituted for the easy harmony of his model. He proposed that Balechou should reproduce the "Baigneuses" and wrote enthusiastically: "Il n'est qu'un Balechou en France; je ne suis pas content des gravures de mes autres marines depuis que j'ai vu les vôtres; si vous voulez vous charger de ce travail, il vous en reviendroit un très-grand avantage, et à mes peintures une très-grande gloire." At the same time Wille enters in his diary: "Wrote to M. Balechou at Avignon. I complimented him on his 'Bathers,' which he has engraved after M. Vernet. I have ordered fifteen to twenty proofs of him and one proof before letters."[1]

In his exile Balechou was not forgotten by his friends in Paris, nor did the scandal which had banished him prevent Nattier from at once sending him his portrait of "Mme. l'Infante Duchesse de Parme sous la figure de la Terre,"[2] but the Academy remained inexorable and on the 18th August, 1764, this unfortunate man died in exile.

On the fifteenth of the following month Grimm writes: "We have just lost one of our most famous engravers. Balechou died a short while back at Avignon, where his irregular conduct had for some years past banished him. He did not draw correctly, but he had a most singular vigour and warmth of execution. Some things which he had engraved after Vernet have the greatest reputation and sold for a high price during his life. Their value will not be lessened by his death. The only great engraver now remaining in France," adds Grimm, with proper patriotism, "is a Hessian, who is called M. Wille."

In spite of the rules laid down by the Academy in the case of Balechou, difficulties of a similar character continued to arise from time to time. The word "arbitraire," affixed to one of the questions put for decision, left certain points undecided, and various courses were open, more especially when the process employed was that usual one which involved a mixture of etching and line engraving, or the preparation of the plate à l'eau-forte by one man, in order that it should be terminated au burin by another.[3] It was not long before Etienne Fessard—sufficiently esteemed to be employed by Boucher to engrave his "Light of the World"

[1] Mém., Sept. 25th, 1762. See also Balechou's reply, ibid., t. i., p. 208, and Lagrange, "Joseph Vernet," pp. 212, 213.
[2] P. V., Feb. 23rd, 1753.
[3] We have seen Le Mire employing Le Veau in this way (pp. 102, 105). Moreau was also thus serviceable to Wille (Mém., Nov. 13th, 1765; July 29th, 1766).

and "L'Amour désarmé"—became involved in an action at law on this account.

The action was brought by "le Sieur Germain" to recover two proofs—"eaux-fortes"—taken by Fessard from plates engraved after Germain père. Once more the quarrel was submitted to the Academy, but on this occasion judgement was given without reserve in favour of the engraver.[1] "It is," they say, " the established custom from all time that the proofs which are pulled in the course of the work, and specially of the first *ébauche*, which is called *eau-forte*, are never handed to the proprietor of the plate unless, indeed, there is an express stipulation to the contrary."

. It is to the beginning of this affair that Wille probably refers, under the date February 29th, 1760, when he writes that he and Cochin "have been cited before the Grand Council to judge and esteem a portrait of the King that M. Fessard has engraved for an individual with whom he is at law. The affair is not ended." Indeed, it reappears in the journal on June 15th, 1761, when Cochin and Wille are " again cited before the Grand Council to examine and judge the engraving, executed by M. Fessard, from the King's portrait."

During the course of the century the Academy formed that great collection of engravings which was transferred, in 1792, to the " Cabinet du roi," together with those of the " sur-intendance de Versailles," the " dépôt des Menus-Plaisirs," the " maison de ville de Paris " and of various other establishments.[2] In 1693 the society possessed only three plates; two portraits, one of Claude Perrault, the other of Chancellor Séguier, together with the engraving of the " catafalque" which had figured at his funeral obsequies. From 1706, when the regulations came into force which obliged engravers on their reception to give the plates of two portraits prescribed by the Academy, these diploma works became a valuable property.

These collections once established were frequently enriched by the generosity of " honorary amateurs " and other friends and patrons. Courtin[3] presented a series of engravings by Michel Aubert;[4] de Julienne gives " l'œuvre de Watteau "—" quatre

[1] P. V., April 4th and July 24th, 1761.
[2] See "Not. hist. sur la Chalcographie " (Musée Nat. du Louvre).
[3] P. V., April 7th, May 26th, 1736. Jean Courtin was a " peintre-graveur " born at Sens. He died at Paris in 1752. See A. B. C. Dario, Mariette.
[4] Mariette says of Michel Aubert, " mort à Paris à la fleur de son âge, en 1740," but if this is so there were two Michel Aubert, for we find engravings signed in this name in the La Fontaine of Oudry. The date of 1757 is also given as that of his death. See the note to Mariette's article.

beaux volumes, reliez en maroquin, contenant une suitte de toutes les estampes gravées d'après Watteau, Académicien." [1] From Boucher the society received two sets of " Pastorals" and of " Chinese figures," engraved after his drawings by an English artist, John Ingram. [2] In 1737 Duchange gave them a copy of his magnificent publication, " La galerie du Palais du Luxembourg." [3]

A few years later, through the generosity of Coypel, they came into possession of the two hundred and twenty-three plates engraved by de Caylus from the drawings of the Royal collections, [4] and amongst other noteworthy donors may be cited Chardin, who on May 30th, 1778, is said to have " prié l'Académie d'accepter la collection des estampes gravées d'après ses ouvrages reliés en un volume in-folio"; Surugue, who on finding the plate engraved by Bernard Picart of the portrait of de Piles, presented it to the Academy, together with a hundred proofs; and Jean-Jacques Caffieri, who, according to his wont, gave a fine set of engravings on condition that his liberality should be acknowledged by a return of equal munificence in kind. [5]

In addition to the other sources through which the possessions of the Academy were increased, the tax of two proofs imposed on the publication of any engraving before its author could put it on the market with the obligatory "cum priv. regis," soon became profitable. Books, if they contained engravings, required the same privilege, [6] but books seem to have borne in practice a small proportion of the tribute levied from the publishers of prints.

Nicolas de Larmessin offers proofs of his reproduction of Lancret's " Amours du Bocage," which are " reçues et aprouvées pour jouir . . . du privilège du Roy accordé à l'Académie par Arrêt du Conseil du 28 de Juin 1714." In like manner the Academy obtained proofs of his best work, " Les Pèlerins de Cythère," after Watteau; of the " Frère Luc," after Wleughels;

[1] P. V., Dec. 31st, 1739.
[2] P. V., Jan. 31st, 1744. He was born in London (1721), but worked chiefly in Paris. He is said to have engraved the etching by Cochin of the " Illumination à Versailles à l'occasion du second mariage du Dauphin, le 9 février 1747 " (see Portalis and Béraldi). Chal. du Louvre, No. 4034.
[3] P. V., Oct. 5th, 1737. [4] P. V., May 27th, 1747.
[5] P. V., April 30th, 1774.
[6] P. V., April 1st, 1786, we find Le Barbier l'aîné applying for this " privilège" on account of the edition of Gessner illustrated from his designs, and on May 27th, 1747, Fréret submitted to the Academy the project for his work on " Costume " and the " Sieur Carême" was " nommé pour en faire les dessins et les planches " with the title of " dessinateur attaché à l'Académie pour ce sujet." Carême was expelled the Academy Dec. 16th, 1778.

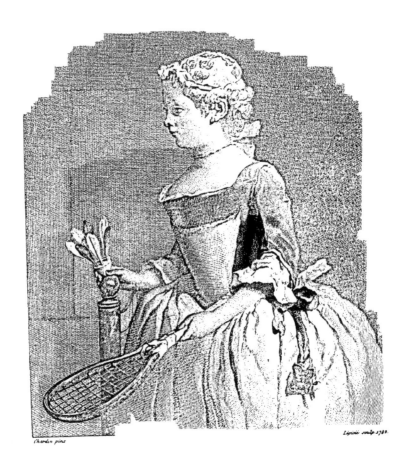

"Les oies du Frère Philippe" and "Les quatre heures du jour," after Lancret.[1]

"M. Moyreau," says Bachaumont, "a beaucoup gravé, d'après les tableaux de Wouvermans passablement,"[2] and the enormous series of engravings after Wouvermans which Jean Moyreau seems to have passed his life in executing, found its way into the port-folios of the Academy.[3] To this immense work Moyreau now and then added a little scene after Raoux, or a "Conversation de Matelots" after Claude le Lorrain,[4] but as a rule he is absolutely faithful to his favourite master. From Charles-Nicolas Cochin also a vast quantity of work was received—at first chiefly proofs from plates after Restout de la Joue;[5] then we find mention of Chardin: La Blanchisseuse, La Fontaine, L'Ecureuse, Le Garçon Cabaretier.[6]

These engravings are amongst the best executed by Cochin, though as an interpreter of Chardin he was surpassed by Bernard Lépicié,[7] who succeeded Dubois de Saint-Gelais as Secretary to the Academy in 1737. "A good engraver," says Bachaumont, "he has wit and letters; he writes well enough in prose, and makes pretty fair verses, which he usually puts at the foot of his engravings." To this, he adds in conclusion, "il faut le voir. Il est poly, obligeant et communicatif."[8] Rarely do we find Lépicié as satisfactory, as full of interest and simple charm as in his sufficient yet modest translations of Chardin's masterly work. The long series from which the Academy regularly profited begins with "La Gouvernante" (1739) and includes the noble "Bene-dicite" (1744). Lépicié must, indeed, stand first on the list of those who have interpreted Chardin, although that list contains the names of Laurent Cars and Le Bas, not to mention lesser lights such as Fillœul and Pierre-Louis Surugue.[9]

Few artists, says M. Duplessis, found amongst their contem-poraries interpreters equally intelligent, and he suggests that either Chardin himself superintended those who reproduced his work, or that the engravers themselves were captivated by the qualities of

[1] P. V., Dec. 31st, 1735; Jan. 26th, 1737.
[2] Wille, Mém., Appendix.
[3] P. V., Feb. 23rd, April 26th, Sept. 28th, 1737; March 29th, 1738; 1739; 1740; Sept. 26th, 1744. He exhibited constantly at the Salons from 1737 to 1761.
[4] P. V., Sept. 28th, 1743; April 25th, 1744; Sept. 28th, 1759.
[5] P. V., Sept. 28th, 1736; March 2nd, 1737; March 29th, 1738.
[6] P. V., June 27th, 1739; Sept. 24th, 1740.
[7] 1698-1755. He was a pupil of Jean Mariette, but completely abandoned the practice of engraving after his appointment as Secretary and Historian to the Academy.
[8] Wille, Mém., Appendix, and Feb. 3rd, 1761.
[9] See Chap. V., p. 81, note 7.

Chardin's execution and seized instinctively on the essential
beauties of his art.

With the engravers who paid enforced homage to the Academy
came the painters who, as did Chardin, presented prints after their
own works. Nattier brings proofs of Tardieu's famous reproduc-
tion of his portrait of the Queen.[1] He is preceded by de Troy[2]
and followed by Duplessis,[3] " peintre Académicien," who presents
engravings of his portrait of M. Gluck, " musicien célèbre."
Duplessis, it should be remembered, had, like Boissieu,[4] a strong
natural feeling for landscape, but had been forced to take to
portraits in order to earn his bread.

By the middle of the century the Academy had made a
thriving business out of this branch of their collections. They
bought and sold and gave commissions on their own account to
the engravers, whom they persisted in regarding as an inferior
order. Plates after works by de Troy and Le Brun were pur-
chased in 1764-1765; in 1770 they made 1,716 lt. from the sale
of prints, the larger part of which was derived from Demarteau's
diploma work—a reproduction of " Lycurgue blessé " after Cochin,[5]
to which reference has already been made more than once.

The receipts from this source touched their highest point in
1773, when they amounted to 3,878 lt., of which 714 are
accounted for by the sale of Porporati's[6] popular rendering of " La
chaste Suzanne " after Santerre. In 1776 eighty-three proofs of
this work were sold, and again in 1777 the chief profits were
brought in by the sale of the same print.

The inventory, taken in 1775, shows that in addition to fifty-
four portraits and the engraving of the funeral pomp of Chancellor
Séguier, the Academy were then in possession of three hundred
and twenty-eight historical and other subjects, a collection which
was steadily increased until the total—including diploma works,
purchases and gifts—had reached in 1789 over four hundred and
seventy pieces.[7]

[1] P. V., March 22nd, 1755. [2] P. V., Jan. 7th, 1736.
[3] P. V., Feb. 25th, 1775. See p. 160.
[4] 1736-1810. See "Hommage rendu . . . par le Conseil du Conservatoire des
Arts" and "L'Eloge par Dugas de Montbel," Lyon, 1810; also Wille, Mém.,
July 28th, 1762. Some of his best drawings were made in 1765, when he accompanied
Alexandre de la Rochefoucauld to Italy. The Print Room in the British Museum
has several specimens of his work : Interior of a mill ; Water-colour landscape ; Study
in sepia of a bridge, etc., etc.
[5] P. V., Sept. 2nd, 1769.
[6] 1741-1816. A. and R. May 8th, 1773, on the "Suzanne" after Santerre.
[7] See also Müntz, "L'Académie de Peinture et de Sculpture à la Chalcographie du
Louvre."

This inventory is also particularly interesting, because it was in 1775 that the society began to give commissions—none too generously paid—to its engraver members. We get the particulars of these bargains two years later.[1] The " planches gravées au profit de l'Académie " are, we are told, to be carried out at the fixed price of 4,000 lt., whilst only 2,000 lt. are to be paid for such as are executed as diploma works. Coustou represented that the sum of 2,000 lt. was too low for the execution of work out of which the Academy expected to make money, as those entrusted with such commissions would naturally delay their performance for other and more profitable orders. The committee, however, stood firm, and as a check on the long delays of which Coustou spoke, a resolution was brought in,[2] by which it was enacted that engravers should in future, like Porporati and Demarteau, present their work and have their fate decided on the same day.

This rule, by which aspirants were *agréés* and *reçus* on the same day, protected engravers from the attacks of the *imprimeurs* by the suppression of a dangerous interval. In accordance with it we find Simon-Charles Miger, Cochin's *commis*—certainly no distinguished talent—received on Carle Van Loo's "Supplice de Marsyas,"[3] which he had been commissioned to engrave for the Academy, whereas the elder Lempereur, *agréé* in 1759, was not received till 1776, when he also was ordered to finish the "Enlèvement de Proserpine," after de la Fosse.[4] Miger was, however, also obliged to execute, as a gift, the portrait of Michel Van Loo,[5] and a few years later induced the Academy to pay him 300 lt. for the portrait of Laurent Cars,[6] which he had engraved after Perronneau.

Better business was done when in August, 1782, the company bought from his sister for 3,400 lt. all the plates left by Jacques Flipart. Even at that date the work of this fine engraver had a considerable sale, for he had engraved many of the most popular works of Greuze: " L'Accordée de Village; Le Paralytique; Le Gàteau des Rois"—suggesting, as far as possible, the manner in which Greuze painted—placing his tints side by side. To this end Flipart carried his work almost to completion with the etching-needle, a system in which he was followed by others—

[1] P. V., May 31st, 1777.
[2] P. V., July 26th, 1777. The death of Coustou was announced on the same day.
[3] See p. 47, note 1.
[4] No. 985, Chal. du Louvre.
[5] P. V., Jan. 31st, 1778. No. 2213, Chal. du Louvre.
[6] P. V., May 25th, 1782.

such as his pupils the two Ingouf[1]—who were of inferior skill.

Though the acquisitions of the library could not so easily be turned into money, they were valuable and important. The "Gazette Littéraire" was regularly received from the Duke de Praslin, but for the most part the presents sent in were works of a costly character magnificently illustrated, such as Descamps' "Vies des Peintres" and "Voyage pittoresque," Saint-Non's "Voyage pittoresque d'Italie" and the "Description général de la France," illustrated by Née and Masquelier.[2] During the same years too came in the "Histoire de la France," published by Le Bas, d'Argenville's "Voyage pittoresque de Paris" and Choiseul-Gouffier's "Voyage pittoresque de la Grèce." Tribute too was received from the "Directeur-général [des bâtiments] de S. A. S. l'Electeur Palatin," who sent in for approbation "la Galerie de Dusseldorf, gravée sous sa direction,"[3] and from England, whence "Le Sieur Cozens" sent his "Principles of Beauty" with Bartolozzi's illustrations.[4]

The Academy—whilst deriving profit from the exertions of engravers—had always refused to acknowledge the art as equal with Painting and Sculpture in the designation of the society, but by an odd accident their last consultations were devoted to the concerns of the despised engravers. On the "27 Juillet 1793, l'an II de la République Françoise," they received a report from Wille, Lempereur, Levasseur, Moreau and Renou, on Bachelier's invention, "pour remplacer le miroir dont se servent les graveurs pour retourner de droit à gauche les objets qu'ils ont à graver." Twelve days later the society was suppressed by the decree of the National Assembly,[5] together with all other organisations of a similar character endowed by the nation.

[1] See p. 88, note 1. Both were popular engravers in the later years of the century. François-Robert le jeune (1747-1812) sent to the Salon in 1793 "Le Retour du Laboureur," "La Liberté du Braconnier, d'après Benazech," and "Canadiens au Tombeau de leur Enfant, d'après le Barbier l'ainé." This last had the honour to be reproduced in terra-cotta by Marin, who exhibited the group in 1795.

[2] See for these gifts: P. V., March 31st, 1764; May 2nd, 1761; Nov. 25th, 1769; 1777-1780.

[3] P. V., Nov. 29th, 1776.

[4] P. V., Oct. 29th, 1785.

[5] "Décret rendu sur la proposition du Comité d'instruction publique. Article Ier. Toutes les Académies et Sociétés littéraires, patentées ou dotées par la Nation sont supprimées. . . . La Commune des Arts a été établie par un Décret du 4 Juillet précédent. Les Ecoles ont étés maintenues provisoirement par un Décret du 28 Septembre 1793" (P. V., 1793, p. 224).

The revolt against privilege had found expression the more Engravers effectually because the work of centralisation as begun by Richelieu and the and Colbert had been perfectly accomplished. All the associations Academy. which had been created under the old rule, to complete the rigid circle of its police, were swept away by the spirit which proclaimed the gospel of liberty, of fraternity, of equality. The fall of the Academies was but an insignificant detail in the great overthrow of that despotism which had been founded on the ruins of Huguenot France. The outburst of 1789, with its hateful passions and bloodguiltiness, was needed to unlock those sources of spiritual life which had been arbitrarily sealed by the rulers of France. Once more the thoughts of men were kindled as with fire from on high, and their dreams were visited by the generous vision of a new " Harmonia Mundi."

No mystic schemes, such as had satisfied the sixteenth-century monk,[1] could serve the needs of a society which, deprived of all outlook on the unseen, had beheld its nobles lavishing the resources of the state on the lowest forms of personal luxury and its people perishing of hunger and sorrow, whilst the arts of pleasure triumphantly glorified all the desires of flesh. As soon as the way had been made clear the whole nation joined in the heroic attempt to formulate rules for every phase of life and conduct—rules which, standing free from any petty conventions of time and place, should have universal authority; define the relations of the ideal family, the ideal man, the ideal citizen, and draw the world towards that spirit of perfect charity and brotherhood which still remains before us as a dream.

The ideals of this moral evolution were unfortunately—perhaps necessarily—embodied in a fashion disastrous to the arts, on the movement of which it imposed intolerable limitations. No divine gift of beauty or of charm could be accepted in expiation of the failure to fulfil conditions fixed by a tyranny as exacting as that of the Academic rule which it had replaced.

Those who might have learned from Prud'hon the secret of perfect freedom in the application of classic precedent to the treatment of themes inspired by the passions of their own day, followed on the track of David and the archæologists. Carried away by the enthusiasm born of a new creed, they demanded the pedantic sanction of a logical perfection only to be obtained at the cost of every principle of life and growth. Not till a clear note was struck by the leaders of the Romantic movement were the

[1] Franciscus Georgius (1460-1540). His " De Harmonia mundi totius cantica tria," published at Venice in 1525, received the honours of the Index.

Engravers and the Academy. slumbering forces aroused which had been held fast for nearly half a century in the sterile bonds of the doctrinaires.

The Romantic movement released from artificial pressure tendencies which were in genuine harmony with the development of modern democracy, but the task of tracing the relation of their various manifestations to the currents set in motion by the days of '93 has yet to be accomplished.

APPENDIX

(A) LIST OF WORKS BY THE COMTE DE CAYLUS.

(B) NOTE SUR LA FAMILLE DE M. MARIETTE.

(C) EXTRACTS FROM THE "PARTAGE DES BIENS DE LA SUCCESSION DE MONSIEUR MARIETTE."

(D) LIST OF WORKS EXHIBITED AT THE SALON BY

> BEAUVARLET (JACQUES-FIRMIN).
> CARS (LAURENT).
> CATHELIN (LOUIS-JACQUES).
> COCHIN FILS (CHARLES-NICOLAS).
> DAULLÉ (JEAN).
> DEBUCOURT (LOUIS-PHILIBERT).
> DELAUNAY L'AÎNÉ (NICOLAS).
> EISEN (CHARLES-DOMINIQUE-JOSEPH). [Works exhibited at the Academy of St. Luke.]
> FLIPART (JEAN-JACQUES).
> LARMESSIN (NICOLAS).
> LE BAS (JACQUES-PHILIPPE).
> LEMPEREUR (LOUIS-SIMON).
> MOREAU LE JEUNE (JEAN-MICHEL).
> SAINT-AUBIN (AUGUSTIN DE).
> SAINT-AUBIN (GABRIEL DE). [Works exhibited at the Academy of St. Luke and at the Colysée.]
> WILLE (JEAN-GEORGES).

(A)

THE WORKS OF DE CAYLUS

For his printed works see Lewine, " Bibliography of Eighteenth-Century Art," pp. 98-100.
For the catalogue of his MSS., which are of an enormous number, see Cochin, Mém.
inéd., Appendix II.
His discourses at the Academy having a special interest will be found in order below.

1732.	Juin 7.	Discours sur les Dessins.
1747.	Juin 3.	Réflexions sur la Peinture (Sorbonne MSS.).
,,	Sept. 2.	Discours sur la Manière (Sorbonne MSS.).
,,	Nov. 4.	Discours sur l'harmonie et sur la couleur (Sorbonne MSS.).
1748.	Fév. 3.	Vie d'Antoine Watteau.
,,	Av. 27.	Vie de M. Trémolières.
,,	Juil. 6.	Vie de M. Le Moyne.
,,	Sept. 7.	Dissertation sur l'Amateur.
,,	Nov. 29.	Vie de M. Le Sueur.
1749.	Mars 1.	Vie de M. Sarrazin.
,,	Mai 3.	Vie de Michel Anguier et celle de Thomas Regnaudin, avec un Discours . . . sur l'art de traiter les bas-reliefs.
1750.	Jan. 10.	Vie de M. Leranbert.
,,	Fév. 7.	Vie de M. Guilain.
,,	Mai 2.	Vie de M. Girardon.
,,	Juil. 4.	Vies de MM. Buyster et Poissant.
,,	Août 1.	Discours au sujet du portrait de M. Dufrénoy, peint par M. Le Brun, dont il a fait présent à l'Académie.
,,	Oct. 3.	Vie de M. Van Opstal et celle de M. Van Clève.
,,	Déc. 5.	Discours sur la Composition.
1751.	Mars 6.	Vie de M. Mignard.
,,	Mai 8.	Vie de François Perrier.
1752.	Juil. 1.	Dissertation sur l'importance et l'étendue du Costume.
,,	Nov. 4.	Réflexions sur la Peinture.
1753.	Oct. 6.	Discours sur l'Etude des Têtes.
,,	Nov. 10.	Discours sur la Peinture des Anciens.
1754.	Mars 2.	Discours sur la Peinture des Anciens. Suite.
,,	Mai 4.	Discours sur la Peinture des Anciens. Suite.
,,	Juin 1.	Mémoire sur les Sculpteurs Grecs.
1755.	Juin 7.	Discours sur la nécessité des Conférences.
,,	Août 2.	Dissertation sur la Gravure.
,,	Août 30.	Mémoire sur la Peinture à l'encaustique et sur la Peinture à la cire fait présent à la Compagnie.

1755.	Oct. 4.	Dissertation sur la légèreté de l'outil.
1756.	Mai 8.	Discours sur l'avantage des vertus de société.
1758.	Déc. 2.	Discours sur l'Hermaphrodite.
1759.	Fév. 3.	Réflexions sur la Sculpture.
"	Oct. 6.	Discours sur l'étude des testes.
1760.	Mars 1.	Discours et proposition aux Amateurs.
1762.	Oct. 30.	M. de Caylus fait présent de la vie de M. Bouchardon . . . dont il a fait lecture cy devant.
1763.	Déc. 31.	Lettre de M. le C. de Caylus concernant un Prix pour la Perspective.
1764.	Mai 5.	Discours sur la nécessité de l'étude de l'Ostéologie.

M. Müntz (Revue Bleue, 29 Mai 1897) mentions also "Dissertation sur les Causes de la Petite Manière de l'École française." This appears to be the "Discours sur la Manière" delivered Sept. 2nd, 1747.

(B)

NOTE SUR LA FAMILLE DE M. MARIETTE

Pierre Mariette, libraire et graveur, rue St. Jacques, à l'Espérance, en 1660, eut trois enfans. Savoir :

1°. Denis Mariette, libraire et graveur en 1691, Syndic de sa communauté en 1726. Il épousa N. Langlois, fille de François Langlois[1] dit de Chartres libraire en 1634 dont le portrait a été gravé par Pesne d'après Van-Dyck qui l'a représenté jouant de la musette, parcequ'il en jouait supérieurement ; il était connaisseur en tableaux, dessins et estampes, dont il faisait un grand commerce, et sous ce rapport il était honoré de la confiance de Charles 1er roi d'Angleterre. Il mourut en sa maison rue St. Jacques et fut inhumé à St. Benoit. Il n'eut de son mariage qu'une fille, mariée à N. Chomel médecin.

2°. Jean Mariette, libraire rue St. Jacques, aux Colonnes d'Hercule en 1702 ; fut aussi dessinateur et graveur, ayant eu pour maitre J. B. Corneille, peintre, son beau frère ; il se distingua dans cet art, et mit au jour plusieurs morceaux pleins d'esprit et de goût, la plupart d'après ses dessins. Il épousa Geneviève Coignard fille de Jean Baptiste Coignard, libraire. Il fit bâtir sa maison rue St. Jacques et mourut en 1742, il fit un legs de 10,000 livres aux pauvres de St. Benoit, où il fut inhumé ; son portrait a été gravé d'après Pesne par Daullé ; il laissa de son mariage une fille, femme de Jean Baptiste Corneille, peintre dont on voyait plusieurs tableaux estimés dans les églises de Notre dame, des Carmes déchaussés et des Chartreux.

3°. Une fille Marie Madeleine Mariette femme de J. B. Corneille peintre ;

et 4°. Une fille Hélène Geneviève Mariette femme de J. B. l'Espine, libraire du Roi.

Jean Mariette laissa Pierre Jean Mariette Libraire en 1714 rue St. Jacques aux colonnes d'hercule, avec cette devise : *Nec plus ultra* ;[2] il fut imprimeur en 1722, il acheta conjoinctement avec son père d'Antoine Urbain Coustelier moitié du privilége de l'ouvrage des historiens des Gaules et de France, collection volumineuse dont le

[1] This is an error. Denis Mariette married "Justine Abonnenc." She died in 1753, her husband having predeceased her in 1741. This and other corrections are supplied by Mr. Percy Mariette, the present representative of the family.

[2] This legend is given to Mariette erroneously by Delatour. Mr. Mariette tells me that it should be "Haec meta laborum." The motto "Nec plus ultra," with the sign of the "Colonnes d'Hercule," is said, however, to have been in use by the Langlois, who were connected with the Mariettes.

premier volume in f⁰ n'a paru qu'en 1738 ; d'autres libraires estimés sont devenus associés et en 1802 il y avait 13 volumes imprimés ; le gouvernement a fait continuer les 14ᵉ et 15ᵉ.

P. J. Mariette fit paraître ce goût héréditaire pour les arts en général, particulièrement pour les dessins et les estampes et il se perfectionna en voyageant en Allemagne et en Italie. Ses grandes connaissances en cette partie sur laquelle il était souvent consulté le mirent dans le cas de mériter la confiance des personnages les plus distingués et de plusieurs souverains.

Il fut auteur de plusieurs Ouvrages, savoir :

Des Lettres à Mʳ de Caylus sur la fontaine de Grenelle ; Des descriptions qui se trouvent dans le recueil du planches gravées d'après les tableaux de Mʳ Crozat ;

Des descriptions des travaux relatifs à la fonte en bronze de la statue équestre de Louis XV.

Mais le plus interessant de tous est son *Traité des pierres gravées* qui lui fait autant d'honneur par la pureté du style qu'à ses presses par la beauté d'exécution typographique. Les grandes relations le mirent à même d'étendre son commerce de la manière la plus brillante et de pousser sa fortune jusqu'où elle pouvait aller ; on peut dire qu'il réalisa dans son état la devise que son père avait adoptée.

En 1750 il se démit de son imprimerie en faveur de L. F. Delatour et vendit son fonds de Librairie en conservant par honneur une part dans l'ouvrage des historiens de France ; et en 1752 avec l'agrément et l'estime du chef de la magistrature, il fut pourvu d'un office de secrétaire du roi, controleur général de la grande chancellerie de France : Il épousa Angélique-Catherine Doyen,[1] fille de Louis Doyen, notaire, et mourut en 1774, en sa maison, rue St. Jacques, Paroisse St. Benoit, où il fut inhumé.

On a deux gravures de son portrait dont une de St. Aubin d'après le dessin de Cochin.

Il laissa quatre enfans, Savoir :

1°. Jean-Pierre Mariette, conseiller à la Cour des Aides ;
2°. Corneille-Guillaume Mariette, maistre des comptes ;
3°. Angélique-Geneviève Mariette, femme de J. B. Brochant ;
4°. Geneviève-Thérèse Mariette femme d'Achille le Begue, secrétaire du roi.

Cette note est de Mʳ Delatour, successeur de Mʳ Mariette.

(C)

EXTRACTS FROM THE "PARTAGE DES BIENS DE LA SUCCESSION DE MONSIEUR MARIETTE"

(Mʳ Guespereau, Notaire, 13 Avril 1776)

"A l'Egard des Estampes, livres et autres objets composant le cabinet dud. sieur Mariette, la vente en a été faite par M. Chariot, Huissier Commissaire Priseur au châtelet suivant son procès-verbal en date au commencement du [*sic*] mil sept cent soixante quinze : Le prix de laquelle vente s'est trouvé monter en totalité à la somme de trois cent quatre vingt treize mille quatre cent soixante une livres cinq sols, dans laquelle somme d'après la déclaration faite par lad. dame Mariette dans l'in-

[1] In another note given by Delatour the date 1722 stands for that of this marriage, but this date is incorrect. See p. 26, note 4.

ventaire fait après le décès dud. sieur son mary, il a été reconnu que la portion dans lesd. Estampes livres et autres objets qui provenaient des successions de M. et M^de Mariette père et mère qui étaient propres fictifs dud. défunt sieur Mariette et appartenant auxd. sieurs et dames ses enfants, monte à la somme de deux cent treize mille neuf cent trente six livre huit sols, et que la portion revenante à lad. dame Mariette pour ce qui faisait partie de la communauté monte à la somme de cent soixante dix neuf mille cinq cent vingt quatre livres dix sept sols ; sur laquelle somme de deux cent treize mille neuf cent trente six livres huit sols revenantes auxd. sieurs et dames héritiers dud. sieur Mariette, il convient déduire celle de vingt un mille quatorze livres dix huit sols pour la remise de dix pour cent sur les premiers trois cents mille livres et de huit pour cent sur le surplus accordé au sieur Bazan marchand d'Estampes pour l'arrangement dud. cabinet, la confection du Catalogue et ses vacations à lad. vente, et pour les frais du procès-verbal d'icelle, en sorte qu'il ne revient plus auxd. héritiers de net dans le prix de lad. vente que la somme de cent quatre vingt douze mille neuf cent vingt une livres dix sols qui entrera en masse."

"Plus a donné et légué aux pauvres de la Paroisse de Croissy où était située sa maison de campagne, la somme de six cent livres. . . ."

"Plus led. sieur Mariette a déclaré qu'il désirait qu'on remit au sieur Jogan et à sa femme une somme de trois cent livres pour l'entretien et la nourriture de leur fils qui était pour lors en apprentissage chez M. Beauvarlet, graveur, et aussy ce qu'il faudrait payer aud. sieur Beauvarlet pour les mois d'apprentissage, et ce pendant quatre années à partir du premier janvier mil sept cent soixante quatorze, passé lequel temps il ne serait plus rien payé."

"Plus à donné et légué à M. Mariette son fils ainé un diamant jaune qu'il avait reçu de M. le Prince Eugène en le priant de le conserver comme une marque des bontés que ce prince avait eües pour luy et comme une marque honorable pour leur famille."

Art. 7.

"Maisons rue St. Jacques.

"Il dependait de la succession du défunt sieur Mariette et repris en nature une grande maison située à Paris rue St. Jacques dans laquelle est décédé led. sieur Mariette ; laquelle maison en composait autrefois trois et n'en forme plus qu'une aujourd'hui au moyen de la reconstruction que M. et M^de Mariette ayeux paternels des parties en ont fait faire à neuf. Laquelle maison avec une autre maison sise à Paris susd. rue St. Jacques vis-à-vis la rue des Mathurins où pend pour enseigne la croix d'or aussi reprise en nature, ont été venduës à sieur Claude Nicolas Buffault marchand de vin à Paris."

Art. 11.

"Autre maison rue St. Jacques.

"Plus il dépend de lad. succession une autre maison sise à Paris rue St. Jacques Paroisse St. Benoist, où pend pour enseigne les trois croissans ; laquelle maison les parties conviennent de laisser en commun entr'elles pour être les loyers d'icelles echus et à écheoir touchés par led. sieur Mariette conseiller et être par luy employés jusqu'à due concurrence au payement des arrérages des rentes et pensions viagères et autres charges annuelles de la succession dud. sieur Mariette."

LIST OF WORKS EXHIBITED AT THE SALON

BEAUVARLET (JACQUES-FIRMIN), Gr.

1763 Le Jugement de Paris.
L'Enlévement des Sabines.
L'Enlévement d'Europe.
Galathée sur les Eaux.
D'après Lucas Giordano.

1765 Deux petits Enfans, s'amusant à faire jouer un chien sur une Guitarre.
D'après M. Drouais le fils.
Une offrande à Vénus et une autre à Cerès. D'apres M. Vien.
Deux desseins d'après les Tableaux de feu M. Carle Vanloo ; l'un la conversation
Espagnole ; l'autre la lecture. Ces morceaux sont destinés à être gravés.

1767 Monseigneur le Comte d'Artois et Madame. D'après M. Drouais le fils.
Deux dessins : l'un, Mercure et Aglaure, d'après la Hire ; l'autre, une Fête
de Campagne dans l'intérieur d'un Maison, d'après Teniers.
Ces Morceaux sont destinés à être gravés.

1769 La Conversation Espagnole. Gravée d'après Carle Vanloo.

Dessins au Crayon noir.

Une Vendange. D'après David Teniers, de 2 pieds de largeur sur 17 pouces
de haut.
La Vierge avec l'Enfant Jesus et le petit Saint Jean.
Deux Pastorales. Dessinés d'après les Tableaux de M. Boucher, premier
Peintre du Roi, et destinés à être gravés.

1771 Cinq Dessins ovales, dont quatre sont les quatre Heures du jour, et le
cinquième une Prêtresse tenant une Corbeille de Fleurs. D'après les
Tableaux de feu M. Carle Vanloo.
Deux Dessins qui représentent des Sultanes. D'après les Tableaux de feu
M. Carle Vanloo, qui sont au Château de Menars.
La Conversation. Estampe d'après feu M. Carle Vanloo.

1773 Le Portrait de M. le Marquis de Pourbalio, Ministre du Roi de Portugal.
D'après le Tableau de L. M. Vanloo ; la Mer et le fond sont peints par
M. Vernet.
Le Portrait de J. B. Pocquelin de Moliere. D'après le Tableau de Bourdon.
La Lecture Espagnole. D'après le Tableau de Carle Vanloo.

Dessins destinés à être gravés.

Les Couseuses. D'après le Tableau du Guide ; du Cabinet de feu M. le
Baron de Thiers.
Télémaque, racontant ses Aventures à la Nymphe Calipso. D'après le
Tableau de Raoux.
Le Médecin aux Urines.
La Marchande de Gibier.
Ces deux Dessins sont d'après les Tableaux de Gerard d'Ow : du
Cabinet de M. le Duc de Choiseul.

Beau-
varlet
(Jacques-
Firmin).

1775 Quatre Morceaux de la suite de l'Histoire d'Esther :
 Esther couronnée par le Roi Assuérus.
 Evanouissement d'Esther devant Assuérus.
 Mardoché refuse de fléchir les genoux devant Aman.
 Repas donné par Esther à Assuérus. D'après le Tableau de M. de
 Troy le fils.

Estampes.

La Confidente.⎫
La Sultane. ⎬ D'après les Tableaux de M. Carle Vanloo.

1777 Le Triomphe de Mardoché.
 La Toilette d'Esther.
 Aman arrêté par ordre d'Assuérus.
 Suite de l'Histoire d'Esther, d'après M. de Troy le fils.

Estampes.

Le Portrait de M. Sage.
Le Portrait de M. Bouchardon. C'est le Morceau de Réception de l'Auteur.

1779 La Marchande d'Amour. D'après le Tableau de M. Vien.

1781 Toilette d'Esther. D'après le Tableau de M. de Troy ; hauteur 18 pouces,
 largeur 22.

1783 Esther, couronnée par Assuérus. Estampe gravée d'après de Troy.
 Renaud et Armide. Dessin au papier bleu, d'après le même, pour être
 gravé.

1793 Triomphe de Mardochée. D'après Detroye. 2 pieds et demi de hauteur, sur
 un pied et demi de large.
 Télémaque dans l'Isle de Calypso, d'après —. Largeur 1 pied 8 pouces, sur 1
 pied 5 pouces de haut.

CARS (LAURENT), GR.

1737 Deux Sujets des Œuvres en gravûres.

1738 Œuvres gravées.

1747 Un Sujet gravé, représentant le Temps qui enleve la Vérité ; dédié à M. de
 Tournehem ; d'après le dernier Tableau de feu M. le Moyne, Premier
 Peintre du Roy.

1753 L'Enlévement d'Europe, d'après M. Le Moyne, Premier Peintre du Roy.
 L'Aurore enléve Céphale, d'après le même.
 Epreuve à l'eau-forte pour faire Pendant au Morceau ci-dessus. Ce Tableau
 est au Roy.
 Une Nativité ; d'après M. Carle-Vanloo.
 Une Dame variant ses amusemens ; d'après M. Chardin. Ce Tableau est tiré
 du Cabinet de M. de Vandieres et l'Estampe luy est dédiée.

178

1755 Trois Sujets d'après feu M. Le Moine, premier Peintre du Roi : **Cars**
 Le premier. Adam et Eve. **(Laurent).**
 Le second. L'Aurore qui enleve Cephale.
 Le troisième. Hercule qui terrasse Cæus (épreuve à l'eau forte).
 C'est le Morceau de réception de M. Le Moine à l'Académie.
 Plusieurs Portraits, en médaillon, gravés sur les desseins de M. Cochin : dont
 entr'autres celui de M. Boucher, et celui de M. Chardin.
 Trois Sujets des Fables de la Fontaine :
 L'Ane chargé de Reliques.
 Le Chasseur, le Pâtre et le Lion.
 Le Meunier, son Fils et L'Ane.

1757 L'Aveugle trompé. D'après le Tableau de M. Greuze.
 Trois Portraits en Médaillons. Messieurs Slodtz. D'après les Desseins de
 M. Cochin.

1761 Le Sacrifice d'Iphigénie.
 Hercule combat Cacus.
 Ces deux Estampes sont d'après le Moyne.
 Le Frontispice du Catalogue de MM. les Chevaliers de l'Ordre du S. Esprit.
 Allégorie d'après le dessein de M. Boucher.
 Vignette pour le même Livre, où est la médaille du Roi.

CATHELIN (LOUIS-JACQUES), Gr.

1775 Le Portrait de M. Turgot, Brigadier des Armées du Roi. D'après le Tableau
 de M. Drouais.
 Le Portrait de feû M. Paris de Montmartel. La tête, d'après M. de la Tour,
 le reste d'après le Dessin de M. Cochin.
 Le Portrait de M. Vernet, Peintre du Roi. D'après M. L. M. Vanloo.
 Le Portrait de M. Jéliotte. D'après M. Tocqué.
 Le Portrait de M. Tocqué, Peintre du Roi. D'après le Tableau de M.
 Nattier.
 Le Portrait de Moliere. D'après le Tableau de Mignard.

1777 Le Portrait de M. l'Abbé Terray, ancien Contrôleur-Général. D'après
 M. Roslin ; c'est le Morceau de Réception de l'Auteur.

1779 Le Portrait de M. Franklin. D'après le Tableau de Mde. Filleul.

1781 Le Portrait de Louis XV. D'après Louis-Michel Vanloo.
 Un Corps-de-Garde Italien, on y voit une dispute de Joueurs. D'après le
 Valentin.

1783 Mort de Lucrece. D'après Pellegrini.
 Portrait en Médaillon de M. le Bas. D'après M. Cochin.
 Autre Portrait en Médaillon de M. Sacchini. D'après M. Jay.
 Portrait en petit de Charles Rollin. D'après C. Coypel.

1787 Portrait de M. d'Agay, Intendant de Picardie. D'après Chevalier.
 Portrait de Mlle. Déon de Beaumont. D'après M. Ducreux.
 Portrait de M. Grétry. D'après Madame Lebrun.

1789 Portrait de M. Louis, Secrétaire perpétuel de l'Académie Royale de Chirurgie.
 D'après M. Greuze.

179

Cathelin (Louis-Jacques).	1789	Portrait de J. J. Balechou, Graveur. D'après le pastel de M. Arnavon, Chanoine d'Avignon.
	1800	Esseid-Aly-Effendy, ambassadeur de la sublime Porte-Ottomane. Portrait de Nicolas Poussin, peint par lui-même. Portrait de Buffon. Portrait de Bernard de Jussieu.

COCHIN FILS (CHARLES-NICOLAS), Dess. et Gr.

As Cochin died in April, 1790, he saw none of the work at the Salons of '91, '93, '96, though some of it was arranged for by him, as for example the two views of Rouen, before his death.

1741 Un Dessein à la gloire des Arts, représentant l'Académie Royale de Peinture et de Sculpture conduite par le génie du Dessein, qui s'élève au Temple de Mémoire, sous la protection de Sa Majesté.

Un Dessein dont le sujet est tiré de l'Histoire romaine, représentant Virginius qui tue sa fille.

Autre Dessein tiré pareillement de l'Histoire Romaine, qui représente L. Junius Brutus, Consul Romain, qui fait mourir ses deux fils pour avoir conspiré contre la République.

Une Estampe où l'on voit la décoration du Feu d'artifice, qui a été tiré à Versailles en 1739, à l'occasion du mariage de Madame Premiere avec Dom Philippe, deuxième Infant d'Espagne.

Dix petits Desseins de différens Caprices, et une Estampe représentant le Triomphe de la Religion Chrétienne.

1742 Un Dessein représentant la pompe funebre érigée dans l'Eglise Cathedrale de Notre-Dame de Paris, le 22 Septembre 1741, à l'occasion du decès de la Reine de Sardaigne.

Cette pompe, ordonnée par M. le Duc de Rochechoüart, Premier Gentilhomme de la Chambre du Roy, a été composée et conduite par M. de Bonneval, Intendant et Contrôleur general de l'Argenterie, Menus Plaisirs et Affaires de la Chambre de Sa Majesté.

Dessein allegorique, qui représente la lumiere du Messie qui penetre les Mages de l'ancienne Loy, et se fait connoitre aux Prophetes et aux Patriarches.

Autre Dessein, où l'on voit Mars qui reçoit de la Géometrie des Leçons pour se conduire dans les travaux de la Guerre.

Six petits Desseins pour le Lutrin de Boileau :

Chant I. La Discorde sous la figure d'un vieux Chantre, éveille le Prélat, et luy reproche son indolence.

Chant II. La nuit annonce à la mollesse étenduë dans les bras du sommeil, la division et le trouble qui va s'élever dans l'Eglise.

Chant III. Le Sacristain, le Porte-Croix, et le Perruquier étant venus de nuit pour rétablir le Lutrin, sont effrayez, et fuyent à la vûë d'un Hibou : la Discorde, sous la figure de Sidrac, leur reproche leur lâcheté et les rallie.

Chant IV. Le Grand Chantre et les Chanoines se jettent sur le Lutrin et le mettent en pieces.

Chant V. Rencontre du Prélat et du Grand Chantre ; bataille des Livres sur le Perron de la Sainte Chapelle : le Prélat met en fuite le Chantre et les Chanoines, en leur donnant sa benediction.

1742 Chant VI. La Pieté accompagnée de la Foy, l'Esperance et la Cochin
 Charité, vient se plaindre à la Justice du désordre que la Discorde cause Fils
 dans l'Eglise. (Charles-
Un petit Dessein où est écrit au bas, Le Medecin observateur. On y voit un Nicolas).
 jeune Medecin qui tâte le pouls à une Dame malade.
 Neuf petits Sujets tirez de Virgile :
 Georgiques, liv. II. Un Laboureur à Table avec toute sa Famille,
 représente la douceur de la vie champêtre.
 Æneïde, liv. I. Ænée sort de la nuée qui l'environnoit, et se fait
 connoître à Didon.
 Æneïde, liv. II. Laocoon, Prêtre de Neptune et ses Fils, sont tuez
 par deux Serpens d'une grandeur extraordinaire.
 Æneïde, liv. III. . Ænée ordonne à sa Troupe de prendre les armes
 pour chasser les Harpies qui venoient troubler leur repas.
 Æneïde, liv. IV. Mort de Didon.
 Æneïde, liv. VII. Ascagne et quelques Troyens ayant blessé·à la
 chasse un Cerf appartenant à la sœur du gardien des troupeaux du Roy
 Latynus, la Discorde excite les Paysans à prendre les armes pour venger
 sa mort.
 Æneïde, liv. IX. Nisus et Euryale, deux Amis intimes, après avoir
 traversé le camp des Latins, et y avoir fait un grand carnage, furent
 découverts par un parti de Cavalerie, qui les obligea à prendre la fuïte
 vers un Bois : Euryale fut atteint en fuyant, et fait prisonnier : Nisus
 appercevant son Amy entre les mains des Ennemis, se cacha dans le Bois,
 et lança quelques darts dont il tua plusieurs Soldats : le Chef de la Troupe,
 furieux de la mort de ses Gens, se jette sur Euryale pour le tuer ; alors
 Nisus se montre, et veut en vain détourner sur luy-même le coup qui
 menace son Amy.
 Æneide, liv. X. Ænée ayant blessé le Roi Mezence, est prêt a le
 tuer ; Lausus, fils de Mezence, couvre son pere avec son Bouclier, et
 s'oppose à la colere d'Ænée.
 Æneïde, liv. XI. Pallas, fils d'Evandre, ayant été tué dans un
 combat, Ænée luy renvoye son corps : ce Pere vient au devant, et est saisi
 de douleur à la vüe d'un si triste spectacle.

1743 Quatre Vignettes, et huit Culs-de-lampe, destinez pour une nouvelle Edition
 des Œuvres de Rousseau.
 Plusieurs petits Desseins, dont trois concernent l'Art Militaire.

1745 Un grand Dessein sous Glace, à la mine de plomb, représentant la Céremonie
 de l'Audience accordée par le Roy à l'Ambassadeur Turc.

1746 Morceaux pour un Livre de Voyage, in-4° représentans les differens usages
 des Peuples d'Orient. D'après les Desseins de M. Cochin fils. Par M.
 Tardieu fils.

1748 Deux autres [sujets], des Animaux ; d'après les Desseins de M. Cochin fils. Par
 M. Tardieu.

1750 Les quatre Fêtes gravées du premier Mariage de M. le Dauphin, dessinées par
 Cochin fils.
 Le Bal paré.
 Le Bal masqué dans la grande gallerie de Versailles.
 Ouvrage de M. Cochin le pere.
 Le Mariage dans la Chapelle de Versailles.
 La Comédie.

Cochin	1750	Un Dessein représentant le Roy, tenant grand appartement dans la grande
Fils		Gallerie de Versailles : la Table de jeu du Roy, celle de la Reine et d'autres
(Charles-		Tables distribués dans ladite Gallerie pour différens jeux.
Nicolas).		Autre Dessein représentant les Illuminations des deux grandes Ecuries de

Versailles jointes ensemble par des Arcades de lumiere : les deux Desseins se gravent actuellement.

Les vingt-neuf Estampes de l'Histoire de France de M. le Président Haynaut, in-4°, en vingt-neuf Parties, sous verres et bordures, dessinées et gravées par le même.

Le Portrait de M. Bailleul et de son Epouse, dessiné par le même.

1753 Trois Vignettes, dont l'une représente les Arts ; gravées d'après le Dessein de M. Cochin le fils par *M. Galimard.*

Quarante-six petits Portraits en Médaillons, dessinés par M. Cochin le fils.

1755 IV Desseins pour l'Histoire du Roi, par Médailles.

Pre Médaille, la Naissance du Roi.

Dans le Bas-relief ovale, on voit Madame la Duchesse de Bourgogne couchée sur un lit au moment qui suit sa délivrance : on lui présente le jeune Prince qu'elle vient de donner au monde. Au-dessous est une Femme représentant l'Espérance. Forcée d'abandonner deux petits enfans que lui enleve la mort sous la figure d'une femme voilée, elle tend les bras à l'enfant nouveau-né qui est dans le Bas-relief. A droite, une Femme arrose un laurier dans un vase ; allusion au Prince naissant. A gauche, une autre Femme enveloppe de voiles funéraires deux jeunes Cyprès ; symboles des deux jeunes Ducs de Bretagne morts, l'un en 1705 et l'autre en 1712.

Seconde Médaille, sur la mort de Louis-le-Grand.

Dans le Sujet en Bas-relief, on voit Louis XIV au lit de la mort. Ce Bas-relief décore la face d'un tombeau sur les côtés duquel sont rangées cinq Urnes sépulcrales, d'autant de Princes de la Famille Royale, morts avant le feu Roi. Quatre Femmes en pleurs expriment la désolation de la France ; en haut l'Immortalité sur des nuages soutient la Médaille.

Seconde Médaille sur la mort de Louis XIV et troisiéme du Livre.

La Renommée attache le Médaillon de Louis XIV à une pyramide élevée sur un tombeau. Le Médaillon de Louis XV est soutenu par le Génie de la France ; ce Génie porte un bouclier d'où rayonnent des traits de lumiere. La France se tourne avec inquiétude vers son Génie tutélaire, et jette ses regards sur le portrait de son jeune Monarque. Aux pieds du tombeau de Louis le Grand, on voit la Discorde et la Guerre enchaînées : elles font effort pour rompre leurs chaines et pour se relever, mais les rayons du Bouclier semblent, en éclairant leurs mouvemens, les rendre immobiles.

Quatriéme et cinquiéme Médaille :

La Régence déférée au Duc d'Orléans.

La Prudence reçoit de la Justice les rênes d'un Char qu'elle doit con-duire sur un chemin difficile ; les Animaux d'especes diverses, attelés à ce Char, sont les symboles des caractères opposés dont le contraste semble partager un peuple nombreux en differentes classes, si la Main qui les gouverne ne sçait les tenir unis. Le Lion est l'emblême de ces hommes dont le courage aspire à l'indépendance. Le Chien courageux mais fidéle et soumis, représente le Sujet dont la valeur est animée par ses Maitres. Le Mouton et le Renard sont le symbole, l'un de la simplicité, l'autre de l'intrigue.

Plusieurs Desseins de Ruines antiques et autres vûes d'apres nature, dessinées en Italie. Tirés du Cabinet de M. le Marquis de Marigny.

1755 Quatorze Desseins faits à Rome, d'après les Tableaux et Sculptures des Cochin
 grands Maitres. Fils
 Six Vignettes d'après les Desseins de M. Cochin, dont entr'autres la Peinture, (Charles-
 le Génie du Dessein et la Couleur, désignées par une Muse qui tient un Nicolas).
 prisme : un Génie s'oppose aux ravages du Tems. Par *M. Gallimard.*
 Six petits Morceaux gravés d'après M. Boucher et M. Cochin. Par *M. Flipart.*

1757 Trois Portraits en Médaillons. Messieurs Slodtz. D'après les Desseins de
 M. Cochin. Par *M. Cars.*
 Six petits morceaux sous un même verre, dont quelques-uns d'après les desseins
 de M. Cochin. Par *M. Flipart.*

1761 Licurgue blessé dans une sédition. Dessein au crayon rouge.
 Les quatre premieres Estampes de la suite des Ports de France, d'après
 M. Vernet, gravées en société avec M. Cochin. Par *M. Le Bas.*

1763 Les quatre Estampes de la seconde suite des Ports de France, d'après M.
 Vernet, gravées en société avec M. Cochin. Par *M. Le Bas.*
 Cinq petits Morceaux, d'après M. Cochin. Par *M. Flipart.*

1765 Un dessein destiné à servir de Frontispice au livre de l'Encyclopédie. On y
 voit les Sciences occupées à découvrir la Vérité. La Raison et la
 Métaphysique cherchent à lui ôter son voile. La Théologie attend sa
 lumiere d'un rayon qui part du Ciel : prés d'elle la Mémoire et l'Histoire
 ancienne et moderne. A côté et au-dessous sont les Sciences. D'autre
 part, l'Imagination s'approche avec une guirlande, pour orner la Vérité.
 Au-dessous d'elle sont les diverses Poésies et les Arts. Au bas sont
 plusieurs Talens qui dérivent des Sciences et des Arts.
 Plusieurs desseins allégoriques sur les règnes des Rois de France. Ils sont
 le commencement d'une suite d'estampes que l'on grave, pour être placées
 dans le livre de l'Abrégé Chronologique de l'Histoire de France, par M.
 le Président Henault.

1767 Plusieurs dessins allégoriques sur les règnes des Rois de France . . . destinés à
 être gravés pour . . . la nouvelle édition de l'Abrégé Chronologique, etc.
 Un Dessein représentant l'Ecole du modèle dans l'instant où les jeunes Gens
 concourent au Prix d'Expression fondé par feu M. le Comte de Caylus.
 Les deux Estampes de la quatriéme suite des Ports de France ; par M. Vernet,
 gravées en société avec M. Cochin. Par *M. Le Bas.*
 Allégorie sur la vie de feu Monseigneur le Dauphin.
 La Justice protège les Arts.
 Notre Seigneur au Tombeau, d'après le Caravage.
 Une Sainte Catherine, d'après P. de Cortonne.
 Tous ces Morceaux, imitant le crayon, sont gravés d'après les Dessins
 de M. Cochin. Par *M. Demarteau.*

1769 Plusieurs Dessins allégoriques sur les règnes des Rois de France.
 Ils sont destinés à être gravés pour l'ornement de l'Abrégé chrono-
 logique de l'Histoire de France par M. le Président Hénault.
 Douze Estampes de cette même suite.
 Le Portrait de M. de Parcieux, et autres Dessins.
 Lycurgue blessé dans une sédition.
 Gravé dans la manière qui imite le crayon, d'après le dessin de M.
 Cochin. Par *M. Demarteau.*

1771 Un Dessin destiné à recevoir les diverses Inscriptions relatives à l'établissement
 de l'Ecole Royale Militaire. On y voit les Armes du Roi ; la Médaille
 frappée à l'occasion de cet Edifice ; sur les côtés, les Figures Allégoriques
 de Mars et de l'Etude ; et en bas, quelques-uns des Exercices des Elèves.
 Plusieurs Dessins, qui ont été gravés pour servir à l'ornement de la Traduction

Cochin Fils (Charles- Nicolas).	1771	de Térence, par M. l'Abbé le Monnier ; le Frontispice de sa Traduction de Perse et autres.

La France témoigne son affection à la ville de Liège. Cette estampe a été gravée en reconnoissance de l'exemption du Droit d'Aubaine accordée par le Roi aux Citoyens de la ville de Liège.

Une Figure, Etude d'après nature.

Cette Estampe et la précédente sont gravées à l'imitation du Crayon, d'après les Dessins de M. Cochin. Par *M. de Marteau.*

Quatre Estampes ; deux pour les Comédies de Térence, une pour le Poëme de la Peinture, et une pour le Frontispice des quatre Poétiques, traduites par M. l'Abbé Batteux. D'après M. Cochin. Par *M. de St.-Aubin.*

Dix-huit Portraits en Médaillon. D'après M. Cochin. Par *M. de St.-Aubin.*

1773 Plusieurs Dessins des Aventures de Télémaque. Destinés à une Edition in-8° de ce Livre.

Deux Dessins, allégoriques sur l'Histoire de France. Continuation de la suite, destinée à orner l'Abrégé chronologique de l'Histoire de France, par feu M. le Président Henault.

Les Portraits de MM. Piron, Philidor, Beaumé et Cochin. D'après les Dessins de M. Cochin. Par M. *De Saint-Aubin.*

Frontispice du Livre intitulé, *Essai sur le caractère, les Mœurs et l'Esprit des Femmes* : par Monsieur Thomas. D'après le Dessin de M. Cochin. Par *M. De Saint-Aubin.*

1775 Un Sujet de l'Astrée.

Deux Sujets de l'Iliade d'Homere.

Quatre Sujets des Aventures de Télémaque.

Huit Sujets des principales Fêtes de l'année. Ces Dessins ont été composés pour le Missel de la Chapelle de Versailles.

Quatre Dessins des principales Pieces de Théâtre de M. de Belloy.

Autres Dessins. Sujets Allégoriques.

Le Portrait de feû M. Paris de Montmartel. La tête, d'après M. de la Tour, le reste d'après le Dessin de M. Cochin. Par *M. Cathelin.*

Six Portraits en Médaillon : M. de Trudaine, M. Pierre, M. l'Abbé Raynal, etc. D'après les Dessins de M. Cochin. Par *M. De Saint-Aubin.*

Télémaque aborde dans l'Isle de Calipso. D'après le Dessin de M. Cochin. Cette Estampe est pour l'Edition projettée in-8°, dont le texte doit être gravé. Par *M. De Saint-Aubin.*

1777 Un Frontispice Allégorique. D'après les Dessins de M. Cochin. Estampe par *M. de Saint-Aubin.*

Plusieurs Portraits en Médaillons. D'après les Dessins de M. Cochin, sous le même numéro. Par *M. de Saint-Aubin.*

Deux quadres contenant chacun six petits Sujets. D'après MM. Cochin, Monnet et Moreau, pour les Editions de Roland Furieux, Télémaque, etc. Par *M. Delaunay.*

1779 Le Portrait de feûe Mde. G * *.

Le Portrait de M. de Fontanieu, Intendant et Contrôleur-Général des Meubles de la Couronne.

Le Portrait de M. le Comte Maurice de Brühl de Martinskirke.

Le Portrait de feû M. J. J. Dortons de Mairan.

Ces Portraits sont d'après M. Cochin. Par *M. Miger.*

Sujet Allégorique, dans lequel doit être placé le Portrait de Mgr. le Duc d'Orléans.

Ce Morceau doit servir de Frontispice à l'Ouvrage, intitulé: *Description des Pierres gravées de S. A. S. Mgr. le Duc d'Orléans.* Ouvrage petit in-folio.

1779 Vignette destinée pour le même Ouvrage. Cochin
 Les deux Estampes sont faites d'après les Dessins de M. Cochin. Par Fils
 M. De Saint-Aubin. (Charles-
 Portrait par M. De Saint-Aubin. J. J. Caffieri, Sculpteur du Roi. D'après Nicolas).
 M. Cochin.

1781 Vue du Port du Havre, faisant la seizieme Estampe de la collection des Ports
 de France; cette vue est dessinée par M. Cochin et gravée en société par
 MM. Cochin et Le Bas.
 Ella a 28 pouces de large, sur 20 de haut. Par *M. Le Bas.*
 Un Dessin représentant l'enlèvement des Sabines.
 Autre Dessin. Les Nimphes de Calipso, mettent le feu au vaisseau bâti par
 Mentor.
 Plusieurs Dessins dont les sujets sont tirés de l'Emile de J. J. Rousseau,
 destinés à l'édition de Genève.

1783 Portrait en Médaillon de M. Le Bas. D'après M. Cochin. Par *M. Cathelin.*
 Le Portrait de M. Perronnet, Chevalier de l'Ordre du Roi, premier Ingénieur
 des Ponts et Chaussées. D'après M. Cochin. Par *M. de Saint-Aubin.*
 Portrait de M. Pigalle, Chevalier de l'Ordre du Roi. D'après M. Cochin.
 Par *M. de Saint-Aubin.*

1785 M. Pérignon, de l'Académie Royale de Musique. D'après M. Cochin. Par
 M. Miger.

1791 Une petite Gravure, d'après M. Cochin. Par *M. Ancelin.*

1793 Un grand Cadre contenant différens Sujets d'après Rotenhamer, Beaudouin,
 Bonnier, et plusieurs Vignettes pour les Œuvres de Gessner, Roland, les
 Œuvres de Rousseau, et d'après Cochin, le Barbier et Marillier. Par
 Ponce.
 Un grand Cadre contenant 18 Vignettes, pour Roland, d'après les Dessins de
 Cochin. Par *Ponce.*
 Un Cadre contenant des Vignettes d'après Cochin, pour la Jérusalem et le
 Poëme des Mois. Par *la Cit. Cernel.*
 Un Cadre contenant six Vignettes, d'après Cochin, Moreau, Monnet, Eisen et
 Marillier, pour différens Ouvrages. Par *la Cit. Cernel.*
 Une Estampe d'après le Citoyen Cochin, pour le Poëme de la Peinture. Par
 la Cit. Cernel.
 Vue du Port et de la Ville de Rouen, prise de la pointe de l'Isle de la Croix,
 au Sud-Sud-Est.
 Vue du Port et de la Ville de Rouen, prise de la petite chaussée, à l'Ouest de
 la Ville.
 Dessinés d'après nature par C. N. Cochin, et gravés sous la direction
 de Lebas et Choffard.
 Ces deux Estampes sont les Nos 17 et 18 de la Collection des Ports
 de Mer de France, d'après Vernet et se trouvent chez Bazan, rue
 Serpente, N° 14.

1796 Un cadre contenant cinq vignettes d'après les dessins des citoyens Cochin,
 Regnault, Monsiau, Moreau et Marillier, destinées à orner les œuvres de
 Virgile, de Rousseau, de Montesquieu et de Deshoulières. Par *Nicolas
 Ponce.*

DAULLÉ (JEAN), Gr.

1742 Trois Sujets gravez :
 Claude Deshais Gendron, Doñeur, Medecin de la Faculté de Montpellier. D'après M. Rigaud.
 Catherine Mignard Comtesse de Feuquieres, tenant la Portrait de son Pere, peint par lui-même.
 Hiacinthe Rigaud, Ecuyer, Chevalier de l'Ordre de S. Michel, ancien Direñeur, et Reñeur de l'Academie Royale de Peinture et de Sculpture, avec son Epouse, peint par lui-même.

1743 Trois portraits gravez d'après differens Maitres :
 Celui de Marguerite de Valois, Comtesse de Caylus ; d'après M. Rigaud, Ecuyer, Chevalier de l'Ordre de S. Michel.
 Pierre Louis Moreau de Maupertuis, d'après M. De Tourniere.
 Pierre Augustin Le Mercier, imprimeur ordinaire de la Ville, d'après M. Van Loo, Premier Peintre du Roy d'Espagne.

1745 Le Portrait gravé de Claudius de S. Simon, Episcopus Princeps Metensis. Par Franciæ S. R. J. Princeps. D'après M. Rigaud.

1748 Douze Morceaux gravez.

1750 La Naissance et le Triomphe de Venus, d'après l'Esquisse de M. Boucher.
 Les Amours en gayeté, d'après le même.
 L'Enfant qui joue avec l'Amour, d'après Wandik.
 L'Essayeuse de Fleches, d'après M. Nonnotte.
 Le Portrait du Pere Chambroy, Abbé General de Sainte Geneviéve de Paris, d'après M. Peronneau.

1753 Départ de Marie de Médicis, appelé communément le Quos Ego ; d'après Rubens.
 Deux Portraits de jeunes gens en pied ; d'après le même.
 Une Madeleine, d'après le Corrége.
 Une Vierge et l'Enfant Jesus, d'après Carle Maratte.
 Un Diogène, d'après l'Espagnolet.
 Le Portrait à Cheval de M. de Nestier, Ecuyer ordinaire de la grande Ecurie du Roy ; d'après M. de la Rue, agréé de l'Académie.

1755 Cinq Sujets :
 Le Portrait de Monsieur * * * en Robe de taffetas rayé, d'après le Tableau de M. Nonnotte.
 Le Portrait de Madame Favart, sous l'habit de Bastienne, d'après le Dessein de M. Carle Vanloo.
 L'Amour menaçant, d'après le Tableau de feu M. Coypel, premier Peintre du Roi.
 La Musique pastorale, }
 Les Amusemens champêtres, } d'après les Desseins de M. Boucher.

1757 S. Pierre, tiré de la Gallerie Royale de Dresde, d'après le Lanfranc.
 Les Charmes de la Vie Champêtre, dédié à M. le Marquis de Marigny, Direñeur et Ordonnateur Général des Bâtimens de Sa Majesté, d'après M. Boucher.
 Le Portrait de Monseigneur De Lamoignon, Chancelier de France. D'après M. Valade.

1757 Le Portrait de Racine. D'après Santerre **Daullé**
 Le Portrait d'un Vieillard. D'après Rubens. **(Jean).**
 Un Savoyard montrant la Lanterne magique. D'après M. Pierre.
 La Muse Uranie, d'après M. Jeaurat.

1759 Jupiter sous la forme de Diane, Amoureux de Calisto, d'après le Poussin.
 Dédié à M. de Betzky, Général Major et Chambellan de Sa Majesté
 l'Impératrice de toutes les Russies, Chevalier de l'Ordre de Sainte Anne.
 Le Turc qui regarde pêcher, d'après M. Vernet.
 La Grecque sortant du Bain, d'après M. Vernet.
 La surprise du Bain, d'après le Nain.
 Une Chienne Braque avec ses petits, d'après M. Oudry.

DEBUCOURT (LOUIS-PHILIBERT)

1781 Le Gentilhomme bienfaisant. Un Seigneur ouvre sa bourse pour soulager
 une famille, dont le père expire, dans l'instant que l'on vient pour dettes
 enlever les meubles de la maison. Ce Tableau a 20 pouces de large, sur
 17 de haut.
 L'Instruction Villageoise. Tableau de 15 pouces de large, sur 12 de haut.
 Le Juge de Village. De même grandeur.
 La Consultation redoutée. De 13 pouces sur 11.
 Plusieurs petits Tableaux.

1783 Vue de la Halle, prise à l'instant des réjouissances publiques données par la
 Ville le 21 Janvier 1782, à l'occasion de la naissance de Monseigneur
 le Dauphin. 3 pieds 8 pouces de large, sur 2 pieds 9 pouces de haut.
 Un Charlatan. 8 pouces de large, sur 6 de haut.
 Deux petites Fêtes, même grandeur.
 Plusieurs petits Tableaux.

1785 La feinte caresse. Un vieillard sourit en regardant le portrait commencé de
 sa jeune épouse qu'il fait peindre, tenant le sien en médaillon, tandis
 qu'appuyée sur son épaule, elle lui caresse la joue, et profite de sa folle
 confiance, pour glisser un billet au jeune Artiste, qui lui baise la main.
 15 pouces de large, sur 12 de haut.
 Autres Tableaux.

DELAUNAY L'AÎNÉ (NICOLAS), Gr.

1777 Marche de Silene. D'après Rubens.
 Endymion.
 Léda.
 Le Portrait de M. l'Abbé le Bloy. D'après M. Roslin.
 La Complaisance Maternelle.
 L'Heureuse Fécondité. D'après M. Fragonard.
 Trois Sujets, sous le même quadre, pour la Nouvelle Héloïse.
 Première Ruine Romaine.
 Seconde Ruine Romaine.
 Le Four à Chaux.
 La Chûte dangereuse.

Delaunay l'aîné (Nicolas).	1777	Deux quadres contenant chacun six petits Sujets. D'après MM. Cochin, Monnet et Moreau, pour les éditions de Roland Furieux, Télémaque, etc. Noce interrompue. D'après M. le Prince.

Delaunay l'aîné (Nicolas). 1777 Deux quadres contenant chacun six petits Sujets. D'après MM. Cochin, Monnet et Moreau, pour les éditions de Roland Furieux, Télémaque, etc.
Noce interrompue. D'après M. le Prince.

1779 La Bonne Mère. D'après M. Fragonard.
Le Bonheur du Ménage. D'après M. le Prince.

1783 La Partie de plaisir. D'après Wœnix.
Dites, s'il vous plaît.
Les Beignets.
Deux Estampes gravées d'après M. Fragonard.
La Gaieté Conjugale. D'après le Dessin de M. Frendeberg.

1785 La Consolation de l'Absence. D'après Lavreince.
L'Enfant chéri. D'après le Prince.

1787 La première leçon d'amitié fraternelle. D'après M. Aubry.
Angélique et Médor. D'après Raoux.
Le Chiffre d'Amour. D'après M. Fragonard.
L'abus de la crédulité. D'après M. Aubry.

1789 Portrait de feû M. de Troy fils, Directeur de l'Académie de France à Rome.
Portrait de feû M. le Clerc, Professeur de perspective.

1791 L'Education fait tout. Estampe gravée d'après M. Fragonard.
Autre Estampe. La gaieté de Silene.
Une Estampe. Le petit Prédicateur.
Les Regrets mérités.

EISEN (CHARLES-DOMINIQUE-JOSEPH)

[EXPOSITIONS DE L'ACADÉMIE DE ST. LUC]

1751 Un Tableau, représentant Icare et Dédale, fait pour la reception de l'Auteur.
Un Plafond allégorique, représentant la Nature qui tient une Corne d'abondance d'une main, et de l'autre retient par une de ses ailes le Génie qui semble toujours s'écarter du vrai. On y voit les attributs de l'Architecture, de la Sculture et de la Peinture.
Plusieurs Dessins et Esquisses.

1752 L'Histoire de Lucas Sinorelli, un Tableau de toile de quatre pieds sur trois en hauteur, représentant l'Attelier d'un Peintre occupé à faire le Portrait d'un jeune Homme qui vient d'être tué ; ce que l'on reconnoît à l'expression d'un Vieillard où la douleur et la fermeté se confondent. Ce Sujet est tiré de l'Histoire abregée des Peintres de Depille.
Une Esquisse du Serpent d'Airain qui a été représenté en grand.
Deux Desseins faisant Pendant en hauteur, faits pour Madame la Marquise de Pompadour, dont l'un représente une Automne, dessinée d'après un Bas-Relief d'yvoire qui lui appartient.
 Et l'autre un Printemps dessiné et composé par le sieur Eisen. Ces deux Desseins sont gravés par Madame la Marquise de Pompadour.
Un Dessein qui avoit été fait pour servir de Cul-de-Lampe à l'Oraison Funébre de Madame HENRIETTE DE FRANCE.
Plusieurs Desseins.

1753 Un Dessein d'une Vue de Paris du Pont Royal au Pont Neuf. Les figures Eisen
représentent l'entrée de Son Excellence M. le comte de Kaunitz Ritzberg, (Charles-
Ambassadeur de l'Empereur. Le Dessein a environ trois pieds et demi Domin-
de large sur deux de haut.[1] ique-
Plusieurs autres desseins tirés des Contes de la Fontaine. Joseph).
D'autres qui doivent servir d'Ornement au Poeme de la Christiade.
Le Dessein du Frontispice fait pour la nouvelle édition d'Alphonse du Fresnoy.
Autre pour la nouvelle Edition du Puffendorff.
Plusieurs Vignettes pour le même Ouvrage.
Plusieurs autres Desseins d'un Œuvre, suivis à l'usage de différens Artistes,
Architecture, Sculpture, Ciselure, Orfévrerie, Bijouterie, que l'Auteur fait
graver pour lui contenant six feuilles chaque Livre, dont il vient de mettre
le premier au jour, qu'il a eu l'honneur de dédier à M. le Marquis de
Voyer d'Argenson (Le reste de cet article manque sur l'édition A. Le
suivant est sans doute le même qui est en tête des œuvres d'Eisen sur cet
édit. A.) Maréchal des Camps et Armées du Roi, Lieutenant Général
pour Sa Majesté en sa Province d'Alsace, Gouverneur de Romorantin,
Inspecteur Général de Cavalerie de Dragons, Directeur Général des
Haras du Royaume.
Le Portrait d'une Demoiselle, peint à l'huile, de grandeur de Tabatière.

1756 Un Frontispice de l'Histoire Militaire de Flandre. L'on voit, dans ce Dessein,
Minerve tenant une Médaille qui représente le Roi ; elle ordonne à la Re-
nommée d'aller publier les exploits guerriers de ce Prince et de le couronner
de lauriers. Cette Médaille est soutenue par le Tems que des Enfans
enchaînent, et dont ils arrachent la faux, pour retarder l'instant où ce
Monarque bien-aimé doit être placé avec ses Ayeux au Temple de
Mémoire : c'est le vœu qui fait l'Auteur comme le plus respectueux et
plus fidèle sujet de SA MAJESTÉ, hauteur de 11 pouces 8 lignes, sur
7 pouces de large.
Un Frontispice qui doit servir en Cour d'Hollande : l'on voit dans ce Dessein
une Figure qui caractérise la Hollande sur son Thrône, tenant d'une main
une Couronne d'abondance, de l'autre une Caducée ; un Indien qui lui
présente les Tributs de sa Nation ; à côté, un Génie tenant les armes de
la Maison de Nassau ; deux autres sont occupés à tenir un Gouvernail,
l'autre met la boussole autour du tronc ; plusieurs ballots de Marchandises
caractérisent le Commerce ; le fond représente un Combat Naval, de
7 pouces 8 lignes de hauteur, sur 4 pouces 8 lignes de largeur.
La Vignette de l'Epître Dédicatoire du même Ouvrage représente les Armes
de Monseigneur le Duc d'Orléans que Minerve couronne ; on voit à côté
les Génies qui caractérisent la Guerre et les Arts. Ce Dessein a 8 pouces
de long, sur 3 pouces de haut.
Le premier Sujet du Pastor Phido représente Neve du grand zele montant,
préchant au bord du Fleuve Alphe, à l'ombre d'une plaine, lorsqu'un
Habitant des eaux, lui remettant son Fils entre les mains, lui recommande
d'en avoir soin, devant être le bien et l'appui de sa Patrie ; l'on voit, dans
le fond le Temple de ce Dieu, et dans un côté du lointain, un orage se
préparer. Ce Dessein a 6 pouces de haut, sur 4 pouces de large.
La Poësie. L'on voit dans ce Sujet des Poëtes et des Philosophes appliqués à
étudier cet Art, et les autres s'empresser de montrer leur Ouvrage à
Appollon pour avoir ses lumieres.
La Peinture, la Sculpture et l'Architecture. L'on y voit la Peinture avec ses
Attributs ; la Sculpture appliquée à faire un Buste du Roi ; l'Architecture

[1] A la place de cet article, l'éd. A contient le suivant : Un petit portrait de grandeur d'une
Tabatière, peint à l'huile.

Eisen **1756** achevant un modele en élévation : l'on voit au bas des Génies occupés à
(Charles- dessiner d'après la bosse.
Domin-
ique- L'Astronomie. L'on y voit des Etudians aux Astres ; un tient un papier, sur
Joseph). lequel est tracée une Mappemonde ; dans le fond, des Ingénieurs qui
 travaillent sur le terrein ; au-dessus de cet Sujet, est Appollon qui préside.

La Statue Pédestre du Roi : des jeunes Militaires faisant l'exercice auquel
préside Minerve. Ces quatre Desseins ont chacun 10 pouces 11 lignes,
sur 8 pouces 8 lignes de long.

Deux Desseins allégoriques de même grandeur.

Un jeune Militaire étudiant l'Art de la Guerre, tandis qu'un Officier de ses
amis entre doucement dans le Cabinet, accompagné de la Générosité
voilée ; elle pose sur la table un depôt et semble appréhender d'être
apperçue dans l'action généreuse qu'elle fait. Ces Figures sont historique-
ment habillées. Le jeune Guerrier entrant dans le Cabinet du Firmacie,
son bienfaiteur, accompagné de la reconnoissance, qui vient pour lever le
voile de la générosité qui accompagne toujours ce Philosophe, qui se levant
prestement, pour aller d'une main prendre le bras de la Reconnoissance,
et accueillant de l'autre le jeune Militaire qui s'en saisit et la baise. Ces
deux Desseins ont chacun six pieds de haut, sur 4 pieds de long.

Deux Desseins de même grandeur. Le premier représente Hercule qui
étouffe Antée. L'autre représente Bellerofon qui combat Chienne.

Deux autres Desseins représentans Saint Sébastien, faits pour servir d'Esquisse
à un Tableau d'Autel, de 8 pouces de haut, sur 4 de large.

Un jeune Seigneur au Berceau, entouré des Arts, de 11 pouces de hauteur, sur 5
de large.

Une Etude d'un Cheval ; d'un pied 1 pouce de long, sur huit pouces de large.

Trois Paysages dessinés au crayon rouge.

Un représentant l'entrée d'une Forêt déserte, des Animaux que des Gens
menent. Ce dessein a 14 pouces 10 lignes de long, sur 10 pouces de
haut.

Les deux autres représentent une Tempête sur Mer, de chacun 1 pied de haut,
sur 10 pouces de large.

Une Pastorale, lavée à l'encre de Chine, de la longueur de 7 pouces, sur
5 pouces de haut.

Une Estampe représentant la Gallerie du Roi de Pologne, le Génie des
beaux Arts ordonne de placer la nuit du Corrége, qui est le principal
Tableau que possede ce monarque : au bas sont des Génies qui s'amusent
à chercher l'avis du Peintre dont il examine les Tableaux. Le fond
représente la Gallerie où sont attachés les Tableaux. Cette Estampe a
8 pouces de long, sur 6 de haut.

Plusieurs Desseins de différentes grandeurs.

1762 Un Tableau de quatre pieds, sur trois pieds, représentant Lucas Signiorelli, qui
peint son Fils qui vient d'être tué.

Un Projet dessiné pour une Chapelle de Communion.

Une Esquisse de Tableau d'Autel de ce même Projet, représentant Notre
Seigneur qui fait la Cène avec ses Apôtres.

Autre Esquisse, représentant l'Annonciation de la Vierge, exécutée en grand.
Ce Tableau a 13 pieds ½ de haut, sur 10 pieds de large, fait pour l'Église
Collégiale de Douay en Flandre.

Autre Esquisse, représentant le Mariage de la Vierge.

Le Portrait de Madame Vincent.

Le Portrait de M. l'Abbé de * * *.

Quelques Esquisses et plusieurs Desseins.

1764 Sainte Genevieve assise dans la Campagne, faisant la lecture. Ce Tableau est

1764 destiné pour la Chapelle d'un Château; il porte 6 pieds de haut sur Eisen
 4 pieds de large. (Charles-
 L'Enlevement de Proserpine. Domin-
 Plusieurs desseins à la mine de plomb, et lavés à l'encre de la Chine, repré- ique-
 sentant différens Sujets. Joseph).

1774 Le Triomphe de Cybele et les Forges de Vulcain, représentés tous deux par
 des enfans. Ces Tableaux portent 12 pouces de haut, sur 15 de large.
 Diane et Endimion. Ce Tableau est de la même grandeur que le précédent.
 Erigone, et l'Amour sous la forme d'une grappe de raisin. Hauteur 14 pouces,
 largeur 16 pouces.
 L'Aurore semant des fleurs et chassant les Ombres de la Nuit. Hauteur
 15 pouces, largeur 16 pouces.
 Sainte Famille, et pour Pendant le Songe de Saint Joseph.
 Ces deux Desseins sont à la Sanguine, rehaussées de blanc.
 La Charité représentée par une Femme entourée d'Enfans. Dessein à la
 plume et au bistre.
 Les trois Grâces. Petit Dessein colorié de forme ronde.
 Deux Desseins coloriés, dont un représente un Marché. Ils sont pendans.
 Des Enfans jouant avec une Chèvre, Dessein à la plume et à l'encre de Chine.
 Plusieurs Desseins.

FLIPART (JEAN-JACQUES), Gr.

1755 Adam et Eve, d'après le Tableau de M. Natoire. Du Cabinet de M. de
 Villette, Trésorier de l'Extraordinaire des Guerres.
 Une Sainte Famille, d'après Jules Romain. De la Gallerie du Roi de Pologne,
 Electeur de Saxe.
 Six petits Morceaux gravés d'après M. Boucher et M. Cochin.

1757 Deux Estampes d'après M. Chardin.
 Six petits morceaux sous un même verre, dont quelques-uns d'après les desseins
 de M. Cochin.

1763 Vénus et Enée. D'après M. Natoire.
 Un Morceau gravé d'après M. Boucher, servant de Frontispice à la vie des
 Peintres.
 Une jeune Fille qui pelotte du cotton. D'apres M. Greuze.
 Le Portrait de M. Greuze. D'après un Dessein fait par lui-même.
 Cinq petits Morceaux, d'après M. Cochin.

1765 Une Tempête. D'après M. Vernet.
 La vertueuse Athénienne. }
 La jeune Corinthienne. } D'après M. Vien.

1767 Le Paralytique servi par ses Enfans.
 Une jeune Fille qui pleure la mort de son Oiseau. D'après M. Greuze.

1771 L'Accordée de Village. D'après le Tableau de M. Greuze, du Cabinet de
 M. le Marquis de Marigny.

1773 Une Tempête au Clair de la Lune. D'après M. Vernet.
 Une Chasse aux Tigres. D'après le Tableau de F. Boucher; du Cabinet
 du Roi.

1777 Le Gâteau des Rois. D'après M. Greuze.

LARMESSIN (NICOLAS DE), Gr.

1737 Quatre sujets gravez d'après differens Maitres.

1738 Œuvres en gravûres.

1739 Un Sujet des Ouvrages en gravûre.

1741 Le Portrait de Monseigneur le Dauphin d'après M. Toqué.
Les Quatre Heures du jour, d'après M. Lancret.

1742 Le Calendrier des Vieillards, d'après M. Boucher.
Les Remords, d'après M. Lancret.
On ne s'avise jamais de tout, d'après le même.

1743 Le Fleuve Scamandre ; gravé d'après M. Boucher, Professeur de l'Académie.

1745 Les 4 Saisons, d'après M. Lancret, et son dernier Ouvrage.
Le Portrait gravé de M. l'Abbé de Clairvaulx, peint par Mademoiselle Loir.

1746 Un Morceau gravé.
La Savoyarde ; d'après M. Pierre.

1747 La Savoyarde ; d'après M. Pierre.

1748 Le Portrait gravé de M. de Woldemar de Lowendal, Comte du S. Empire,
Maréchal de France, Chevalier des Ordres du Roy ; d'après M. Boucher,
Professeur.

1751 Un Frontispice allégorique, d'après M. Boucher, Professeur.

1753 Quatre Sujets de l'Ancien Testament ; sçavoir, la Création, le Passage du
Jourdain, David, Isaie.

LE BAS (JACQUES-PHILIPPE), Gr.

1737 Deux sujets en gravûre d'après Tenieres.

1738 Œuvres gravées.

1739 Deux sujets des Ouvrages gravez.

1740 Huit Sujets pour la Traduction Angloise de l'Histoire ancienne de M. Robin.
Rendez-vous de Chasse ⎫
Le Chasseur fortuné ⎭ d'après Van-Falens.

1741 Le Sanglier forcé, d'après Wouwermens, dédié à M. le Comte de Tessin.
Prise du Héron, d'après Vanfalens, dédié au Docteur Mide.
Deux Estampes d'après Berghem ; l'une représentant le Soir, l'autre le
Matin.
Deux Païsages d'après Téniéres ; l'un, une Vûë de Flandre ; et l'autre,
l'Arc-en-Ciel.

192

1742 Cinq Sujets gravez.
 Le Negligé, ou Toilette du matin. D'après M. Chardin.
 Halte de Cavalerie. D'après Wouvermans.
 Départ de Chasse. D'après Wanfalens.
 Le Midi de Berghem, dédié à M. le Baron de Thiers.
 L'après-diné de Berghem, dédié au même.

1743 Quatre Sujets gravez d'après différens Maitres.
 Moisson, ou 3ᵉ vûë de Flandres ⎫
 Jeu de Boule, ou 4ᵉ vûë de Flandres ⎬ d'après D. Teniers.
 Conversation galante, d'après M. Lancret.
 Courrier de Flandres, d'après Bott.

1745 Neuf Morceaux gravez.
 Le Siffleur de Linottes.
 Le Gagne-petit.
 La Ferme.
 La Basse-cour.
 La Guinguette Flamande.
 La Pêche.
 La Vente de la Pêche.
 Le tout d'après David Tenier.
 La premiere et seconde vûe de Beauvais, d'après M. Boucher.

1746 Sept morceaux gravez d'après Teniers; dediez par l'Auteur à differens
 Seigneurs, parmi lesquels sont,
 Le Concert et Famille de Teniers.
 Le Port de Mer.
 La Tentation de S. Antoine.
 Le Fluteur.
 Le Chimiste, etc.

1748 Trois Fêtes flamandes; d'après David Teniers.
 Vûe de Santuliet, Village d'Hollande; d'après Wanderver.
 Vûe de Schevelinge, aussi Village de Hollande.
 Le Maitre Galant; d'après Lancret.

1750 Les Philosophes Bachiques, de David Teniers. Tiré du Cabinet de M. le
 Comte de Vence.
 Les Miseres de la Guerre, d'après le même. Du Cabinet de M. le Marquis
 de Calviere.
 Les Pêcheurs Flamands, d'après le même. Tiré du Cabinet de M. le Comte
 de Vence.
 Vûe de Flandre, d'après le même. Dédiée à M. Slodtz l'aîné.
 Autre Vûe de Flandre. Dédiée à M. Slodtz de S. Paul.
 Autre Vûe de Flandre. Dédiée à Mylord, Comte de Castlemain.
 Fête Flamande, d'après le même. Tirée du Cabinet de M. le Comte de
 Choiseuil. Dédiée à Madame la Marquise de Pompadour.

1751 L'Enfant prodigue; d'après D. Teniers, Nº 61.
 Départ pour la Pêche; d'après M. Vernet de Rome.
 Port de Mer d'Italie; d'après le même.

1753 Les Fêtes de la Ville du Hâvre de Grace, en six Morceaux, dessinées sur les
 lieux, par le Sieur Descamps, Peintre et membre de l'Académie de Roüen;
 à l'occasion du voyage et du séjour que le Roy y a fait en 1749, les-
 quelles Fêtes ont été présentées à Sa Majesté, ainsi qu'à la Famille Royale,
 le 29 juillet, par les Députés de ladite Ville, ayant à leur tête M. le Duc
 de S. Aignan, le Comte de S. Florentin, et M. Rouillé.

Le Bas (Jacques Philippe).

1753 Embarquement de Vivres; d'après le Berghem; dédié à M. le Comte de S. Florentin.

1755 Six Morceaux.
Neuvième Vûe d'Anvers, d'après Teniers.
Dixième Vûe d'Anvers, d'après le même.
Du Cabinet du Roi de Pologne, Electeur de Saxe.
La Pêche Hollandoise, et la Vûe de la Montagne de Tersato: petits Paysages d'après Ruysdal.
Le Portrait de M. Grandval, d'après le Tableau de feu M. Lancret.
L'Œconome, d'après le Tableau de M. Chardin, Conseiller et Trésorier de l'Académie.

1757 Deux Estampes, d'après M. Chardin, dédiées à la Reine de Suéde.
L'une, la bonne éducation.
L'autre, l'Etude du Dessein.
La fin du Jour ⎫
Le Jour naissant ⎭ d'après Teniers.
Deux autres Estampes, d'après le même, représentans des Canards; dédiées a M. le Baron de Nagel.
Des gens qui écossent des légumes, d'après M. Greuze.

1759 Plusieurs Estampes tirées du Livre intitulé: Les Ruines des plus beaux Monuments de la Grêce. Dédié à M. le Marquis de Marigny, par M. le Roi, Architecte du Roi.

1761 Les quatre premieres Estampes de la suite des Ports de France, d'après M. Vernet, gravées en société avec M. Cochin.

1763 La récompense Villageoise, d'après le Tableau original de Claude le Lorrain, du Cabinet du Roi.
Les quatre Estampes de la seconde suite des Ports de France, d'après M. Vernet, gravées en société avec M. Cochin.

1765 Les quatre estampes de la troisiéme suite des Ports de France, par M. Vernet, gravés en société avec M. Cochin.

1767 Les deux Estampes de la quatrième suite des Ports de France; par M. Vernet, gravées en société avec M. Cochin.

1769 L'une des seize Estampes qui sont gravées à Paris pour l'Empereur de la Chine. Elle représente un combat des Chinois contre les Tartares. Elle est gravée d'après le dessin fait en Chine par le P. Castillon, Jésuite.

1771 Trois Estampes, faisant partie des seize qui sont gravées à Paris pour l'Empereur de la Chine, et qui représentent ses Conquêtes ou des Cérémonies Chinoises. Elles ont 2 pieds 9 pouces de haut, sur 1 pied 7 pouces de large.
La Revue de la Maison du Roi au Trou-d'Enfer.
Deux Estampes; l'une la Source abondante; l'autre, les Occupations du Rivage. D'après M. Vernet.
Vue des environs de Groningue. D'après Ruisdaal.
Troisième et IVᵉ Fêtes Flamandes. D'après Teniers.
Deux autres. Du Cabinet de M. le Duc de Choiseul.
L'Embarquement des Vivres. D'après Berghem.
Autre, dont le titre est: *Pensent-ils à la Musique*. D'après Téniers; du Cabinet de M. le Duc de Praslin.
La Vue de l'ancien Pont de Messine. D'après le Tableau de Claude Lorrain, appartenant au Roi. Elle fait le pendant à la Récompense Villageoise.

1773 Achille reconnu par Ulysse. D'après Teniers.

Un Paysage. D'après Pinnaker.

La Sainte Famille. D'après Reimbrant.

Les trois Moulins, et la Route de Flandres. D'après Breughels de Velours.
Ces cinq morceaux sont du Cabinet de M. le Duc de Choiseul.

Les Satyres et les Driades. D'après Berghem.

Un Taureau. D'après P. Potter.

Le marché conclu, la cinquieme et la sixieme Fête de Village. Trois Sujets,
d'après Teniers ; du cabinet de M. de Baudouin, Capitaine aux Gardes
Françoises.

La septieme Fête de Village. D'après Teniers ; du Cabinet de M. le Duc
de Cossé.

1775 Le Retour à la Ferme. D'après Berghem ; du Cabinet de M. le Duc de
Cossé.

L'Embarquement des Vivres. Du Cabinet de M. le Duc de Praslin.

Plusieurs Estampes. D'après Teniers ; du Cabinet de M. le Marquis de
Brunoy.

Plusieurs Estampes. D'après Teniers ; du Cabinet de M. le Comte de
Baudouin.

1777 Vue du Port et de la Citadelle de Saint-Pétersbourg sur la Nerwa, prise dessus
le Quai, près du Palais du Grand-Chancelier Comte de Beſtouchef. Elle
doit être dédiée à Sa Majesté l'Impératrice de toutes les Russies. D'après
le Tableau de M. le Prince, appartenant à Madame la Marquise de
l'Hôpital.

Ancien Aqueduc de Pénestre, près de Rome. D'après Corneille Poulembourg ;
dédié à M. le Duc de Cossé, et tiré de son Cabinet.

IXᵉ Fête Flamande. D'après le Tableau de D. Teniers, dédiée à M. le
Comte de Baudouin.

Vues du Cotentin, en deux Estampes. D'après les Tableaux de Michau, aussi
dédiées à M. le Comte de Baudouin.

Ruines d'Ephèse et l'ancien Temple. D'après Bartholomée Bréemberg ;
dédiées à la M. le Duc de Nivernois, et tirées de son Cabinet.

1779 Port de Dieppe. D'après M. Vernet.

Figures de l'Histoire de France ; Ouvrage proposé par souscription.

1781 Deux Cadres contenant chacun 35 sujets de figures de l'Histoire de France,
dessinés par M. Moreau, le jeune.

 Nota. Il a paru 6 livraisons de 18 Estampes chacune de cet Ouvrage,
proposé par souscription, la septieme paroît aſtuellement.

Vue du Port du Havre, faisant la seizieme Estampe de la colleſtion des Ports
de France ; cette vue est dessinée par M. Cochin et gravée en société par
MM. Cochin et le Bas.

 Elle a 28 pouces de large, sur 20 de haut.

Deux vues de l'Isle-Barbe, sur la riviere de Saone, au-dessus de Lyon, gravées
d'après les Tableaux de M. Olivier, ancien Pensionnaire du Roi de
Sardaigne. Largeur 28 pouces, hauteur 20.

La belle Après-dinée, d'après un Tableau de Carle Dujardin, tiré du Cabinet de
S. A. S. Mgr. le Prince de Condé. Cette Estampe de 13 pouces de haut,
sur 11 de large, fait pendant à la Fraiche-matinée.

Vue des environs d'Anvers.

Vue des Environs de Bruxelles.

 Ces deux Estampes faisant pendant, de 14 pouces de large, sur
10 de haut, sont gravés d'après Breugle de Velours, et dédiées à S. A. R. le
Prince Charles de Lorraine.

Le Bas
(Jacques-
Philippe).

1781 Second Vue de Bruges, d'après le même Auteur, tiré du **Cabinet de S. A. S.** Mgr. le Prince de Condé. 16 pouces de large, sur 12 de haut.
Un cadre renfermant plusieurs Dessins pour l'Histoire de France, gravés sous la direction de M. Lebas à qui ils appartiennent. Par *M. Moreau le jeune.*

1793 Vue du Port et de la Ville de Rouen, prise de la pointe de l'Isle de la Croix, au Sud-Sud-Est.
Vue du Port et de la Ville de Rouen, prise de la petite chaussée, à l'Ouest de la Ville.
Dessinés d'après nature par C. N. Cochin et gravés sous la direction de Lebas et Choffard.
Ces deux Estampes sont les Nᵒˢ 17 et 18 de la Collection des Ports de Mer de France, d'après Vernet, et se trouvent chez Bazan, rue Serpente, Nᵒ 14.

LEMPEREUR (LOUIS-SIMON), Gʀ.

1761 Les Forges de Vulcain, d'après M. Pierre, dédiée à M. le Marquis de Marigny. Quelques autres Estampes.

1763 Les Baigneuses. D'après M. Carle Vanloo, Premier Peintre du Roi.
L'Enlévement d'Europe. D'après M. Pierre.

1765 Le Triomphe de Silene. D'après feu M. Carle Vanloo.
Titon et l'Aurore. D'après M. Pierre.
Ces Tableaux sont du Cabinet du Roi.
Le Portrait de Mᵐᵉ Lecomte. D'après le Dessein de M. Watelet.

1767 Le Portrait de M. Watelet. D'après le Dessein de M. Cochin.
Le Portrait de M. de Belloy, sujet allégorique, d'après le Tableau de M. Jollain, Peintre du Roi. La Ville de Calais présente au Génie de la Poésie le Médaillon de M. de Belloy, pour être attaché à la Pyramide de l'Immortalité. Sur la Pyramide, on voit un Bas relief où le Roi Edouard est représenté condamnant à la mort Eustache de Saint-Pierre et ses généreux Compagnons. Au bas est un Enfant qui tient les clefs et les armes de la Ville, et près de lui un Chien, symbole de la fidélité de ces vaillans Citoyens. On aperçoit dans le fond le Port de Calais.
C'est sous les ordres de M. le Duc de Charost, Gouverneur de Calais, que cette Estampe a été gravée.

1769 Les Jardins d'Amour. Estampe connue aussi sous le nom de la Famille de Rubens, dont elle présente les Portraits. D'après le Tableau de Rubens.

1773 Le Festin Espagnol. D'après Palamede Stevens.
Les Sermens du Berger. D'après M. Pierre.
Les Présens du Berger. D'après F. Boucher.

1775 Une Vieille faisant des remonstrances à sa Fille. D'après le Tableau de M. Wille le fils.

1777 La Mère indulgente.
Les Conseils Maternels. D'après les Tableaux de M. Wille le fils.
Le Portrait de M. Jeaurat, Recteur de l'Académie. D'après M. Roslin ; c'est le Morceau de Réception de l'Auteur.

1779 L'enlèvement de Proserpine. D'après le Morceau de Réception de la Fosse.
Cette Estampe est . . . de la suite que l'Académie fait graver.

1779 Sylvie guérit Philis de la piquuure d'un Abeille. Lem-
L'Amour ranime Aminte dans les bras de Sylvie. pereur
Sylvie fuit le loup qu'elle a blessé. (Louis-
Ces trois Sujets tirés de l'Aminte du Tasse, sont d'après M. Boucher. Simon).

1781 Une Vénus. Estampe gravée d'après Annibal Carrache.

1789 Les Graces lutinées par les Amours. D'après M. de la Grenée.
Les Amours enchaînés par les Graces. D'après le même.

MOREAU LE JEUNE (JEAN-MICHEL), Dess. et Gr.

1777 Deux quadres contenant chacun six petits Sujets. D'après MM. Cochin,
Monnet et Moreau, pour les éditions de Roland Furieux, Télémaque,
etc. Par *M. Delaunay.*

1781 Deux Cadres contenant chacun 35 sujets de figures de l'Histoire de France,
dessinées par M. Moreau, le jeune.
Nota. Il a paru 6 livraisons de 18 Estampes chacune de cet Ouvrage,
proposé par souscription, la septieme paroît actuellement. Par *M. Le Bas.*
Cérémonie du Sacre de Louis XVI.
Ce Dessin a été ordonné par M. le Maréchal Duc de Duras ; c'est
le moment où Sa Majesté prononce le serment.
Estampe gravée d'après la même Dessin.
L'Estampe de même grandeur que le Dessin, a 30 pouces de long,
sur 19 de haut.
Dessin de l'Illumination, ordonnée par M. le Duc d'Aumont, pour le mariage
du Roi.
Cette vue est prise du bas du tapis vert, d'où l'on voit toute l'étendue
du Canal.
Cette Estampe et ces deux Dessins précédents appartiennent au Roi.
Dessin représentant Louis XV à la Plaine des Sablons, passant en revue les
Régimens des Gardes-Françoises et Suisses, l'instant est celui où les troupes
défilent devant Sa Majesté.
Ce Dessin a 1 pied de haut, sur 2 pieds 3 pouces de long.
Trois Etudes au pastel, une tête de Femme et deux de Vieillards.
Le Portrait de Paul-Jones, dessiné d'après nature, en 1780.
Vingt-neuf Dessins in-4° des Œuvres de J. J. Rousseau, pour l'édition de
Bruxelles.
Un cadre renfermant plusieurs Dessins pour l'Histoire de France, gravés sous
la direction de M. Lebas à qui ils appartiennent.
Autre cadre contenant cinq Dessins in-8° pour les Œuvres de l'Abbé Métastase,
et une grande vignette pour mettre à la tête de la Description générale de
la France ; le sujet est l'établissement de l'Ordre de la Toison d'Or, par
Philippe le Bon, Duc de Bourgogne.
Une vue de l'Orangerie de Saint-Cloud.
Plusieurs Dessins in-4°, sujets de la Henriade, qui formeront la premiere
livraison des Estampes proposées par souscription, pour l'ornement des
Editions de M. de Voltaire.
Cette livraison paroîtra en Janvier 1782.
Arrivée de J. J. Rousseau au séjour des Grands Hommes ; sur le devant,
Diogene souffle sa lanterne.
Cette Estampe paroîtra au jour dans trois mois.
Plusieurs Dessins et Esquisses.

197

Moreau le jeune (Jean-Michel).

1783 Quatre Dessins des Fêtes de la Ville, à l'occasion de la naissance de Mgr. LE DAUPHIN:

Le premier, l'arrivée de la Reine à l'Hôtel-de-Ville.

Le second, le Feu d'Artifice.

Ces deux dessins ont 27 pouces de long sur 17 de haut.

Le troisieme, le Repas donné par la Ville à leurs Majestés.

Le quatrieme, le Bal Masqué.

Dessin allégorique pour la convalescence de MADAME Comtesse d'Artois.

14 pouces de long, sur 10 de haut.

Autre Dessin allégorique. 12 pouces de haut, sur 9 de large.

Douze Dessins pour les Œuvres de Voltaire, dont la collection est dédiée a S. A. R. Frédéric-Guillaume, Prince de Prusse.

Fabricius recevant des Députés au moment qu'il fait cuire des légumes. Ce Dessin appartient à M. le Duc de Chabot.

Fête projettée sur l'emplacement de l'Orangerie et de la pièce des Suisses à Versailles pour la Naissance de Mgr. le Dauphin, en deux Dessins de trente-trois pouces de long sur treize de haut ; le premier représente le plan et la coupe sur la plus grande longueur ; le second la vue perspective prise de l'Orangerie.

Portrait de Madame de la Ferté.

1785 Dix-huit Dessins pour les Œuvres de Voltaire :

Catilina	
Olympie	
Oreste	
Adélaïde du Guesclin	
Don Pedro	
Irene	Tragédies.
Agathocle	
Les Guesbres	
Les Scythes	
Les Loix de Minos	
Socrate, drame	
L'Ecossaise	
Le Baron d'Otrante	Comédies.
Le Dépositaire	
Memnon	
Zadig.	Contes.

2 dessins.

Le Frontispice pour les Estampes des Œuvres de Voltaire.

Portraits, Dessins.

M. Renou, Adjoint à Secrétaire de l'Académie.

M. Martini, Graveur.

M. Guillotin, Docteur en Médecine de la Faculté de Paris.

Mlle. le Prince.

Mlle. Saugrain, Graveur.

Mlle. De Corancès.

Dessins.

Caïus Marius qui, par son seul regard, arrête le Soldat qui veut le tuer.

Mort de Caton d'Utique.

Un quadre contenant 15 Dessins, pour les Figures de l'Histoire de France, Ouvrage dédié au Roi.

1787 Un grand Dessin représentant l'Assemblée des Notables.

Dessin ordonné par le Roi.

1787 Autre, représentant Tullie, faisant passer son Char sur le corps de son Pere ; il Moreau
 doit être gravé pour la réception de l'Auteur. le jeune
 Ce Dessin appartient à M^me des Entelles. (Jean-
 Sept Dessins destinés à orner l'édition de Voltaire : Michel).

Sophonisbe ⎫
Eriphile ⎬ Tragédies.

L'Ingénu ⎫
Candide ⎪
La Princesse de Babylone ⎬ Contes.
Jeannot et Colin ⎪
La Fée-Urgelle ⎭

1789 Quatre Estampes pour les fêtes de la Ville.
 Ouverture des Etats-Généraux, du 5 Mai 1789.
 Constitution de l'Assemblée Nationale, du 17 Juin suivant.
 Tullie faisant passer son char sur le corps de son pere.
 C'est le morceau de réception de l'auteur.
 Patriotisme et fidélité au Roi.
 Le 24 Février 1525, Jean le Sénéchal, Seigneur de Molac et de
 Carcado, Capitaine de cent hommes d'Armes, Gentilhomme de la Chambre
 de François premier, sauva la vie à ce Prince par le sacrifice de la sienne.
 Voyant un Arquebusier prêt à tirer sur le Roi, il se précipita au-devant du
 coup et fut tué.
 Estampe dédiée à M. le Marquis de Molac, Chef de nom et armes
 des grands Sénéchaux féodés et héréditaires en Bretagne.

1791 Douze Cadres. Portraits de Deputés. Par MM. Moreau et Labadie.
 Cadre contenant dix Dessins. Sujet du Nouveau Testament.
 Un Cadre contenant dix Dessins. Sujet tiré du Nouveau Testament. Autre
 cadre représentant la Procession d'Isis.
 Le Dessin du Frontispice des Cérémonies Religieuses.
 Deux Estampes, représentans les Etats-Généraux.
 Un Cadre contenant dix Dessins. Sujet tiré du Nouveau-Testament.
 Une Tête de Femme, dessein.

1793 Une Estampe représentant la Comédie et la Tragédie, d'après les dessins du
 Citoyen Moreau. Par *Ponce*.
 Un Cadre contenant six Vignettes, d'après Cochin, Moreau, Monnet, Eisen
 et Marillier, pour différens Ouvrages. Par *Ponce*.
 Deux Cadres contenant chacun dix Dessins pour les Evangeles.
 Les Funérailles d'une Reine d'Egypte. 2 pieds de large, sur 1 pied 7 pouces
 de haut.
 Pour l'Histoire générale et particulière des Religions et du Culte
 de tous les Peuples.

1796 Un cadre contenant cinq vignettes d'après les dessins des citoyens Cochin,
 Regnault, Monsiau, Moreau et Marillier, destinées à orner les œuvres de
 Virgile, de Rousseau, de Montesquieu et de Deshoulières. Par *Ponce*.
 Ces objets appartiennent à l'auteur.
 Un cadre renfermant dix dessins des actes des Apôtres.
 Un *Idem*, renfermant six dessins du voyage d'Anacharsis.
 Un cadre renfermant quatre dessins, deux de l'Iliade, et deux de Juvénal.
 Deux Dessins de la vie de Phocion, et deux de celle de Marc-Aurelle.

1798 Cadre contenant 47 dessins faits pour une édition de Gesner, en quatre volumes
 in-8°, que le C. Renouard publiera le 1^er Vendémiaire prochain.
 Cadre contenant 18 dessins, Actes des Apôtres, pour l'édition in-8° du nouveau
 Testament de Saugrain.
 Un Dessin pour Anacharsis.

Moreau le jeune (Jean-Michel).

1798 Un Dessin représentant Régulus retournant a Carthage, pour les œuvres de Montesquieu, in-4°.

1799 La Comédie et la Tragédie, d'après Moreau par *Ponce*.

1800 La réception de Mirabeau au Champs-Elysées d'après Moreau, le jeune. Par *Masquelier*.

SAINT-AUBIN (AUGUSTIN DE), Gr.

1771 Quatre Portraits et Etudes, dessinés d'après nature.
Vertumne et Pomone. D'après feu M. Boucher.
Quatre Sujets des Métamorphoses. Dont trois d'après M. Boucher, et un d'après M. le Prince.
Quatre Estampes ; deux pour les Comédies de Térence, une pour le Poëme de la Peinture, et une pour le Frontispice des quatre Poétiques, traduites par M. l'Abbé Batteux. D'après M. Cochin.
Une Estampe de la Suite des Conquêtes de l'Empereur de la Chine.
Dix-huit Portraits en Médaillon. D'après M. Cochin.
Cinq Portraits en Médaillon.
Le Portrait de feu M. de Crébillon. D'après le Buste de M. le Moyne.
Le Portrait de M. Diderot, en Médaillon. D'après le Dessin de M. Greuze.
Une Estampe représentant un ancien usage Russe. D'après le Dessin de M. le Prince, tiré du voyage de feu M. l'Abbé Chappe de Haute-Roche.

1773 Le Portrait de feu M. Helvétius. D'après L. M. Vanloo.
Les Portraits de MM. Piron, Philidor, Beaumé et Cochin. D'après les Dessins de M. Cochin.
Frontispice pour l'Histoire de la Maison de Bourbon. D'après F. Boucher.
Frontispice du Livre intitulé, *Essai sur le caractère, les Mœurs et l'Esprit des Femmes* : par Monsieur Thomas. D'après le Dessin de M. Cochin.

Dessins.

Portraits et Etudes.
Autres Portraits en Médaillon.
Un Concert Bourgeois, et un Bal Paré.

1775 Six Portraits en Médaillon : M. de Trudaine, M. Pierre, M. l'Abbé Raynal, etc. D'après les Dessins de M. Cochin.
Télémaque aborde dans l'Isle de Calipso. D'après le Dessin de M. Cochin.
Cette Estampe est pour l'Edition projettée in-8°, dont le texte doit être gravé.
Deux Cadres ; ils renferment chacun douze Sujets et Têtes ; d'après les Pierres gravées du Cabinet de M. le Duc d'Orléans.
Dessins. Plusieurs Portraits et Etudes, d'après Nature.

1777 Dessins. Douze Dessins à la Sanguine et douze lavés à l'encre de la Chine et au bistre ; d'après les Pierres gravées antiques du Cabinet de M. le Duc d'Orléans, dont on se propose de donner une Collection.
Ils sont renfermés sous deux quadres.
Plusieurs Portraits en Médaillons, et Etudes de Têtes dessinées à la mine de plomb, mêlées d'un peu de pastel.

Estampes.

Vénus. D'après le Tableau du Titien, qui est au Palais Royal.
Un Frontispice Allégorique. D'après les Dessins de M. Cochin.
Alexis Piron. D'après le Buste, en marbre, de M. Caffiéri.

1777 Plusieurs Portraits en Médaillons. D'après les Dessins de M. Cochin.

1779 Sujet Allégorique, dans lequel doit être placé le Portrait de Mgr. le Duc d'Orléans.

Ce Morceau doit servir de Frontispice à l'Ouvrage, intitulé: *Description des Pierres gravées de S. A. S. Mgr. le Duc d'Orléans.* Ouvrage petit in-folio.

Vignette destinée pour le même Ouvrage.

Les deux Estampes sont faites d'après les Dessins de *M. Cochin.*

Portrait. J. J. Caffieri, Sculpteur du Roi. D'après *M. Cochin.*

L. E. Baronne de * * *.

A. S. Marquise de * * *.

Dessinés et gravés par Augustin de Saint Aubin.

1783 Un cadre renfermant quatre ovales, dans chacun desquels est représentée une figure de Femme vue à mi-corps, dessinée au crayon noir, mêlé d'un peu de pastel.

Plusieurs Portraits, dessinés à la mine de plomb mêlée de pastel.

Deux cadres contenant chacun douze Dessins à la sanguine, d'après les pierres gravées antiques, du cabinet de Monseigneur le Duc d'Orléans.

Gravures.

Le Portrait de M. Perronnet, Chevalier de l'Ordre du Roi, premier Ingénieur des Ponts et Chaussées. D'après M. Cochin.

Portrait de M. de la Motte-Piquet, Chef d'Escadre.

Portrait de M. Pigalle, Chevalier de l'Ordre du Roi. D'après M. Cochin.

Portrait de M. Linguet. D'après M. Greuze.

Portrait de M. Pélerin, savant Antiquaire.

1785 M. Necker, ancien Directeur-Général des Finances. D'après M. Duplessis.

M. de Fénélon, Archevêque de Cambray. D'après Vivien.

Un quadre renfermant 8 Portraits.

Autre quadre, contenant 6 vignettes et frontispices.

1789 Portrait de M. Necker. D'après M. Duplessis. Format in-12, gravé en Juillet 1789.

Lekain, dans le rôle d'Orosmane. D'après M. le Noir, Peintre du Roi.

Un Cadre renfermant plusieurs petits Portraits d'Artistes de la Société des Enfans d'Apollon.

Deux demi-figures dans des ovales et faisant pendant, dessinées et gravées par l'Auteur.

Plusieurs Portraits dessinés à la mine de plomb, mêlés d'un peu de pastel.

1793 Jupiter et Léda, d'après le Tableau original de Paul Véronèse, qui était dans la Collection du ci-devant Palais-Royal. Grandeur du Cadre, 17 pouces de haut, sur 14 pouces de long.

Un petit Portrait en Médaillon imitant le Camée, d'après Sauvage.

Vénus Anadyomène, d'après le Tableau original du Titien, qui étoit dans la Collection du ci-devant Palais Royal. Hauteur 11 pouces, sur 8 de large.

SAINT-AUBIN (GABRIEL DE)

Par M. de Saint-Aubin, Adjoint à Professeur.

1774 Le Triomphe de l'Amour sur tous les Dieux. Plafond de 3 pieds de haut, sur 4 pieds de large.

L'Ecole de Zeuxis. . . . L'an du monde 3564. Hauteur, 1 pied 10 pouces, largeur, 1 pied 6 pouces.

Effet du Tremblement de terre de Lisbonne. Hauteur, 2 pieds 6 pouces, largeur, 2 pieds.

Un Sujet des Contes de la Fontaine. Hauteur, 1 pied 3 pouces, largeur, 1 pied.

Fête de Village et Pendant. Hauteur, 2 pieds, largeur, 2 pieds 8 pouces.

L'Amour maternel et filial, représenté par une Femme allaitant son enfant. [See sketch of "Mère donnant de la bouillie à son enfant," rep. de Goncourt, "L'Art du XVIII. Siècle."] Hauteur, 1 pied 4 pouces, largeur, 1 pied 2 pouces.

Une jeune Dame faisant réciter la leçon à un petit garçon. Hauteur, 12 pouces, sur 9 pouces de large.

Plusieurs Tableaux.

EXPOSITION AU COLYSÉE.

1776 Son portrait fait par lui-même, de 14 pouces de haut sur 11 de large.

La Tentation de Saint Antoine de forme ronde.

Deux pendants de dix pouces de haut sur dix de large : l'un est une scène tragique, l'autre un concert. Esquisses.

Une mère allaitant son enfant en peinture éludorique, de 17 pouces de haut sur treize de large.

Le Triomphe de Pompée, même peinture de dix pouces de haut sur treize de large.

Le trait de bienfaisance de la Reine à Fontainebleau de 5 pouces de haut sur 7 pouces de large, esquisse à gouache.

Une Sevreuse et des enfants, deux pastels de quinze pouces de haut sur quatorze de large.

La Rentrée du Parlement.

Le Roi posant la première pierre de l'amphithéâtre des écoles de Chirurgie.
 Ces deux pendants sont de 9 pouces de haut sur 6 de large.

Vue de l'intérieur de la rotonde du Colysée.

Un Paysage.
 Ces deux pendants de forme ronde sont de 5 pouces de diamètre.

Nouveau trait de bienfaisance de la Reine arrivé au village de Saint Michel, de 6 pouces de haut sur 8 de large.

Le Carnaval du Parnasse, représentant le caractère des 3 théâtres, de 9 pouces de haut sur douze de large.
 Ces deux numéros sont des gouaches.

NOTE.—I have not seen the *livret* of this exhibition, which is described by M. Guiffrey (" Expositions de l'Académie de Saint-Luc," p. xv) as nothing more than " un Salon posthume de l'Académie de Saint-Luc." The extract given above is taken from the de Goncourt ("L'Art du XVIII. Siècle," pp. 417, 418). They add that, three years after the death of Gabriel, Pahin de la Blancherie re-exhibited, at his famous Salon de la Correspondance, the little sketch for a "plafond projeté en 1752" and " Un Paysage avec figures dans le genre de Watteau."

WILLE (JEAN-GEORGES)

1757 La Devideuse, mere de Gerard Daw, d'après Gérard Daw.
La Ménagere Hollandoise, d'après le même.
La Tricotteuse Hollandoise, d'après Mieris.

1759 Le Portrait de M. de Boullongne, Contrôleur Général des Finances, Commandeur et Grand Trésorier des Ordres du Roi, d'après le Tableau de feu M. Rigaud.

1761 Le Portrait de M. le Marquis de Marigny, d'après le Tableau de M. Tocqué.
Le petit Physicien, d'après Gaspard Netscher.

1763 La Liseuse. D'après Gérard Dow.
Le Jeune Joueur d'Instrumens. D'après Schalken.

1765 Les Musiciens ambulans. D'après M. Dietrich, Peintre de S. A. Electorale de Saxe.

1767 L'Instruction Paternelle. D'après G. Therburg.
L'Observateur distrait. D'après F. Mieris.

1769 Le Concert de Famille. D'après le tableau de Scalken.

1771 Les Offres réciproques. D'après le Tableau de M. Dietricy, Peintre de l'Electeur de Saxe.

1777 Les bons Amis. D'après A. Ostade.
Agar présentée à Abraham. D'après Diétricy.
Le repos de la Vierge. D'après le même.

1779 Mort de Marc Antoine. D'après Pompeo Battoni.

INDEX

206

CHISWICK PRESS: CHARLES WHITTINGHAM AND CO.
TOOKS COURT, CHANCERY LANE, LONDON.

Lightning Source UK Ltd.
Milton Keynes UK
UKHW011022110119
335396UK00014B/851/P